THE ANDY
GOLDSWORTHY
PROJECT

THE ANDY
GOLDSWORTHY
PROJECT

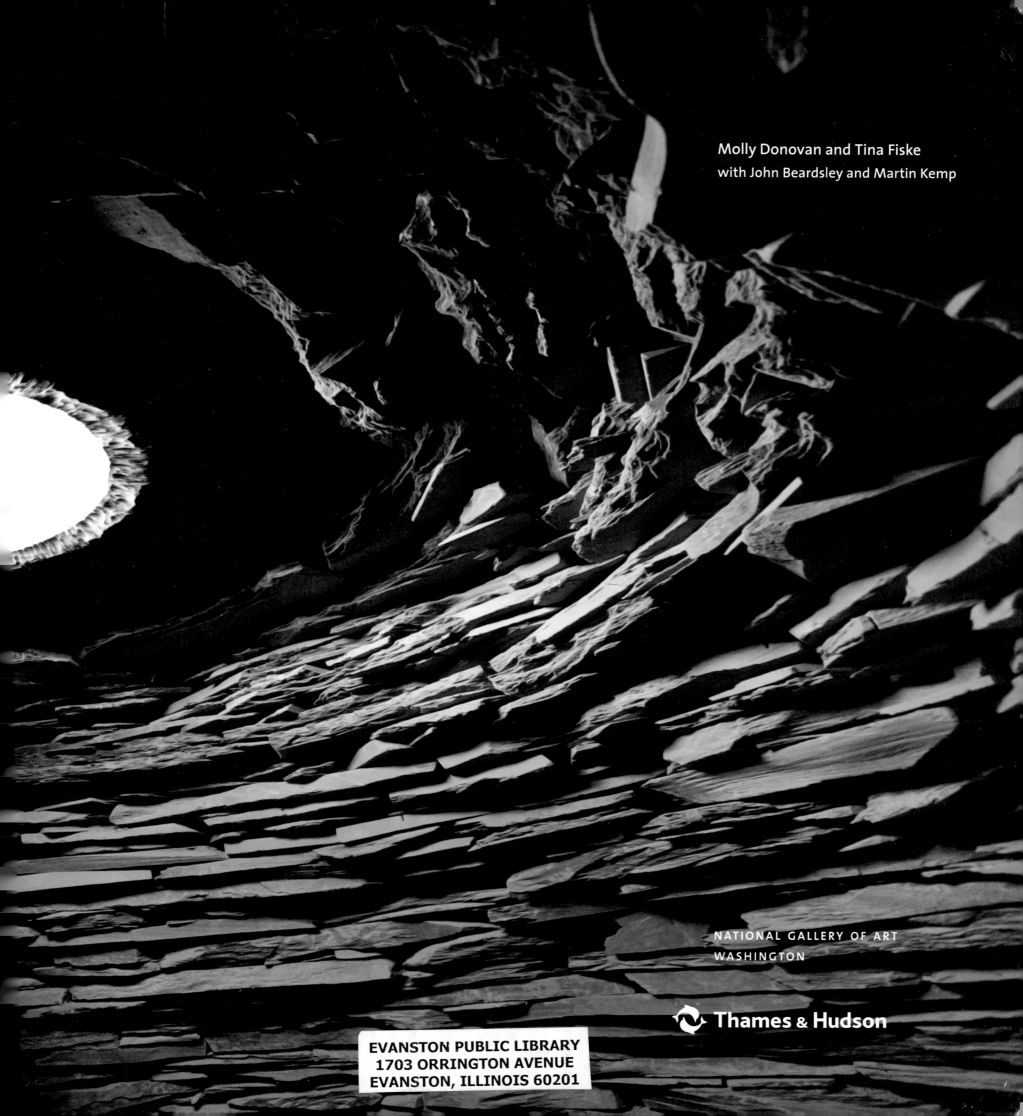

Molly Donovan and Tina Fiske
with John Beardsley and Martin Kemp

NATIONAL GALLERY OF ART
WASHINGTON

Thames & Hudson

This volume was made possible with the generous support of Glenstone.

Produced by the Publishing Office
National Gallery of Art, Washington
www.nga.gov

Judy Metro, *Editor in Chief*
Chris Vogel, *Deputy Publisher and Production Manager*
Julie Warnement, *Senior Editor*
Wendy Schleicher, *Senior Designer*

Separations by Robert J. Hennessey
Printed on DacoStern by Dr. Cantz'sche Druckerei, Germany

Details of *Roof* in progress: pages ii–iii, vi–vii, x, xviii–1, 14–15, 64–65, 204, 210

Library of Congress Catalog Card Number
2009934445

British Library Cataloging-in-publication Data
A catalogue record for this book is available from the British Library

First published in hardcover in the United States of America in 2010 by Thames & Hudson Inc., 500 Fifth Avenue, New York, New York 10110
thamesandhudsonusa.com

First published in hardcover in the United Kingdom in 2010 by Thames & Hudson Ltd, 181a High Holborn, London wc1v 7qx
www.thamesandhudson.com

Published in association with the National Gallery of Art

isbn 978-0-500-23871-4

10 9 8 7 6 5 4 3 2 1

CONTENTS

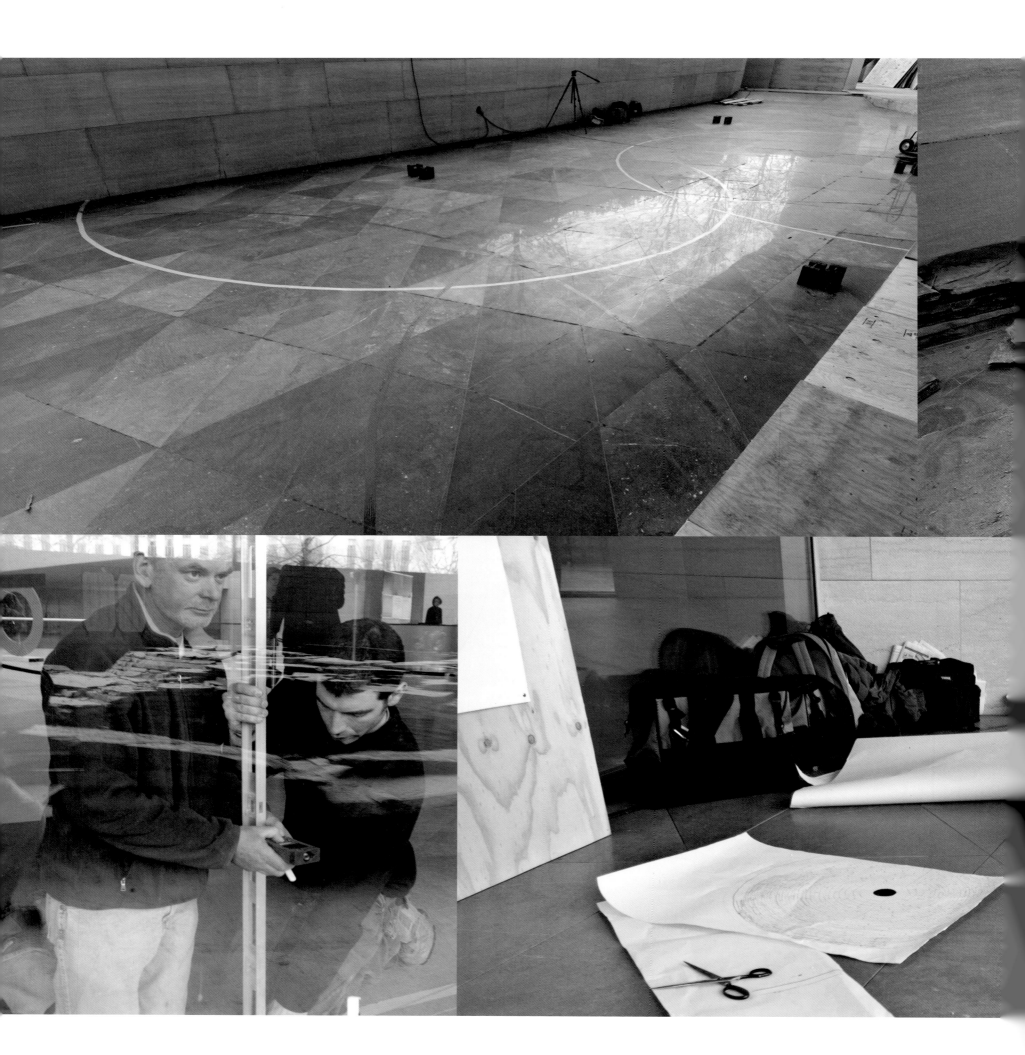

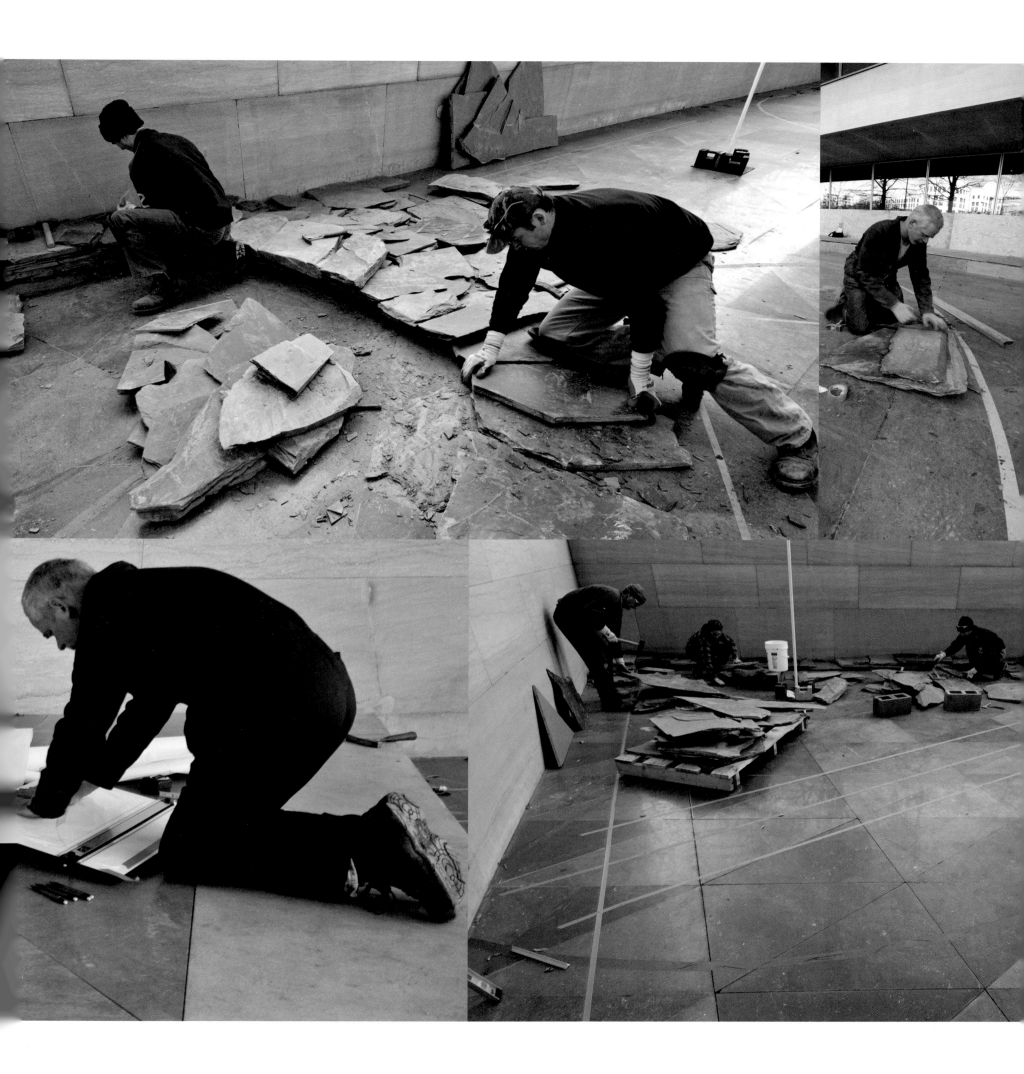

Molly Donovan

PREFACE

In the fall of 1997, Andy Goldsworthy completed the first section of his *Storm King Wall*, the sinuous line of stone on the edge of the Storm King Art Center property (cat. 46). I was then in the midst of research on modern and contemporary sculpture for possible inclusion in the National Gallery of Art Sculpture Garden. I found myself cycling back to Goldsworthy's work, and when I saw the *Storm King Wall* in 1998, my appreciation for the artist's work deepened. Coming from the land while reconsidering our relationship to it, the wall enables a slow conversation between man and nature. I was in good company in my admiration for this work.

With the hope of commissioning a project for the Gallery and with the support of Director Earl A. Powell III, I invited the artist to Washington for a site visit, which took place in February 2003. Goldsworthy had never been to Washington, let alone to the Gallery. We explored the museum's campus and drove around the city, circum-navigating the National Mall several times. The direction for the project was insistently the artist's own from the beginning. A number of possible sites were discussed, including the Gallery's Sculpture Garden and the Potomac River basin, but Goldsworthy chose to focus on a site in the Gallery's East Building, designed by I. M. Pei and opened in 1978.

In the end, Goldsworthy's work for the Gallery took two forms, one ephemeral (the mode for which he is so well known) and one more permanent (as in the *Storm King Wall*). In the first phase of the project he made a group of works on Government Island, Virginia, which he documented in a diary; in the second phase he constructed for the East Building an installation of stacked slate domes entitled *Roof*. Both phases were proposed by the artist, and accepted and acquired by the Gallery.

In thinking about how best to present this work in book form, I was guided by the notion that it would take consideration of both parts of this project to understand the whole. Once Goldsworthy's project for the Gallery was completed, it seemed to offer an ideal example of how these two seemingly distinct parts of his working method fit together; indeed, it serves as a case study within the context of his entire oeuvre. *The Andy Goldsworthy Project* thus encompasses his work for the Gallery as well as his larger ongoing practice of making both temporary and commissioned, permanent works.

This volume is the first since the 1990 publication *Hand to Earth: Andy Goldsworthy Sculpture 1976 – 1990* to include substantial texts by a group of scholars, each addressing a different but related aspect of Goldsworthy's art. It also presents for full consideration Goldsworthy's commissioned, sculptural installations — up to now an important but lesser known portion of his output.

In his foreword, John Beardsley discusses the critical reception of Goldsworthy's work relative to that of land art and its deep tradition in Goldsworthy's native Britain. Martin Kemp's essay focuses on the structural intuition at work in the making of *Roof* and the rich historical resonances of its form. Carolyn Forché graciously allowed us to reprint her poem "Museum of Stones," which so perfectly connects *Roof* to the museum and beyond. My own essay details the process of Goldsworthy's project at the Gallery and the post-1960s works to which it most closely relates. The book also includes a complete catalogue of Goldsworthy's permanent, commissioned works from April 1984 through September 2008, providing specific details regarding their creation. Compiled and written by Tina Fiske, it is the only reference of its kind and one that will serve as a resource and revelation here forward.

It is my hope that this volume will not only engender a greater knowledge of the artist's practice, but also allow readers to "detach" from earlier notions about Goldsworthy, land art, or even the role of nature in our culture.[1] More important, the book aims to establish Goldsworthy's works not as nostalgically placed figures in the untamed landscape, but rather as foundational and rooted, built from and intrinsically linked to our nature-based environment.

NOTE

1 "Romantic Detachment" (16 October – 7 November 2004) was the title of a joint project between P.S. 1 / MoMA in New York and Grizedale Arts, the commissioning and residency agency in the Lake District of Great Britain; they joined together to present the "collisions and intersections between the ideals of a Euro-centric tradition and a new world vision" (see *www.grizedale.org/database/view.php?id=134*). It took place in Grizedale Forest twenty years after *Seven Spires* (cat. 1), Goldsworthy's first commissioned work.

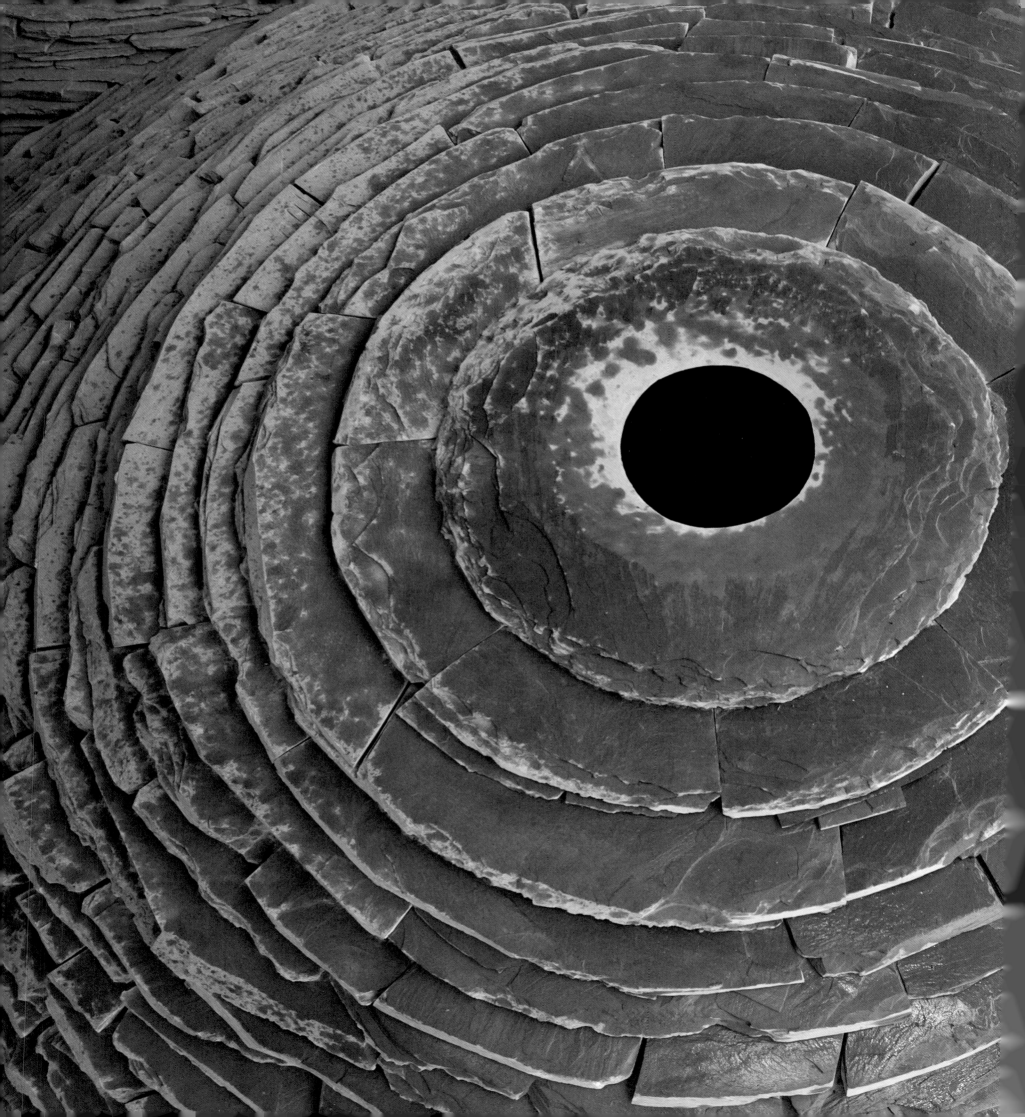

John Beardsley

FOREWORD

Critical appraisal of Andy Goldsworthy's work can be as facile and dismissive as the work itself is popular. Indeed, the two phenomena may be related, as if the appreciation of a large public is somehow a guarantee of a fundamental lack of intellectual rigor. While art history provides numerous examples of artists who are at once widely praised and critically admired, such has not generally been Goldsworthy's case. To some degree, this is a circumstance of the artist's own creation; he has been as scrupulous about the presentation of his work as he has been about its production, generating not only a meticulous photographic record of his sculpture but also a series of thematic books over which he has retained editorial and creative direction. While this has been good and even necessary for the representation of the full range of his art, it has been less beneficial for fostering robust independent discourse: this volume, for instance, is the first since *Hand to Earth* in 1990 to include analytical texts by multiple authors, each addressing a different and substantial aspect of Goldsworthy's work. Add to these factors an avant-garde that in the years since minimalism has been deeply suspicious of beauty, craftsmanship, formal directness, and the absence of irony, and we have the makings of a critical climate chilly to artists of Goldsworthy's kind.[1]

For my part, this volume presents an opportunity to challenge several widespread misconceptions about Goldsworthy's art. I begin by addressing an imbalance in the reception of his work: his ephemeral projects are more familiar than his commissioned, permanent installations; to the extent that the permanent pieces are known, they are sometimes misunderstood as conventional object sculptures.[2] Goldsworthy has made both temporary and permanent works since 1984; *Roof*, the National Gallery of Art sculpture documented and celebrated in this publication, is a recent instance of a phenomenon that goes back well over two decades in his work, in which he has simultaneously created both small-scale temporary projects and large-scale permanent sculptures. In some ways, Goldsworthy recapitulates the versatility that has come to characterize environmental art over the past generation. Initially identified almost entirely with the large-scale, remote Western earthworks of artists such as Michael Heizer, Robert Smithson, and Walter de Maria or with the flamboyant but equally large installations of Christo and Jeanne-Claude, environmental art now encompasses an almost limitless range of temporary and permanent works at various scales in a wide variety of media and a broad array of landscape contexts—urban and rural, cultivated and

wild. Even many of the original earth artists have broadened their pursuits: Heizer, best known for the 1969–1970 *Double Negative*, two huge cuts in the escarpment of a vast mesa in southern Nevada, went on to make sculptures in public urban settings: for instance, *Adjacent, Against, Upon*, 1976, three boulders on concrete plinths in a public park on the Seattle waterfront, and *Levitated Mass*, 1982, a large stone suspended above water at Madison Avenue and 56th Street in New York.

Goldsworthy exemplifies many of the better impulses in evidence among environmental artists today: close attention to the qualities of a site, including topography, materials, and history, and a finely tuned response to those conditions, which on some occasions results in a permanent piece, on others in a temporary one. Goldsworthy describes a symbiotic relationship between the permanent and temporary; he insists that without the permanent installations, there would be no way to know his work except through photographs of the ephemeral projects. For an artist who values direct visual and perceptual experience, not to mention a manner of bodily participation, this represents an unacceptable limitation in the presentation of his work. Moreover, his permanent pieces are far from traditional object sculptures; almost without exception, they are calibrated to specific material and spatial conditions. Many work with existing landscape features, notably the remnants of agricultural structures like stone buildings and walls; others engage with urban landscape and architecture. Whether temporary or permanent, his work should also be rescued from the notion that it is somehow decorative, nostalgic, or sweetly sentimental; rather, it is embedded in multiple social histories of landscape, including a deeply contested tradition of public access to open lands. Moreover, although Goldsworthy is known chiefly for sculptures in natural settings, he also works in the most constructed of landscapes in urban contexts, as at the National Gallery of Art in Washington DC. In this, too, Goldsworthy is representative of the best tendencies among contemporary environmental artists, exemplifying an understanding that even cities are landscapes and that place encompasses cultural as well as natural systems.

How do we explain the overshadowing of the permanent by the temporary, the urban by the rural? Goldsworthy's ephemeral works in rural contexts are made with the most arresting materials, expressive of beauty but also melancholy and decay: yellow elm and orange maple leaves, heron feathers, oak limbs, red poppy petals,

but also sheep urine, bird guano, ice, and spit—even wool from a ewe's corpse. They are often made in remarkable locations, whether windswept beaches, treeless moors, or shadowy streambeds. They embody a kind of bravura, a sense of racing against time in extreme circumstances, whether in rain or cold or dark. Perhaps most pertinent, however, Goldsworthy's ephemeral works are widely perceived as being in accord with environmental ethics, with an idea perhaps most explicitly articulated a half century ago by Aldo Leopold in *Sand County Almanac* when he insisted that we have to "examine each question in terms of what is ethically and esthetically right, as well as what is economically expedient. A thing is right when it tends to preserve the integrity, stability, and beauty of the biotic community. It is wrong when it tends otherwise." [3]

Goldsworthy is certainly not alone in trying to protect the integrity, stability, and beauty of the biotic community; one thinks of his countrymen Richard Long and David Nash, among many others. They make sculptures with a relatively modest impact on the landscape, often fabricated from found or recycled materials. Long is known to work with stones gathered on his walks, arranging them in lines or circles along his routes; Nash typically uses dead trees; while Goldsworthy has employed salvaged slate, timber, and rubble. His *Spire*, 2008, for the Presidio in San Francisco, for instance, was created from mature but dying trees cleared as part of a reforestation process; his 2001 *Stone River* (cat. 72) at Stanford was constructed of sandstone from university buildings toppled in 1906 and 1989 Bay-Area earthquakes. *Roof* (cat. 101) continues the practice: it is made of slate discarded as unmarketable in the quarrying process. That Goldsworthy shares a quality of modesty with some of his compatriots should not obscure significant differences among them; Goldsworthy's work is particularly distinct from Long's, for instance. For the latter, walking in the landscape is itself the work of art; for the former, art finds expression in sculptural projects that often assume an architectonic character.

From the positions of Goldsworthy or Long, it is a small step to the phenomenon of artists as environmental activists, such as the late German artist Joseph Beuys, who labored to protect wetlands and plant trees, or, more recently, Fritz Haeg, the latest in a series of people to militate against the lawn—in his case, by recommending that it be replaced by food crops. By comparison, many of the monumental expressions of land art have a more ambiguous relation to environmental ethics. One could certainly argue that projects such as Michael Heizer's *Double Negative* or Robert Smithson's *Spiral Jetty* are disruptions of relatively pristine environments, but matters are much more complicated. Land art draws people out into landscapes that they might not otherwise see; in this sense, it provides a mediated experience of place that might foster appreciation and even preservation. James Turrell's *Roden Crater Project*—the transformation of an extinct volcano into a naked-eye observatory through construction of elaborate sky- and light-viewing chambers—is especially expressive of this ambiguity: the artist undertook massive reshaping of the cinder cone, stripping it of delicate vegetation. But the vegetation

will ultimately be reestablished, and the project has provided long-term protection for the cone, which—like others around it—might otherwise have been mined to make cinder blocks.

Whatever one's position on the relationship between land art and environmental ethics, there is little question that Goldsworthy's ephemeral works have become widely emblematic of low-impact land art. By comparison, his permanent pieces are less readily available for ideological adoption. They are also less flashy; his stone works in particular are expressive of a particularly ancient form of agricultural craftsmanship, one that is so commonplace as to be almost invisible as art in rural contexts. It is a tradition with which the artist is deeply familiar; he worked part-time on a farm for pocket money as teenager and to support himself while in college. His enthusiasm for walling has found numerous expressions; one of the most sustained—even epic—is a project he has been working on since 1996 to restore some forty-five abandoned sheepfolds in Cumbria in the northwest of England. Strung along the path of drove routes from the Scottish Highlands to the south, the folds became obsolete with the consolidation of flocks and the closing of common grazing lands in the late eighteenth century. In addition to rebuilding dilapidated walls, Goldsworthy placed standing stones, which he termed drove stones, in some of the enclosures. Goldsworthy attributed a kind of "subversiveness" to this project: "it is difficult to know if it is art." [4] But clearly the artist was not making freestanding objects: these sheepfolds are deeply embedded in the histories of their particular places.

Goldsworthy's wall projects are indicative of the artist's attraction to the vernacular. They are expressive of a "layered lineage": they are constantly in the process of transformation—made, added to, destroyed, repaired, and preserved. They have aesthetic qualities all their own, which he enumerated in terms of "the way a wall is made, the nature and shape of stone, sculptural qualities." They also reveal a relation to topography, which Goldsworthy described as "the way they draw a landscape." At the same time, they embody associations with skilled labor, past and present; as an expression of admiration for their traditions, Goldsworthy employed professional drystone wallers and masons. He tried working alongside these professionals for a time, but noted, "if I make the walls, they become art. If a waller makes them, it relates them to a practical and professional tradition." His projects often remake what was there: the 2,278-foot-long *Storm King Wall* (cat. 46) traverses the ghost of an existing wall initially constructed by farmers with stones collected at the edge of a field as they cleared it. Over the years, trees had taken root in the wall, "redrawing the place." Like the Sheepfolds Project, the *Storm King Wall* exemplifies what the environmental historian William Cronon has called "changes in the land." [5] In this instance, the changes are the histories of deforestation, grazing, tilling, abandonment, and reforestation that are characteristic of much of America's East Coast.

That Goldsworthy's permanent works are less obviously available for ideological adoption than the ephemeral ones does not mean they are without ideological overtones: many are suggestive

of difficult, even oppressive events in the social histories of landscape. As confirmed in the 2007 publication *Enclosure*, his walls are particularly associated with an episode in British history known as inclosure or, more commonly, enclosure. Especially between 1750 and 1850, the British parliament passed thousands of Acts of Inclosure, which privatized land once considered common, causing massive social dislocation as landless farmers were forced into cities and factory jobs. Vast areas were walled off to be tilled or grazed for the exclusive benefit of landowners; the upper-class taste for grouse, pheasant, and deer hunting insured that still more land was sequestered.[6] Many people found they no longer had access to open land even for recreational purposes; in response, the first local associations for the preservation of access to ancient footpaths were formed in the early nineteenth century. In 1865, a national organization was created called the Commons, Opens Spaces, and Footpaths Preservation Society, now known simply as the Open Spaces Society (oss). Beginning in 1884 and every year until 1914, a liberal member of Parliament, James Bryce, introduced a bill to guarantee the freedom to roam; it failed each time.[7]

The struggle for public access to land has continued. Numerous ramblers associations were established in the early twentieth century to secure such rights; in 1932, in one of most celebrated acts of resistance to enclosure, six people were arrested (and five imprisoned) for leading a mass trespass on a mountain known as Kinder Scout in the Peak District.[8] By 1949, the tide was shifting. That year, the National Parks and Access to the Countryside Act allowed the government to negotiate rights-of-way agreements with landowners; the act also designated open spaces including mountains, moors, heaths, downs, cliffs, foreshores, and, in 1968, woodlands and riversides. The 1949 act required county councils in England and Wales to map all the rights-of-way in their jurisdictions; they have appeared ever since on Ordnance Survey maps, making the paths available to everyone. In the Thatcher years, public access was dealt a setback through a policy of privatization of Forestry Commission lands; instituted in 1981, the policy was not abandoned until 1994. Meanwhile, an organization called the Ramblers' Association launched a Forbidden Britain campaign to insure broader statutory access to open countryside. Mass trespasses again increased, including an incident in 1991 when 500 ramblers crossed then-forbidden Thurlstone Moor in South Yorkshire. The centuries-long campaign for the freedom to roam finally culminated in 2000 with the passage of the Countryside and Rights of Way Act; specific lands were mapped and designated publicly accessible in 2005, constituting approximately 12 percent of England and Wales.

It might seem a stretch to position Goldsworthy's work within this history of conflicts over public rights to land, but several of his works, proposed and built, have addressed enclosure. In Scotland, enclosures were known as the Highland Clearances; they were particularly brutal in the late eighteenth and early nineteenth centuries, forcing many people to immigrate to North America.[9] Some years ago, Goldsworthy was approached about making a memorial to the clearances on a prominent hill in the Scottish Highlands. Goldsworthy suggested building a stone enclosure around the top of the hill that would prevent people from having access to it. He never received a response to his potentially disturbing proposal, but he did build something similar, *Outclosure* (cat. 115), at Yorkshire Sculpture Park in 2007. It is a circular structure straddling a path through a wood, with walls 2 meters high and no entrance. Those traversing the path have to go around the structure: they are literally enclosed out of the space. A more personal experience with enclosure generated Goldsworthy's very first wall project, significantly titled *Give and Take Wall* (cat. 7), for, as Goldsworthy stated, "social relations defined the project." The artist entered into prolonged negotiations with a landowner for long-term lease to a field adjacent to his home in Penpont, Dumfriesshire; the owner would give him access to only half of it. Goldsworthy built a stone wall to divide the field, with round enclosures to either side; each enclosure is open to the half of the field on the other side of the wall. Photographs taken over a period of years show that the part of the field on his side that Goldsworthy "gave" to the landowner is still grazed by the latter's sheep and remains in grass, while the part of the field the artist "took" is now growing up in trees. Ideas about enclosure even inflected some of the artist's initial conceptions for the National Gallery of Art project. Thinking to build a sheepfold-like wall to bisect the space, he wrote in a preliminary proposal in late January 2003, "Drystone walls are beautiful but many were made during the enclosures acts in the eighteenth and nineteenth centuries when land reforms evicted many from the land. This in turn caused many people to leave Britain and go to places such as America. I like the idea of sculptures leaving Europe, just as people did, and finding form in America. The sculpture becomes about repression and freedom, past, present and future." Although Goldsworthy switched from the language of walls to domes for the Gallery project, the allusions to social history remain. In *Roof* as in *Outclosure* and *Give and Take Wall*, we see the convergence of an interest in vernacular craftsmanship with an expression of the ways that social relationships are manifest in built form.

It is also possible to see Goldsworthy's ephemeral works in the context of the contested histories of enclosure, rambling, and trespass. The artist has lived in Penpont since 1986; one of the reasons he gave for moving to Scotland is its history of more liberal public access to land. "There's a stronger right to roam on open ground, along rights-of-way like rivers. These are very important links from home to the world." In England, by comparison, "the sense of not being able to go places is very strong." There are indeed significant common-law and legislative differences between the two countries with respect to the rights to roam. Although common land was divided among interested proprietors by the Scottish Parliament as early as 1695, there has long been a widespread belief in the existence of a general public right of access to land that has recently been written into law.[10] While England's Countryside and Rights of Way Act gave access only to specifically mapped and designated lands, Scotland's Land Reform Act, passed in 2003, codified a common-law tradition by which people were assumed to have a right of free access for educational, recreational, and practical purposes to all lands and waters—mountains, moorlands,

forests, farmlands, coasts, and riverbanks—that were not otherwise specifically restricted.¹¹ Goldsworthy is attentive to these distinctions and has found his way to the place he finds most conducive to his art. In a sense, almost everything he does in the open air engages the issues around public rights of access: his rambling in pursuit of opportunities to work might be seen both as affirming the ancient Scottish right to roam and as a challenge to the histories of enclosure in both England and Scotland.

As a young artist living in Cumbria, Goldsworthy worked on beaches, in forests, or at quarries. Then, as now, he consulted Ordnance Survey maps to find public rights-of-way over which he could pass to produce his ephemeral works. Once, coming out of a forest, he recalled, "I walked straight into a landowner having a shoot." The outcome wasn't as dire as it was on Kinder Scout: Although the landowner was not cordial, Goldsworthy applied for and received a job as a gardener on the estate. To this day, Goldsworthy generally does not own the land he works on. "It could be private, it could be public, but even private land has some public access," he reported, pointing to *Penpont Cairn* (cat. 66), which is on a large private estate in Scotland: a gate was made in a nearby fence to give people access to it. Typically, Goldsworthy does not secure permission to the sites where he makes his temporary works; if he wants to create something permanent, he enters into what can be complex and sustained negotiations. The *Sheepfolds Project* in Cumbria is an intriguing case in point: it involved permissions from many quarters, including public planning agencies, private landowners, and preservation groups. Several of the sheepfolds were on common land that did not appear as such on public land registries; they required the purchase of defective title insurance to protect against any future disputes over ownership (see cats. 42, 70). Fortunately for the artist, his growing reputation has afforded him ever-greater rights of access to private land as patrons have sought out his work. But he has remained true to his interest in "the social nature of landscape," especially its history of complex transactions over ownership and access. While his work might sometimes be perceived as charmingly ephemeral or naively beautiful, it can also be regarded as participating in a long history of economic conflict and territorial challenge.

Nor does the artist shy away from complex histories in other contexts. In the south of France, for instance, he is engaged in another sustained project to restore abandoned agricultural structures in the Réserve Géologique de Haute-Provence, near Digne-les-Bains. Invited to work in the area by the Musée Gassendi in Digne, Goldsworthy first built a series of three cairns to mark the valleys of the three main rivers in the reserve, which historically served as the region's principal axes of circulation and communication. In 2002, he instigated a still more ambitious project that he calls *Refuges d'Art*, reactivating abandoned and dilapidated structures that fell into disuse as rural populations declined and patterns of land use changed. He has completed six buildings so far; he is aiming for ten, along what will be a nine-day walk from village to village. Each of these structures contains an installation in clay or stone: darkened or daylit chambers,

walls with niches, and rooms with arches or cairns, for instance. The houses are meant to be available to trekkers in the company of guides for visiting, eating, and sleeping. They are functional, in other words, but also exemplify the artist's notion of "building-as-sculpture." Some have a particularly evocative connection to history: at least one of the buildings, an abandoned house at Ferme Belon near Draix (see cat. 93), was used as a meeting and training place by French resistance fighters during Nazi occupation in World War II. Local accounts related to Goldsworthy tell of a sentry who fell asleep one night, allowing German soldiers to attack the house and kill all the occupants. Because they were there under aliases, no one knows the identities of the people who were killed. The darkened basement of this structure is now occupied by Goldsworthy's eleven interwoven limestone arches, which honor vernacular traditions, local materials, and techniques of construction. But in their image of interlocking strength, they can also be seen to honor the history of resistance.

Goldsworthy's international stature has also provided him with opportunities to work in museums—themselves the locus of significant social histories. His projects in the landscape have an explicit relation to site; by comparison, his museum works might be considered more distant from localized and particularized narratives. But even these sculptures resonate with their contexts. *Roof*, for instance, is designed to fit the specific physical and spatial qualities of its place, a courtyard enclosure selected by the artist: it spills into the museum and out into the public landscape, defying the actual and figurative limitations of its space, linking inside and outside, cloistered and public, museum and urban landscape. But more than this, the work conveys the artist's appreciation for the historical connections between specific cultures and particular materials and building technologies. Most evident in *Roof* (perhaps even self-evident for Washington) is the allusion to the significance of the dome in expressing the ideals of the American republic. But there are more subtle social histories evoked here as well. Goldsworthy's quest for suitable materials for this project led him to Arvonia, a village in rural Virginia settled by Welsh emigrants who developed the local slate resources in emulation of their forebears in Britain.

Goldsworthy's art addresses itself to some of the most compelling subjects of contemporary art, among them materiality, temporality, and process. He engages with a remarkable range of natural materials, which he deploys in ways that often reveal the processes of their manipulation. Temporality is inscribed in his works in almost limitless ways: the time of making, the time of dissolution, the times of natural and cultural history. But time is also understood in Goldsworthy's work in terms of bodily experience—the motion of the body through space over time. In the case of the ephemeral works, the body is the artist's own, and the photographic record is an opportunity to share vicariously in his rambles. In the case of the permanent projects, the invitation is literal: the work is there—at least in part— to inspire our own roaming. Goldsworthy is quite explicit about the idea that his landscape projects are completed by people walking to,

and creating connecting pathways among, them. As Goldsworthy said of a suite of red sandstone striding arches (cat. 119) located on three hilltops in Dumfriesshire, "The work isn't finished until [a] path has been made. Those arches need a line and the line is as much part of the work as the arches."[12] The same dynamic is at work in Digne, where trekkers can connect the various *refuges d'art*. There, too, the lines the artist draws in the landscape stitch it together, topographically and historically; they also function like a circulatory system, connecting the parts of an organism; and they transgress the usual political and property boundaries. They produce a sense of being at liberty in the landscape, appealing to whatever measure of wanderlust is alive in each of us. With *Roof*, Goldsworthy achieves a similar effect by giving the visitor views of the piece from two levels within the museum; a path is implied from the street, past the piece on the museum's ground level, and on to the mezzanine above. As we traverse the path, we complete the sculpture through an act of bodily and cerebral participation. That may indeed be the most deeply satisfying aspect of Goldsworthy's work.

NOTES

1 For an instance of chilly critical reception of Goldsworthy's work, see Roberta Smith, "The Met and a Guest Step Off in Opposite Directions," *New York Times*, 3 September 2004, *http://www. nytimes.com/2004/09/03/arts/design/X03SMIT. html?r=1&scp=2&sq=andy%20goldsworthy& st=cse*. For mention of Goldsworthy's lack of irony and the inhospitable critical climate for such work, see Simon Schama, "The Stone Gardener," *New Yorker* (22 September 2003), *http://www. newyorker.com/archive/2003/09/22/030922craw_ artworld*.

2 For a discussion of permanence in Goldsworthy's work, see Tina Fiske's introduction on page 68.

3 Aldo Leopold, "The Land Ethic," in *A Sand County Almanac* (1949; repr. ed., New York, 1989), 224–225.

4 Andy Goldsworthy, conversations with the author, August 2008. All subsequent unattributed quotations refer to these conversations.

5 William Cronon, *Changes in the Land: Indians, Colonists, and the Ecology of New England* (New York, 1983).

6 There are several book-length histories of enclosure. See, for example, G. E. Mingay, *Parliamentary Enclosure in England: An Introduction to Its Causes, Incidence, and Impact, 1750–1850* (London and New York, 1997). A brief history can be found in the chapter "Of Walking Clubs and Land Wars" in Rebecca Solnit's excellent book, *Wanderlust: A History of Walking* (New York, 2000), 159–167.

7 A brief history of the oss is available at *http:// www.oss.org.uk/history/history.html*; a short history of efforts to establish rights to roam in England can be found at *http://www.ramblers.org.uk/ freedom/rightto roam/history.html*.

8 The episode had distinct class dimensions: frustrated by a lack of progress by rambling and open space associations, a group of youthful members of the Communist-inspired British Workers' Sports Federation, headed by an unemployed twenty-year-old Manchester mechanic named Benny Rothman, led 400 ramblers on a mass trespass from Hayfield, Derbyshire, to Kinder Scout. After scuffles with gamekeepers on the mountain, Rothman and five others were πindicted for various offences against the public order; at his trial, Rothman defended himself and his compatriots with working-class rhetoric: "We ramblers, after a hard week's work in smoky towns and cities, go out rambling for relaxation, a breath of fresh air, a little sunshine…. But we find when we go out that the finest rambling country is closed to us, just because certain individuals wish to shoot for about ten days a year" (see Roly Smith, "Scout's Honor," *Guardian*, 17 April 2002, *http://www.guardian.co.uk/society/2002/ apr/17/guardiansocietysupplement*). Notwithstanding his spirited self-defense, Rothman and four others were convicted of "incitement to riotous assembly" and received between two and six months in prison — sentences that appalled even the cautious ramblers associations that had opposed the mass trespass. In the wake of the verdicts, some ten thousand ramblers attended a rally for access to the peak (see Solnit 2000, 166).

9 For a history of enclosure in Scotland, see Eric Richards, *The Highland Clearances: People, Landlords, and Rural Turmoil* (Edinburgh, 2008).

10 Some legal scholars question whether or not there was a common-law "right to roam" in Scotland. See David Sellar, "Community Rights and Access to Land in Scotland" (proceedings from a workshop on Old and New Commons, Centre for Advanced Study, Oslo, 11–13 March 2003), *http:// www.caledonia.org.uk/land/documents/Community-Rights-and-Access-to-Land-in-Scotland.pdf*.

11 For a comparison of English and Scottish land access laws, see *http://www.outdooraccess-scotland.com/default.asp?nPageID=37&nSubCon tentID=0* and *http://www.scotways.com/faqs/detail. php?catid=10#81*.

12 Mark Fisher, "Knowing His Place," *Scotsman*, 2 October 2008, 44.

ESSAYS

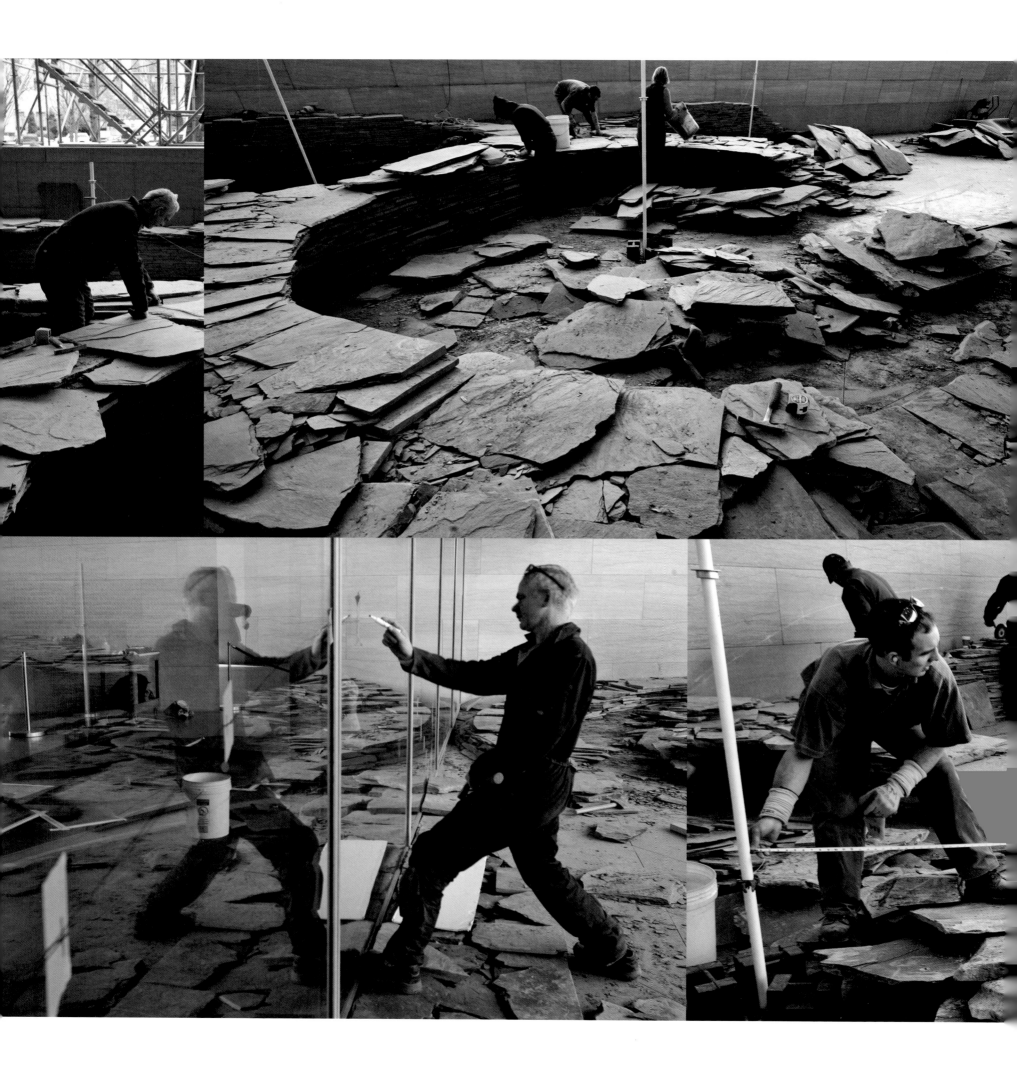

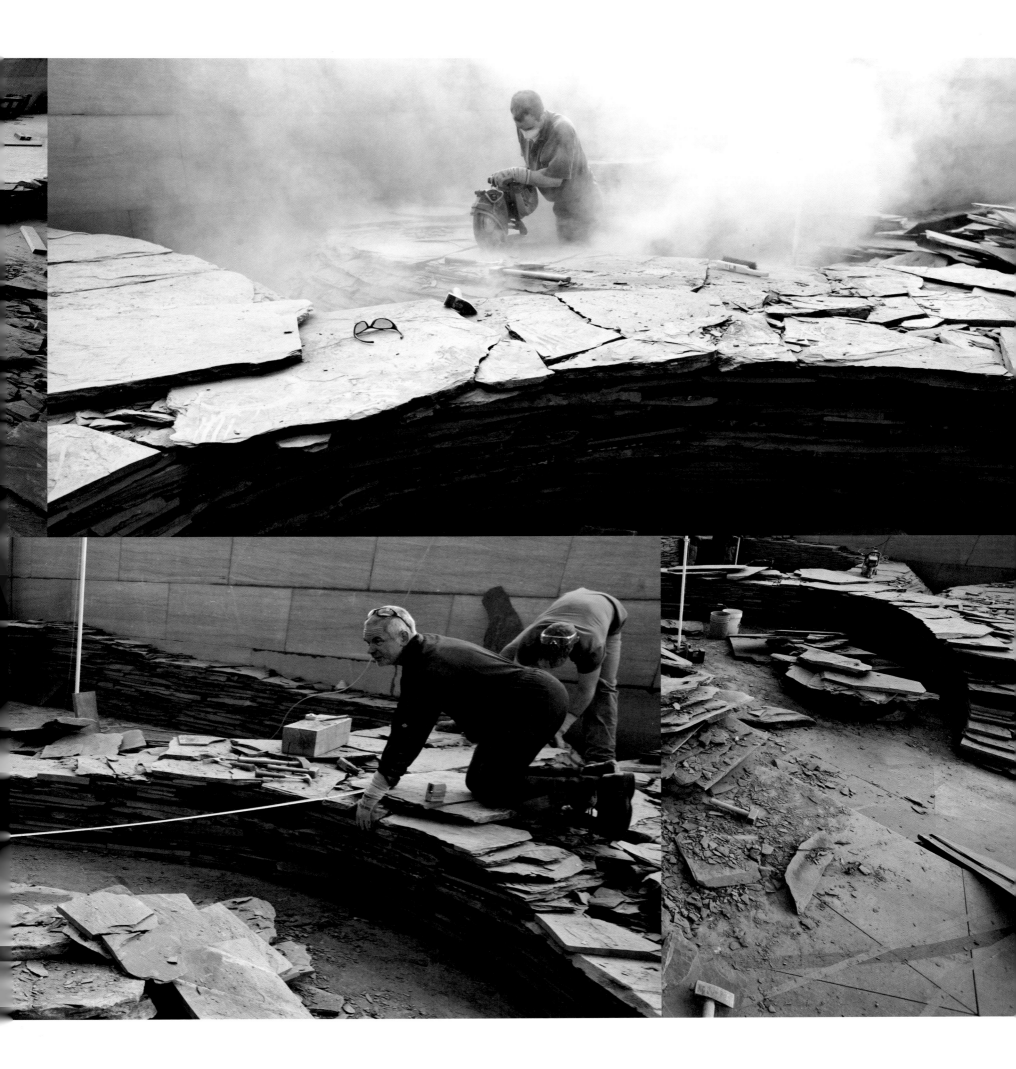

AN UNCANNY RIGHTNESS
STRUCTURE AND INTUITION
IN ANDY GOLDSWORTHY'S *ROOF*

Andy Goldsworthy's father was a mathematician. F. A. (Al in) Golds-worthy was professor of applied mathematics at Leeds University, having previously lectured at Manchester. He was founder-editor of the *Journal of the Institute of Mathematics and Its Applications*, the first issue of which appeared in 1965. The guidance to authors stressed that the *Journal* was to be cross-disciplinary:

The *Journal* will publish carefully selected papers describing original research in all areas of the application of mathematics. Especially welcome will be papers which develop mathematical techniques applicable to more than one field. The *Journal* will not as a rule publish papers which are of a very specialized nature with consequent limited application and interest.

Allin Goldsworthy himself specialized in problems of fluid flow, not least the passage of fluids past aerofoils and obstacles of various geometrical shapes.[1] His interests extended on a cosmic scale into the motions of interstellar gases. These may sound like very visual subjects, but the pages of his publications are dense in equations rather than pictorial or even diagrammatic representations of the phenomena of flow.

Unlike his father, Goldsworthy demonstrated no obvious ability in mathematics at school, nor, for that matter, in most other academic subjects. He still only resorts to mathematics to deal with basic issues of dimensions, and then only when absolutely necessary, as with the hugely complex project for *Roof* (cat. 101). He does not involve himself in any of the standard calculations of the engineer when building the gravity-defying constructions for which he is renowned. Yet a number of his most ambitious creations involve highly adventurous "geometrical" constructions that stretch engineering to its limits.

This paradox lies at the heart of this essay. The forms and processes that Goldsworthy uses tap deeply into the engineering of nature, often involving the kinds of complex static and dynamic structures that have taxed the analytic powers of such mathematically minded biologists as D'Arcy Wentworth Thompson, whose *Growth and Form* (1917) remains the masterpiece of geometrical biology.[2] Goldsworthy's cairns, arches, domes, and related structures seem to stand within a long tradition of structures mathematically contrived by human engineers. Yet, he works by instinct and experience, not by predetermined calculation. His autonomous building practice connects man with the structural intuition of the spider, while his collaborative works align man with other cooperative species such as the bee, the swallow, the bowerbird, and the ant. The webs, honeycombs, nests, and hills these animals forge depend upon profound mathematical principles, of which their designers are of course wholly unaware.

On second thought, this formulation depends on how we define "awareness." If we mean a conscious engagement cast in the form of analytical understanding, the spider has no such awareness of why and how its web achieves its optimum design. If, on the other hand, "awareness" can embrace the idea of an instinctual and experiential practice based upon the nature of materials and the visual-cum-somatic manipulation of them in a way that feels inevitable and right, then the spider exhibits deep levels of awareness. We may say, metaphorically, that the spider is in tune with the mind of nature. Goldsworthy's level of consciousness is of course at a different level from that of a spider, but when he is totally immersed in the mental and physical process of construction, he can at those moments seem to be closer to a spider tuning into nature than to his father writing his mathematical papers.

But again, second thoughts intervene. Allin Goldsworthy clearly possessed some instinctual fascination with the flows he expounded. Scientists enter fields to which they are intuitively attracted. He was immersed imaginatively in the nature of fluids in motion. This immersion is expressed in terms of high mathematics. His son contemplates the river surging, gyrating, and bubbling over the rocks at the foot of the fields surrounding his farmhouse at Penpont in Dumfriesshire. He is immersed imaginatively in what Thompson called the "riddles" of form in such phenomena. Goldsworthy expresses his immersion through an imaginative collaboration with the flow of the water, engaging quite different mental capacities than those his father used. He makes works that allow us to share his deep intuitions, excavating latent instincts in our own minds. Yet the results, whether they are mathematical in the professor's sense, or material in the artist's way, can be seen as partaking in special forms of beauty. This underlying affinity is a matter not of influence or conscious exchange but of what I have called structural intuitions.[3]

It is the nature of a successful work of art, in contrast to an exposition in science, that it presents the spectator with an open field for associations, even beyond those consciously defined by the artist. The artist sets the parameters for the *types* of resonances, but does not enumerate or prescribe them. No artist presents us with a richer field of possibilities than Goldsworthy. He seems to tap into

what Philip Ball has called the Self-Made Tapestry, that is to say, the patterns formed in nature through processes of self-organization, with or without the action of genetic imperatives.[4] These patterns do not know disciplinary boundaries. They do not respect our conceptual definition of organic and inorganic worlds. They have provided humans with constant inspiration since the earliest phases of mark-making, design, and construction.

In the first two sections of this essay, I will be looking at the rippling sets of associations evoked by *Roof:* firstly, at some related built structures, particularly those of ancient and vernacular origins; and secondly, at patterns of form in nature as discerned by science. In the third part, I will study the actual building of the slate domes — *Roof* comprises nine — in terms of the design processes through which they came into being.

RESONANCES 1: HUMAN HANDIWORK

The dome is an ancient form, like the arch. Both have been developed into structural forms of great sophistication, capable of bridging very large spaces. Both have been pushed into new realms by designers using computer design. Goldsworthy is of course alert to the great industrial and urban traditions of the bridge and the dome, but in many ways he may be said to stand apart from them: his structures, after all, are works of art and "function" differently.

Bridges, like domes, are more than mere utilitarian structures. Those at San Francisco and Sydney have assumed iconic status as symbols of their cities. Domes tend to carry even greater associational baggage, politically and symbolically. Anyone thinking about building domes in Washington can hardly escape their portentous nature in this most "capitol" of capital cities. We know that Goldsworthy was especially taken by Jefferson's shallow dome at the University of Virginia, which corresponds to the upper quarter of a sphere, with the notionally complete sphere "embedded" in the space below. We know from an analysis of Jefferson's nearby Monticello dome that it is engineered with considerable skill, drawing upon French precedents to minimize its weight.[5] Jefferson's dome set the tone for what has become an insistent American tradition in countless civic contexts.

However, Goldsworthy's domes and arches really do not belong comfortably, in terms of their construction, in this later historical succession. They are simply too "primitive," or rather too "natural." Like the earliest prehistoric and vernacular builders, he does not use contrivances to make the component parts of his structures adhere to each other. There are no adhesives, mortars, ties, chains, concealed wooden or metal armatures, concrete, inner and outer shells, or other such devices. The stepping of the domes in *Roof* may bear some visual similarity to the wondrous dome of the Pantheon, but the great ancient structure relies upon the Roman engineers' extraordinary mastery of concrete.

His arches reveal the "primitive sophistication" of his constructive methods very clearly. An arch like the one that consumed four attempts over two days in 1982 (fig. 1) belongs with a series of vernacular structures that owe nothing to trained engineers.[6] A notable

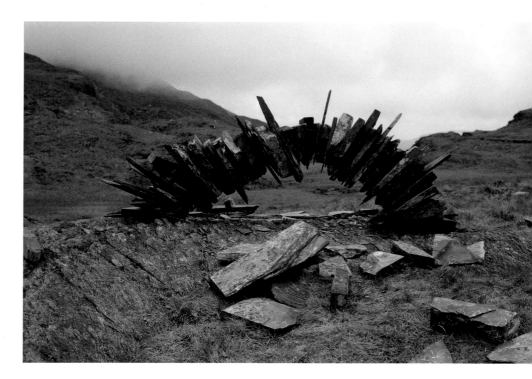

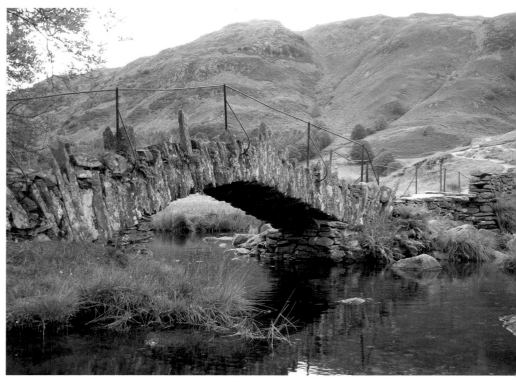

1 Andy Goldsworthy, *Slate Arch*, 1982, Blaenau Ffestiniog, Wales

2 Slater Bridge, Little Langdale, Cumbria

example is Slater Bridge in Little Langdale, Cumbria (fig. 2), one of a series of packhorse bridges of remarkable simplicity and startling durability.[7] It may well date back to the seventeenth century. If anything, Goldsworthy's arch is even more basic, since he does not need to make allowances for traffic passing over and under his construction. Indeed, he is making an arch in a sculptural sense rather than a bridge, endowed with even implicit functionality.

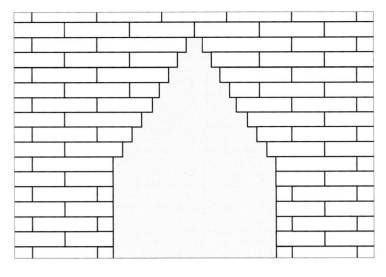

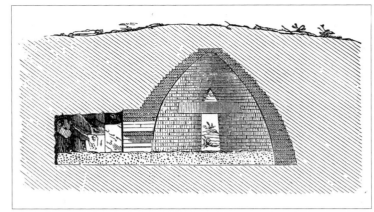

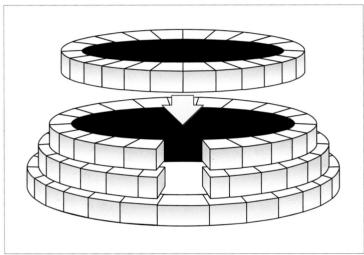

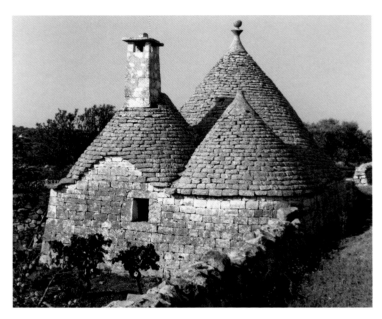

4

3 Corbelled arch construction in a wall

4 Corbelled dome construction, ring by ring

5 Section of the so-called Treasury of Atreus, Mycenae, from *Grundriß der Kunstgeschichte 1, Die Kunst des Altertums / Wilhelm Lübke* (Essingen, 1908)

6 A compound trullo, Valle d'Itria

Roof is no less "primitive." It does not rely upon the stock form of voussoirs, the wedge-shaped or tapered blocks arranged radially that are the customary standby of stone or brick arches, vaults, and domes. His Washington domes are corbelled—that is to say, composed from flat beds, or courses, of stone lying horizontally, arranged so as to jut out progressively into space in the manner of a cantilever to support a load above (fig. 3).

Most corbels take the form of brackets, projecting to limited degree and embedded securely in the host wall. What Goldsworthy has done is to create a dome with a hemispherical outer profile through corbelling with no adhesive devices (fig. 4). As the stone layers progress upward, the center of gravity of the upper beds comes to hang vertiginously over space, beyond the vertical line rising from the inner footing of the dome.

In fact, the dome lends itself to this technique better than the arch. Ascending ring by ring, with the stones packed tightly into their horizontal layers, each circumferential course effectively becomes an integrated structure. Each upper ring compresses and consolidates the integrity of that below it. Longer, radially disposed bridging stones can be used to assist in tying the shorter blocks together, as is tradi-tional in drystone walling techniques. This means that the dome rises as a self-supporting structure at each stage, with no need for temporary supports such as centering. When the desired height has been obtained, the dome can be topped with a single capstone, which can be solid or have an oculus cut in it as in *Roof*. The resulting form of the whole becomes a kind of solid in its own right.

For existing parallels we have to look at some very early and vernacular buildings. Perhaps the closest comparison is the so-called Treasury of Atreus (fig. 5), one of a series of Mycenaean beehive tombs built in the thirteenth century BC. The pitch of the dome is notably steeper than a hemisphere, in a way that minimizes the forces of tension in the lower parts of the walls.

A more recent parallel is provided by the trulli of Puglia in the south of Italy (fig. 6), which still serve as effective houses and agricultural stores. Indeed, one remarkably picturesque Puglian town, Alberobello, presents us with an extensive townscape of trulli. Construction methods seem to have varied somewhat over the centuries and in different centers, but the archetypical *casella* is a modestly curved cone formed by a series of corbelled dry stones (*pietre cannéla)* and covered

externally by a parallel layer of thinner stone tiles (*pianche*) (fig. 7).[8] The date of the earliest Puglian examples and their ancestry is unclear, but they clearly depend on ancient roots and can be seen as the distant descendants of the Mycenaean tholos tombs. When the conical forms of varied dimensions are clustered together over stocky vertical walls, they serve as vaults for a series of adjoining spaces. Externally the families of abutting domes resonate tellingly with *Roof*.

A more complex point of comparison is the Eskimo igloo.[9] The classic mode of construction is to add the blocks in a rising spiral, initially almost vertically above each other in the lower layers and then progressively upward in a series of voussoirs. The Inuit builder does of course benefit from the way that the snow blocks tend to become cemented together by ice at their interfaces. The optimal form for an igloo is not a hemisphere, as normally assumed, but close to a parabola in section, or, to be more precise, a catenary curve, which is mathematically more complex than the parabola. The catenary, formed when a chain (*catena*) is suspended from its ends, provides when inverted one of the most stable forms for an arch or dome.

Where the igloo is relevant to *Roof* is less in its manner of construction than in the vernacular achieving of an optimal structure in the absence of any applied mathematics. The structure has resulted from a deep, empirical engagement with the physical properties of the given building materials coupled with sustained experience in what is strong and what is not. And, as will be seen, the catenary inadvertently came to assume a special role in the actual building of Goldsworthy's domes.

What characterizes the tholoi, the trulli, the igloos, and all the related structures worldwide is that they adopt to greater or lesser degree the "beehive" form, that is to say, they are pitched more steeply than a hemisphere, with a profile that curves more tightly toward the top. They are in effect catenary or catenary-like in vertical section. As a

7 Typical trullo construction, drawn from *Storia e Destino dei Trulli di Alberobello: Prontuario per il restauro* (Brindisi, 1997)

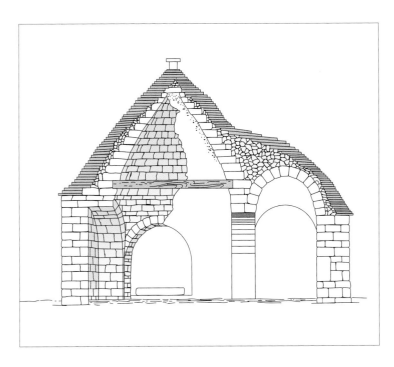

building type, the stone beehive dates back at least to megalithic times. Goldsworthy's cairns, rising from a widening base and tapering more gradually in an exaggerated ovoid form, are characteristically personal variations on this traditional mode of drystone building. Chris Drury has skillfully built a number of corbelled, beehive stone shelters.[10]

Not the least remarkable aspect of *Roof* is that the domes are *both* hemispherical in profile *and* corbelled. Or, as we will see, they are hemispherical in their outward guise. The hemispherical dome, for all its canonical status geometrically, is notably less stable than the more steeply pitched forms and does lend itself obviously to corbelling.

RESONANCES 2: NATURE'S HANDIWORK

The patterns of form and force that Goldsworthy consistently draws out of his visual and physical engagement of nature are the types of formation, static and dynamic, that recur across the natural world. Such common features are not the standard stuff of science. Scientific specialization has decreed that specificities rather than commonalities prevail. As Thompson said in 1917,

The search for differences or essential contrasts between the phenomena of organic and inorganic, of animate and inanimate things has occupied many men's minds, while the search for community of principles, or essential similitudes, has been followed by few.[11]

The situation is now somewhat changed, as the power of computers allows us to simulate the generation of an infinite variety of forms from simple mathematical formulas. Fractals and chaos theory have been most prominent in such modeling of physical phenomena and organic morphologies.[12] However, it remains true to say that the kind of "community of principles" of which Thompson spoke remains on the fringe of most sciences, though arguably central to all. The immediate future of Thompson's mathematical morphologies after 1917 lay with the arts of painting and sculpture and most notably with architecture and engineering.[13] The leading visionary designer of buildings and bridges, Cecil Balmond, is the latest in the line of engineers to further Thompson's quest.[14]

Thompson for his part would have been fascinated by the structural and physical implications of Goldsworthy's inventions — though he would not have been satisfied until he had sorted out their mathematical rationale. Goldsworthy's own quest intuitively delves into the "essential similitudes" that lie behind the shapes generated over time, as "so many portions of matter…have been moved, moulded and conformed."[15] Thompson readily admitted to what might be called an "aesthetic" tool in his diagnostic equipment: "it is another plane of thought from the physicist's that we contemplate… [the mathematical morphologies'] intrinsic harmony and perfection, and 'see that they are good.'"[16] This sense of "goodness" or "rightness" is what many scientists feel when they first glimpse a possible solution to a problem, often long in advance of the formal verification or proof. Frequently the intuition of rightness is fed by analogy, that is to say, by reference to comparable behaviors in phenomena

other than the one being investigated. It is this sense to which I refer in the title of this essay. Goldsworthy's rightness is "uncanny" because it is not based upon logic and often defies belief, particularly gravitational belief.

In looking at just a few of the resonances potentially embedded in *Roof*, it should be said at the outset that it is the inherent properties of the Virginia slate that constitute the foundational morphology. The test run at building a dome at the quarry was essential in acquiring a feel for the stone, particularly its cleavage properties. It is all too easy for the spectator to ignore the sheer toughness of the work involved in this and other of his sculptures. The carver's hammer shatters the slate into razor-sharp edges. The buzzing saws throw clouds of abrasive dust into the breathed air. All this is in keeping with Goldsworthy's insistence on the edgy toughness of natural engineering. He is not involved with some kind of rural ease or comfort, but with a profound struggle to reconcile force and mass. The slate domes in their flat, corbelled courses serve to reconstitute the kind of flat-bedded strata that we can all recognize as typical of sedimentary rock. In fact, slate is a metamorphic rock resulting from the crystallization of minerals in shale. Flat, plate-like minerals, such as mica, are laid down in parallel layers and dictate the characteristic cleavage plane of slates used in roofing.[17] In nature, we can sense how bent or uplifted strata speak of the vast power of the shaping forces of the earth. The racing curves of the strata in *Roof* manifest a powerful shaping hand, and, as we will see, carry strong implications of flow.

Comparable hollow structures or arched structures are rare in nature, but upheaval, collapse, sedimentation, and erosion can result in some remarkably vertiginous topographies. Most famous of the natural arches is Rainbow Bridge (fig. 8) in Utah, the sandstone arch of which

8 Rainbow Bridge, Glen Canyon National Recreation Area, Utah

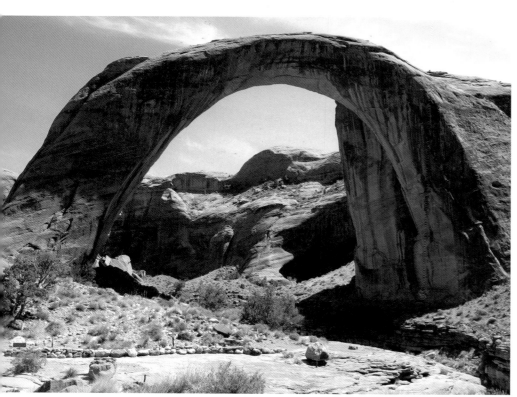

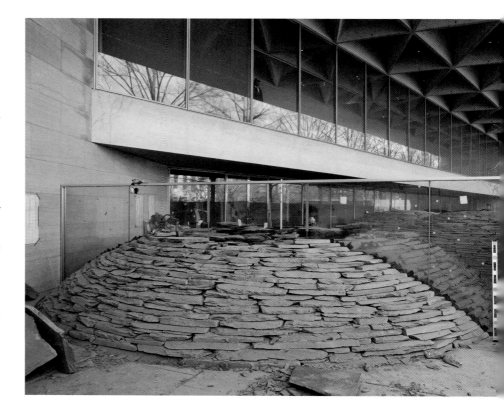

9 Andy Goldsworthy, *Roof*, 2004–2005, National Gallery of Art, Washington

spans some 278 feet.[18] Interestingly, the Navajo name for what we call the bridge is "the hole through the rock." Culturally, one person's bridge is another person's hole. As a sculptor, Goldsworthy works as much with "holes" as with what surrounds them. The profile of the Utah bridge—a thin segment of a circle above and something close to the catenary below—is uncannily like the final sectional form of the domes in *Roof*, to be examined later.

Once the decision was taken to cluster a series of domes—sometimes "overlapping" in such a way that they merge to greater or lesser degrees, rather than remaining separate or just touching—a series of resonances arise beyond those evoked by the dome in its singular form. We are in effect dealing with what Thompson calls "cell aggregates."

Perhaps the easiest way to understand the geometry is to envisage the quarter spheres of the domes as the visible part of notionally complete spheres—the tips of spherical icebergs, as it were. If we then imagine the spheres as selectively pressing against each other across a horizontal plane and merging in certain places, their junctions will be flat circular planes orientated vertically. The junction planes of the visible portions of the domes will comprise segments of these circular planes. The profile of the planes can be readily envisaged by looking at the two points at which domes "extrude" through the glass walls (fig. 9). What we are doing here is a very simple form of descriptive geometry, the science defined in the eighteenth century by the French mathematician Gaspard Monge.

In nature, this geometry operates as one of the basic forms of aggregation in bubbles and cells. The geometry of bubbles and their clusters was first systematically investigated by J. A. F. Plateau, the

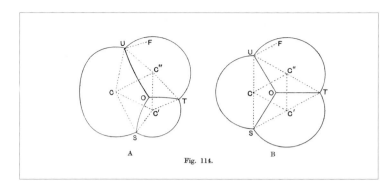

10 D'Arcy Wentworth Thompson, "Three Bubbles," from *On Growth and Form* (Cambridge, 1917), 472

Belgian nineteenth-century physicist. He showed that the partition planes in clusters of three or four bubbles always meet at angles of 120 degrees. The same basic principles apply to small aggregations of cells. The abutting of the domes in *Roof* necessarily obeys Plateau's rules. Thompson explains that if the three bubbles are not of equal size, the partition surfaces will be gently curved rather than straight, the degree of curvature depending on the relative size of the spheres (fig. 10). The slate spheres are of course rigid, and their partitions would be flat planes regardless of relative size.

Scaur Water, a stream near Goldsworthy's property at Penpont, daily provides rich arrays of bubble clusters as the water cascades over semisubmerged rocks. The geometrical forms are familiar to us all—think of any mixture of soap or detergent bub-

11 Andy Goldsworthy, *Wool laid on sheet of ice lifted from nearby pool*, December 2007, Scaur Water, Dumfriesshire

bling in water—whether or not we actively think about their geometry. A work such as his wool and ice construction of December 2007 becomes especially relevant in this context. Strands of wool, collected from fences and shrubs, were laid in concentric circles on a sheet of ice lifted from the margin of the river. Released into the onrushing current, the sheet of ice entrancingly revolved and tilted amongst the spiral eddies, slowly melting while performing its watery ballet surrounded by gurgling vortices and varied clusters of bubbles (fig. 11).

Small and ephemeral though the iced wool circles were, the way they behaved during their fleeting life possesses special affinities with the stony morphologies of *Roof*—not least in the matter of motion or implied motion. For all their static robustness, the curved strata of the slate domes are full of implicit motion, like convex expressions of the sunken center of vortices in water. To be sure, they are not spiral in arrangement, but our eye does not readily make this distinction. The vortex effect is particularly potent when *Roof* is seen from the upper floor, with a deep black void at the center of each inverted hollow of concentric whorls.

The resonances also assume a cosmic scale. More than one of the currently favored models for the cosmos characterizes it as a kind of foam, with galaxies disposed along the partition surfaces. One uses a system of cells, or tessellation, named after the Russian mathematician Voronoi (fig. 12).[19] If we take a series of unevenly distributed points on a plane and calculate which will be the closest point for objects distributed across the plane, the boundaries will form as series of convex polyhedra. A foam is such a latticework extended

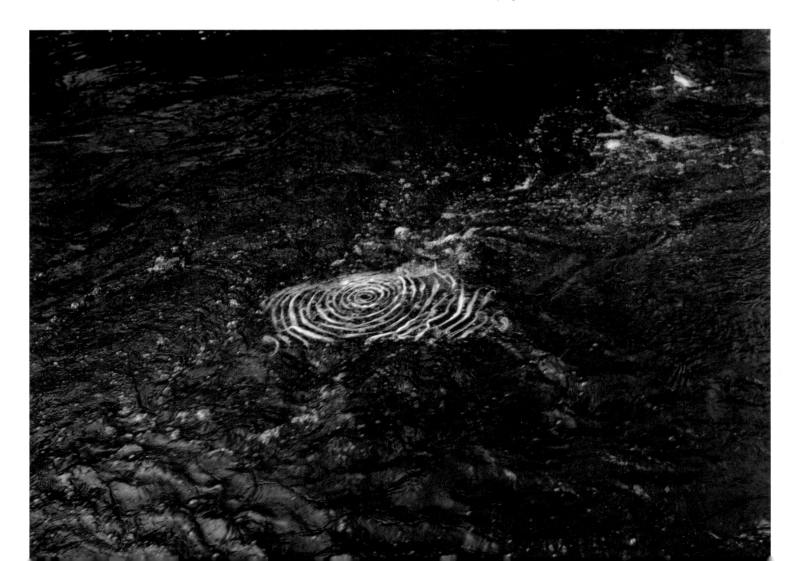

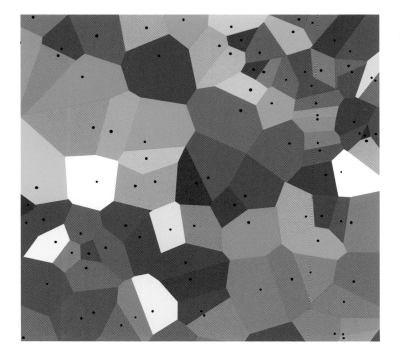

12 Colored Voronoi tessellation

13 René Descartes, "Celestial Vortices," from *Principia philosophiae* (London, 1644)

into three dimensions. If the points are designed as vacuums or "sinks," we can imagine the objects scuttling toward the nearest void before disappearing. Goldsworthy's black holes can, in this light, be envisaged as points of attraction that (in inverted form) suck in any object within its particular field of force, according to the boundary conditions of Voronoi cells. His cells retain their fundamental roundness, but the principle is the same.

Even more surprising is the more distant historical parallel with the vortex model of the cosmos devised by Descartes in the seventeenth century (fig. 13). He envisaged a type of transparent globule that stood between the most refined particles of light and the coarse material of the earth and planets. These globules flowed in the apparent voids of the universe as perpetual whirlpools. Interplanetary space is seen as a kind of dynamic foam. In this positing of invisible entities to make sense of a physical model of the cosmos, Descartes was not proceeding in a manner different from modern theoretical physicists, with their Higgs boson, dark matter, and string theory.

A responsive and engaged viewer of *Roof* is implicitly (and the reader of this essay explicitly) invited to see additional possible resonances. None involve "influence," and some may be thoroughly irresponsible in terms of hard science or orthodox history. What they do show, even at their most tenuous, is that Goldsworthy is dealing both with configurations of "essential similitudes" across natural forms and phenomena and with the cognitive machinery we have evolved for extracting such organizing principles from the chaos of sensory appearance. The process nvolves "structural intuitions" of the deepest and most basic kinds.

A DRAWN-OUT PROCESS

Goldsworthy's many drawings for *Roof* testify to the sustained and arduous process that went into their design. Anyone looking at the finished work would not be surprised to learn this. That the process was sustained is what would be assumed. What is surprising is the sheer number of drawings, given that Goldsworthy had not generally undertaken elaborate designing on paper.[20]

There are two main reasons why his response to this commission was exceptional. The first is its sheer complexity. Many of his works involve unitary constructions—even the great meandering walls are singular not plural in their form. Combining nine domes in a single composition is altogether a different challenge. We know that he did consider a single dome at one stage, and at others thought about seven, ten, and fifteen. One of the determining factors in the choice of nine was the relation of the height of the domes to a standing person. More than one of the sketches of the dome's elevation includes a standing figure.

The other reason relates to the context. Whereas he is accustomed to determining the space needed by one of his constructions, even when some limits are set by a gallery or room when working indoors, the particular space outside the glass wall of the I.M. Pei building is very assertive. Its long, thin ground plan, framed by the stark stone overhang, the diagonally coffered roof above, and the

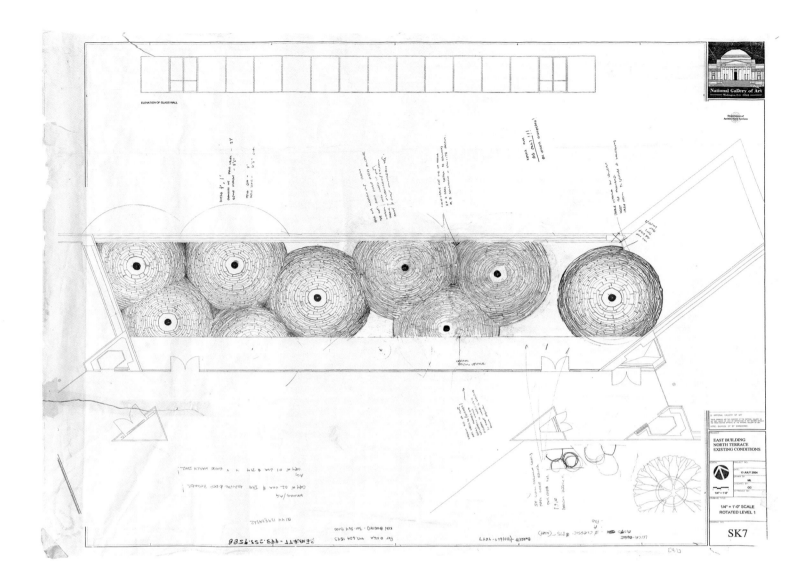

14 Andy Goldsworthy, *Ground Plan, North Terrace, SK7*, National Gallery of Art, Washington

incisive retaining wall, exists as a non-negotiable given. The floor itself is at two different levels. A strip of pavement level with the atrium floor runs alongside the window. The main trench or "pool" is set 10 inches lower than this pavement. As always in such an assertive architectural context, it is better to enter into a dialogue with it than to fight it.

A key decision was whether one or more of the domes would extrude though the glass walls into the space of the atrium and the terrace outside at one end. Once the National Gallery of Art agreed to the extrusions, with all the various safety considerations that needed to be taken into account, the constraints of the original space had to be both respected and selectively violated, providing a quite different kind of dynamic to the geometry of the plans.

The Gallery supplied Goldsworthy with a set of large-scale ground plans of the trench of space. These provided the ground-base on which he improvised sets of circles of varied number and diameter. The plans are often marked by compass holes at the centers of multiple circles, some visible and some either not taken further or actually rubbed out. Ghost circles of rejected arrangements haunt the drawings.

Sometimes the center of a particular circle is tested in a number of adjacent positions. Occasionally no compass holes are visible at the centers of particular circles, indicating that they were drawn freehand or around circular shaped pieces of paper. There is no set or uniform way of proceeding. A particular design problem is tackled in what instinctively seems to be the most effective way. Each drawing develops its own kind of rationale in relation to the given geometry of the plan (fig. 14).

When he began to investigate in detail the plan and elevation of a single dome, a similarly fluid and responsive process ensued. The plan of each dome is based on a set of ever more tightly spaced circles with the center as a blackened void. Sometimes the width between the circles is laid out on a drawn radius, to guide the opening of the compasses. More often, the widths are judged by eye. The visible portions of the tiles are then sketched by hand across enough of the dome to give a clear sense of the effect. The sectional elevations are drawn on the same scale vertically below the plan. On one occasion the varied widths between the circles in the plan are clearly transferred or "projected" by parallel lines onto the arc of the elevation, but this seems not to be the regular procedure.

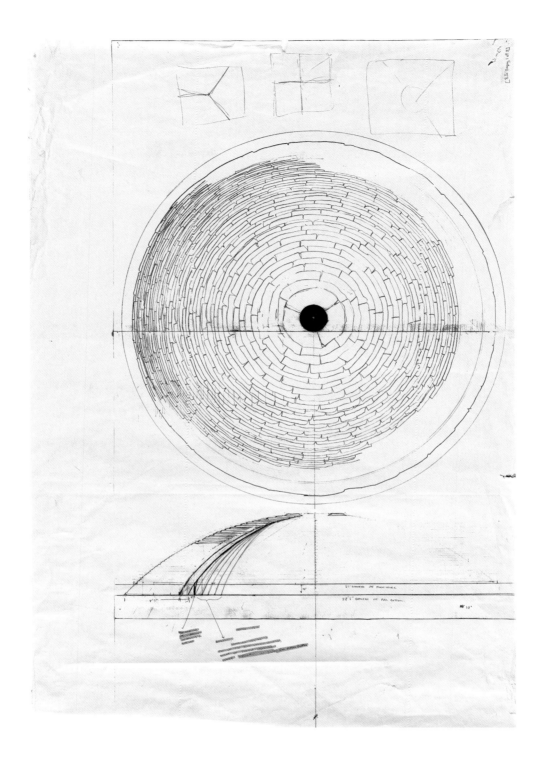

The initial and enduring conception for the outer profile of the elevation remained that of the quarter segment of a circle. The profile of the inner surface was determined by a smaller circle on a higher center vertically over the center of the outer profile. Multiple, closely spaced compass holes regularly bear witness to much trial-and-error repositioning of the profiles. The outer profile was not, apparently, always the first one drawn, though the scale of the drawing meant that the outer profile was always effectively predetermined. Again, the design process is responsive and improvisatory rather than driven by a preconceived system.

The consultant engineer, Dennis McMullan, was presented with a plan and elevation to judge the floor loading. Goldsworthy drew series of alternatives for the inner profile of a dome in colored felt-tip (fig. 15). He asked, "Could you tell me if any of the blue inner profiles might be possible for the domes outlined in pink on the main plan." On the same drawing, Goldsworthy noted, "this line OK.— approved by Dennis on site visit."

The artist reached a point at which he was satisfied, at least to the extent that building could begin. But what of the huge weight of the planned structures? On 8 October 2004, the engineer's report was delivered. The brief was "to investigate the effects of a definitive location and height of Goldsworthy works installation on the area previously known as the Japanese Garden and verify the weight of the domes, previously estimated by the Artist. Specific consideration will be given to the concentrated effects at the overlapped domes

and to the structural impact, if any, to the need for a supporting wall at each side of the glass wall." The weight of each dome was calculated as 81 tons. A comprehensive set of calculations was appended, and the scheme was given the go-ahead.

McMullan's brief did not include the question of whether the domes would actually stand up. That was Goldsworthy's business, and not subject or even amenable to the engineer's intricate calculations.

The construction team, crucially including his highly skilled and experienced drystone wallers from Britain, began laying down the first rings of heavy slate, allowing for the vertical walls that mark the intersection of the domes. Suddenly, one of the structures, as it rose in advance of the others, showed alarming signs of sagging inward, beyond the normal settlement. There was no point in adding further layers, which would only exacerbate the problem. A crisis had arrived.

Goldsworthy decided that the footing of the lower rings needed to be wider, and he decided to add a series of wedges to the inner surface of the sagging dome to force the rings back

16 Andy Goldsworthy, *Working Drawing over Photocopy*, National Gallery of Art, Washington

into their required horizontal disposition. The version of the elevation actually used in the working space, and still attached to its drawing board, speaks vividly of the revisions that were required. The internal profile is repositioned by hand at least three times, with necessary adjustments at the raised edge of the "pool." Dimensions are laboriously recalculated. The result is that the wall in section tapers from a much wider base to the same width at the top. The top of the capstone is noted as "6' 5"—to compensate for settlement" (fig. 16).

The result of the redrawing of the inner profile means that it no longer neatly observes the constant curvature of the compass-drawn arc. Extended to the full half circle, the innermost profile begins to approximate to the catenary curve. If a diagonal is drawn from the foot of the outer profile to the edge of the capstone, it now lies entirely within the thickness of the wall. There is therefore a notional cone incorporated within the fabric of each dome. Whether or not this is the decisive factor, it does seem to provide a rule of thumb for the dome's potential stability. But the definitive rules for such a corbelled dome of circular outer profile are still to be fully determined. In any event, the

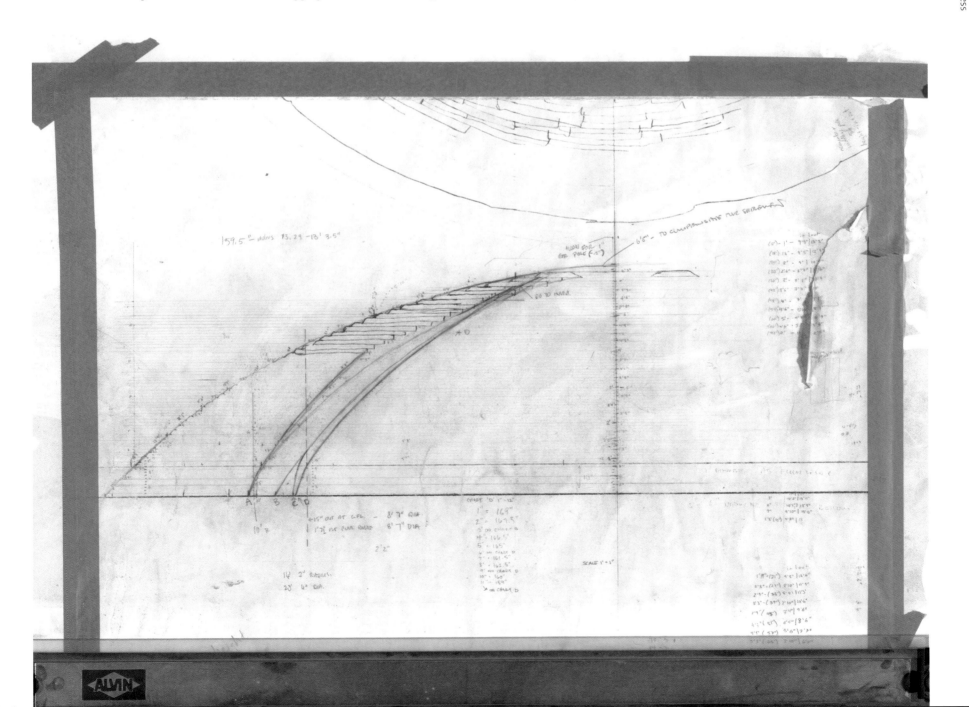

widened footing did the job, and construction could continue. There were no further threats of collapse.

Once a dome was complete, and the capstone ring was in place, the whole structure effectively "congealed" into a single entity, without the potential vulnerability that characterized the incomplete structure. After the last ring was placed on the eighth dome, it supported the weight of twenty-six people (fig. 17).

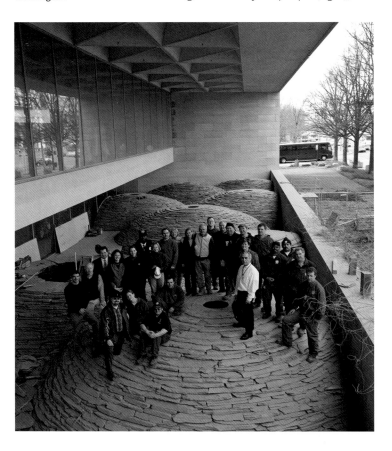

17 Goldsworthy, center, and associates on eighth dome, *Roof,* National Gallery of Art, Washington

A TOUGH PROCESS

Roof speaks of process, if not of the constructional drama in its totality. It is a process of stony severity and structural probity. The maker is in complex dialogue with the forms and forces of nature, not imitating but emulating them. This is no cozy presentation of an amenable landscape. What the artist wills and what nature wants exist in a challenging equilibrium.

Nature exhibits extraordinary sets of optimum structures, evolved over millions of years to achieve their ends in the most economical way, with no insufficiency and no redundancy. They are incredibly tough on their own scale and austerely rigorous in their design. If we combine the older insights of Thompson, the wonders of modern genetics, and the complexities of chaos theory, we can begin to understand but rarely emulate what nature has achieved. The spider's web continues to set standards for engineers concerned with the manufacture of filaments that combine extreme thinness with strength and flexibility.

Natural forms are also potentially self-renewing over the ages in a way that human inventions are not. The spiral shell of a mollusc has been re-created countless times, each individual yet remorselessly following the same template. DNA operates in ways that make the engineers' blueprints seem truly primitive. Even the chaotic vortices of turbulent water have danced to the same patterns of probability ever since water first flowed on our planet. In both senses, nature sets the toughest challenge for the artist who operates at the edge of what is structurally possible.

Roof is poised at that edge. Yet, it is fascinating to speculate, if our civilization ceased, and the I. M. Pei building had to survive in a bleak sci-fi desert with no maintenance, whether it or Goldsworthy's *Roof* would be best placed to endure. I would back *Roof.* However, in the long term, both would almost certainly surrender to nature.

NOTES

1 See, for example, F. A. Goldsworthy, "Magnetohy-drodymanic Flows of a Perfectly Conducting, Viscous Fluid," *Journal of Fluid Mechanics* 11 (1961), 519–528.

2 D'Arcy Wentworth Thompson, *On Growth and Form* (Cambridge, 1917).

3 Martin Kemp, *Visualizations: The Nature Book of Art and Science* (Oxford, 2000), 1–2.

4 Philip Ball, *The Self-Made Tapestry: Pattern Formation in Nature* (Oxford, 1999).

5 Douglas Harnsberger, "'In Delorme's Manner…' An X-Ray Probe of Jefferson's Dome at Monticello Reveals an Ingenious 16th-Century Timber Vault Construction Concealed within the Dome's Sheathing," *Bulletin of the Association for Preservation Technology* 13, no. 4 (1981), 3–8.

6 For Goldsworthy's diary for the making of the Welsh slate arch, see the Andy Goldsworthy Digital Catalogue, *http://www.goldsworthy.cc.gla. ac.uk/image/?id=ag_02212&t=1*. More generally, for the arch as a form and early vernacular bridges, see Andy Goldsworthy and David Craig, *Arch* (London, 1999).

7 For more on Slater Bridge, see *http://www.visit cumbria.com/bridges.htm*.

8 Pietro Massimo Fumarola, *A passeggio in Valle d'Itria: Cicerone di me stesso* (Fasano, 1990).

9 Richard Handy, "The Igloo and the Natural Bridge as Ultimate Structures," *http://pubs.aina.ucalgary. ca/arctic/Arctic26-4-276.pdf*.

10 See particularly Drury's *Wave Chamber*, Kielder Water and Forest Park, Northumberland, 1995, and *Eden Cloud Chamber*, Eden Project, Cornwall, 2002: *www.chrisdrury.co.uk*. I am grateful to Chris Drury for discussing these and related structures with me.

11 Thompson 1917, 7.

12 For chaos and fractals in the broad context of natural pattern, see Ball 1999.

13 Martin Kemp, *Seen / Unseen: Art, Science, and Intuition from Leonardo to the Hubble Telescope* (Oxford and New York, 2006), 210–221.

14 *Cecil Balmond: Frontiers of Architecture 1*, ed. Michael Holm and Kjeld Kjeldsen (Louisiana Museum of Modern Art, Humlebaek, 2007), especially Martin Kemp, "The Natural Philosopher as Builder," 90–98.

15 Thompson 1917, 7.

16 Thompson 1917, 7.

17 Robert N. Pierpont, "Slate Roofing," APT *Bulletin* 19, no. 2 (1987), 10–23.

18 H. D. Miser, K. W. Trimble, and Sidney Paige, "The Rainbow Bridge, Utah," *Geographical Review* 13, no. 4 (October 1923), 518–531.

19 Kemp 2000, 148–151.

20 Goldsworthy had drawn out other works, but not to the extent used with *Roof*. He has also commissioned plans for houses and refuges from architects (such as cats. 105 and 117; drawings in Musée Gassendi and Glenstone, respectively) and for certain arches from engineers (such as cats. 108 and 119; plans in AGA).

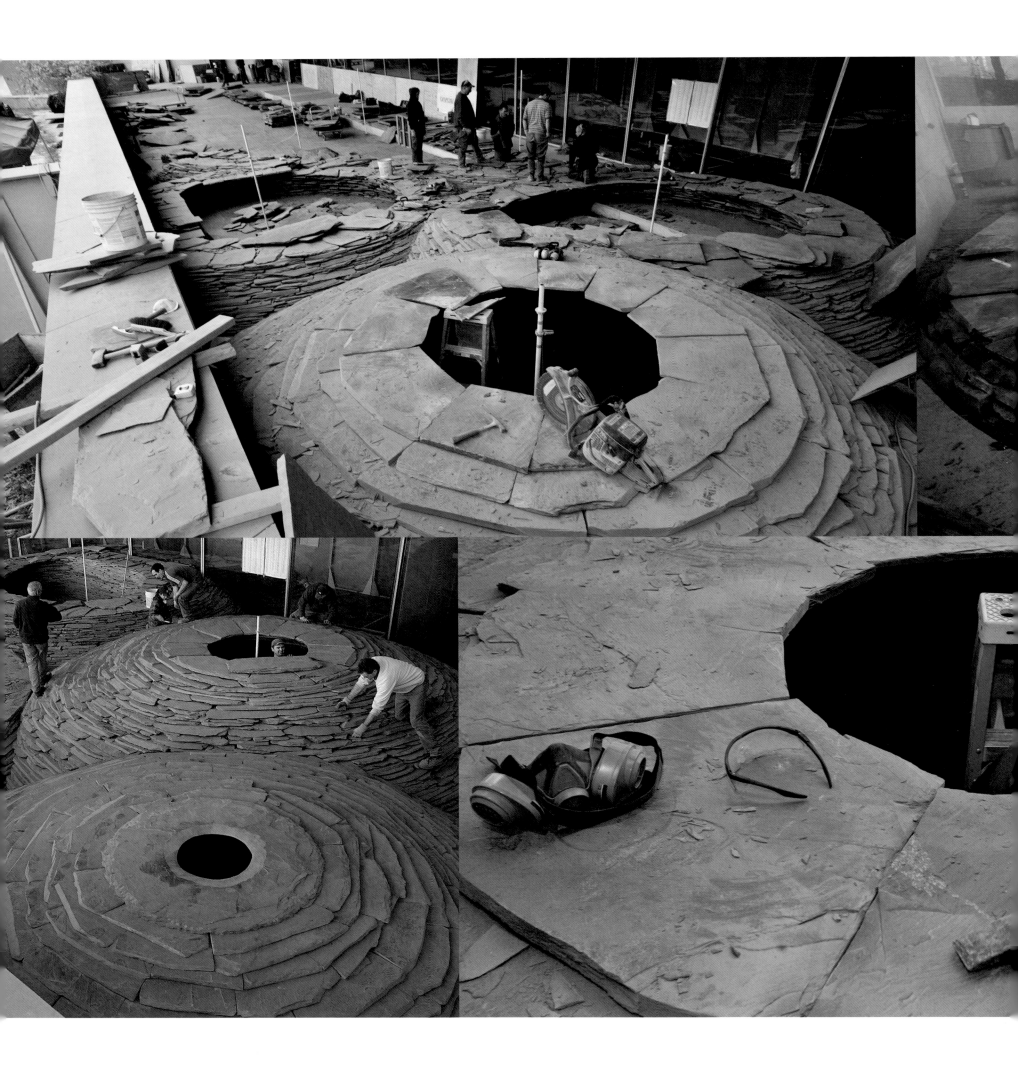

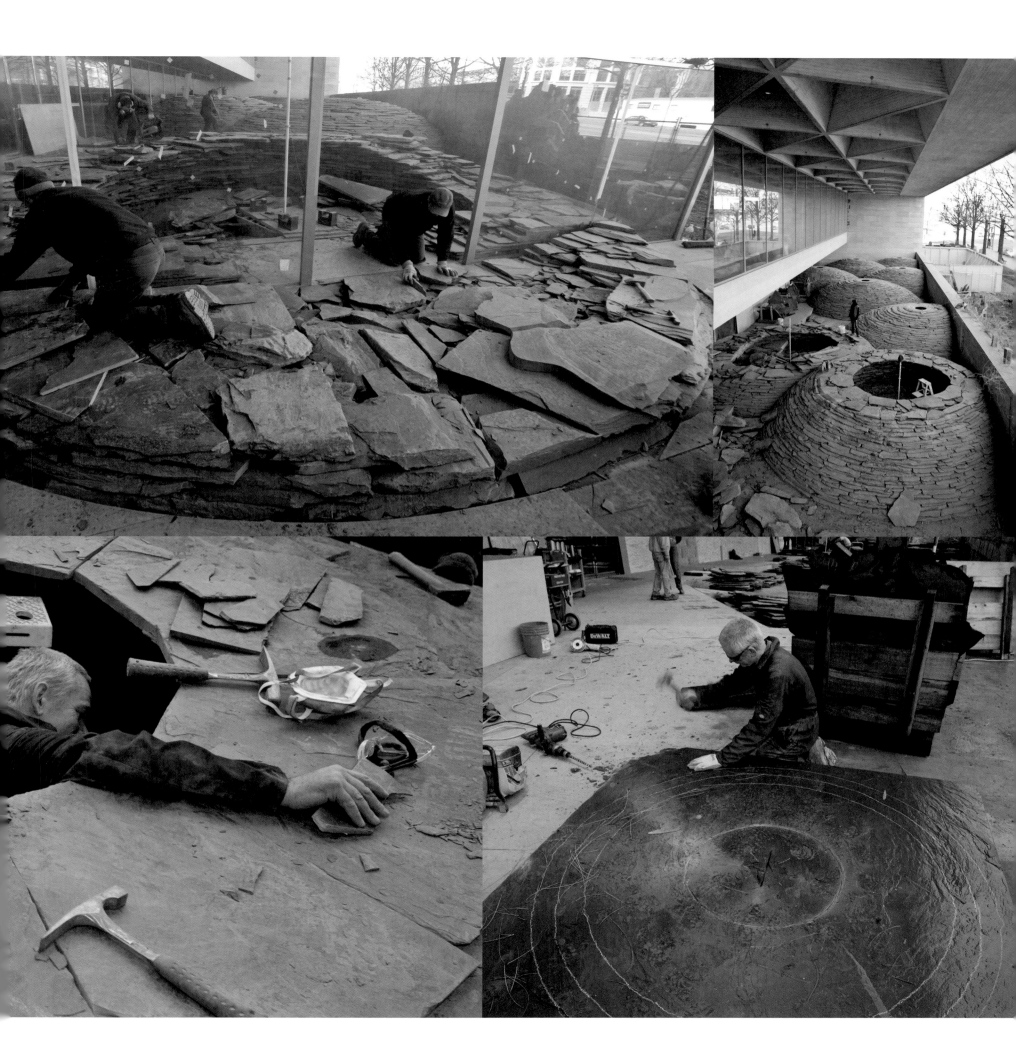

This is your museum of stones, assembled in matchbox and tin,

collected from roadside, culvert, and viaduct,

battlefield, threshing floor, basilica, abattoir,

stones loosened by tanks in the streets

of a city whose earliest map was drawn in ink on linen,

schoolyard stones in the hand of a corpse,

pebble from Baudelaire's *oui*,

stone of the mind within us

carried from one silence to another

stone of cromlech and cairn, schist and shale, hornblende,

agate, marble, millstones, and ruins of choirs and shipyards,

chalk, marl, and mudstone from temples and tombs,

stone from the silvery grass near the scaffold,

stone from the tunnel lined with bones,

lava of the city's entombment,

chipped from lighthouse, cell wall, scriptorium,

paving stones from the hands of those who rose against the army,

stones where the bells had fallen, where the bridges were blown,

those that had flown through windows and weighted petitions,

feldspar, rose quartz, slate, blueschist, gneiss and chert,

fragments of an abbey at dusk, sandstone toe

of a Buddha mortared at Bamiyan,

stone from the hill of three crosses and a crypt,

from a chimney where storks cried like human children,

stones newly fallen from stars, a stillness of stones, a heart,

altar and boundary stone, marker and vessel, first cast, load and hail,

bridge stones and others to pave and shut up with,

stone apple, stone basil, beech, berry, stone brake,

stone bramble, stone fern, lichen, liverwort, pippin and root,

concretion of the body, as blind as cold as deaf,

all earth a quarry, all life a labor, stone-faced, stone-drunk

with hope that this assemblage, taken together would become

a shrine or holy place, an ossuary, immovable and sacred

like the stone that marked the path of the sun as it entered the human dawn.

Molly Donovan

GOLDSWORTHY'S REVEAL

Andy Goldsworthy's project for the National Gallery of Art began in February of 2003 with a visit by the artist to the museum. A two-phase set of installations resulted: the first, ephemeral, completed in October 2003 and recorded, in part, in photographs and a diary; the second, a sculpture entitled *Roof* (cat. 101), completed in March 2005. What follows is the story of the project's development and its relationship to the artist's career-long project of building structures both temporary and more lasting.[1] To grasp Goldsworthy's larger project, we must look beyond the material surfaces of his works to the natural conditions that inform his choice of expressive means—for *Roof*, light, shadow, and the hole. This relationship between conditions and means in his work has much to tell us about our own culture, particularly its relationship to nature; to the human nature of the landscape, both rural and urban; and to the position of the museum therein. As we shall see, these concepts are rooted in the specific building forms and methods that Goldsworthy employed in *Roof*—the dome, the reveal, the dovetail, and the join.

During his first visit to the Washington museum Goldsworthy walked around the campus (both exterior and interior spaces) and made his observations.[2] The artist immediately focused on the stone buildings on the National Mall and inquired about the local and regional sources of the stones. As no definitive history of Washington building stones exists, research proved more involved than expected. Gallery staff identified two quarries that provided stone for Washington at the time of its founding. Seneca Creek quarry in Germantown, Maryland, was the source of the red sandstone for the Smithsonian Castle, completed in 1855 by James Renwick, who also designed other early buildings in Washington. Government Island in Stafford County, Virginia, was once home to the quarrying operation for Aquia Creek sandstone, the building stone used in the original structures of the White House and the Capitol. Given the porous, brittle nature of sandstone, it was later replaced or reinforced in both buildings with stronger stone. Still, portions of the original material remain in the historic structures.

Goldsworthy proposed to begin the project by making ephemeral work at one of the quarries, followed by the construction of a more permanent structure, possibly made of stone, in the Gallery itself. Ultimately, he chose Government Island sight unseen and requested little information about its history beforehand, wanting to experience the place firsthand when he arrived. It was only after his stay on the island that he visited the White House, one of the important buildings to feature stone from there.[3]

For nine days, from 1 to 19 October 2003, Goldsworthy constructed ephemeral works in situ out of found leaves, grass, and clay, which he then documented with photographs and a diary before they were blown or washed away, recycling back to the centuries-old quarry. (See Government Island photographs on pages 36–43 and the Washington Diary on pages 45–63).

Goldsworthy's first diary entry from Government Island begins with the quarry itself:

The quarrying has left holes in the island. I am reminded of information my son recently found on the internet about a place called Goldsworthy in Australia; "Once a mining town with a population of about 500, Goldsworthy no longer exists. All that remains to mark the town is a row of trees by the road. Before mining took place, Mount Goldsworthy was 132 metres high, now it is just a big hole in the ground." Leaving a hole is not like levelling a hill. I prefer a quarry that leaves as much, if not more, surface area than before it began.

Here Goldsworthy considers both mining (in the case of Mount Goldsworthy) and quarrying (in the case of Government Island) as a subtractive process of human mark-making, an erasure; and yet he notes an additive aspect as well, pointing to the creation of "surface area," a feature of building processes innate to human culture. The idea of the quarry has long interested artists as a negative space that once contained a mass (fig. 1). As such, its spatial construct has proved irresistible, particularly to sculptors.[4]

He goes on in the same diary entry to discuss the exertion of force that once defined the island: "Although the disused quarries are now settled there was a time when the effort of extracting the stone would have given the place, at times, violent

1 Joseph Mallord William Turner, *A Quarry, Perhaps at Saltram*, 1813, Tate, London

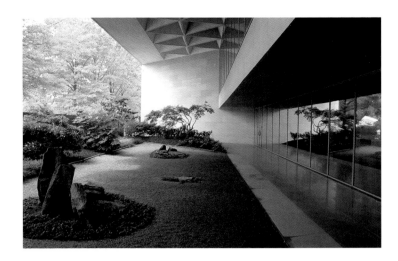

2 Japanese garden, 2003, National Gallery of Art, Washington

I have learnt a lot this week and have made progress in understanding a quality of light I have never previously been able to deal with properly. This is important to me. I have worked for 23 years. Not understanding a woodland floor on a sunny day represents a serious gap in my perception of nature. I have previously made works on sunny days in woods but usually despite the conditions rather than because of them.

The passage recalls the related challenges faced by nineteenth-century photographers working en plein air in the forest of Fontainebleau outside Paris.[5] It also reflects Goldsworthy's own use of photography (literally "light writing") as a kind of diary, which dates to his student days. In another passage, Goldsworthy regrets that his ephemeral works will not be able to capture the sense of movement as a film might.[6] Paradoxically, his permanent installation at the Gallery (*Roof*) would incorporate time and movement more deeply than anything he completed in the ephemeral phase.

energy." He connects this idea to a temporary work he has just made with red leaves on the tip of a sharp-edged rock: "The combination of red and a point has a violence about it. A passer by said it looked like blood."

In addition to its history of violent contact between man and nature, the Government Island quarry fascinated Goldsworthy in the quality of light and shadow there, which could also convey a violent force. "The light was extraordinary—at times hypnotic and nauseating as the strong winds violently blew the surrounding trees—creating a much layered sea of shadows across the rock face," he wrote on 15 October, a terribly windy day. He noted the important dynamic of the light the next day as well:

The work that I have made here has, I feel, understood the changing light that passes through this place. They [*sic*] have succeeded because they have worked with a specific time, place and material—a meeting of light and form which I have never achieved in similar conditions before. I have been allowed into a new way of looking.

Roof was installed in the East Building of the National Gallery of Art over the course of nine weeks in the winter of 2004/2005—a little more than a year after his work on Government Island. It was the first commissioned work for I. M. Pei's East Building since its inauguration in 1978. Goldsworthy selected a long, narrow space on the north side of the building as his site. This exterior space, just outside a bank of floor-to-ceiling windows and protected by a cantilevered overhang, was originally home to a reflecting pool measuring 139 by 26 feet. Due to leakage problems, the pool had been replaced almost at once by a series of dry-scape treatments, most recently a Japanese garden (fig. 2).[7] Goldsworthy presented two options for the site: the set of slate domes with centered oculi that became *Roof*, and an alternate work, of equal interest to him, that would have filled the former pool with dried, cracked clay from a quarry in Friendsville, Tennessee, which had provided the stones for the entire Gallery campus—the West Building in 1941, the East Building in 1978, and the Sculpture Garden in 1999. Through the clay floor, Goldsworthy planned a curvilinear channel (fig. 3). After a series of meetings with curators, administrators, structural engineers, and the board of trustees, the former proposal, more ambitious, permanent, and sculptural, was selected over the more modest, ephemeral, and low-lying one.

3 Andy Goldsworthy, Proposal drawing for *Clay with Boulders*, 2005, National Gallery of Art, Washington

This "new way" refers to the shadows created by the light and form, as the diary entry from 18 October conveys:

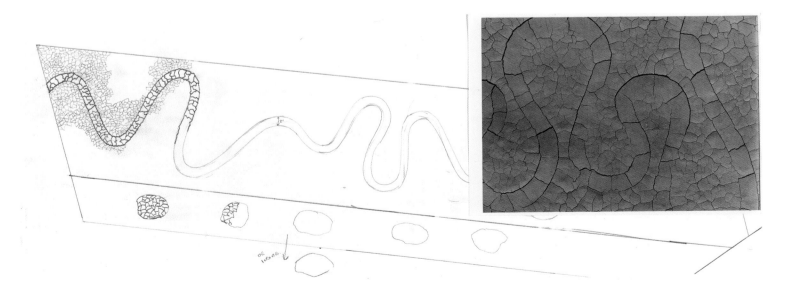

4 Andy Goldsworthy, *Slate Throws*, 19 February 1988, Blencathra Mountain, Cumbria

5 Andy Goldsworthy, Slate work installed in outer wall, studio, c. 1999, Bogg Farm

Since both the Government Island and Seneca Creek quarries had long ceased their operations, obtaining stone from them for the installation was not an option. Instead, Goldsworthy selected a quarry in Buckingham County, Virginia, just south of Charlottesville, which offered the same slate as that used on the roofs of many prominent Washington buildings.[8] In his choice of slate, Goldsworthy honored the original function of the particular site: "Slate is a reflective material and could project light into the space — which I believe was I. M. Pei's intention when he designed the pool."[9] With its elegant dark gray color and reflective sheen owing to rich mineral deposits, Buckingham Virginia slate is particularly suited to register and reflect changes in light. It also bears a close resemblance to the local slate Goldsworthy first worked with in Wales in 1980 and in Cumbria in 1988 (fig. 4), and it happens that the slate quarry in Buckingham County was founded by Welsh émigrés. In addition, slate had the strength and integrity needed for the planned design of nine conjoined and stacked domes, unsupported except by the horizontal slates themselves.

Goldsworthy had also worked with slate in numerous public sculptures in the United Kingdom (cats. 4, 5, 6, 8, 13, 27, 49, 50), other examples on Bogg Farm, Goldsworthy's studio (fig. 5),[10] and two cairns in the United States (cats. 31, 32). They all employ a stacked, overlapping structure, which recurs in *Roof*. And just as one cairn (cat. 32) was made from repurposed slate roofing shingles, *Roof* was made from cast-off materials, namely cuts of a certain scale created as a by-product of the quarrying process.

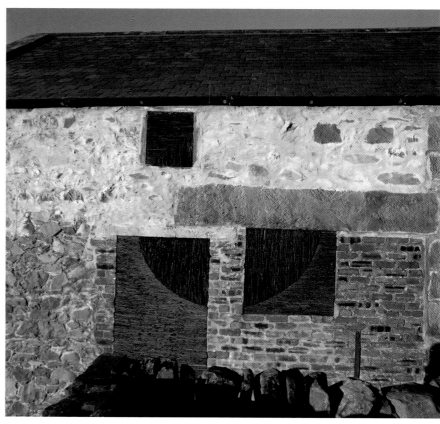

abundance among the many federal buildings in Washington, including the neoclassical dome in the atrium of John Russell Pope's West Building of the National Gallery of Art. What *Roof* shares with this dome and that of the Jefferson Memorial, also designed by Pope, is its low profile. Its lineage ranges from the Pantheon in Rome to Thomas Jefferson's Rotunda at the University of Virginia in Charlottesville. These low-profile domes represent the top section of a complete circle, well illustrated in Jefferson's drawing from 1819 (fig. 7). Goldsworthy saw a copy of this drawing while working on a test dome for *Roof* in Arvonia, Virginia; it supported his desire to make low-profile domes for *Roof* because they would convey the idea of a circular shape completed below grade in the mind's eye.

The artist assembled a team including his assistant Jacob Ehrenberg and the five British drystone wallers who work with him on stone projects: Steve Allen, Mark Heathcote, Andrew Mason, Gordon Wilton, and Jason Wilton. As with a large number of Goldsworthy's permanent projects, they were joined by student volunteers from Cornell University, where Goldsworthy was an adjunct professor from 2000 to 2008.[12] Local students from the Maryland Institute College of Art also provided assistance.[13] At first, ten domes were planned, but after the team started working, the artist edited one out to afford a better view from the ground floor of the conjoined sections of the domes. Owing to the strict confines of the exterior space, the weight and rigidity of the stone, and the ambition

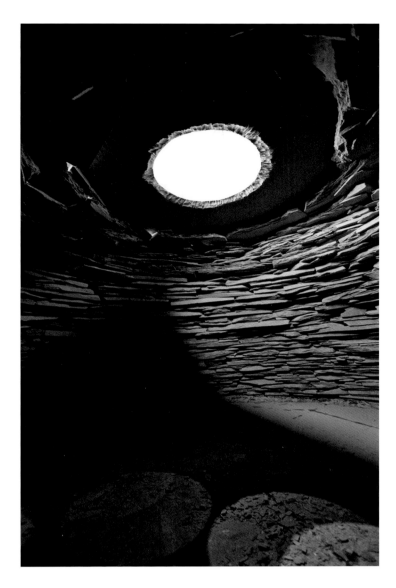

6 Interior of one of the domes, *Roof*, winter 2005

7 Thomas Jefferson, *University of Virginia: Southern Elevation of Rotunda*, 1819, University of Virginia Library, Charlottesville, Thomas Jefferson's Architectural Drawings, Special Collections

The artist soon focused on the site's northern orientation. The soft gray winter light was familiar to Goldsworthy, who grew up in England and makes his home in the Scottish Lowlands. It is a light that one of Goldsworthy's favorite poets, Carolyn Forché, evokes in her poem "Blue Hour."[11] With *Roof*, Goldsworthy pushes up a quiet truth about this light, one that he has taught himself to see over the course of thirty-some years of making holes. He knew, given the northern light and the cantilevered overhang, that he could achieve the blackest of holes in his chosen location at the Gallery. As very little light enters the area, the primordial time-telling function of the sun is evident only from within the work, a position barred to the public and readily accessible only while the work was in process (fig. 6). Thus Goldsworthy upends the traditional function of oculi in rooftop domes as passages for admitting light into a building, enhancing vision and clarity. Instead, the oculi of *Roof* function by presenting only darkness.

Another primary inspiration for *Roof* was the prominence of domed buildings throughout the Mall. More than any other feature, the dome defines the realm of civic architecture and can be found in

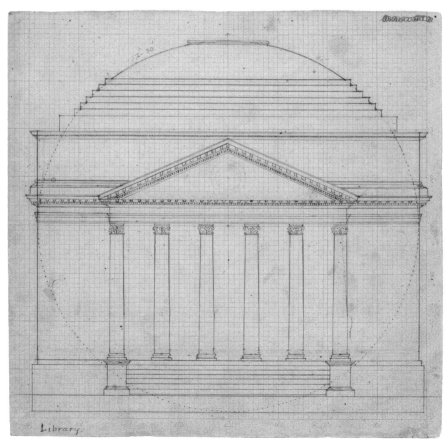

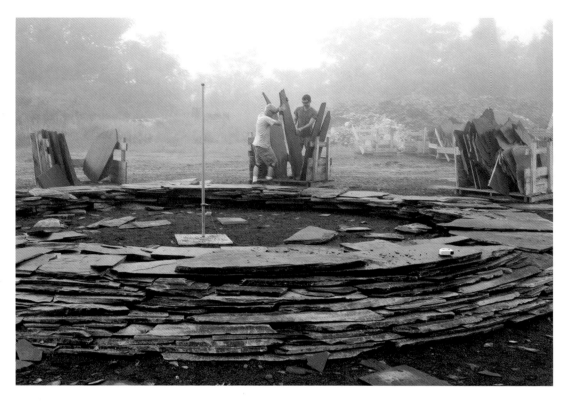

8 above, Test dome, *Roof*:
Andy Goldsworthy (left), Jacob
Ehrenberg (right), 14 July 2004,
Buckingham County, Virginia

9 below, Andy Goldsworthy
making preparatory drawings
for *Roof*, 16 July 2004, National
Gallery of Art, Washington

10 right, Tape delineating the
contours of *Roof*, 17 July 2004,
northern window, East Build-
ing, National Gallery of Art,
Washington

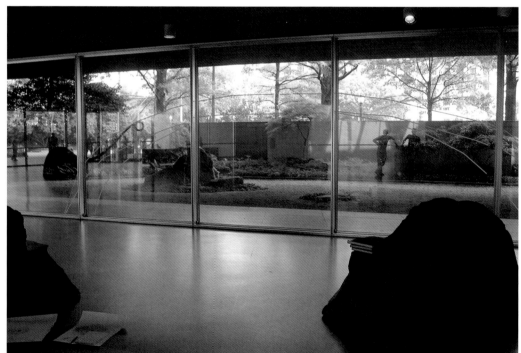

of the project, Goldsworthy made more preparatory drawings than usual. Nonetheless, he maintained his improvisational practice by refusing to make maquettes for the work. Together with Ehrenberg, he did make a portion of a test dome in the Buckingham quarry in July 2004 to determine the amount of slate that would be needed and to gain a feel for the stone (fig. 8), but after he cut his hand on a razor-edged stone, the trial was aborted. (Based on his experience working with slate, Goldsworthy had written nine months before that "the sharp edges [of the slate] occasionally draw blood and are a material, along with brackens stalks, that I associate with bleeding hands."[14]) Thereafter, he insisted on doing his planning on site by using scale and elevation drawings and by marking the space with tape to help determine the heights and diameters of the domes (figs. 9, 10). Goldsworthy decided that the ideal height would be one that would just prevent viewers at the ground-level windows from seeing into the oculus at the apex of each dome. By observing the height of various visitors at the museum, he settled on 5½ feet, which in turn helped to determine the diameter (27 feet) and number of domes (nine).[15]

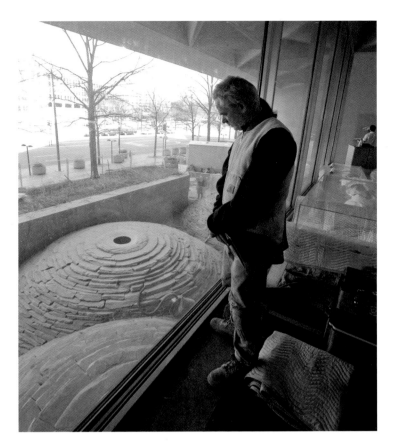

Equally important in Goldsworthy's planning was the view afforded through the same set of windows from the mezzanine, one floor aboveground. From here, the black holes would be powerfully visible, and Goldsworthy determined the placement of the domes with the composition of oculi in mind. Tentative locations for the oculi were marked out with cardboard circles held overhead by Ehrenberg and Lindsay Macdonald, a Gallery assistant on the project, while Goldsworthy directed from the mezzanine. He would often stand with his feet against the mezzanine window wall and position his body so that it appeared in the window's reflection of one of the holes (fig. 11). During a radio interview while making *Roof*, he commented:

Looking into a black hole is like looking over a cliff's edge.... I've always been drawn to the black hole—I've been making them since 1976 and I keep on making them.... I can't stop making them, and I have the same urge to make a hole as I do to look over a cliff edge.[16]

This comment conjures the example of Yves Klein's 1960 *Leap into the Void* (fig. 12), studied by Goldsworthy during his foundation-year coursework at Bradford College of Art. He recalls understanding Klein's famous "gesture"[17] as a moment captured in a photograph and his use of the body as a way of exploring the world.[18] This idea of the void as an occasion for discovery signals Goldsworthy's own entry in the discourse, for his own holes act as real and imagined passages, as conduits (sometimes arduous ones) for observation. And while Goldsworthy's holes are materially empty, they fill a number of metaphorical gaps.

It should be clear by now that Goldsworthy presents two works in *Roof*. Upon entering the East Building and looking left to the north window wall, one sees domes intersecting, rising, and falling in the space. This sense of a landscape of rolling hills is all the more evident from the way two of the domes appear to cut through the glass membrane and pass into the public space of the building. The apparent passage was a crucial gesture for *Roof*. At one point, Goldsworthy likened

11 Andy Goldsworthy at mezzanine window, winter 2005, National Gallery of Art, Washington

12 Yves Klein, Harry Shunk, and Janos Kender, *Leap into the Void*, 1960, The Metropolitan Museum of Art, New York

this sculptural extension to a caged animal reaching its claws through the bars, a potent reference to art's primitive nature and its sometimes complex relationship with museums.[19] Realizing this aspect of the work proved technically challenging. To give added support, Goldsworthy and his team built up the walls of the domes just outside the glass and made the sections of the domes inside the museum solid. Katy May, associate conservator of sculpture at the Gallery, devised a way to make the domes enter the museum seamlessly, as it was essential for the artist that this transition be convincing: May applied silicone that cured to the slate but not the window, thus allowing for slippage in the case of a vibration (engineers had insisted on a buffer between the slate and the glass). She then tooled and faux-painted the silicone with slate dust and pigment, making it look like slate (see page 65, top right). Thus, for structural reasons, the work does not technically adhere to the building, but rather is freestanding as it makes its apparent progress into the museum. These "rolling hills" appear very different as conditions of natural light change with the time of day. *Roof* is able to convey tremendous scale or to seem small and silent, growing and retreating according to weather and light conditions.

To be seen fully, however, the domes must also be experienced from a second vantage point, from the mezzanine. From here, the work reveals itself in a surprisingly new way: one sees the black holes in the centers of the domes. The holes are so evenly and absolutely dark, and the rims of slate defining them so sharply honed, that it is hard to believe they are openings into hollow domes rather than pieces of velvet laid on top of capstones. This sense of the black is so palpable that it registers not as a void but as something positive. This recalls Goldsworthy's statement about his first holes, made at the beach in Southport, Cheshire, in 1977, when he was a student at Preston Polytechnic (fig. 13):

13 Andy Goldsworthy, *First Hole, Sand*, July 1977, Southport, Cheshire

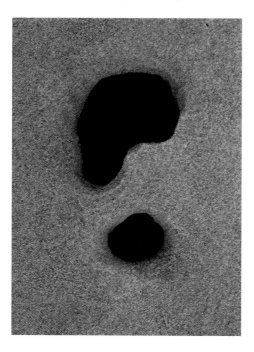

It was as if you had torn a hole in a curtain in a dark room and there's light pouring in. You can imagine it was the reverse of that. This black pour came—it was the equivalent of that . . . it wasn't just a hole. It was as if that hole was full of black . . . as if that black was beginning to bubble out of the ground like a well of black.[20]

By creating two views of *Roof* on as many levels, Goldsworthy incorporated time and movement into the experience of a seemingly static stonework, soliciting the spectator's movement through the building (and creating the desire for visual penetration and understanding) while capturing the changes in light through the day. Adding to the sense of movement are the domes themselves—slate stacked in ripple-like conjoined structures, with their holes hovering amid these swirling forms. From the mezzanine, one can imagine them as whirlpools of stone forced up to the top of an eddy, an effect created by the tension and confines of the long, narrow space. Indeed, the eddy relates to the shadow, for eddies are the "shadows" behind an object, usually a rock formation in a river, and their character can range from that of a calm refuge to a turbulent force, depending on the conditions of flow. This was acknowledged by the artist, who suggested that the traffic on Pennsylvania Avenue parallel to the site was like the current of a river.[21] To allow this view, scrims covering the entire window wall on the north side of the building needed to be removed, thus revealing the museum's connection to the city.

In the end, the relationship between *Roof* and the space of the Gallery's East Building is both sympathetic and tense. The cool slate of *Roof* complements the warm Tennessee pink marble of the East Building; its rounded domical forms press against Pei's angular asymmetries. This tension gives *Roof* a living, breathing presence. It is a reminder that the art museum is a space for creative forces to be cultivated and honored, not just entombed.

LIGHT, SHADOWS, AND HOLES

Light and its counterpoint, darkness, ultimately defined both the ephemeral work on the island and the installation at the Gallery. On Government Island, the tree canopy filtered light and created patterns of shadows below that tended to obscure form and vision. These shadows relate directly to *Roof*, whose dark holes—created in the controlled light under the protective coffers of the East Building—dramatically reiterate this obfuscation. Indeed, shadows are to some of Goldsworthy's ephemeral works what holes are to many of his more permanent sculptures. Not surprisingly, the former body of work explores the more quickly changing relationships between man and nature, the latter the slower shifts.

Shadows, defined as they are by the sun and its location in the sky, are a marker of time, and thus a natural means for Goldsworthy in his ephemeral work.[22] While it is counterintuitive (against our "nature") to lie down on the pavement when it begins to rain, or on a stone slab when the snow begins to fall, that is exactly what Goldsworthy does when he makes one of his rain or snow shadows (fig. 14). For his Yorkshire Sculpture Park snow shadow, he lay on a stone for the duration of a snowfall, so that when it finished, and he got up, his form was delineated as an absence (of snow) against stone. The opposite is true with his frost shadows. For these works he stands near white grass on a sunny morning when the temperature has dipped below freezing and casts a shadow while the sun melts the contours around his form, leaving his figure as a presence (of frost) against green grass (fig. 15).

These indexical traces mark the gentle, fleeting human imprints on nature while evoking photography, from William Henry Fox Talbot, whose 1839 account of his discovery of the negative-

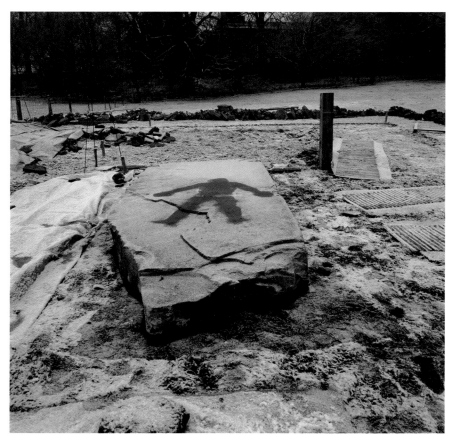

its insistent transformation of pale skin into red pigment, evokes the violence and immolation of the Vietnam War and related events, Goldsworthy's varied exploration of body shadows has a broader reference: it addresses the relationship of man and nature as well as the opposition of figure and ground at the basis of our vision, suggesting that the dominant view of man as a figure against the background of nature needs correction.

The holes Goldsworthy makes in a variety of materials continue his interest in working with light, but in the register of slower time and greater permanence. In 1980, at his first solo show at LYC Museum and Art Gallery in Banks, Cumbria, Goldsworthy compiled a photographic diary detailing how to make a hole with diagrams and instructional texts. His first commissioned hole, made in 1981, was on the grounds outside the Serpentine Gallery in London (fig. 17). In 1984, he created a hole in the floor inside the Frans Hals Museum (fig. 18) in Haarlem, The Netherlands, followed a few months later by a cut into the floor at the Serpentine Gallery (fig. 19).

If Goldsworthy's shadow works suggest the passage of time, these holes evoke, at least at first, the permanence of death. They call to mind Claes Oldenburg's 1967 *Placid Civic Monument* (fig. 20), a 6-foot-long, 3-foot-wide trench dug according to Oldenburg's specifications by a cemetery worker in

16 Dennis Oppenheim, *Reading Position for Second Degree Burn*, 1970, Irish Museum of Modern Art, Dublin

14 Andy Goldsworthy, *Snow Shadow*, February 2007, Yorkshire Sculpture Park (cat. 116, in progress)

15 Andy Goldsworthy, *Frost Shadow*, Penpont, Dumfriesshire

positive process of photography was subtitled "On the Art of Fixing a Shadow,"[23] to Lee Friedlander's shadow photographs. Of special relevance is Dennis Oppenheim's 1970 *Reading Position for Second Degree Burn* (fig. 16). This work—a photograph of the artist, badly sunburned except for an area of his chest where a strategically placed book on military tactics gave protection—was formative for Goldsworthy as a student. He reworked Oppenheim's model, using his body (instead of a book) to shield the land (instead of the body). And while Oppenheim's work, in

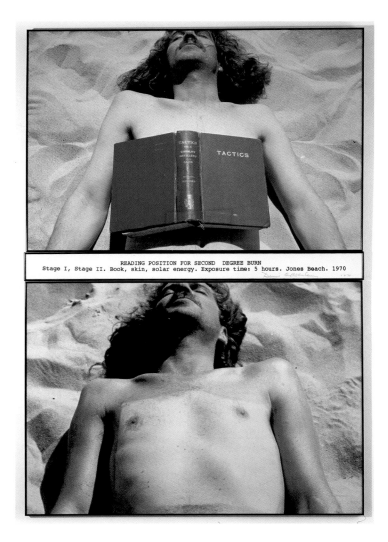

READING POSITION FOR SECOND DEGREE BURN
Stage I, Stage II. Book, skin, solar energy. Exposure time: 5 hours. Jones Beach. 1970

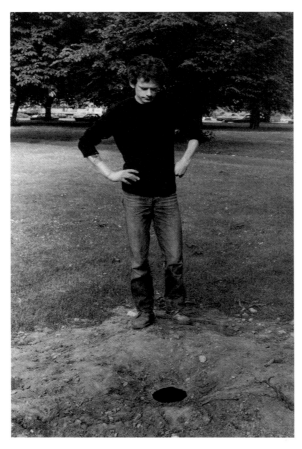

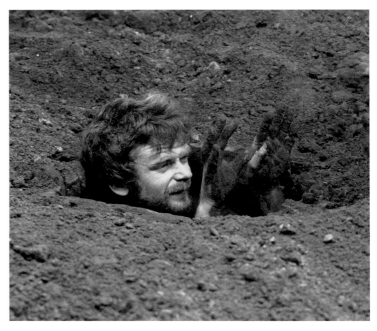

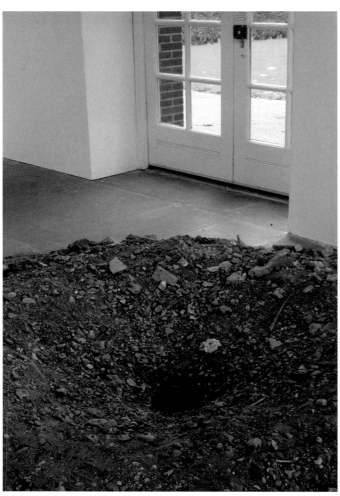

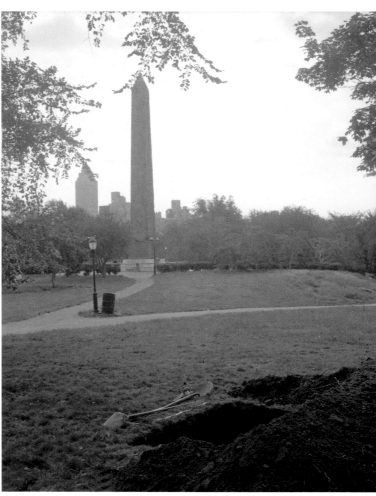

17 above, left, Andy Goldsworthy with *Hole* outside the Serpentine Gallery, summer 1981

18 above, right, Andy Goldsworthy inside *Hole* in Frans Hals Museum, August 1984, Haarlem, The Netherlands

19 far left, Andy Goldsworthy, *Hole*, 1984, Serpentine Gallery, London

20 left, Claes Oldenburg, *Placid Civic Monument*, 1967, New York City Parks, Photo Archive

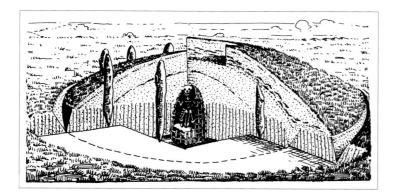

the focus from morbidity (as might have been the case with free-standing domes) to the possibility of renewal. He determined that he wanted to balance the funereal connotation of the domes with a composition evoking regeneration and the division of cells.[27]

NATURE AND CULTURE

The stated principle for Goldsworthy's project at the Gallery is that cities were once natural settings and their forms derive from geologic sources.[28] The speed with which we often move through our urban centers allows little time to reflect upon how they came into being in relation to the surrounding environments. This awareness is further obscured by the fact that more of us live in cities than ever before, thus changing our relationship to the natural world, a phenomenon that has been the subject of numerous studies.[29] The effect of this has been, by many accounts, the demise of our respect for nature.[30] Similarly, we pass through art museums with increasing speed, which blurs the connection between human works and the rhythms of nature, something that Goldsworthy's art prompts us to consider.

Goldsworthy has explored the human imprint in urban as well as rural settings (fig. 23). As a student in 1975, he made his first out-door works, Sol LeWitt-like, human-scaled modular structures, on the streets of Bradford, West Yorkshire.[31] Of his mature works, Golds-worthy's project for London, the fleeting *Midsummer Snowballs*, June 2000, is particularly noteworthy. For this work, the artist installed thirteen snowballs,

23 Andy Goldsworthy, *Rain Shadow*, 19 June 1993, Central Park, New York

21 Cross section of a Neolithic tomb, The Netherlands

22 Robert Smithson, *The Museum of the Void*, 1969, Museum Overholland, Niewersluis

New York's Central Park next to the Metropolitan Museum of Art. Olden-burg alternatively referred to this work both as *Hole* and as *Grave*, testifying to what Suzaan Boettger has described as "the recurrent avant-garde tendency to connect museums with death" while also taking direct aim at U.S. involvement in Vietnam. Oldenburg said of the work: "*Grave* is a per-fect [anti] war monument. Like saying no more."[24] Goldsworthy's holes also evoke graves—the domical forms in *Roof* reference burial mounds (fig. 21)—and can be read within a long tradition relating museums, as symbols of culture, with death. In this vein, Robert Smithson's words resonate: "Visiting a museum is a matter of going from void to void....Museums are tombs, and it looks like everything is turning into a museum" (fig. 22).[25] Importantly, with *Roof* as with his Serpentine holes, Goldsworthy took pains to connect art spaces to the natural world, suggesting a living exchange between the two.[26] In addition, his decision to create intersecting domes in *Roof* shifts

28

24 Andy Goldsworthy, *Mid-summer Snowballs* (elderberry snowball, Moorfields, London), June 2000

each 1.5 meters in diameter and imbedded with natural and man-made materials ranging from pinecones and elderberries to barbed wire. This intervention was completed on one of the longest days of the year. As Londoners passed by, they probed the strange forms, which gradually melted into puddles, spilling their varied contents (fig. 24).

Another important urban installation, the 1991 *Seven Holes* (cat. 29), was made for the Greenpeace headquarters in London. Goldsworthy, who installed a subterranean series of stepped clay discs, commented:

I always had this instinctive wariness of the language that ecological organizations had early on, that human nature was excluded from it, from nature.... The work at Greenpeace was made as an expression of support for Greenpeace. But also drawing attention to nature as here in the city too.... And it visually works the same as *Roof* in that respect... by "penetrating" the floor of the building to remind people that nature is here too, in us, in the building, in the place.[32]

Goldsworthy has made many other works, temporary and permanent, in urban settings.[33] This engagement with cities reflects his interest in social histories and in what he terms "the human nature of the landscape,"[34] both constructed and tamed. He is particularly interested in the man-made British landscape. As he said of his work, "You're aware of the human context in the landscape. You're the next layer."[35] This statement calls to mind one made by Matthew Coolidge, founder of the Center for Land Use Interpretation: "There isn't a molecule on the surface of the earth that hasn't passed through some human agent of change. It's unavoidable, don't you think? There are six billion of us now. I don't see how we could tread lightly."[36]

If there is an underlying thesis in Goldsworthy's work, it might be summed up in a line from Shakespeare's *King Lear*, when Lear says to Edgar: "Thou art the thing itself; unaccommodated man is no more but such a poor, bare, forked animal as thou art." This line, which Goldsworthy discovered as a student, became a truism for him—a reminder that we are indivisible from nature, indeed we too are nature.[37] It holds a primary place in his thinking, for his art acts in the very place where man and nature intersect.[38] It stands in opposition both to the classical, biblical confidence in human dominion over nature and to the willing subservience of man to nature rooted in Romanticism. Instead, he posits a realistic view of nature—both positive and negative and often redeeming—through observation, practice, and constant building. Perhaps the black holes at the center of the domes in *Roof* represent our blindness to the intimate place of nature in culture, suggesting lacunae not only in our vision but in our knowledge.

THE DOME

The domical forms in *Roof* arose from Goldsworthy's desire to make black holes in a space where cutting into the marble pavers on the ground was prohibited. This problem and its solution date to his first domical structure in slate—the temporary *Slate Hole*, made in 1987 at the Fabian Carlsson Gallery in London (fig. 25). There, too, the artist created a volume, a low-profile dome, aboveground. So, a dome in order to make a hole. And yet the dome for Goldsworthy has its own meanings and motivations as well.

Domical forms began, as Goldsworthy and a dictionary remind us, on the ground as houses (*n. [F. dôme, It. duomo, fr. L. domus a house]*). Just as the trajectory of the dome through history is long,[39] Goldsworthy's engagement with houses and domes extends throughout his career. His first dome / house was made (in snow) with Looty Pijamini, an Inuit guide at Grise Fiord in 1989 (figs. 26–28).[40] The shape of this structure was a Brunelleschi-style dome rather than the low-profile dome he used for *Roof*. Its hole was functional as an entry point, a door. Since then Goldsworthy's work has taken him into every type of environment across the globe, making for a peripatetic existence and perhaps at the same time creating a longing for home that is reflected in his production of houselike structures.[41] The difference between such sculptures and architecture, as artist Gordon Matta-Clark noted, is "whether there is plumbing or not."[42] This statement is particularly applicable to Matta-Clark's own incised buildings and altered structures, which refer to derelict, found buildings (fig. 29). In his *Refuges d'Art* project in Digne, France, Goldsworthy rehabilitated derelict buildings and created permanent, functional structures as part of a walk that provides art experiences and shelter for those undertaking it (cats. 76, 84, 93, 100, 105, 123). This proliferation has continued with *Roof* and more recently with *Stone House* (cat. 103) and the triumvirate *Clay Houses* (cat. 117). As he asserted in 2005, "home is the source."[43]

25 Andy Goldsworthy, *Slate Hole*, 1987, Fabian Carlsson Gallery, London

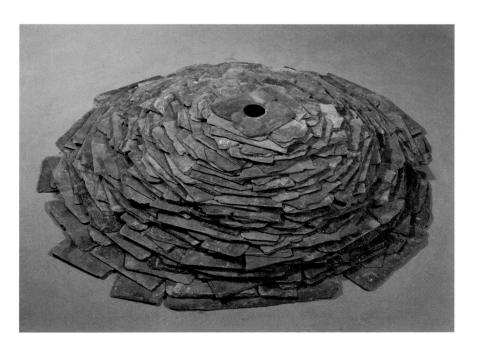

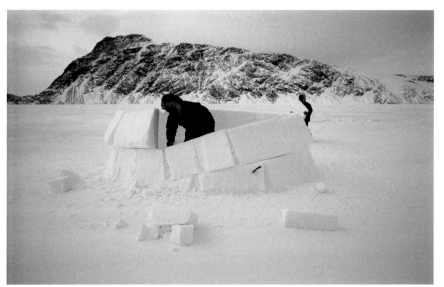

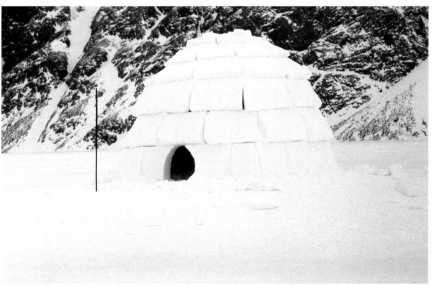

26–28 Andy Goldsworthy making a snow house with Looty Pijamini, 18 April 1989, Grise Fiord

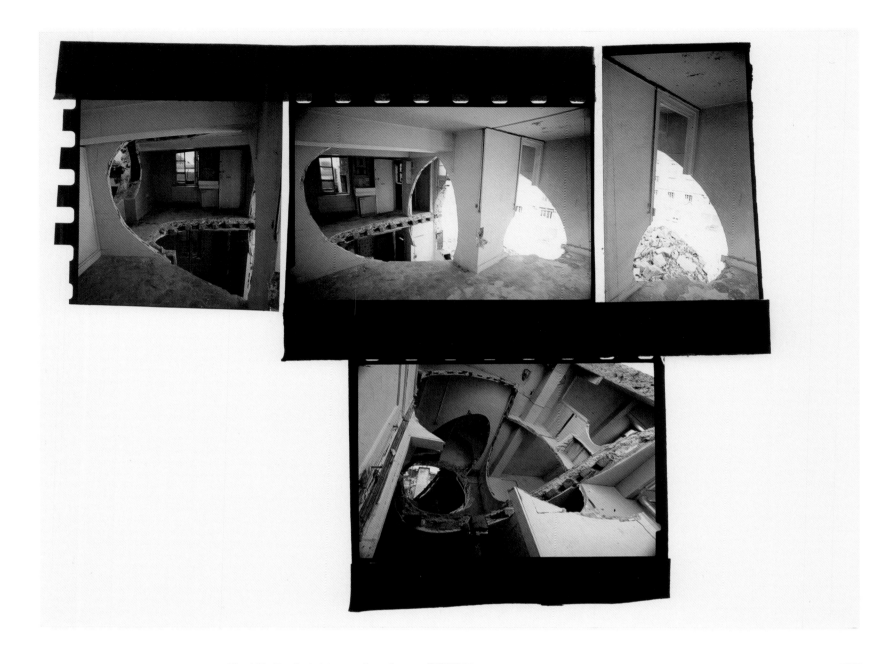

29 Gordon Matta-Clark, *Conical Intersect*, 1975, National Gallery of Art, Washington, The Glenstone Foundation, Mitchell P. Rales, Founder

30 Hutton Roof Crags, 2009, Cumbria

The title *Roof* might seem to refer simply to the covering of buildings, especially since the work is made of slate, a common roofing material. However, in early usage the English word "roof" applied to moundlike geologic forms. In his proposal for *Roof*, Goldsworthy alluded to this by mentioning Hutton Roof Crags, a natural hill-like formation in southeastern Cumbria with an abundant limestone "pavement" on its top that once provided a source for building materials but is now protected as a National Natural Preserve (fig. 30). Below the hill is the village of Hutton Roof, which developed from the extensive quarrying activity on the hill above. In his sculpture *Hutton's Roof* (cat. 54), a work installed on the actual roof of the National Museum of Scotland in Edinburgh, Goldsworthy made specific reference to this landmark, which bears the name of James Hutton, a major figure

in the Scottish Enlightenment. In *Roof*, Goldsworthy returned the roof to the ground, like the original Hutton Roof, and in so doing brought the modern word back to its roots, and even in some measure (via its use of slate and of northern light) to the artist's home.

This return may be viewed in light of recent discussions on contemporary urbanism, particularly the suggestion that the postmodern city is a spatio-temporal construct fusing the citadel and the garden.[44] In its rational, built structure, with referents to grand civic architecture, *Roof* suggests the citadel; with its connected, rolling, earthbound dome-scape, it suggests the garden. Taken together, these suggestions replace an ideology of mutual exclusiveness with the hope of coexistence between humans and nature.

THE REVEAL, THE DOVETAIL, AND THE JOIN

Because of how they are made, many of Goldsworthy's works are best described in building and architectural terms. Through some thirty years of practice, the artist has developed a toolbox of forms that build upon one another in repeated, interconnected ways.

In carpentry or "joinery" (the term used more commonly in Goldsworthy's native England), a reveal is the staggered (not flush) meeting of two sidepieces (usually stone or wood) forming the frame of an opening (fig. 31). Left showing after the casing is put on the edge of a doorway or window, a reveal is often seen as decorative, even ornamental.[45] It is similar to molding, sometimes identical with it.[46] However, a carpentry reveal also does important work: it strengthens the join; it covers unsightly irregularities between the wall and the wood framing; and it acts as a framing device to lead the eye through an aperture. "Reveal" is a particularly fitting term to describe the cantilevered layers of slate that make up *Roof*. They provide structural strength to the domes, and they lead the eye toward the darkened oculi (see page 14, left). The term also operates as a metaphor for the way the work structures our attention. Because *Roof* has two views, the reveal (in the sense of making visible) comes with the elevated mezzanine view of the oculi. Things are not what they first seem. Deeper looking is needed.

Dovetailing is the practice in carpentry of creating a fan-shaped tenon that forms a tight interlocking joint when fitted into a corresponding mortise (fig. 32).[47] There exists no corresponding drystone-walling term for fitting together intersecting slates — indeed neither Goldsworthy nor his team had dovetailed stone before — and so the joiner's manual is useful. Importantly, both drystone walling and dovetailing in joinery use no adhesives, but pure tension and gravity.

This aspect of *Roof* is a compelling feature, one that necessitated all of the artist's inventiveness and technical skill, much of it self-taught,[48] and all the capability of his team of drystone wallers.[49] The dovetails in *Roof* are no ordinary joins, and while clean and beautiful, the unyielding, brittle character of the slate made the task of fitting the material together much more difficult. The work demanded nine weeks of gritty, rigorous labor, and pressed materials and techniques to their limits, creating real risks and occasional failures. While

31 Carpentry reveal
32 Dovetail join

traditional drystone walling, indigenous to his native Britain, employs mostly hand tools,[50] for *Roof* both hand and machine tools were used (see cover). Indeed, Goldsworthy embraces technology and likes to dispel the romanticized notion that he is opposed to it by arguing that he would no more swim to the United States from Britain than use only hand tools.[51] By using both, he introduced a tension between the machine-cut stones in *Roof* and their hand-worked edges, which are visible particularly in the top layers of the stacked slate approaching the holes.

The join, understood at its broadest, is something that Goldsworthy was exploring in his ephemeral works on Government Island, Virginia. He wrote in his Washington Diary on 19 October 2003 about the relationship between two works, one a serpentine clay line inside a stone cut, and the other a line of grass stalks zigzagging over the cut (and the curved clay line):

I don't remember ever making two different but connected works like this before. The idea of seeing one work through another appeals to me — it sits well alongside my belief that works and ideas are linked to another.

As we have seen, Goldsworthy's work embraces oppositions — between man and his environment, nature and culture, indoors and outdoors, dark and light, urban and rural settings, the ephemeral and the permanent, life and death, absence and presence, figure and ground, hand and machine. To see his project whole, however, we must attempt to combine the binaries, *join* them, and complete the model that Goldsworthy's art represents. Only in this way can we grasp the tensile strength involved in h s practice. His work presents the natural and the human not as divided entities but as a nuanced, interconnected form. For its part, *Roof* both declares and bridges the gap between the museum and its natural surroundings. It also reminds us of the dynamic relationship between the artist and the art museum, a building that is a shelter and sentinel of tradition as well as a home for our living, breathing, creative nature.

NOTES

1 See Tina Fiske's introduction to the catalogue of works for a discussion of permanence in Goldsworthy's work.

2 See preface.

3 The nearly unspoiled character of Government Island made it an attractive site for this project (the quarry itself was preserved to a high degree). Seneca Creek quarry, on the other hand, was hidden by overgrowth featuring an abundance of poison ivy and poison oak and a den of copperheads. Permission to work at Seneca Creek quarry would have been difficult to obtain, as it falls under both national and county jurisdictions.

4 Among numerous examples, Robert Smithson's important *Broken Circle / Spiral Hill*, made in an abandoned quarry in Emmen, The Netherlands, in 1971, may be singled out. A more recent example is British sculptor Rachel Whiteread's photograph of the Carrara marble quarry in Italy, which she showed during a lecture at the National Gallery of Art, *Conversations with Artists*, Diamonstein-Spielvogel Lecture, 12 October 2008.

5 For the role the forest played in early photography, particularly in works by Eugène Cuvelier and Gustave Le Gray, see Sarah Kennel, "An Infinite Museum," in *In the Forest of Fontainebleau: Painters and Photographers from Corot to Monet* (National Gallery of Art, Washington, 2008).

6 "I thought of Thomas [Riedelsheimer], director of 'Rivers and Tides.' My images will not have this sense of movement and I know Thomas would have enjoyed filming this work and would have understood its energy" (Washington Diary, 15 October).

7 Goldsworthy—who began making holes more than ten years before he visited Japan (in three trips between 1987 and 1990)—has maintained a practice both parallel and coincidental with certain Eastern philosophical tenets. The idea of a hole as a positive form, one that conveys a recursive function, rather than the absence of form, has remained foremost among them. The hole is a prominent feature in traditional Japanese gardens, providing apertures for contemplation and for more practical purposes such as recycling natural refuse.

8 For information on the history of slate as a roofing material, see Joseph C. Jenkins, *The Slate Roof Bible* (Grove City, Penn., 2003).

9 Goldsworthy, Proposal statement, *Roof*, 2004, National Gallery of Art and Andy Goldsworthy's archive (AGA). *Roof* would become Goldsworthy's first public slate work in the United States.

10 I saw these works at the artist's studio in June 2003. Their elegant quality so impressed me that when Goldsworthy asked about regional sources for slate, I was eager to support this inquiry.

11 Carolyn Forché addressed this light in the notes to her poem "'Blue Hour." Her preface provides a meditation on the term: "When my son was an infant in Paris, we woke together in the light the French call *l'heure bleue*, between darkness and day, between the night of a soul and its redemption, an hour associated with pure hovering. In Kabbalah, blue is *hokhmah*, the color of the second *sefirah*. In Tibetan Buddhism, the hour before dawn is associated with the ground luminosity, or 'clear light,' arising at the moment of death. It is not a light apprehended through the senses, but is said to be the radiance of the mind's true nature." Carolyn Forché, *Blue Hour: Poems* (New York, 2003), 71.

12 Gerri Jones, head of the program for professors-at-large at Cornell University, where Andy Goldsworthy was Andrew D. White Professor-at-Large for eight years, arranged for three students to visit during the first part of the installation. The students who assisted on the project with Jones were Jane Padelford, Katherine Schiavone, and Danna Kinsey.

13 Fred Lazarus, president of the Maryland Institute College of Art, enabled students Barrett Thornton and Bennett Grizzard to lend their talents to the making of *Roof*. They were referred by Therese O'Malley, associate dean of the Center for Advanced Study in the Visual Arts at the Gallery.

14 Goldsworthy, Proposal statement, *Roof*, 2004; he first visited the Buckingham quarry on 20 October 2003.

15 This relationship to human scale connects *Roof* to minimalist sculpture, particularly to Robert Morris' and Richard Serra's works, and to Tony Smith's *Die*, model 1962, fabricated according to the artist's instructions in 1968 (the version Smith owned is now in the Gallery's collection). Smith, alluding to its man-sized, coffinlike construct, famously said "Six foot box. Six foot under" (*Tony Smith: Two Exhibitions of Sculpture* [Wadsworth Atheneum, Hartford, and The Institute of Contemporary Art, Philadelphia, 1966], n.p.).

16 Goldsworthy, interview with Susan Stone, National Public Radio, aired 25 March 2005.

17 Goldsworthy later understood the work as the photomontage it is, but when it was taught at Bradford, it was not presented as such. Goldsworthy, conversation with the author, 7 August 2005.

18 *Dimanche, the Newspaper of a Single Day* was prepared as part of the Paris Festival d'Avantegarde and published 27 November 1960.

19 Goldsworthy, conversation with the author, winter 2005. These stone "cuts" through the window glazing also connect to the man-made cuts in the stone quarry at Government Island.

20 Goldsworthy, conversation with the author, 2 October 2005.

21 Goldsworthy, conversation with the author, winter 2005.

22 In *Time* (London and New York, 2000), Goldsworthy anthologized his practice involving different facets of temporality by contrasting ephemeral and permanent works. For his slide cabinet of ephemeral works, see the documentary film *Rivers and Tides*. His work has also included time-based media, such as his video *Snow Shadow Fold* documenting the "snow shadows" at the Yorkshire Sculpture Park in 2007.

23 Sarah Greenough et al., *On the Art of Fixing a Shadow* (National Gallery of Art, Washington, 1989). It is a specific effect of nature, indeed what William Henry Fox Talbot called "natural magic," rather than a deceptive illusionism that is revealed at the moment of discovery in Goldsworthy's work.

24 Suzaan Boettger, "A Found Weekend, 1967: Public Sculptures and Anti-Monuments," *Art in America* (January 2001), 84.

25 Robert Smithson, "Some Void Thoughts on Museums," *Arts Magazine* 41, no. 4 (February 1967), 41.

26 See *The Sublime Void: On the Memory of the Imagination* (Antwerp, 1993), for extended references to this idea.

27 Goldsworthy, conversation with the author, autumn 2004.

28 Goldsworthy, Proposal statement, *Roof*, 2004.

29 See Luis M.A. Bettencourt, José Lobo, et al., "Growth, Innovation, and the Pace of Life in Cities," Theoretical Division, MSB284 Los Alamos National Laboratory, Los Alamos New Mexico, Santa Fe Institute, 6 March 2007 at *http://www.santafe. edu/events/workshops/images/3/36/Bettencourt_ et_al_2007.pdf*; and Marc G. Berman and J. Jonides, "The Cognitive Benefits of Interacting with Nature," *Psychological Science* 19 (2008), 1208–1212. Both studies are discussed in Jonah Leher's article "How the City Hurts Your Brain... and What You Can Do about It," *Boston Globe*, 2 January 2009 at *http://www.boston.com/bos- tonglobe/ideas/articles/2009/01/04/how_the_ city_hurts_your_brain/*. The Santa Fe study mentions the creative innovation possible in cities, balancing out this view.

30 See Bill McKibben "Can Anyone Stop It?" *New York Review of Books*, 11 October 2007, 38–40, and *The End of Nature* (New York, 1989). Goldsworthy grew up in the generation aware of Rachel Carson's *Silent Spring* (Boston, 1962), the book credited with launching the environmental movement. A compelling, apocalyptic exhibition by curator Massamiliano Gioni (*After Nature*, New Museum, New York, 2008) explored the view of impending environmental peril through the lens of Werner Herzog's documentaries.

31 Reproduced in Goldsworthy, *Time*, 2000, 180.

32 Goldsworthy, conversation with the author, 7 August 2005.

33 At the Museum of Jewish Heritage in New York City (see cat. 92), Goldsworthy installed eighteen hollowed stone boulders; eighteen saplings were planted in these stone casements by Holocaust survivors, among others. In yet another installation in New York (8 May–16 June 2007), Goldsworthy and a team of assistants covered the walls of Galerie Lelong with white porcelain clay, which was designed to dry, crack, and fall to the floor. The sight of white walls at the beginning gave way to the look of rubble on the floor and fragmented "maps" on the walls where the porcelain stayed. In between these two states were the frightening sounds of falling clay. Six and a half years after 9/11, in the midst of the Iraq war, this work addressed the entropy and destruction of both natural and man-made environments.

34 Goldsworthy, conversation with the author, 2 October 2005.

35 Goldsworthy, conversation with the author, 2 October 2005.

36 Matthew Coolidge, quoted in John Strausbaugh, "Take Nature, Add Humans, Observe Results," *New York Times*, 24 September 2006, 30.

37 Goldsworthy, conversation with the author, 28 May 2004. The artist, who had read the play at age seventeen, paraphrased this line (*King Lear* [Folger ed.] act 3, scene 4, beginning at line 113). He recalled that it had had a profound effect on him, reducing everything to nature and reinforcing man's animalistic quality.

38 Goldsworthy shares this sentiment with Jackson Pollock, who stated, "I am Nature" (Carter Ratcliff, *The Fate of a Gesture: Jackson Pollock and Postwar American Art* [New York, 1996], 68). Another comparison might be made to the oft-cited line from English philosopher Francis Bacon (1561–1626), whose original Latin text translates as "Nature reigns…and art is man added to Nature" (*The Works of Francis Bacon*, ed. James Spedding, Robert Leslie Ellis, and Douglas Denon Heath [Boston, 1857], 3:190). Shakespeare also gives us (in *The Winter's Tale* [Folger ed.], act 4, scene 4, line 114) "the art itself is nature."

39 See E. Baldwin Smith, *The Dome: A Study in the History of Ideas* (New Jersey, 1950). For a post-1960s, Land Art–centered discussion of domical structures and earth mounds and their relationship to ancient forms, see Lucy Lippard's *Overlay: Contemporary Art and the Art of Prehistory* (New York, 1983).

40 For more information on his project at Grise Fiord, see Goldsworthy, *Touching North* (London, 1989).

41 A similarly peripatetic group of artists, including Rikrit Tiravanija, met with scholars to discuss "finding a place, a house, that could be a meeting point and rest stop away from our routines. Most of us at that time were very nomadic in work and in life, and I think there was a need for some distance from the circuitry of the art world—to have a thinking 'site.'" See Rikrit Tiravanija, "Remote Possibilities: A Roundtable Discussion on Land Art's Changing Terrain," *Artforum* (summer 2005), 291.

42 Anne M. Wagner, "Splitting and Doubling: Gordon Matta-Clark and the Body of Sculpture," *Grey Room* 14 (winter 2004), 28, citing Joan Simon, "Gordon Matta-Clark, 1943–1978," *Art in America* (November–December 1978), 13. As Wagner wrote, "Simon borrows this phrase from the interview with Matta-Clark conducted by Donald Wall, 'Gordon Matta-Clark's Building Dissections.'" The text of this interview has since been reprinted in *Gordon Matta-Clark*, ed. C. Diserens (London, 2003), 181–186, 182.

43 Elson Lecture, 17 March 2005, National Gallery of Art.

44 Abraham Akkerman, "Femininity and Masculinity in City-Form: Philosophical Urbanism as a History of Consciousness," *Human Studies* 29 (April 2006), 2:229–256. The gendering in this article is not an argument I am pursuing.

45 This view of Goldsworthy's art as decorative is presented in Roberta Smith, "The Met and a Guest Step Off," *New York Times*, 3 September 2004.

46 See Jim Tolpin, *Woodworking Wit and Wisdom* (Cincinnati, Ohio, 2004), 31–32, and Nick Engler, *Woodworking Wisdom* (Emmaus, Penn., 1997), 40–41.

47 Steve Allen, the master drystone waller who worked with the team on *Roof*, helped me to understand the construction of the interconnected sections of the domes and assisted in the identification of "dovetailing" as the closest and most appropriate term to describe the method of construction (though it is not a term the artist himself used). Martin Puryear uses related methods of carpentry to make his sculptures in wood. He shares with Goldsworthy an attention to vernacular, sometimes archetypal, forms and methods.

48 One nonconventional type of join the artist has used is "spit welding" (his term for using his own saliva to join materials such as ice, snow, and stone in freezing conditions).

49 *Roof* was the most challenging work they made with the artist. Goldsworthy and team, conversations with the author, 2 October 2005.

50 Drystone walling is nearly extinct in the United States, where conventional building techniques often employ veneer stonework.

51 Andy Goldsworthy, Diamonstein-Spielvogel Lecture, National Gallery of Art, 23 January 2005.

PHOTOGRAPHIC SUITE

Clay
Worked into a Stone
Edges to Catch the Passing Light
Government Island, Virginia

Andy Goldsworthy
16 October 2003
suite of seven cibachrome prints
National Gallery of Art, Washington,
Patrons' Permanent Fund
2004.74.1

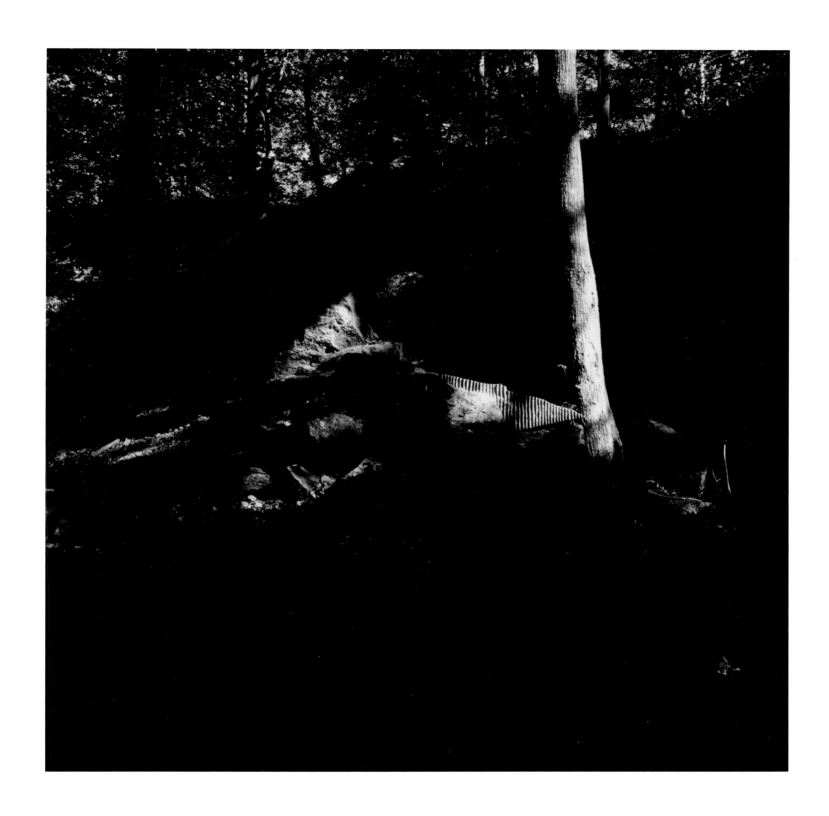

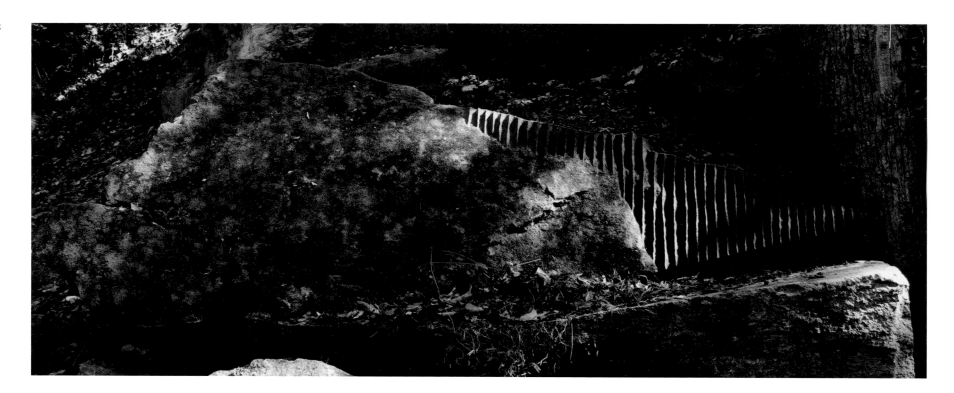

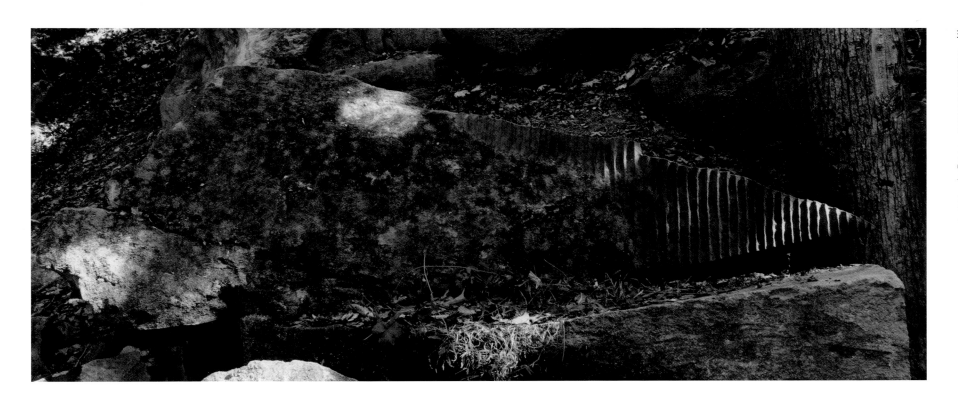

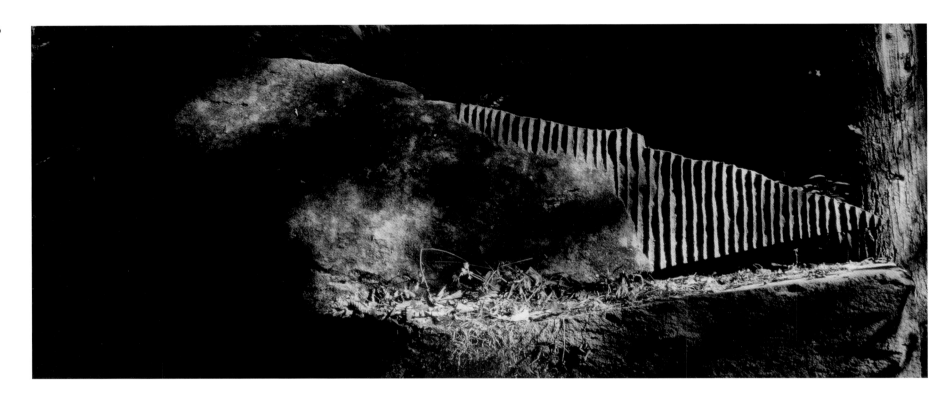

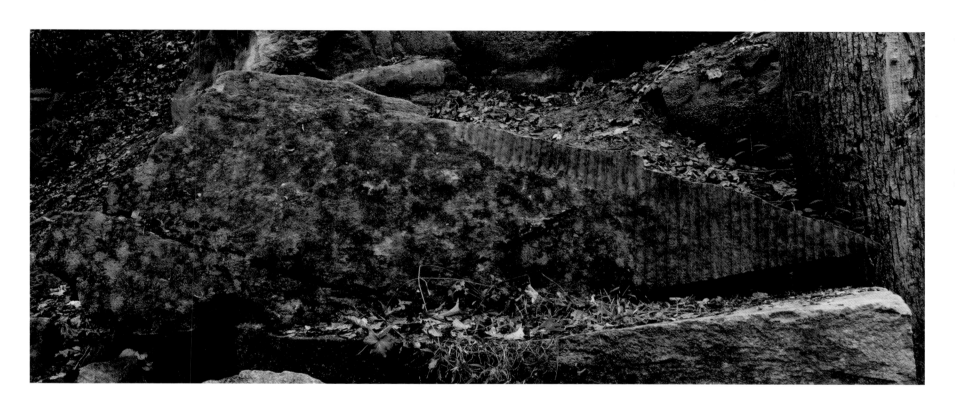

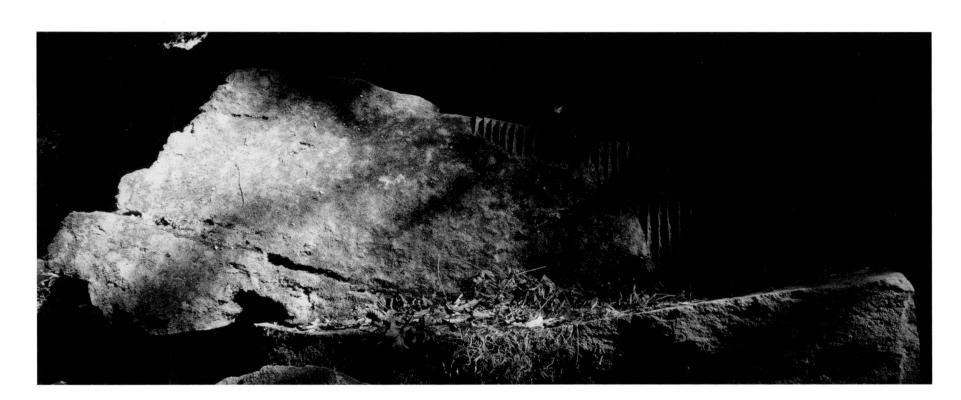

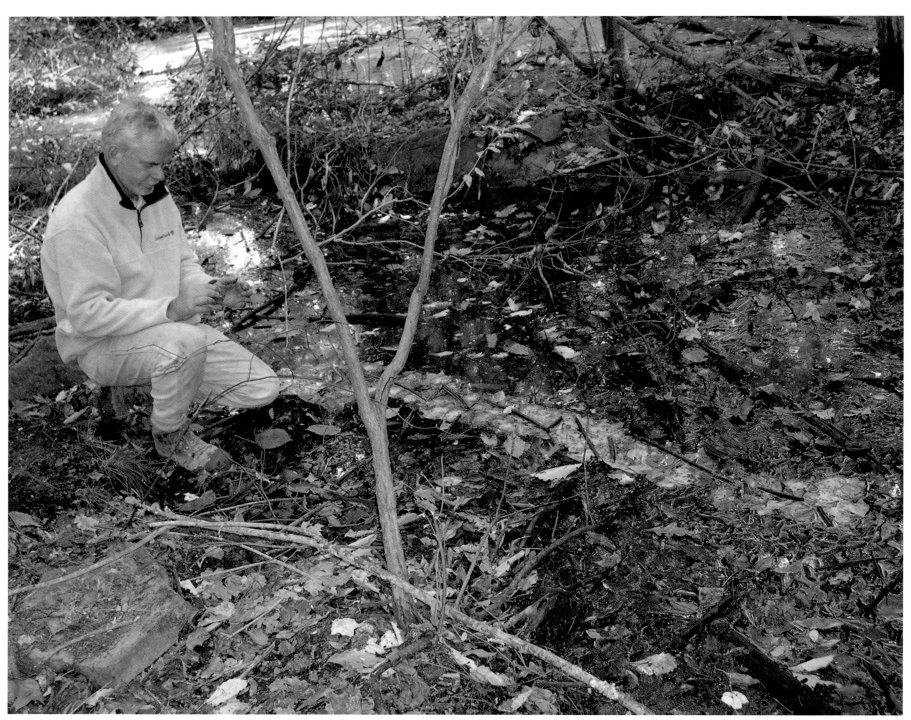

The artist working on Government Island, 17 October 2003

Washington Diary

Andy Goldsworthy
11–19 October 2003
suite of twelve silver dye bleach prints
mounted on nine sheets of white paper with text
National Gallery of Art, Washington,
The Nancy Lee and Perry Bass Fund
2004.74.2

OCTOBER 11, 2003

I ARRIVED LATE LAST NIGHT AND WENT TO THE ISLAND THIS MORNING. IT IS MUCH SMALLER THAN I EXPECTED BUT WHAT AN INTERESTING PLACE! THE PROMINENCE OF THE BUILDINGS THAT CAME OUT OF IT, THE CAPITOL AND THE WHITEHOUSE AMONGST THEM ARE IN SUCH CONTRAST TO THIS MODEST, INTIMATE, HIDDEN PLACE.

I AM HERE BECAUSE THE NATIONAL GALLERY AT WASHINGTON DC HAS ASKED ME TO MAKE A PROPOSAL FOR THEIR COLLECTION. I SUGGESTED THAT AS A STARTING POINT THAT I WORK AT THE QUARRIES FROM WHICH SOME OF THE BUILDINGS OF WASHINGTON WERE TAKEN. I HOPED THAT BY GOING TO THE CITY'S PHYSICAL SOURCE THAT I MIGHT GAIN INSIGHT TO ITS ORIGIN, CONNECTION AND RELATIONSHIP TO THE LAND.

THE EXTRACTION OF STONE HAS LEFT THE ISLAND MORE INTERESTING THAN IF IT HAD NOT BEEN TOUCHED, NOT ONLY HAS BEEN ENRICHED BY THE WORKING AND HISTORY OF THE PLACE IT IS ALSO A MORE DIVERSE ENVIRONMENT.

THE QUARRYING HAS LEFT HOLES IN THE ISLAND. I AM REMINDED OF INFORMATION MY SON RECENTLY FOUND ON THE INTERNET ABOUT A PLACE CALLED GOLDSWORTHY IN AUSTRALIA;

"ONCE A MINING TOWN WITH A POPULATION OF ABOUT 500, GOLDSWORTHY NO LONGER EXISTS. ALL THAT REMAINS TO MARK THE TOWN IS A ROW OF TREES BY THE ROAD.

BEFORE MINING TOOK PLACE, MOUNT GOLDSWORTHY WAS 132 METRES HIGH, NOW IT IS JUST A BIG HOLE IN THE GROUND."

LEAVING A HOLE IS NOT LIKE LEVELLING A HILL. I PREFER A QUARRY THAT LEAVES AS MUCH, IF NOT MORE, SURFACE AREA THAN BEFORE IT BEGAN.

I STRUGGLED TO FIND SOMETHING TO MAKE. THE LEAVES HAVE HARDLY BEGUN TO CHANGE COLOUR AND I ONLY FOUND A FEW RED LEAVES TO WORK WITH. I STUCK THESE WITH WATER TO THE TIP OF A TAPERED ROCK IN ONE OF THE QUERCETUM QUARRIES THAT POCKET THE ISLAND - DRAWING THE STONE TO A RED POINT. THE COMBINATION OF RED AND A POINT HAD A VIOLENCE ABOUT IT. A PASSER BY SAID IT LOOKED LIKE BLOOD.

ALTHOUGH THE ASLEEP QUARRIES ARE NOW SETTLED THERE WAS A TIME WHEN THE EFFORT OF EXTRACTING THE STONE WOULD HAVE GIVEN THE PLACE, AT TIMES, VIOLENT ENERGY.

THE RED LEAVES ON THE STONE CHANGED WITH THE LIGHT - BECOMING MORE VIVID AS THE SUN SHONE DIFFUSED THROUGH THE HAZY SKY. AN ELUSIVE RED. IT WILL BE MORE EVIDENT IN A WEEK OR SO WHEN THE OPENING OF THE CANOPY WILL ALLOW MORE LIGHT TO REACH THE WOOD FLOOR - AT PRESENT THE LIGHT IS DRY AND DULL. IT NEEDS TO RAIN!

I arrived late last night and went to the island this morning. It is much smaller than I expected but what an interesting place! The prominence of the buildings that came out of it, the Capitol and the White House amongst them are in such contrast to this modest, intimate, hidden place.

I am here because the National Gallery at Washington DC has asked me to make a proposal for their collection. I suggested that as a starting point that I work in the quarries from which some of the buildings of Washington were taken. I hoped that by going to the city's physical source that I might gain insight to its origin, connection and relationship to the land.

The extraction of stone has left the island more interesting than if it had not been touched. Not only has [it] been enriched by the working and history of the place it is also a more diverse environment.

The quarrying has left holes in the island. I am reminded of information my son recently found on the internet about a place called Goldsworthy in Australia;

"Once a mining town with a population of about 500, Goldsworthy no longer exists. All that remains to mark the town is a row of trees by the road.

Before mining took place, Mount Goldsworthy was 132 metres high, now it is just a big hole in the ground."

Leaving a hole is not like levelling a hill. I prefer a quarry that leaves as much, if not more, surface area than before it began.

I struggled to find something to make. The leaves have hardly begun to change colour and I only found a few red leaves to work with. I stuck these with water to the tip of a tapered rock in one of the overgrown quarries that pocket the island—drawing the stone to a red point. The combination of red and a point has a violence about it. A passer by said it looked like blood.

Although the disused quarries are now settled there was a time when the effort of extracting the stone would have given the place, at times, violent energy.

The red leaves on the stone changed with the light—becoming more vivid as the sun shone diffusely through the hazy sky. An elusive red. It will be more evident in a week or so when the opening of the canopy will allow more light to reach the wood floor—at present the light is dry and dull. It needs to rain!

Oct 12, 2003

THE QUARRY HAS BEEN LEFT AS IT WAS THE DAY WORK STOPPED. THE BEDROCK NEATLY WORKED TO A VERTICAL FACE IN PREPARATION FOR THE NEXT BLOCK TO BE CUT OUT.

A STRONG SENSE OF WORK CAN STILL BE FELT IN THE TEXTURED SURFACE. THE MARKS LOOK TOO BIG TO HAVE BEEN CHISELLED AND COULD HAVE BEEN MADE WITH A STONE AXE.

I WORKED MILD IN AN EDGE - WORKING THE LIGHT AND SURFACE OF THE STONE. I WANTED TO DO JUST ENOUGH - A TRANSPARENT TOUCH. THE QUARRY WORKERS TOUCH SEEN THROUGH MINE.

I WORKED EARLY IN THE EARLY MORNING LIGHT WITH LITTLE IDEA OF HOW IT WOULD LOOK WHEN FINISHED. I DO NOT UNDERSTAND THIS PLACE WELL ENOUGH TO BE ABLE TO WORK TOWARDS A MOMENT - I HAVE TO DEAL WITH IT AS I SEE AND FIND IT. SURPRISINGLY THE SCULPTURE WORKED WELL WITH THE SUN CASTING A VARIETY OF LIGHT AND SHADOW ACROSS ITS SURFACE. IT WAS A GOOD ATTEMPT AT WORKING WITH A LIGHT THAT I HAVE ALWAYS FOUND DIFFICULT TO WORK WITH - DAPPLED SUN THROUGH TREES IN WHICH FORM IS LOST UNDER ITS CAMOUFLAGING EFFECT.

TODAY THE LIGHT WORKED TO THE SCULPTURE'S ADVANTAGE AND BROKE DOWN THE FORM OF THE HARD EDGE, REDUCING ITS PROMINENCE AND MAKING IT AN INTEGRAL PART OF THE STONE. THE SUN AND SHADOW TONED DOWN THE EDGE BUT HEIGHTENED THE TEXTURE OF THE WALLS. LATER WHEN THE SUN SHONE ON TO THE FACE, RATHER THAN ONE SIDE, THE WORK BECAME FLATTENED AND LOST ITS CONNECTION TO THE STONE. IT LOOKED STUCK ON RATHER THAN WORKED INTO THE SURFACE.

BEGAN ANOTHER WORK - SIMILAR TO YESTERDAY, WITH RED LEAVES ON A TAPERED STONE. THE RED IS SO ELUSIVE. THE STONE WAS INITIALLY IN THE SHADE AND THE RED SEEMED QUITE STRONG. AS I FINISHED, HOWEVER, THE DAPPLED LIGHT REACHED INITIALLY KILLED OF THE RED. THE LEAVES WERE CAST INTO SHADOW AND MADE DARK IN COMPARISON TO THE PATCHES OF LIGHT THAT FELL UPON THE STONE AND ITS SURROUNDINGS. SOON HOWEVER, ALL SORTS OF AMAZING QUALITIES BEGAN TO OCCUR AS THE SUN TOUCHED THE LEAVES. AT ONE POINT A TREE CAST A BLACK LINE ACROSS THE VIBRANT RED. THERE WERE MOMENTS WHEN THE TIP OF THE STONE WAS ILLUMINATED AGAINST DARK SHADOW.

IT WAS WONDERFUL BUT OUT OF MY CONTROL - THINGS CHANGED SO QUICKLY - I WAS NOT PREPARED FOR WHAT HAPPENED AND WAS NOT ABLE TO PROPERLY SEE OR UNDERSTAND WHAT HAD OCCURRED.

IF IT IS SUNNY TOMORROW I MAY REPEAT THE WORK. I WOULD LIKE TO SEE THE TRANSITION FROM SHADE TO LIGHT - AND THE CHANGES IN-BETWEEN. IT COULD BE AN IMPORTANT WORK. THE WAY IN WHICH COLOUR BECOMES ALIVE REVEALS A MEANING THAT I FEEL TO BE IN THIS PLACE.

The quarry has been left as it was the day work stopped. The bedrock neatly worked to a vertical face in preparation for the next block to be cut out.

A strong sense of work can still be felt in the textured surface. The marks look too big to have been chiselled and could have been done with a stone axe.

I worked mud to an edge. Working the light and surface of the stone. I wanted to do just enough — a transparent touch. The quarry workers touch seen through mine.

I worked early to the early morning light with little idea of how it would look when finished. I do not understand this place well enough to be able to work towards a moment — I have to deal with it as I see and find it. Surprisingly the sculpture worked well with the sun casting a variety of light and shadow across its surface. It was a good attempt at working with a light that I have always found difficult to work with — dappled sun through trees in which form is lost under its camouflaging effect.

Today the light worked to the sculpture's advantage and broke down the form of the mud edge, reducing its prominence and making it an irregular part of the stone. The sun and shadow toned down the edge but heightened the texture of the walls. Later when the sun shone on to the edge, rather than one side, the work became flattened and lost its connection to the stone. It looked stuck on rather than worked into the surface.

Began another work — similar to yesterday, with red leaves on a tapered stone. The red is so elusive. The stone was initially in the shade and the red seemed quite strong. As I finished, however, the dappled light reached initially killed [off] the red. The leaves were cast into shadow and made dark in comparison to the patches of light that fell upon the stone and its surroundings. Soon however, all sorts of amazing qualities began to occur as the sun touched the leaves. At one point a tree cast a black line across the vibrant red. There were moments when the tip of the stone was illuminated against dark shadow.

It was wonderful but out of my control — things changed so quickly. I was not prepared for what happened and was not able to properly see or understand what had occurred.

If it is sunny tomorrow I may repeat the work. I would like to see the transition from shade to light — and the changes in-between. It could be an important work. The way in which colour becomes alive revived a memory that I feel to be in this place.

OCT 13, 2003.

REMADE YESTERDAY'S WORK.

IT WAS GOOD TO DO SO. EVEN THOUGH I KNEW WHAT TO EXPECT THE CHANGES WERE SO VARIED, FAST AND FLEETING THAT I WAS STILL TAKEN BY SURPRISE AND MISSED ONE OR TWO INTERESTING MOMENTS I HAD THOUGHT TIME WAITING SEVERAL HOURS WATCHING THE SUN PASS OVER A WORK FOR THE SECOND TIME MIGHT BE TEDIOUS (PART OF ME WANTED TO USE MATERIAL A DIFFERENT WORK ALTOGETHER) BUT FOUND IT EVEN MORE INTERESTING THAN THE FIRST ATTEMPT. I LEARNT SO MUCH ABOUT THE RED AS IT REACTED TO THE LIGHT. THE TENSION AS THE TIP BECAME ILLUMINATED WAS PALPABLE. THERE WAS ONLY ONE SHORT MOMENT OR TWO WHEN THE STONE WAS, MORE OR LESS, COMPLETELY IN SUNLIGHT FOR THE REST OF THE TIME IT WAS PART IN AND PART OUT OF SHADOW — WHICH GAVE THE RED AN EXTRAORDINARY VIVIDNESS.

I PARTICULARLY LIKED THE MOMENT WHEN JUST THE TIP WAS CAUGHT IN THE LIGHT — SURROUNDED BY DARK SHADOWS.

THE COLOUR DRAINED AWAY AS THE SUN WENT DOWN AND NO LONGER REACHED INTO THE PLACE WHERE I WORKED. STRANGELY THE RED WAS STRONGER WHEN THE ROCK WAS IN SHADOW AT THE START OF THE DAY THAN THE SHADOW AT THE END — PERHAPS IT WAS BECAUSE AT THE DAY'S END I WAS COMPARING IT TO BEING IN SUNLIGHT. THERE SEEMED, HOWEVER, WARMTH IN THE LIGHT THAT BROUGHT OUT THE RED, EARLIER ON THAT WAS ABSENT LATER WHEN THE LIGHT APPEARED MUCH COOLER.

TODAY HAS BEEN A GREAT LESSON IN TIME, COLOUR AND LIGHT.

IT WAS NOT A LARGE WORK BUT IT TOOK A FEW HOURS TO MAKE. THERE WAS SO LITTLE RED. COLLECTING TOOK A LONG TIME. NONE OF THE LEAVES WERE COMPLETELY RED AND HAD BLEMISHES THAT I HAD TO TEAR OUT. THIS WAS A TIME CONSUMING PROCESS WHICH RESULTED IN SMALL PIECES OF LEAVES WHICH IN TURN TOOK MORE TIME TO COVER THE AREA I NEEDED.

I KEPT WETTING DOWN THE LEAVES SO THAT THEY WOULD KEEP THEIR COLOUR OVER THE TIME IT WOULD TAKE FOR THE SUN TO PASS OVER.

ALTHOUGH THE RED WAS DIFFICULT TO DRAW OUT OF THE PLACE — ONCE GATHERED AND CONCENTRATED IT HAD AN INTENSITY THAT WOULD HAVE BEEN LESS HAD THE SURROUNDING TREES ALSO BEEN RED. THE RED WAS A SHOCK — AND WAS WHY THE PERSON WHO PASSED BY THE OTHER DAY SAID IT LOOKED LIKE BLOOD.

Remade yesterday's work.

It was good to do so. Even though I knew what to expect the changes were so varied, fast and fleeting that I was still taken by surprise and missed one or two interesting moments. I had thought that waiting several hours watching the sun pass over a work for the second time might be tedious (part of me wanted to be making a different work altogether) but found it even more interesting than the first attempt. I learnt so much about the red as it reacted to the light. The tension as the tip became illuminated was palpable. There was only one short moment or two when the stone was, more or less, completely in sunlight. For the rest of the time it was part in and out of shadow—which gave the red an extraordinary vividness.

I particularly liked the moment when just the tip was caught in the light—surrounded by dark shadows.

The colour drained away as the sun went down and no longer reached into the place where I worked. Strangely the red was stronger when the rock was in shadow at the start of the day than the shadow at the end—perhaps it was because at the day's end I was comparing it to being in sunlight. There seemed, however, warmth in the light that brought out the red earlier on that was absent later when the light appeared much cooler.

Today has been a great lesson in time, colour and light.

It was not a large work but it took a few hours to make. There was so little red—collecting took a long time. None of the leaves were completely red and [they] had blemishes that I had to tear out. This was a time consuming process which resulted in small pieces of leaves which in turn took more time to cover the area I needed.

I kept wetting down the leaves so that they would keep their colour over the time it would take for the sun to pass over.

Although the red was difficult to draw out of the place—once gathered and concentrated it had an intensity that would have been less had the surrounding trees also been red. The red was a shock—and was why the person who passed by the other day said it looked like blood.

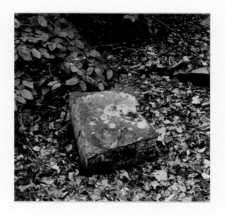

Oct 14, 2003.

Calm and overcast. A relief from the sun. Able to see the wood floor and stones more clearly.

There is a four cornered stone near to the entrance to the island that I pass each day and on which I wanted to lay red leaves. Until now the light has been too difficult.

The calm night and day meant little in the way of fresh fallen leaves and it took a long time to find enough to work with. Today I found it tricky - both the collecting and the working. Tearing out an unblemished portion of a single leaf is time consuming - it took hours to do what at other times has taken minutes. And today I felt it perhaps this was because the work was no successful as I hoped.

I filled each corner of the stone with red. Whether this stone was naturally square or worked and with it doesn't really matter - it is a shape that lies somewhere between bedrock and building.

The red dead as the sky darkened but came alive as it rained heavily. I would have liked also to have made a rain shadow on the path leading to the island and was torn between photographing the stone in the glow of light that seemed to accompany the rain.

I started with the stone - fearing that the leaves might wash off but regretted not making a shadow. I am working in a place laden with human presence. A rain shadow would have emphasized this connection.

The rain had a profound effect on the wood floor - as if suddenly a light had been turned on. The yellow and orange became so much more vivid. Unfortunately I just did not have the energy to respond. I tried, but wandered around aimlessly for an hour or so - getting nowhere but frustrated.

I returned to yesterday's work which was more or less still intact. The red had been cleaned by the rain and had turned orange in contrast to the new wet and black rock both yesterday's and today's works were made with the same red. The four cornered stone remained pale even when wet and consequently the red remained strong. This was interesting to see and made the day feel a little more successful.

Calm and overcast. A relief from the sun. Able to see the wood floor and stones more clearly. There is a four cornered stone near the entrance to the island that I pass each day and on which I wanted to lay red leaves. Untill now the light has been too difficult.

The calm night and day meant little in the way of fresh fallen leaves and it took a long time to find enough to work with. Today I find it tiring—both the collection and the working. Tearing out an unblemished portion of a small leaf leaf [*sic*] is time consuming—it took hours to do what at other times has taken minutes. And today I felt it. Perhaps this was because the work wasn't as successful as I hoped.

I filled each corner of the stone with red. Whether this stone was naturally square or worked that way it doesn't really matter—it is a shape that lies somewhere between bedrock and building.

The red died as the sky darkened but came alive as it rained heavily. I would have liked to have made a rain shadow on the path leading to the island and was torn between photographing the stone in the glow of the light that seemed to accompany the rain.

I stayed with the stone—fearing that the leaves might wash off but regretted not making a shadow. I am working in a place laden with human presence. A rain shadow would have emphasized this connection.

The rain had a profound effect on the wood floor— as if suddenly a light had been turned on. The yellow and orange became so much more vivid. Unfortunately I just didn't have the energy to respond. I tried, but wandered around aimlessly for an hour or so— getting nowhere but frustrated.

I returned to yesterday's work which was more or less still intact. The red had been changed by the rain and had turned orange in contrast to the now wet and dark rock. Both yesterday's and today's works were made with the same red. The four cornered stone remained pale even when wet and consequently the red remained strong. This was interesting to see and made the day feel a little more successful.

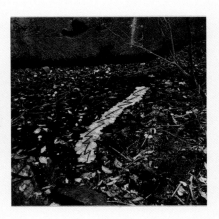

OCT 15 2003.

COOL, SUNNY, VERY WINDY. SO MANY LEAVES ON THE GROUND BUT NOT A GOOD DAY TO WORK THEM. THE LIGHT MADE THEM DIFFICULT TO SEE AND THE WIND BLEW THEM AWAY.

I DECIDED TO MAKE A WORK INSIDE A CUT ACROSS THE QUARRY FACE, AND COLLECTED CLAY ON MY WAY TO THE ISLAND FROM A NEARBY WOOD. THE CUT HAD, I PRESUME, BEEN CARVED OUT IN PREPARATION FOR SPLITTING THE BEDROCK.

I HAD EXPERIMENTED WITH CLAY DURING THE WEEK AND HAD A CLEAR IDEA OF WHAT I WANTED TO DO. IT WAS DIFFICULT TO FIND WORKABLE CLAY THAT WAS NOT TOO SOFT AFTER THE HEAVY OVERNIGHT RAIN. I HAD TO SCRAPE AWAY AT THE BASE OF TREES TO FIND DRIER CLAY WHICH WAS FULL OF FIBROUS ROOTS. SOME OF WHICH WERE POISON IVY. I HAVE NEVER HAD A PROBLEM WITH IVY BUT THEN I HAVE NEVER WORKED IT LIKE THIS BEFORE - I GUESS I WILL NOW FIND OUT IF I AM ALLERGIC N IT OR NOT.

I ROLLED CLAY INTO COILS WHICH I JOINED END TO END IN A CONTINUOUS SERPENTINE LINE ALONG THE OPENING. IT REMINDED ME OF A CARVED SNOW LINE THAT I MADE IN CUMBRIA IN 1984.

I ENJOYED MAKING THIS WORK. IT WAS AN INTERESTING PIECE BUT ALSO A RELIEF FROM THE MINUTIAE OF RECENT LEAVE WORKS. I LIKED THE WAY IT ARTICULATED THE FISSURE - IT FELT AS IF IT BELONGED THERE.

THE LIGHT WAS EXTRAORDINARY - AT TIMES HYPNOTIC AND MESMERISING AS THE STRONG WIND VIGOROUSLY BLEW THE SURROUNDING TREES - CREATING A MULTI LAYERED SEA OF SHADOWS ACROSS THE ROCK FACE I PHOTOGRAPHED AS THE SHADOW OF A NEARBY LARGE TREE WORKED ITS WAY FROM ONE END OF THE WORK TO THE OTHER OVER THE CURVE OF THE DAY - A SLOW RELATIVELY STATIC SHAPE AMONGST THE FRENETIC GYRATIONS OF SHADOWS CAST FROM TREES AT A GREATER DISTANCE - LIKE THE HOUR HAND ON A CLOCK.

I THOUGHT OF THOMAS RIEDELSHIEMMER, DIRECTOR OF "RIVERS AND TIDES". MY IMAGES WILL NOT HAVE THIS SENSE OF MOVEMENT AND I KNOW THOMAS WOULD HAVE ENJOYED FILMING THIS WORK AND WOULD HAVE UNDERSTOOD ITS ENERGY.

I STAYED ON THE ISLAND UNTIL SUNDOWN. I WANTED TO SEE THE WORK IN A CALM LIGHT WITHOUT SHADOW - SO THAT ITS RHYTHM LINE WAS MORE FULLY VISIBLE AND NOT FRAGMENTED BY LIGHT AND SHADOW.

IT WILL BE INTERESTING TO SEE HOW IT CHANGES OVER THE NEXT FEW DAYS AS THE CLAY DRIES, BECOMES PALER, CRACKS AND FALLS APART

DURING THE LONG WAIT FOR THE SUN TO GO DOWN I MADE A WORK WITH YELLOW LEAVES ON A POOL OF DARK WATER AT THE BASE OF ANOTHER QUARRY FACE. I HAD A LINE OF STICKS ON TOP OF THE LEAVES - IT WAS A GOOD SOLUTION TO THE DIFFICULTY OF USING LEAVES ON A WINDY DAY. NOT ONLY DID THE WATER PREVENT THEM FROM BLOWING AWAY IT MADE THE YELLOW STRONGER.

OCT 15 2003.

Cool, sunny, very windy. So many leaves on the ground but not a good day to work them. The light made them difficult to see and the wind blew them away.

I decided to make a work inside a cut across the quarry face and collected clay on my way to the island from a nearby wood. The cut had, I presume, been carved out in preparation for splitting the bedrock.

I had experimented with clay during the week and had a clear idea of what I wanted to do. It was difficult to find workable clay that was not too soft after the heavy overnight rain. I had to scrape away at the base of trees to find drier clay which was full of fibrous roots. Some of which were poison ivy. I have never had a problem with ivy but then I have never worked it like this before—I guess I will now find out if I am allergic to it or not.

I rolled clay into coils which I joined end to end in a continuous serpentine line along the opening. It reminded me of a carved stone work that I made in Cumbria in 1984.

I enjoyed making this work. It was an interesting piece but also a relief from the minutiae of recent [leaf] works. I liked the way it articulated the fissure— it felt as if it belonged there.

The light was extraordinary—at times hypnotic and nauseating as the strong winds violently blew the surrounding trees—creating a much layered sea of shadows across the rock face. I photographed as the shadow of a nearby large tree worked its way from one end of the work to the other over the course of the day—a slow relatively static shade amongst the frantic gyrations of shadows cast from trees at a greater distance—like the hour hand on a clock.

I thought of Thomas [Riedelsheimer], director of "Rivers and Tides." My images will not have this sense of movement and I know Thomas would have enjoyed filming this work and would have understood its energy.

I stayed on the island until sundown. I wanted to see the work in a calm light without shadow—so that its rounded line was more fully visible and not fragmented by light and shade.

It will be interesting to see how it changes over the next few days as the clay dries, becomes paler, cracks and falls apart.

During the long wait for the sun to go down I made a work with yellow leaves on a pool of dark water at the base of another quarry face. I laid a line of sticks on top of the leaves—it was a good solution to the difficulty of using leaves on a windy day. Not only did the water prevent them from blowing away it made the yellow stronger.

56

OCT 16, 2003.

WORKED ON THE POINTED ROCK UPON WHICH I HAD RED LEAVES THE FIRST DAY THAT I ARRIVED. OVER THE PAST FEW DAYS I HAVE NOTICED HOW AND WHEN THE SUN PASSES ACROSS THE ROCK. TODAY I MADE VERTICAL CLAY RIDGES AT ITS TIP TO CUT THE LIGHT INTO LINES OF SHADOW.

THE LIGHT CHANGES THAT OCCURRED TO THE STONE WERE SUDDEN AND SHORT LIVED- UNLIKE THE QUARRY FACE THAT I WORKED WITH YESTERDAY, ACROSS WHICH THE SUN GRADUALLY MOVED. THERE WAS A FIFTEEN MINUTE PERIOD BETWEEN 1:10 AND 1:25 PM WHEN A SUBSTANTIAL PART OF THE STONE AND THE ENTIRE TIP WAS ILLUMINATED WITHOUT ANY FLICKERING OF LEAF SHADOW. THIS WAS THE WORK AT ITS MOST COMPLETE. THERE WERE ALSO MOMENTS LEADING UP TO THAT TIME THAT WERE EQUALLY, IF NOT MORE INTERESTING AS FRAGMENTS OF THE CLAY LINES WERE CAUGHT BY SHAFTS OF LIGHT FILTERING THROUGH THE TREES.

THESE WORKS HAVE BEEN THE MOST SUCCESSFUL I HAVE EVER MADE IN DEALING WITH A LIGHT THAT I FIND MOST DIFFICULT TO WORK WITH - SUNLIGHT THROUGH TREES. THE WOOD FLOOR BECOMES A CAMOUFLAGE PATTERN OF PATCHES WHICH BREAKS UP FORM AND BURNS OUT COLOURS.

THE WORK THAT I HAVE MADE HERE HAS, I FEEL, UNDERSTOOD THE CHANGING LIGHT THAT PASSES THROUGH THIS PLACE. THEY HAVE SUCCEEDED BECAUSE THEY HAVE WORKED WITH A SPECIFIC TIME, PLACE AND MATERIAL - A MEETING OF LIGHT AND FORM WHICH I HAVE NEVER ACHIEVED IN SIMILAR CONDITIONS BEFORE. I HAVE BEEN ALLOWED INTO A NEW WAY OF LOOKING.

I PROBABLY COULD NOT HAVE MADE THESE WORKS LAST WEEK OR NEXT WHEN THE SUN MIGHT CAST A DIFFERENT SHADOW. TIMING RUNS THROUGH THEM IN EVERY SENSE OF THE WORD.

THE CLAY CAME FROM THE QUARRY - I HAD NOT SEEN IT UNTIL NOW. THE RAIN HAD RECONSTITUTED THE DRY HARD EARTH - MAKING IT BOTH VISIBLE AND WORKABLE. IT WAS A PALE TAN COLOUR. WITHOUT SUN THE WORK APPEARED FLAT. THE LINES REMINDED ME OF THE CARVED FLUTING ON COLUMNS. A TREE GREW JUST BEHIND THE STONE WHICH ADDED TO THE SENSE OF A COLUMN BUT ALSO MADE THE CLAY LINES APPEAR AS BARK AND THE STONE AS WOOD.

Worked on the pointed rock upon which I laid red
leaves the first day that I arrived. Over the past few
days I have noticed how and when the sun passes
across the rock. Today I made vertical clay ridges at
its tip to cut the light into lines of shadow.

The light changes that occurred to the stone were
sudden and short lived — unlike the quarry face
that I worked with yesterday, across which the sun
gradually moved. There was a fifteen minute period
between 1:10 and 1:25 pm when a substantial part
of the stone and the entire tip was illuminated with-
out any flickering or leaf shadow. This was the work
at its most complete. There were also movements
leading up to that time that were equally, if not more
interesting. No fragments of the clay lines were
caught by shafts of light filtering through the trees.

These works have been the most successful I have
ever made in dealing with a light that I find most
difficult to work with — sunlight through trees.
The wood floor becomes a camouflage pattern of
patches which breaks up form and burns out colours.

The work that I have made here has, I feel, under-
stood the changing light that passes through this
place. They have succeeded because they have
worked with a specific time, place and material —
a meeting of light and form which I have never
achieved in similar conditions before. I have been
allowed into a new way of looking.

I probably could not have made these works last
week or next when the sun might cast a different
shadow. Timing runs through them in every sense
of the word.

The clay came from the quarry — I had not seen it
until now. The rain had reconstituted the dry hard
earth — making it both visible and workable. It was
a pale tan colour, without sun the work appeared
flat. The lines reminded me of the carved fluting
on columns. A tree grew just behind the stone which
added to the sense of a column but also made the
clay lines appear as bark and the stone as wood.

58

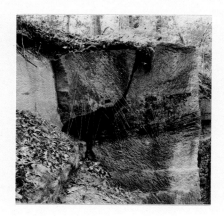

OCT 17 2003

OVERCAST. USED THE FLAT LIGHT OF A CLOUDY DAY TO MAKE A WHITE GRASS STALK LINE DRAWING ON THE QUARRY FACE. I CHOSE A VERTICAL SECTION THAT HAD BEEN MARKS FROM THE PROCESS OF QUARRYING BUT ALSO INTO WHICH A CAVITY HAD ERODED.

THE DAY WAS REASONABLY CALM AND THE PLACE WHERE I WORKED SHELTERED SO WAS ABLE TO HAVE THE LINE DELICATELY OVER THE DARK SPACE OF THE CAVITY WITHOUT IT MOVING OR FALLING DOWN. THE LINE WAS SECURED AT INTERVALS BY CLAY PRESSED INTO PICK MARKS IN THE STONE - SOME OF WHICH HAD BEEN THE RESULT OF THE TOOLS USED TO WORK THE STONE.

IT WAS DIFFICULT TO SEE HOW THE LINE WAS HELD AND IT APPEARED TO FLOAT OVER THE STONE SURFACE. THIS WAS NOT A WORK TO BE MADE ON A SUNNY DAY - THE LINE WOULD HAVE BEEN LOST.

Overcast. Used the flat light of a cloudy day to make a white grass stalk line drawing on the quarry face. I chose a vertical section that had tool marks from the process of quarrying but also into which a cavity had eroded.

The day was reasonably calm and the place where I worked sheltered so was able to hang the line delicately over the dark space of the cavity without it moving or falling down. The line was secured at intervals by clay pressed into pockmarks in the stone—some of which had been the result of the tools used to work the stone.

It was difficult to see how the line was held and it appeared to float over the stone surface. This was not a work to be made on a sunny day—the line would have been lost.

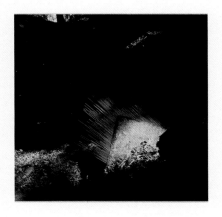

OCT 18 2003,

CLEAR AND BRIGHT. DIDN'T KNOW WHAT TO MAKE. I WAS INTERESTED TO SEE IF A
GRASS LINE MIGHT WORK AS WELL ON A SUNNY DAY AS IT DID YESTERDAY WHEN OVERCAST

I WORKED ON A STONE THAT I KNEW WOULD GO IN AND OUT OF THE SUNLIGHT. I PRESSED
CLAY ALONG TWO OF ITS EDGES INTO WHICH I THEN PUSHED GRASS STALKS. NOT LONG AFTER
I FINISHED THE SUN BEGAN TO PICK OUT SECTIONS OF THE LINE. CONSIDERING THAT I HAD NOT
PAID A LOT OF ATTENTION TO THIS PARTICULAR STONE I FELT PLEASED WITH THE WAY IT WORKED.

THIS DRAWING NEEDED TO BE IN A PLACE OF SHADOW AND LIGHT. I HAVE LEARNT A LOT THIS WEEK
AND HAVE MADE PROGRESS IN UNDERSTANDING A QUALITY OF LIGHT I HAVE NEVER PREVIOUSLY
BEEN ABLE TO DEAL WITH PROPERLY

THIS IS IMPORTANT TO ME. I HAVE WORKED FOR 28 YEARS. NOT UNDERSTANDING A WOODLAND
FLOOR ON A SUNNY DAY REPRESENTS A SERIOUS GAP IN MY PERCEPTION OF NATURE. I HAVE
PREVIOUSLY MADE WORKS ON SUNNY DAYS IN WOODS BUT USUALLY DESPITE THE CONDITIONS
RATHER THAN BECAUSE OF THEM.

Clear and bright. Didn't know what to make. I was interested to see if a grass line might work as well on a sunny day as it did yesterday when overcast.

I worked on a stone that I knew would go in and out of the sunlight. I pressed clay along two of its edges into which I then pushed grass stalks. Not long after I finished the sun began to pick out sections of the line. Considering that I had not paid a lot of attention to this particular stone I felt pleased with the way it worked.

This drawing needed to be in a place of shadow and light. I have learnt a lot this week and have made progress in understanding a quality of light I have never previously been able to deal with properly.

This is important to me. I have worked for 23 years. Not understanding a woodland floor on a sunny day represents a serious gap in my perception of nature. I have previously made works on sunny days in woods but usually despite the conditions rather than because of them.

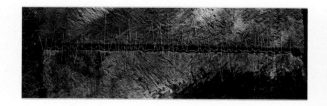

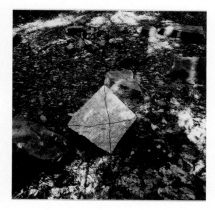

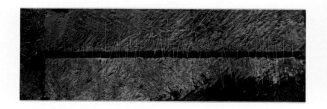

OCT 19 2003.

HEAVILY OVERCAST TO BEGIN WITH. WOULD LIKE TO MAKE A GRASS LINE DRAWING.

I HAD HOPED THAT THE CLAY LINE IN THE CUT WOULD HAVE DRIED AND CRACKED SO THAT I COULD MAKE ANOTHER WORK IN ITS PLACE. IT HAS TAKEN A REMARKABLE LENGTH OF TIME TO DRY AND IS STILL NO WHERE NEAR TO BEING SO. ORDINARILY I WOULD WAIT BUT THIS IS MY LAST DAY. PART OF ME WANTED TO LEAVE IT EVEN THOUGH I KNOW I WOULD NEVER SEE IT DRY. THE IDEA OF LEAVING SOMETHING THAT HAS YET TO HAPPEN AFTER MY DEPARTURE APPEALS TO ME.

I DECIDED TO MAKE ANOTHER WORK ALONG THE CUT. TO POSTPONE THE MOMENT OF REMOVING THE CLAY I COMBINED THE TWO WORKS. I SECURED THE STALKS SO THEY COULD BE LIFTED UP IN ORDER TO REMOVE THE CLAY — A DELICATE OPERATION.

THE LINE WAS HELD WITH LUMPS OF CLAY — STARTING FROM THE LEFT. I REALISED THAT I WAS IN DANGER OF MAKING NOT JUST A LINE WITH GRASS BUT ALSO A DOTTED LINE OF CLAY DABS. I CHANGED THE WAY I SECURED THE LINE SO THAT SOME STALKS WERE HELD ALONG THEIR LENGTH AND NOT THE ENDS.

THIS HELPED ENORMOUSLY. I DID NOT HOWEVER REWORK THE PART ALREADY DONE AND LIKED THE WAY IN WHICH THE CHANGE OF METHOD CAN BE READ.

I COULDN'T DECIDE IF THE TWO WORKS TOGETHER WERE SUCCESSFUL OR NOT. I DON'T REMEMBER EVER MAKING TWO DIFFERENT BUT CONNECTED WORKS LIKE THIS BEFORE. THE IDEA OF SEEING ONE WORK THROUGH ANOTHER APPEALS TO ME — IT SITS WELL ALONGSIDE MY BELIEF THAT WORKS AND IDEAS ARE LINKED TO ANOTHER — I JUST DON'T KNOW IF IT WILL BE SEATED SO OBVIOUSLY. EITHER WAY IT WAS AN INTERESTING AND IMPORTANT THING TO DO.

I REMOVED THE CLAY LINE AND FELT THAT THE GRASS LINE WAS STRONGER FOR BEING ALONE.

I THINK. I WILL HAVE TO WAIT BEFORE I KNOW FOR SURE.

AS I WAITED FOR THE SUN TO GO BEHIND A CLOUD TO TAKE A PHOTOGRAPH, I MADE ANOTHER WORK ON A SQUARE STONE — USING YELLOW LEAVES WITH TWO LINES THAT CROSSED FROM CORNER TO CORNER.

SURPRISINGLY A COMPLETELY OVERCAST DAY THAT BECAME CLEAR ASSISTED WITH A CLOUD THAT PUT THE GRASS LINE MOMENTARILY INTO SHADE. THIS HELPED THE WORK.

I DON'T KNOW WHAT, IF ANY, IMPACT THIS WEEK WILL HAVE ON THE RESULTING SCULPTURE I HOPE TO PROPOSE FOR WASHINGTON. I ONLY KNOW THAT I WILL NOT BE ABLE TO SEE A BUILDING IN WASHINGTON WITHOUT THINKING ABOUT THIS PLACE.

Heavily overcast to begin with. Good light to make a grass line drawing.

I had hoped that the clay line in the cut would have dried and cracked so that I could make another work in its place. It has taken a remarkable length of time to dry and is still no where near to being so. Ordinarily I would wait but this is my last day. Part of me wanted to leave it even though I know I would never see it dry. The idea of leaving something that has yet to happen after my departure appeals to me.

I decided to make another work along the cut. To postpone the moment of removing the clay I combined the two works. I secured the stalks so they could be lifted up in order to remove the clay—a delicate operation.

The line was held with lumps of clay—starting from the left. I realised that I was in danger of making not just a line with grass but also a dotted line of clay dabs. I changed the way I secured the line so that some stalks were held along their length and not the ends.

This helped enormously. I did not however rework the part already done and liked the way in which the change of method can be read.

I couldn't decide if the two works together were successful or not. I don't remember ever making two different but connected works like this before. The idea of seeing one work through another appeals to me—it sits well alongside my belief that works and ideas are linked to another—I just don't know if it has to be stated so obviously. Either way it was an interesting and important thing to do.

I removed the clay line and felt that the grass line was stronger for being alone. I think. I will have to wait before I know for sure.

As I waited for the sun to go behind a cloud to make a photograph, I made another work on a square stone—using yellow leaves with two lines that crossed from corner to corner.

Surprisingly a completely overcast day that became clear obliged with a cloud that put the grass line momentarily into shade. This helped the work.

I don't know what, if any, impact this week will have on the resulting sculpture I hope to propose for Washington. I only know that I will not be able to see a building in Washington without thinking about this place.

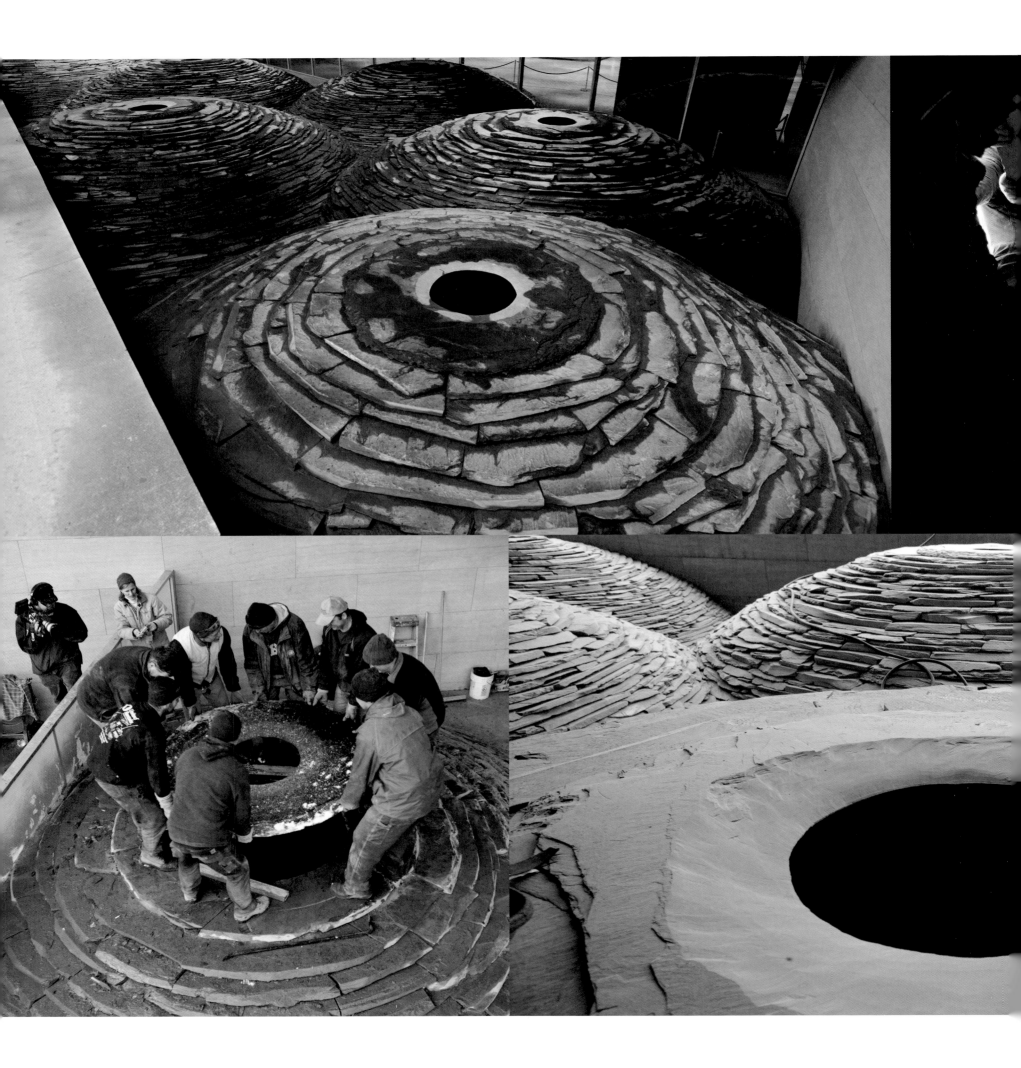

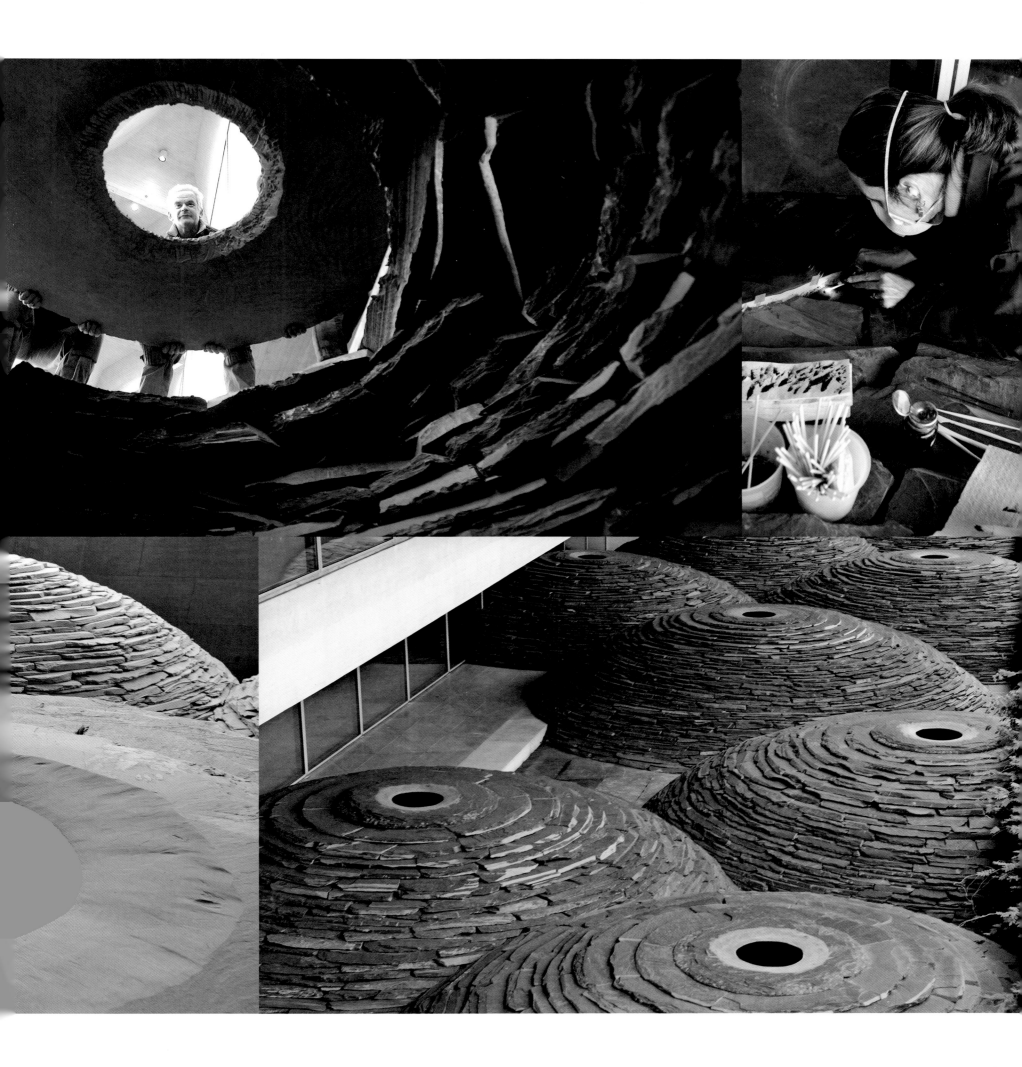

CATALOGUE

Tina Fiske

ANDY GOLDSWORTHY
CATALOGUE OF COMMISSIONED,
PERMANENTLY INSTALLED WORKS

Beginning with the creation of *Seven Spires* (cat. 1) in spring 1984, this catalogue documents and elucidates a specific body of work within the oeuvre of artist Andy Goldsworthy. These works share two features: firstly, they were made, by and large, through a process of commission, and secondly (with the caveats that follow) they are "permanently installed" in their originating site. Their presentation here enables the reader for the first time to consider the development and the range of Goldsworthy's commission-based practice and the more permanent aspects of his artistic output.

In Goldsworthy's commissioned works, the notion of permanence is best described as relative. Of the first five entries, only one still stands: *Hooke Park Entrance* (cat. 3). The others were deemed to have reached the end of their physical life and were decommissioned and destroyed (cats. 1, 2); were deinstalled and reverted to their constituent parts (cat. 5); or were left to decay in situ, leaving physical traces or by-products (cat. 4). Other works, such as *Three Cairns* (cat. 75), perhaps fulfil our expectations of physical indelibility more fully.

What is also clear throughout the catalogue is that the contexts in which Goldsworthy's commissioned works were installed have necessarily influenced or mediated the nature of their fates. The material life span of a given work can be subject to alterations that may occur to its site over time, such as plant regeneration, clear-felling, livestock grazing, changes in ownership or access laws, or even those cyclical changes brought about by seasonal growth. Goldsworthy may indeed intend a work to physically or structurally manifest such changes-in-place, quite literally as with *Chalk Stones* (cat. 80), or more poetically as with *Wood through Wall* (cat. 28). What is evident is that the works included here were often commissioned into, and indeed engage with, very different economies of care. Take, for instance, *Grizedale Wall* (cat. 14) and *Storm King Wall* (cat. 46). The former is now heavily deteriorated; its immediate surrounding context (which gave rise to it) has been subject to radical change in the course of the forest's use and management. The latter, by contrast, is sited in a sculpture park that offers "a far more protected space" (Yorkshire Sculpture Park 2007, 42).

Thus, the term "permanently installed" is perhaps best defined as installed in situ for the life span of the work in question. Goldsworthy does not generally move or relocate works once they have been installed in place—exceptions (see cats. 22, 120) are rare. Very occasion-ally, large-scale works made for temporary exhibition are then acquired for an outdoor space, and they are reinstalled once by Goldsworthy or under his supervision. Should they be subsequently disassembled, as with those commissioned in situ, they revert to their material parts.

Works included in this catalogue, then, were permanently installed in one of three contexts: a public outdoor space; a privately owned outdoor setting; or in interaction with the framework of a public indoor space (that is, a museum or gallery). Already noted are those works built for temporary exhibition and then permanently sited elsewhere outdoors (recent examples are cats. 55, 67, 95, 104, 109, 118.)

The works are arranged chronologically and have been entered according to their date or the period of their permanent installation (for works created for temporary exhibition and then permanently sited elsewhere, the date given is their permanent installation, not their first production). For pairs of structures built over a number of years or built works that were completed in two or three phases, the work is dated to its first phase of construction: See *Storm King Wall*, for instance. See also the group of works that Goldsworthy made from 1999 to 2000 (cats 57, 62, 63, 65, 66) or multiple-structure and site projects (such as cats. 56, 59, 64, 75).

Not included in this catalogue are works commissioned for domestic interior settings. Excluded, then, are at least three very notable groups of works installed within private properties (figs. 1–3), which take on structural relations with their framing architecture and speak of Goldsworthy's increasing dialogue with the house. Yet to include them would then require the inclusion of indoor interventions, which move toward sculpture of a more discrete or portable nature. Also not included are smaller works found in museums (see cat. 50) or works that Goldsworthy built on the grounds of his own house (page 20, fig. 5), which in effect take on the status of draw-ings—drawings in stone—and are speculative ideas that may take form in other locations, perhaps.

By more effectively engaging with the body of commissioned work Goldsworthy has produced—from the first, begun in April 1984, through September 2008—this catalogue endeavors to restore subjectivity, emotion, dwelling, biography, closeness, and materiality to their fullest dimension as critical features of this aspect of his practice, and to reach the real subject of intimacy that is at the core of even his largest works.

Andy Goldsworthy, clockwise from top, 1 *Stone Wall*, 2005, Private Collection, Martha's Vineyard, Massachusetts, 2 *Leafworks*, 1996–1997, installed 1998, Private Collection, California, Promised gift to the Iris and B. Gerald Cantor Center for Visual Arts, Stanford University, 3 *Work for the Door: Clay and Light*, 2004, Collection of Jerry Murdock, Colorado

NOTE TO THE READER

TITLES

Artist's titles are cited.

DIMENSIONS

Dimensions are cited in feet and inches, followed by metric conversions in parentheses. Meters are used for measurements larger than 9 inches; centimeters, for those of 9 inches or smaller. Abbreviations follow:

H	height
W	width
S	span
L	length
D	depth
Ø	diameter
SA	surface area
C	circumference

ARCHIVAL SOURCES

Andy Goldsworthy's archive of papers and his studio collection contain a number of unpublished materials, including drawings, project notes and correspondence, sketchbook diaries, and typed diaries. A list of these materials follows, with the abbreviations used within the catalogue entries.

AGA
Andy Goldsworthy's archive

C
Correspondence (Including faxes, letters, e-mails; Goldsworthy is understood as the unlisted correspondent)

D
Drawings (Unframed, in the studio)

DN
Diary note (Documenting, in diary format, the making of a commissioned work or the undertaking of a residency)

PD
Proposal document (Compiled in relation to large-scale projects or commissions)

PS
Proposal statement (Typically drafted following a site visit)

S
Statement (Made in reference to a project following its completion; if possible, date noted)

SD
Sketchbook diary (Numbering 1–68, these small sketchbooks relate Goldsworthy's daily practice and contain drawings and pencil notations documenting ephemeral works)

ASSISTANCE

The collaborative is a critical aspect of Goldsworthy's commissioned practice. All care has been taken to acknowledge those key individuals whose contribution has helped bring a work to physical fruition. Listed in the caption of each catalogued work are those individuals who worked with Andy Goldsworthy or under his supervision to physically produce the work. Those who administratively supported the development of a project may be acknowledged in the body of the text. For some entries, where perhaps records are not complete, this information is not comprehensive.

Individuals who worked on more than three catalogued works are listed by initials (full names, cited alphabetically, follow). Individuals who worked on less than three catalogued works are listed by full name. Individuals associated with a group are listed by institution name. In some predominantly early works (many of the cairns, for instance) Goldsworthy undertook the principal building work without assistants. On most other occasions, Goldsworthy worked alongside those individuals cited, as in cats. 64, 76, and 123 for example, or in works involving the installation of clay surfaces or forms. For works incorporating an agricultural structure, for his large-scale arch structures, or for his Stone Rivers, Goldsworthy did not participate in the principal stonework but determined the line or form of the work, and moderated and guided the work as it was produced.

Project management

ES	Eric Sawden
JE	Jacob Ehrenberg

Stonework

AM	Andrew Mason
GW	Gordon Wilton
JW	Jason Wilton
MH	Mark Heathcote
SA	Steve Allen
WN	William Noble

Arch construction

BN	Brian Nish
GG	Gordon Grant
GR	George Rennie

Wallers and assistants on early works

AMcK	Andrew McKinna
GA	George Allonby
JS	Joe Smith
KA	Kevin Alderson
MN	Max Nowells
NM	Nigel Metcalfe
PD	Philip Dolphin
PM	Patrick Marold

LITERATURE

The following published sources, authored or coauthored by Goldsworthy, contain specific reference to works included in the catalogue or else illustrate them. Abbreviated forms, which are used in the catalogue entries, follow. This list does not form a complete bibliography for Goldsworthy.

Davies and Knipe 1984
Peter Davies and Tony Knipe. *A Sense of Place— Sculptures in Landscape.* Sunderland, 1984.

Goldsworthy 1985
Andy Goldsworthy. *Rain Sun Snow Hail Mist Calm.* Leeds and Sunderland, 1985.

Goldsworthy 1989
Andy Goldsworthy. *Touching North.* London and Edinburgh, 1989.

Friedman and Goldsworthy 1990
Terry Friedman and Andy Goldsworthy, eds. *Hand to Earth.* Leeds, 1st ed. 1990. 2nd ed. London, 2004. With texts by Miranda Strickland-Constable, Andrew Causey, Paul Nesbitt, Hans Vogels, Sue Clifford and Angela King, Clive Adams, et al.

Goldsworthy 1990
Andy Goldsworthy. *A Collaboration with Nature.* London, 1990.

Goldsworthy 1994
Andy Goldsworthy. *Stone.* London and New York, 1994.

Goldsworthy 1996
Andy Goldsworthy. *Wood.* London and New York, 1996.

Goldsworthy et al. 1996
Andy Goldsworthy, Steve Chettle, Andrew Humphries, and Paul Nesbitt. *Sheepfolds.* London, 1996.

Goldsworthy et al. 1998
Judy Glasman, ed. *Jack's Fold.* Hatfield, 1998. With contributions by Andy Goldsworthy, Steve Adams, Steve Chettle, and Matthew Shaul.

Craig and Goldsworthy 1999
David Craig and Andy Goldsworthy. *Arch.* London, 1999.

Goldsworthy 2000a
Andy Goldsworthy. *Wall.* London and New York, 2000. With text by Kenneth Baker and additional photography by Jerry L. Thompson.

Goldsworthy 2000b
Andy Goldsworthy. *Time.* London and New York, 2000. With chronology by Terry Friedman.

Goldsworthy 2002
Andy Goldsworthy. *Refuges d'Art.* Lyon, 2002. With texts by Nadine Gomez and Irène Magnaudeix.

Goldsworthy 2004

Andy Goldsworthy. *Passage*. London and New York, 2004. With texts by Simon Schama, Richard Dorment, Anne L. Strauss, Susan L. Talbot, Chris Gilbert, Dede Young, and Stephanie Hanor.

Goldsworthy 2007

Andy Goldsworthy. *Enclosure*. London and New York, 2007. With text by James Putnam.

Reina Sofía 2007

Museo Nacional Centro de Arte Reina Sofía. *En las Entrañas del Árbol*. Madrid, 2007. With texts by José Maria Parreño, Tina Fiske, and Andy Goldsworthy.

Yorkshire Sculpture Park 2007

Yorkshire Sculpture Park. *Andy Goldsworthy at Yorkshire Sculpture Park*. Wakefield, 2007. With contributions by Peter Murray, Tina Fiske, and Andy Goldsworthy.

Goldsworthy et al. 2008

Andy Goldsworthy, Nadine Gomez, Jean-Pierre Brovelli, et al. *Andy Goldsworthy Refuges d'Art*. Lyon, 2008.

—————

EXHIBITIONS

Andy Goldsworthy **1987**

 Andy Goldsworthy, Fabian Carlsson Gallery, London, June 1987.

Hand to Earth **1990**

Hand to Earth: Andy Goldsworthy Sculpture 1976– 1990, Leeds City Art Gallery, 22 June–29 July 1990; Royal Botanic Gardens, Edinburgh, 1 August–28 October 1990; Stedelijke Musea, Gouda, 15 December 1990–27 January 1991; and Centre Regional d'Art Contemporain, Midi-Pyrenees, Labege, Toulouse, 15 March–7 April 1991.

Breath of Earth **1995**

Breath of Earth, San Jose Museum of Art, California, 2 February–23 April 1995.

Jack's Fold **1996**

Jack's Fold, Margaret Harvey Gallery, University of Hertfordshire, St. Albans, 8 October–7 December 1996.

Wood **1996**

Wood, Haines Gallery, San Francisco, 16 November 1996–17 January 1997.

Être Nature **1998**

Être Nature, Fondation Cartier, Paris, 17 June–20 September 1998.

Storm King **2000**

Andy Goldsworthy at Storm King Art Center, Storm King Art Center, Mountainville, New York, 22 May– 15 November 2000.

Three Cairns **2002**

Three Cairns, Des Moines Art Center, 19 July–October 2002; Neuberger Museum of Art, Purchase, New York, 26 January–13 April 2003; Museum of Contemporary Art San Diego, La Jolla, California, 26 April–31 August 2003.

Stone Houses **2004**

Stone Houses, The Metropolitan Museum of Art, New York, April–November 2004.

Passage **2005**

Passage, Albion Gallery, London, 11 January–31 March 2005.

Refuges **2006**

Refuges, Galerie Lelong, Paris, 14 April–24 May 2006.

—————

ADDITIONAL FUNDING INFORMATION

Cat. 58

Commissioned by Ballet Atlantique Régine Chopinot with funds from Ministère de la Culture (DRAC PACA) and Conseil Régional Provence Alpes Côte d'Azur (FRAM).

Cat. 59

With funds from the British Council, European Program Leader 2, Conseil Général des Alpes de Haute-Provence, and Conseil Régional PACA.

Cat. 72

Given in honor of Gerhard Casper, President, Stanford University, 1992–2000, for his vision and commitment to making the arts an integral component of university life, by the Robert and Ruth Halperin Foundation.

Cats. 76, 84, 93, 100

With funds from European Program Intereg 2, Ministère de la Culture (Conservation Régionale des Monuments Historiques, DRAC PACA), Conseil Régional PACA, Fondation de France (Programme initiatives d'artistes).

Cat. 105

With funds from European Program Intereg 2 and Leader +, Ministère de la Culture (Conservation Régionale des Monuments Historiques, DRAC PACA), Conseil Régional PACA, Fondation de France (Programme initiatives d'artistes).

Cat. 119

With support from Solway Heritage and funds from Scottish Arts Council, Scottish Natural Heritage, Landfill Tax Credit, Leader Plus, Community Regeneration Fund, Robertson Trust, Dumfries and Galloway Council, and Yorkshire Sculpture Park.

Cat. 123

With funds from Jerry Murdock, Conseil Général des Alpes de Haute-Provence, European Programs Culture 2007–2013, and Leader +.

—————

Every effort has been made to contact the owners of the catalogued works and verify all information.

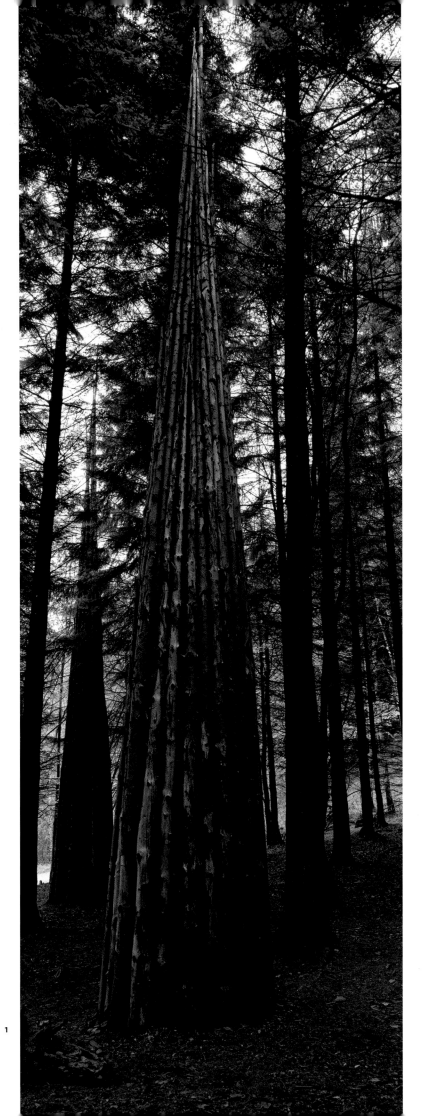

1

1 SEVEN SPIRES, 1984

H 25′ (7.6 m), ⌀ at base 5′ (1.5 m)

Grizedale Forest, Cumbria, UK.
Decommissioned in 1998

Surplus wind-fallen pine from Grizedale and metal rods.
Installation begun April and completed 31 July 1984

*John Ogden, Richard Todd, John Goldsworthy,
Judith Gregson*

Literature: Davies and Knipe 1984, 50–53, 134; Causey,
in Friedman and Goldsworthy 1990, 124, 126–127;
Goldsworthy 2000a, 76–77; Friedman, in Goldsworthy
2000b, 186; Reina Sofía 2007; Yorkshire Sculpture Park
2007, 23–26

Goldsworthy constructed *Seven Spires* in Grizedale Forest,
Cumbria, as part of a Northern Arts Bursary Award.
The work comprised seven sets of pine trunks pinned
together with metal rods to form tall, slender "spires."
Goldsworthy built them approximately 25 feet high,
and located them within and at the edges of a dense
pine canopy. It was the first large-scale work that
Goldsworthy undertook, and it is referred to as his
first "permanent" commission. Goldsworthy used that
term himself at the time, describing in a text how the
"subdued brown light," "stillness," and "little seasonal
change" that characterized the pine forest were "per-
haps necessary in making my first 'permanent' piece
that in a sense has been suspended from processes of
growth/decay—it allowed me to concentrate on one
thing over a long period of time" (Davies and Knipe
1984, 51). He has since suggested, "Even in those early
days when I was making only ephemeral work,
Grizedale represented an opportunity to try out ideas
that might become more permanent" (Yorkshire
Sculpture Park 2007, 23).

Goldsworthy first visited Grizedale as a student
in 1978. He recalled, "David Nash undertook one of the
first residences there, and he came to lecture at the
Art School. He invited me to go and see him [there]"
(Yorkshire Sculpture Park 2007, 23). Goldsworthy sub-
mitted several unsuccessful proposals to Grizedale in
the early 1980s. He began to develop the proposal that
would become *Seven Spires* early in 1983, while working
in the wooded areas around Helbeck, Cumbria. On
10 March, he made five small spires using wind-fallen
birch branches, noting in his diary, "an idea for Grizedale"
(SD 8, AGA). During a visit to the forest in early December,
he made a small-scale, ephemeral maquette of *Seven*

Spires, using bracken (SD 9, AGA). Goldsworthy made both of these smaller groups in clearings. However, it was always his intention that the larger version be integrated under the tree canopy. That decision made the installation process much more demanding and difficult, but as Goldsworthy recognized, the pine significantly determined "the present character of the place," and thus he wanted it to "dictate the idea, scale, form, construction, and location of the piece" (Davies and Knipe 1984, 51).

Goldsworthy also related his use of the spire form to its function within church architecture to break the horizon and lead "the eye skyward." Goldsworthy's spires did not have a building to mediate their ascent, sitting directly as they did on the ground. As Andrew Causey suggested, it was perhaps with the gravity-defying, "ribbed" columns and vaulting of Gothic architecture, rather than the spire as such, that the vertical energy of *Seven Spires* most particularly resonated (1990, 129).

Seven Spires was never intended to be permanent in the sense of being unchanging or indelible. Expected to have a life span of fifteen years, the work stood for fourteen. By 1994, it had already deteriorated, and it was finally removed and destroyed on 30 July 1998. A letter (AGA) from David Penn to Goldsworthy of that date noted, "[T]he spires have gently been extracted from their site without damaging the guardian trees. The [Forestry Commission] took them down to Blind Lane where, after much huffing and puffing, [the spires] were consumed by fire. A quiet demise."

2 SIDEWINDER, 1985

H 8′ 2″ (2.5 m), W c. 4′ (1.2 m), L c. 60′ (18.3 m)

Grizedale Forest, Cumbria, UK. Decommissioned between 1998 and 1999

Snow- and wind-damaged pine and metal rods. Installed spring 1985

John Ogden, Richard Todd, Judith Gregson

Literature: Goldsworthy 1985, foldout spread; Causey, in Friedman and Goldsworthy 1990, 124–141; Goldsworthy 1990, 114–155; Friedman, in Goldsworthy 2000b, 187; Reina Sofía 2007; Yorkshire Sculpture Park 2007, 24

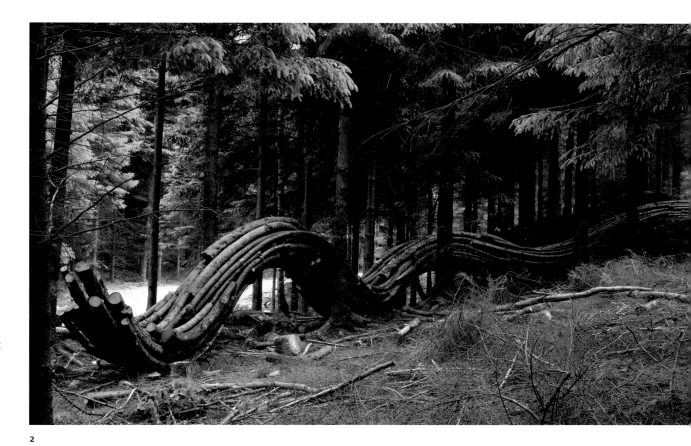

2

Goldsworthy returned to Grizedale in the spring of 1985 to undertake a second commission, for which he expressed the desire to "get to grips with the anarchic growth of the oak, ash and beech" rather than "the formality of pine." Goldsworthy did, however, return to work in the pine canopy, and has since explained that he developed the initial concepts for *Sidewinder* thus:

[It] was as a result of looking for straight trees. Oddly I kept seeing curved trunks that I didn't want for the *Spires*, but it set me off thinking how I might use them. *Sidewinder* used those curved branches. I went for curved branches because they have no commercial value. Foresters would typically cut the curved branches out, leave them for firewood. I've always wanted to work with those things that are marginalised, not liked, not wanted—excess. (Yorkshire Sculpture Park 2007, 24)

Goldsworthy used the curved pine to create a long, arching, horizontal form that cut a dynamic path along the forest floor. He constructed it in much the same way as *Seven Spires* (cat. 1), building its form incrementally by positioning and securing sections of pine trunks. These were first roped in place, and then Goldsworthy used drill attachments fixed to a chain saw to bore holes through the logs, into which he hammered ½-inch-wide metal rods. The two Grizedale projects are the only ones in which Goldsworthy used any kind of internal, structural metal support. Rising and falling through the trees, *Sidewinder* carries a powerful sense of sinuous movement best evoked by lines from a poem published by Carolyn Forché in 1973: "Now pines lift / Linking their dark spines."[1]

Sidewinder was removed sometime around 1998. The exact date of its dismantling and method of disposal are not noted in records at Grizedale.

3 HOOKE PARK ENTRANCE, 1986

H 11′ 6″ (3.5 m), W 4′ 3″ (1.3 m), ∅ 7′ 10″ (2.4 m)

The Architectural Association, School of Architecture, Beaminster, Dorset, UK. Commissioned for Common Ground's *New Milestones Project*

Curved pine and wooden pegs. Installed July 1986

Andy Poore, Samantha Rudd, Lynette Charters, John Ogden, Justin Underhill, Judith Gregson

Literature: Clifford and King, in Friedman and Goldsworthy 1990, 60–61, and Causey, 129–130; Friedman, in Goldsworthy 2000b, 188

Goldsworthy was invited by the environmental organization Common Ground to submit a proposal for an entrance to the Working Woodland at Hooke Park in

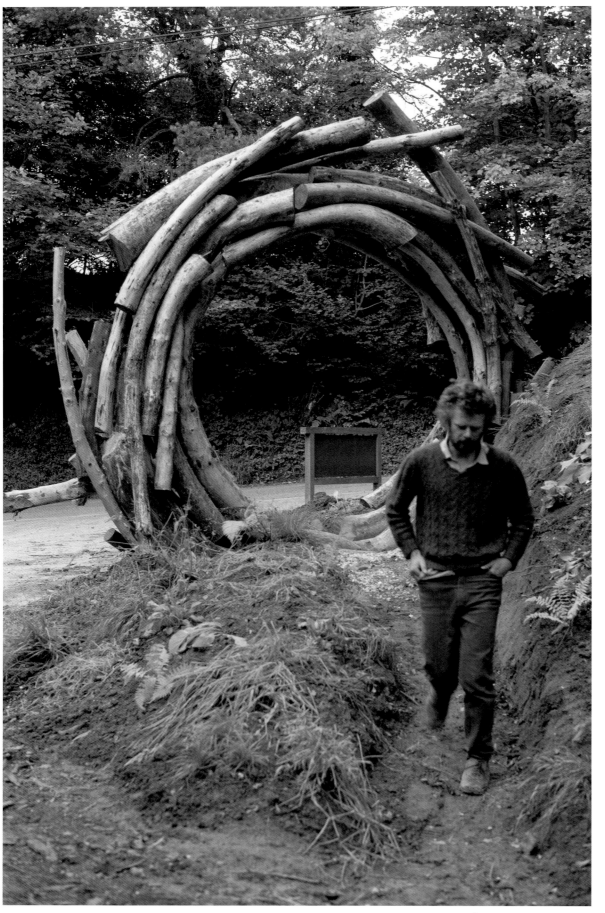

Dorset in 1985. The Working Woodland was founded by furniture-maker John Makepeace, who was keen to "reestablish the economic viability of woodland managed as a renewable resource in a traditional manner."[2] Common Ground initially contacted Makepeace because of his interest in finding new uses for woodlands and for small roundwood thinnings. Goldsworthy's proposal had to take into consideration three factors: (1) any intended work had to use materials from the wood; (2) it would have to incorporate a functional gate; and (3) it would also serve as a landmark to announce the woodland.

Goldsworthy made his first site visit in November 1985, and he noted at the time (PS 1986, AGA, here and following unless noted otherwise): "The hole/arch was my immediate response to the commission—initially taking its curve from the steep banks—a single sunken ring through which cars and people would pass." Indeed, between November 1985 and summer 1986, when he began construction at Hooke Park, Goldsworthy made several smaller-scale, ephemeral test pieces directly relating to the commission, including a "variation on Hooke Entrance" on 14 December at Hampstead Heath in London (SD 12, AGA) and versions at Hooke Park and near his home in Langholm, Scotland, both in April. In this time, Goldsworthy also produced several proposal drawings for a large "hole/arch," which would use roundwood stripped of its bark, and would span the woodland's entrance track: "I wanted the form to come out of the material and the place. I looked for a material which would mould into the entrance space—in the way that a roadside tree forms an arch."

However, "it became apparent that the engineering problems of making an arch over a 25–30 foot span would be daunting," and Goldsworthy redeveloped his proposal accordingly. He subsequently made a series of drawings for "two circles of curved timber marking passage from public road to a privately owned wood." One proposed version featured stone buttressing that would support the circular forms. In another, the ends of the curved timber protruded out from the form. The proposal that he took forward was tighter, with the curves of the timbers articulating the form much more efficiently. Construction took place over four weeks in July 1986. Goldsworthy and his assistants felled and stripped the timber. To get the form that he wanted, Goldsworthy first laid the timber out on the ground as a circle of overlapping trunks. He then pegged them together with 1-inch-diameter pegs made of greenheart wood in Makepeace's workshop

and added further sections of trunk to build up the rings. A barrier, 15 feet in length, was the final part of the work to be completed, and would operate on a drop-bar principle.

British critic Richard Cork appraised the work thus:

While the two projecting "arms" fulfil their role efficiently enough, they dissipate the coiled energy contained in Goldsworthy's circular clusters.... When the "arms" are raised, and restored to the clusters, they ensure that the work as a whole is charged with tension. It calls to mind Ezra Pound's remark about his celebrated marble portrait by Henri Gaudier-Brzeska. Recalling that the hieratic "Head" was most striking, perhaps, two weeks before it was finished, Pound declared that "there was in the marble a titanic energy, it was like a great stubby catapult, the two masses bent for a blow." Goldsworthy's bound pine exudes a similar vitality.[3]

4 SLATE HOLE, 1987

H c. 2′6″ (.8 m), ∅ 4′10″ (1.5 m)

Stone Wood, Scaur Glen, Dumfriesshire, UK

Slate sourced locally. Built summer 1987

Literature: Friedman, in Friedman and Goldsworthy 1990, 147–149; Friedman, in Goldsworthy 2000b, 190 (listed as 1988)

On moving to Penpont, Dumfriesshire, in 1986, Goldsworthy immediately developed plans for an outdoor studio, which, he later wrote, would provide a focus for his work in Penpont. He was introduced to the then Earl of Dalkeith by Jenny Wilson of Dumfries and Galloway Arts Association, and organized the leasing of a small plot of land from the Buccleuch Estates for a period of thirty-five years. The original lease, which became effective on 1 August 1987, applies to "approximately 2.3 acres on the South West side of the Scaur Water in the parish of Tynron." It outlined that the use of this ground "be restricted to the formation, construction and display of sculpture and artwork created from natural materials and the growing of plants and trees." From the outset, Goldsworthy referred to the plot as Stone Wood, and used it as a focus for exploring the relationship between stone and wood, a relationship that he has said he finds powerful and poetic. In October 1987, Goldsworthy established a fund to underwrite his work there, which operated from 1988

to 1994, and attracted a small number of supporters with the help of Sue Clifford and Angela King of Common Ground.

Goldsworthy made three important permanent works at Stone Wood: *Slate Hole*, *Slate Stack* (cat. 6), and *The Give and Take Wall* (cat. 7). In his essay "Monuments," art historian Terry Friedman (1990) referred to *Slate Hole* as the "more modest and first built" of those three works, also noting that it differed substantially from Goldsworthy's earlier earth holes in London, Cumbria, and Japan, which were "swift, single-dayed, and often precarious" in the making. *Slate Hole* itself constituted half of a two-part work, which Friedman described thus:

A heap of earth was first covered with stones and a rowan sapling planted on top; the hole left by digging was then covered over with concentrically placed slates to form an elliptical dome with a small hole carved in the top-most slab. The structure has been planted round

with hazel which will eventually form a protective cage through which it will be possible to peer. (1990, 146)

The planting of trees has formed an important part of Goldsworthy's sculptural language and in a broad sense relates his work to that of David Nash and of other artists such as Alan Sonfist and herman de vries. Goldsworthy might have seen the planting of Nash's *Sweeping Larch Enclosure* at Grizedale in 1978, and he visited Nash's home in Wales on several occasions in the early 1980s; therefore, he would have been well acquainted with Nash's strategies. There are important factors that differentiate their use of tree planting, insofar as Goldsworthy has never explicitly employed techniques of tree husbandry, such as fletching, grafting, or pruning, as Nash has. However, the spatial concerns that Goldsworthy was beginning to explore with *Slate Hole* do bear some relation to Nash's *Ash Dome*, 1977, the twenty-two ash saplings that Nash planted at Cae'n-y-Coed in Wales, which he

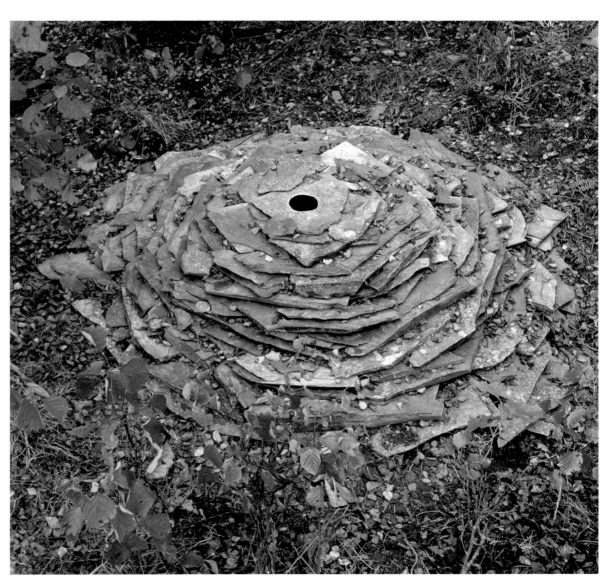

4

has tended over the years to form "a dome of space." Interestingly, time has intervened to enhance a possible likeness between the two works: *Slate Hole* is now difficult to locate at Stone Wood, as its stone structure has long since collapsed and been grassed over. However, the hazel trees that Goldsworthy planted around the dome have established well, with no subsequent intervention from Goldsworthy, and now almost twenty years later they define a "domed" space around the remnants of the work. The only existing record of *Slate Hole*'s counterpart, the "heap of earth" to which Friedman referred, is a small pencil drawing that Goldsworthy did on the wall of his studio at the time.

5 SLATE CONE, 1988

H C. 5′9″ (1.8 m)

Grizedale Forest, Cumbria, UK. Deinstalled about 2000

Slate from Little Langdale, Cumbria. Installed February–March 1988

Literature: Friedman and Goldsworthy 1990, 86; Friedman, in Goldsworthy 2000b, 190

Slate Cone was built in what was at the time the visitors center at Grizedale Forest in Cumbria, and it was Goldsworthy's first commissioned cairn built with a "cone" profile. Goldsworthy used "cone" in the titles of a number of early cairns of this type, but later reverted to using "cairn" or indeed "sentinel." They are particularly ubiquitous in Goldsworthy's permanent and commissioned output, evolving from early ephemeral prototypes:

My first cairn was made at Brough, Cumbria, where I lived from 1981 to 1986. It was made within sight (on a clear day) of the Nine Standards, which are piles of stone on the fell above Hartley at the head of the Eden valley. There are various ideas as to what purpose these piles have. For me, they function as guardians to the valley. Although only ten to twelve feet in height, they are sited so that they dominate the skyline. One has a slight belly to its form, and could have been influential in the making of my own cairns. (Goldsworthy 2007, 62)

Goldsworthy has constructed permanent stone cairns in numerous countries. Often he uses their construction as an orienting exercise or a way of getting to know a place, and their shape and scale is determined by their particular location or context: "[T]he cone is

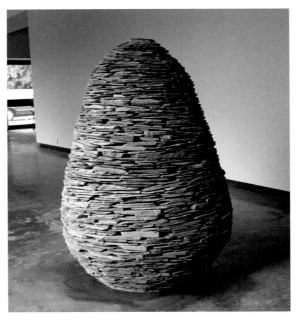

5

one of a few reoccurring forms that I have set free from the usual limitations under which I work. I want it to travel like a glacial boulder, which is occasionally abandoned miles away from its origin—adapting and drawing new meaning from a changed environment" (PS, *Little Africa Cone*, 1991, AGA). As such, they attest to the phenomenologically primed process of acclimation that is a feature of Goldsworthy's practice.

Each cairn is also the product of deep engagement with the form itself. It is a form that has provided Goldsworthy with some resistance: "Uncertainty of outcome is one of the reasons why this form reoccurs so often in my work.... There are always disturbing, unintentional irregularities and shifts within the form—evidence of my losing control during the making" (Goldsworthy et al. 2008, 61). He has also transposed it into other materials than stone, into wood or ice for instance. It is possible to say that, within Goldsworthy's practice, the cairn constitutes what art historian George Kubler called a "form-class."[4] It would seem to exemplify the sense of formal sequence, which is perhaps best understood by Kubler's suggestion that such sequences instantiate the "recurrence of a need" (ST, 55). In his 1962 book *The Shape of Time*, Kubler sought to give foundation to a mode of historical analysis that could recognize the life of a form, or the matter of its persistence over time, as the unfolding of a need "in differing stages of its gratification.... The juncture of each need with successive solutions leads to the conception of a sequence" (55).

Drawing on Kubler, it is possible to think of Goldsworthy's cairns as a "network of gradually altered repetitions of the same trait," a network that spreads out across the various areas of his practice

over time (ST, 37). Moreover, the cairns that he has built in stone have a kind of metronomic function throughout his commissioned work; although he regularly reprises other forms, such as the fold, the frequency of the fold differs from the seriality that the stone cairns arguably actualize. They constitute integers of sameness or similarity, and they function as such across differing contexts and climates. Indeed, the repetition of both forms reveals the levels of temporal acuity present in Goldsworthy's work. Kubler himself suggested how those levels mutually inflect each other:

Our actual perception of time depends upon regularly recurrent events, unlike our awareness of history, which depends upon unforeseeable change and variety. Without change there is no history; without regularity there is no time. Time and history are related as rule and variation; time is the regular setting for the vagaries of history. (ST, 72)

6 SLATE STACK, 1988

H 4′ (1.2 m), W 7′ (2.1 m), D 2′4″ (.7 m), ∅ of circle 3′ (.9 m)

Stone Wood, Scaur Glen, Dumfriesshire, UK

Old roofing slate sourced locally. Built summer 1988, using drystone construction method

Literature: Friedman, in Friedman and Goldsworthy 1990, 147–149; Goldsworthy 1996, 5; Friedman, in Goldsworthy 2000b, 190

Slate Stack was the second of the three works that Goldsworthy built at Stone Wood. It comprises thin slate that he stacked densely in a horizontal fashion to form a short, shallow rectangular wall, within which he stacked slate in vertical layers to form a central cylinder. Goldsworthy had already made two ephemeral stacks of this configuration while working as artist-in-residence at the Lake District National Park early in 1988. On 18 February, he made a temporary version in slate at Little Langdale, and then on 14 March, a stack in ice near Derwentwater. *Slate Stack* was the first, however, in which Goldsworthy packed the slate in contrasting directions with the specific intention of observing the effects of light on the form. With the passage of the sun, the rectangular and circular forms are alternatively illuminated (from dark to light). These effects are additionally modified by the movement of the viewer.

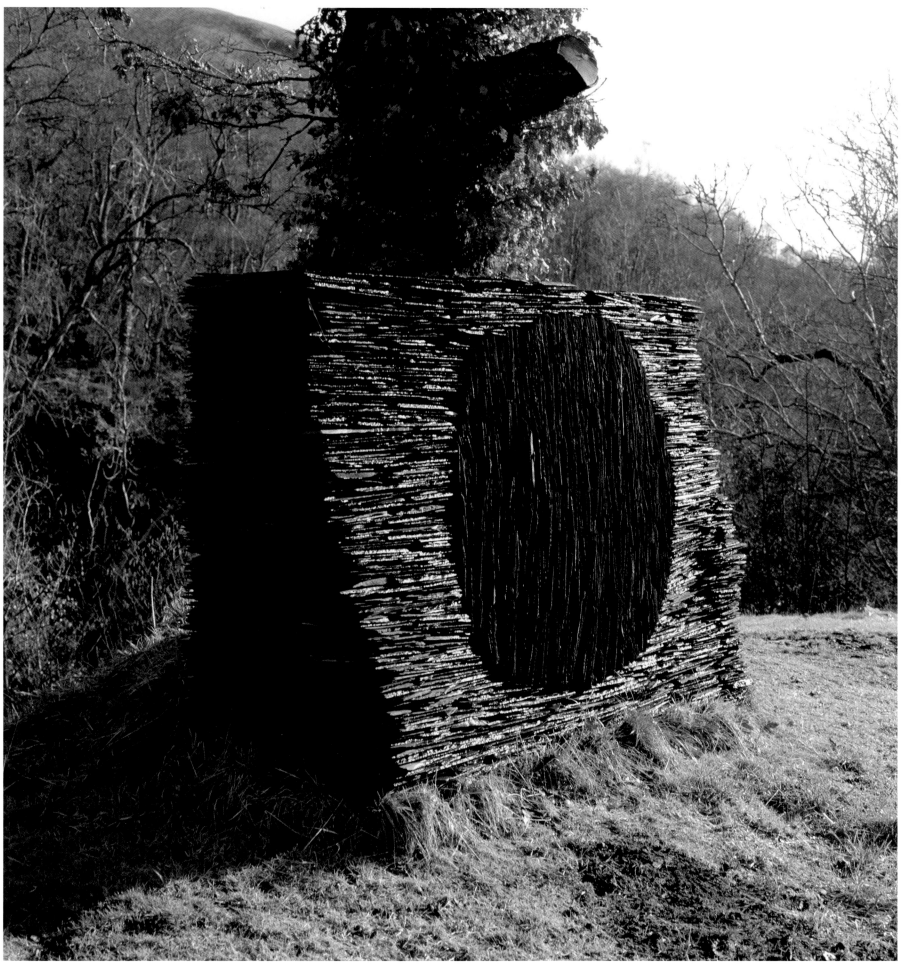

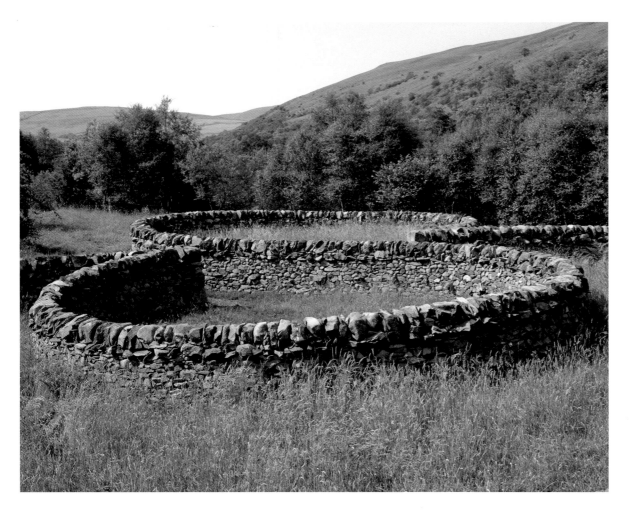

In its use of simple forms, its concern with lighting effects, and its insistent frontality, *Slate Stack* references the relief works of British artist Ben Nicholson. Goldsworthy has long acknowledged Nicholson as an important influence, most especially the white reliefs that Nicholson produced in the 1930s. Nicholson himself made very few large-scale reliefs for exterior contexts, the first of those being the large concrete wall produced for Documenta 3, an international exhibition in Kassel, Germany, in 1964. Along the floor in front of that work, Nicholson had a narrow channel of water installed, inviting light and reflection to modify the structure. Although Goldsworthy did not know of that particular work by Nicholson at the time he made *Slate Stack*, subsequent works that he developed, such as the 1998 *Slate Walls* and particularly the 2002 *Pool of Light* (cat. 84), share many of its concerns.

Goldsworthy built *Slate Stack* close to an old oak tree, which had been burnt at its base and from which the lower branches had been stripped. He had previously considered several ways in which he might work with the tree, and Friedman suggested that *Slate Stack* serve as a protective sentinel to it. It might now be said that those roles have been reversed. The tree has regenerated quite well and now appears to protect *Slate Stack*, which has deteriorated. Over the course of twenty years, *Slate Stack*, which is not fixed in any way, has fared reasonably well, although a considerable amount of slate from the top of the stack has been removed. The structure itself has begun to buckle, but still retains its essential integrity.

7 THE GIVE AND TAKE WALL, 1988

Wall: L 261′ (79.6 m)
Each fold: H 4′ (1.2 m), D 1′ 11″ (.6 m), ⌀ 24′ (7.3 m)

Stone Wood, Scaur Glen, Dumfriesshire, UK

Fieldstone retrieved from a nearby derelict wall.
Installed late autumn 1988

JS

Literature: Friedman and Goldsworthy 1990, 138, 148–151; Goldsworthy 1990, 24, 118–119; Goldsworthy 2000a, 42; Friedman, in Goldsworthy 2000b, 190; Putnam, in Goldsworthy 2007, 12–13; Yorkshire Sculpture Park 2007, 21–22

Part of the agreement by which the Buccleuch Estates leased Stone Wood to Goldsworthy necessitated

that he build a wall to demarcate the boundary of his ground from the field of which it had been a part. It was also intended to serve a practical purpose by keeping sheep and cattle grazing on the hills from wandering into Goldsworthy's land. This prerequisite brought about the third of the permanent works that Goldsworthy built at Stone Wood—his first wall sculpture, *The Give and Take Wall*. To fulfil his obligation, Goldsworthy made a series of drawings for a "proposed wall division sheep sculpture" (D.1988.9, AGA). As those drawings indicate, he explored several possible configurations. The first proposal featured a single circular enclosure, with the opening on Goldsworthy's side and in which he would site a shallow hole/dome. The second proposal included two counterpoised enclosures, built at two ends of a meandering stretch of wall. The third comprised two enclosures joined in the manner of a figure 8. With both of these latter proposals one enclosure would be accessed from Stone Wood, which looped onto the neighboring grazing land, and the other accessed from the neighboring side that looped onto the land Goldsworthy was leasing. This particular configuration would allow sheep and cattle to enter a small portion of Goldsworthy's side.

Goldsworthy realized the third of those proposals, and the resulting *Give and Take Wall* is an important early work that conceptually informs a large proportion of Goldsworthy's subsequent commissioned output. It is the first occasion in which the wall becomes the work, and the first time the sheepfold or enclosure occurs in his oeuvre. It represents the inception of a more conscious/phenomenological response to agricultural spaces as situations in which to work: "the enclosures have a very special quality of space inside—places/spaces in which to make" (D.1988.8, AGA). In addition, it initiated the interface with the farming community that has mediated the creation and continued existence of numerous of Goldsworthy's permanent works since, and, most significantly, it is his first major sculptural statement that references the physical impact of farming on the formation of the landscape.

Goldsworthy's plans to put another sculpture in the enclosure accessible from his side never came to fruition. Within a few short years, however, he noticed that the fold from which the sheep are excluded was showing early signs of tree regeneration. Images taken by Goldsworthy in 1993 already record the appearance of saplings, which he felt rendered the inclusion of another sculpture unnecessary. Goldsworthy has suggested that he took this regrowth to be a significant

conceptual development for the work. As he has said, "It really was the spaces that became the sculpture. That and the change that occurred to the land because of the wall being there" (Yorkshire Sculpture Park 2007, 21). Over twenty years later, with no intervention by the artist, the tree growth in the enclosure is now substantial. By extension, the exclusion of grazing sheep from Stone Wood in its entirety has allowed tree growth to regenerate considerably throughout the whole plot. Thus for Goldsworthy, the regenerated Stone Wood has, by degrees, become a work itself.

8 SLATE CONE, 1988

H 5′5″ (1.7 m)

Government Art Collection, UK

Roofing slate. Installed in Copenhagen, Denmark, 22–28 August 1988

Literature: Goldsworthy and Friedman 1990, 84; Friedman, in Goldsworthy 2000b, 189

Exhibition: Andy Goldsworthy 1987

Slate Cone was first built for Goldsworthy's exhibition at Fabian Carlsson Gallery in London in June 1987. It was acquired by the Government Art Collection and permanently sited in the grounds of the British Embassy in Copenhagen, Denmark, the following year.

8

9 LAMBTON EARTHWORK, 1988

H 9′8″ (2.9 m), L 1,312′3″ (400 m)

Sustrans National Cycle Network, UK

Excavated earth and spoil from site. Installed in December 1988

Steve Fox (excavation work)

Literature: Causey, in Friedman and Goldsworthy 1990, 131–137; Friedman, in Goldsworthy 2000b, 190

The Lambton work was the first of two large-scale earthworks that Goldsworthy made for the organization Sustrans, with the help of Northern Arts, along the disused Consett to Sunderland railway line between 1988 and 1989. They remained the only two earth constructions within his commissioned oeuvre until he built *Bracken Mound* (cat. 98) in 2004. Andrew Causey noted, at the time of their making, that "earthwork sculptures of the size of the Lambton and Leadgate are unique in England" (1990, 136).

Goldsworthy first proposed a large earth river form for nearby Gateshead as early as 1986, noting in an early sketchbook diary (SD 14, AGA), "Possible proposal for Gateshead—want to make from the earth/hill/slope/walk/a feeling of walking on an edge—the top would [be] a soil/earth path." When that project did not proceed, it was suggested that he might make it for the National Cycle Route, which Sustrans was developing along the abandoned rail line. Goldsworthy viewed several sites, and the stretch of ground that he earmarked, and in which the *Lambton Earthwork* is now situated, sits in a low-lying cutting, on what would have been a slight bend along the track. It is also slightly compressed between two pathways, at first narrow, then widening out. Goldsworthy actually submitted three drawings for proposals for the site, which are documented in his slide archive. One of those, entitled "Earth Heaps, Planted with Oaks," included a series of pyramidal earth mounds (with trees planted on top) and contained ideas that Goldsworthy has since returned to. The other, "Split Path, Consett to Sunderland Pathway," which comprised four parallel banks of earth that would run the length of the site, has not recurred in his work.

Goldsworthy proceeded with the proposal entitled "Earth, Consett to Sunderland," which he envisaged as a long, curving pyramidal banking of earth drawn sinuously into and through the space (see D.1988.11 and D.1988.12). Shortly after the work's completion,

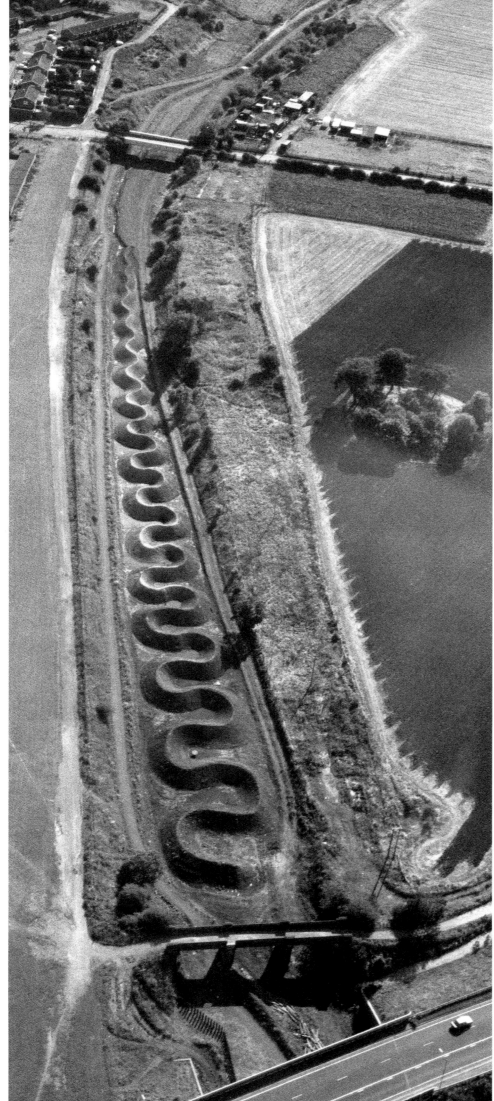

9

Goldsworthy explained in a statement, "I wanted a feeling of movement—of earth rising up and flowing— a river of earth" (s 1989, AGA). In this respect, the construction and design of the earthwork looked ahead to his later exploration of the river form, anticipating, for example, the *Stone Rivers* series (cats. 72, 97, 111) he began in 2001 at Stanford University, California. While those later *Stone Rivers* serve in part as vehicles by which to observe change and the passage of time, the *Lambton Earthwork* was made to be entirely subject to those elements, and has evoked them more associatively as well. Even newly made, the work was and still is "reminiscent of an ancient burial mound, and also bears comparison, as it lies exposed in the cutting slightly below ground level…with an archaeological discovery" (Causey 1990, 136). The passing of years has written itself into the form, and it has been reclaimed a little by its site. It has worn well on the whole: the banking grasses over in the summer months, and an elevated, narrow pathway has been worn in along the top.

The earthwork is popularly known as the *Lambton Worm*, referring to the association that is often made between it and a fierce, legendary creature from local mythology of that name. Goldsworthy did not know of the legend when he conceived the work.

10 LEADGATE MAZE, 1989

H 6′6″ (2 m), W 32′8″ (10 m), L 98′4″ (30 m)

Sustrans National Cycle Network, UK

Excavated earth and spoil from site. Completed late summer 1989 from instructions given by the artist in his absence

Steve Fox (excavation work)

Literature: Causey, in Friedman and Goldsworthy 1990, 134–137; Friedman, in Goldsworthy 2000b, 191

The second earthwork that Goldsworthy undertook for Sustrans and Northern Arts is on the same abandoned railway line as the 1988 *Lambton Earthwork* (cat. 9) but closer to Leadgate, Consett, in County Durham. The location is near the former Eden colliery, which had closed in the 1980s; when Goldsworthy was invited to make his proposal, the site had been subjected to more redevelopment than that for the *Lambton Earthwork*. Adjacent to what was then a new road, the site covers nearly 2 acres and is long and triangular in proportion.

The work at Leadgate constitutes a series of concentric pathways, some straighter, some more curved,

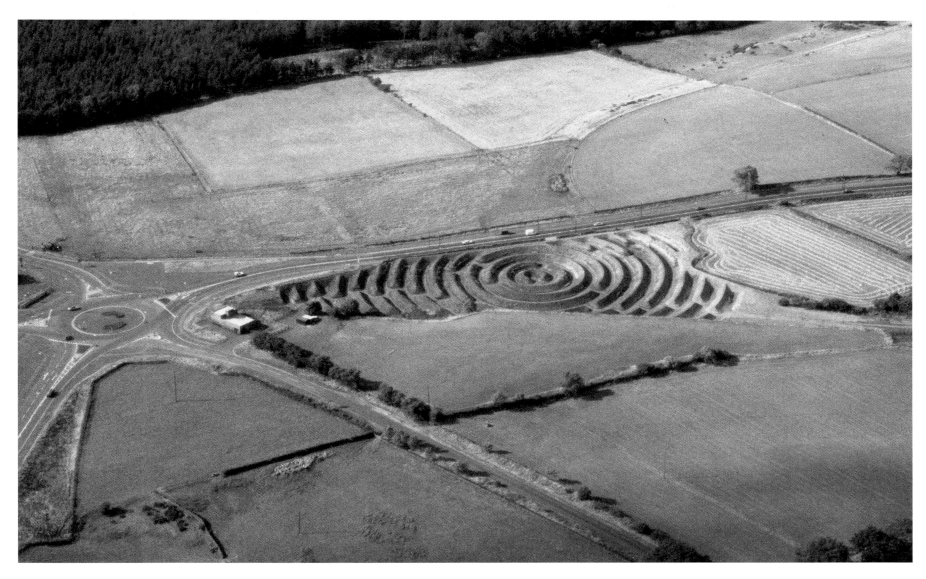

which are enclosed by pyramidal banks or short walls of earth and form a type of maze. Andrew Causey suggested that "Leadgate could be compared with Robert Morris' works involving concentric circles," though he rightly added, however, that *Leadgate Maze*'s similarity with works such as Morris' *Untitled (Johnson Pit#30)*, 1979, in Seattle is "more apparent than real" (1990, 136). Causey also noted of *Leadgate Maze*:

[T]hough the sculpture is huge in size, its scale is human.... Even more than *Lambton*, *Leadgate* is naturally experienced from inside, the viewer is at the core of the sculpture. Goldsworthy is concerned with continuities between art, nature and the human body, and the space created with the sculpture is body space. (1990, 136)

Over twenty years, patterns of use have been writ into the earthwork: specific routes through the maze, particularly one that skirts the outer banks, have been privileged, and are heavily trodden. The body of the work is thickly overgrown and shows little sign of regular access.

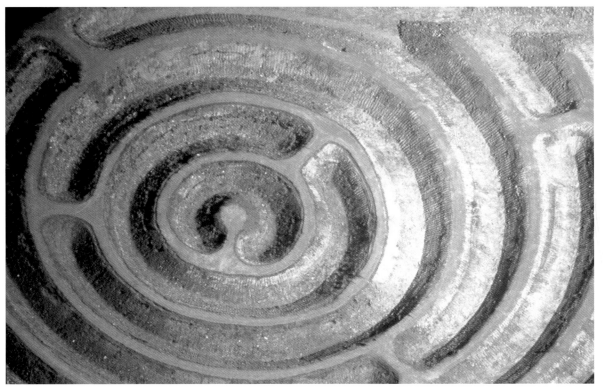

10

11 CAIRN AND LINE TO FOLLOW CHANGES IN COLOR, 1989

Cairn: H 2′7″ (.8 m), ⌀ at base 6′ (1.8 m)
Line: H 8″ (20 cm), W 1′3″ (.4 m), L 55′9″ (17 m)

Private Collection, Arizona, US

Stones collected from surrounding desert.
Installed late November 1989

Literature: Goldsworthy 1990, 28–29; Friedman,
in Goldsworthy 2000b, 191

This private commission in Arizona was the first that Goldsworthy completed in the United States. The collectors invited Goldsworthy to Arizona in 1987 to make a permanent work for their home—they had become acquainted with his work through his gallery show with Fabian Carlsson in London that same year. Goldsworthy made no preliminary visit prior to undertaking the commission. He arrived in Arizona following site visits to properties in Illinois and Pennsylvania, and he conceived, sourced, and installed both the cairn and the line during his stay. Thus, these works have a sense of the pragmatic and real-time site-responsiveness that is distinctive of Goldsworthy's ephemeral sculptures. Indeed, the pair relate to early ephemeral precursors, specifically the stone cairn and stone line that he made to follow changes in color on the beach at St. Abbs, Scotland, in late May 1985.

Goldsworthy made a notation in one of his sketchbook diaries (SD 25, AGA) on completion of the two works: "I have made a cairn and line to follow colours in rocks at [the] river. The rocks collected from where there is so much earth moving." He suggested that the sheer range of colors that he found there prompted him to make this pair of works. He noted that the site was the perfect place to make "more permanent versions of the colour variation works," as the dry climate in Arizona ensures that stone will not discolor in the way that it would in a damper environment. Goldsworthy collected a range of stones, of different colors and sizes, which he transported from the river to the property by car. The line and cairn grew from the same pile of stones, Goldsworthy apportioning the stones between them, as size and color dictated.

12 TOUCHSTONE NORTH, 1990

H 9′ (2.7 m), W 19′ (5.8 m), D 2′9″ (.8 m), ⌀ 5′ (1.5 m)

Dumfriesshire, UK

Whinstone from Morrington and Tynron Quarries, Dumfriesshire, Scotland. Installed April 1990

JS

Literature: Goldsworthy 1989 (under Wednesday, 8 April); Friedman and Goldsworthy 1990, 158–159; Friedman, in Goldsworthy 2000b, 192

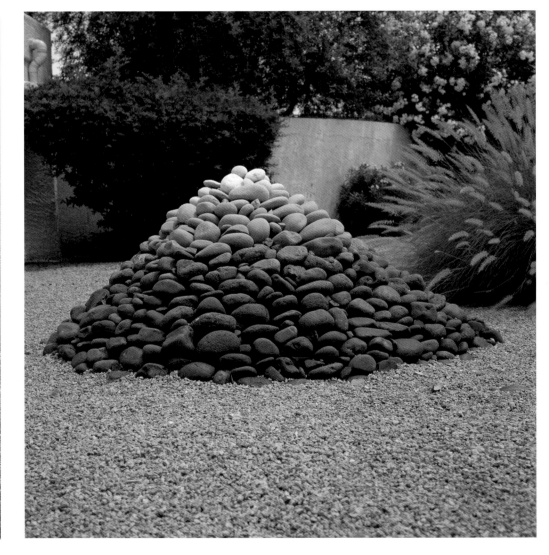

11 left, Line; right, Cairn

Touchstone North comprises a 360-degree arch supported with side buttresses, which Goldsworthy built just north of Penpont, on land belonging to the Buccleuch Estates, which, at the time of construction, was farmed by Mr. and Mrs. Pedden. The distinctive form derives from Goldsworthy's first attempts to construct what he termed a "circular arch" near Swindale Beck in Brough in 1982. Using river stones, heavily propped with hazel sticks, Goldsworthy succeeded in building two 4-feet-high circular arches.

The circular arch recurred in Goldsworthy's work throughout 1988 and 1989. In autumn 1988, he made drawings of a series of man-size circular arches sited at the bottom of curvaceous dips or valleys, with the arches supported on both sides by steep banking or integrated into a run of drystone wall. On 7 January 1989, he built an ephemeral precursor to *Touchstone North* in slate on the site of a small quarry in Scaur Glen. In a diary entry for that day (SD 22, AGA) he noted: "After 3 days and 3 collapses I have finally managed to make—entrance north. This would make a great work on a larger scale north of Penpont. I am surprised how little support at sides is needed."

Goldsworthy made *Touchstone North* a year after his project at Grise Fiord and the North Pole in April 1989. Goldsworthy built "snow round arches... nine or ten, possibly eleven feet high" on two occasions during that project: firstly, as a single form at Grise Fiord and secondly, at the North Pole, where he made four, facing onto each other. In his Grise Fiord diaries, Goldsworthy reprised the idea of making an "entrance north" at Penpont:

It feels right that when I make a work in Penpont to mark and orientate north that it should be made of stone. Snow is stone—it is a white stone....I have always considered snow and ice to be one of the most ephemeral of material[s] that I have ever worked with, but here it has a feeling of permanence and it makes me realise how rhythms, cycles and seasons are working at different speeds in different places. (1989)

Immediately on his return from the North Pole, Goldsworthy began to think about siting *Touchstone North*. He has suggested that he looked specifically for a site, lying to the north of Penpont, that would provide a promontory. He wanted the view north through the sculpture to yield a sense of uninhibited space. He looked for an elevated location, behind which there would be a drop or valley. Goldsworthy drew a line on a map just north of Penpont, which ran over various hilltops. He walked along the line, and immediately

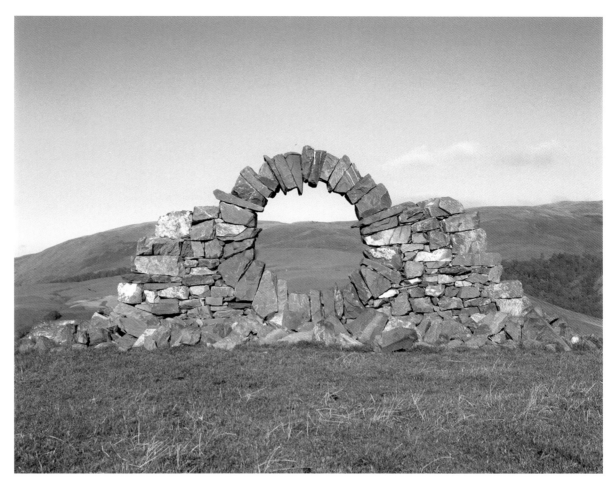

12

felt that the spot on the Pedden farm was right. The then Earl of Dalkeith helped facilitate permission for Goldsworthy to make *Touchstone North*. It has substantial side buttresses, and the circular arch appears to sit within stone rather than directly on the ground (as the North Pole arches did). The buttresses were built up concurrently with the lower curve of the arch. When the curve reached midpoint on both sides, pallets and logs were used to support the arch as it was brought over.

13 SLATE DOME HOLE, 1990

H 3′11″ (1.2 m), ⌀ 16′10″ (5.1 m)

Royal Botanic Gardens, Edinburgh, UK

Langdale slate and willow trees.
Installed summer 1990

JS

Literature: Friedman and Goldsworthy 1990, 139; Goldsworthy 1994, 112–113; Friedman, in Goldsworthy 2000b, 192 (referred to as *Enclosure*)

Goldsworthy was invited to make a proposal for a permanent work for the grounds of the Royal Botanic Gardens in Edinburgh in conjunction with his exhibition *Hand to Earth* at Inverleith House in 1990. He appears to have derived the concept for *Slate Dome Hole* from his initial idea to site a slate hole/dome inside one of the enclosures of *The Give and Take Wall* (cat. 7) at Stone Wood. Goldsworthy's proposal drawing for the gardens bears the following description: "Proposal for the Botanic Gardens, Edinburgh. Slate, Dome, Hole. Protected by dry stone fold planted round with willow" (*Hand to Earth* 1990, 139). This short elaboration illustrates the concentricity that underlay the conception of the work, which registers in its various layers—hole, dome, fold, screen. In this respect, it would seem to reference works such as Alan Sonfist's 1986–1989 *Circles of Time* at Villa Celle in Tuscany. Sonfist's piece comprises a series of "rings," of planting and stone, each of which "represents the narrative natural and cultural history of Tuscany."[5] With *Slate Dome Hole*, the enclosing or encircling elements do not bear the same potent narrative content. For Goldsworthy, the generative core of the work is the hole: "At the centre...is a black hole about six inches in diameter. Six inches of black space generating forty tons of stone. For me this

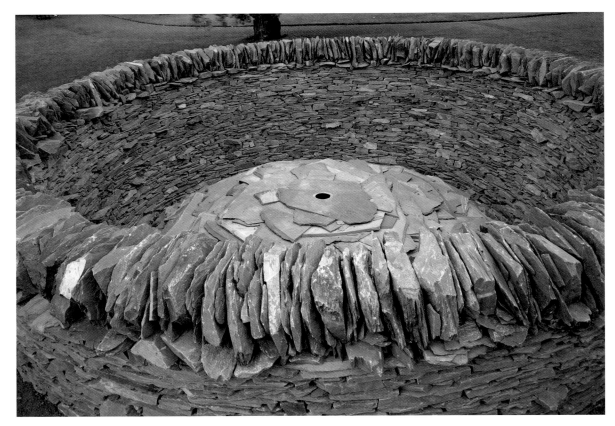

84

13

is how nature works—often small and powerful at the core" (PS, AGA).

Goldsworthy excavated the ground on which the work would be built, so that the dome would appear to swell up from the ground. The enclosure was the first element to be built, around the excavated area. Goldsworthy then built the dome inside. When the stonework was completed, Goldsworthy planted a perimeter of young willow trees around the fold; he has suggested that he chose that particular tree because it has an arrow or slitlike leaf. The resulting work constitutes one of Goldsworthy's most aestheticized folds. This effect may, in part, also be due to Goldsworthy's transposition of an essentially agricultural device—the fold—to a horticultural setting.

14 GRIZEDALE WALL, 1990

H 5′ (1.5 m), L 450′ (137.2 m)

Grizedale Forest, Cumbria, UK

Fieldstone collected from the site.
Installed September 1990

JS, PD, Philip Owen

Literature: Causey, in Friedman and Goldsworthy 1990, 139–140; Goldsworthy 1994, 106, 116–117; Goldsworthy 2000a, 6, 8; Friedman, in Goldsworthy 2000b, 193; Putnam, in Goldsworthy 2007, 14; Yorkshire Sculpture Park 2007, 29–32

Goldsworthy first proposed the idea of a curving wall in December 1988 for Mossdale Farm, a privately owned farm in the Yorkshire National Dales. He was invited to develop some ideas by Dick Capel, and he produced several drawings at the time that featured a long, curving wall, running down a hillside on the land. In one version of the work, "Sycamore Wall—Proposal for Mossdale Farm, Yorkshire Dales," Goldsworthy indicated a sycamore tree (planted) in each curve; in the other, he indicated large boulders in the curves of the wall (D.1988.10; see also D.1990.1 and D.1990.2, AGA).

The Mossdale wall was not commissioned, and while visiting Grizedale in 1990, the network of derelict walls that crisscross the forest prompted Goldsworthy to rethink the proposal for that context. In an extended entry in his sketchbook diary (SD 27, AGA) dated late June of that year, he noted:

weaving wall—a proposal—a derelict wall—rebuilt—response to the trees—trees marking its route—walls within the forest—evidence of a landscape past—a reminder of the forest's history.... This wall is a response to Grizedale as it is now. And possibly it will lose its

purpose—the forest will change—possibly revert to fields—whatever—the wall will be evidence of the forest.

Thus, the wall that resulted at Grizedale was truly rooted in its site in several respects. Firstly, by virtue of the fact that the wall grew from the line of a preexisting structure, Goldsworthy connected it into the cycle of land use specific to the Grizedale area, and into a history of human involvement with the land. Secondly, he elaborated its form and trajectory directly in response to the physical lie of land and tree. Thirdly, the wall also responded to a sense of tenuousness that Goldsworthy intuited at Grizedale at that time: "the trees have suffered wind damage this last year. My perception of the trees has changed—it is not as stable as I thought" (SD 27, AGA).

Though Goldsworthy himself refers to it as *Grizedale Wall*, the work became known early on as "the wall that went for a walk," a title derived from a poem by Norman Nicholson, itself entitled "Wall."[6] The poem has been an important reference for Goldsworthy, not least for the image it conjures of walls effectively walking into time. Goldsworthy believed that *Grizedale Wall* would itself walk into time. It is now considerably deteriorated, and it is his preference that it continue to decline. It was first damaged in 1997, when a storm bought some of the pine trees down across it, causing parts to collapse. In a recent statement, Goldsworthy noted:

I knew that change would continue after the making of my wall, and that I could not dictate or determine what that change would be.... I liked the fallen trees, and the way that they introduced a strong diagonal element to the work. (S 2006, AGA)

A couple of the gaps were repaired, which Goldsworthy subsequently felt to be contrived: "The leaving of the tree was far more honest and interesting." Goldsworthy might have considered rebuilding if it had been tied into the planting of new trees in place of those that had fallen. For him, the entire site would thus have kept its integrity. The clear felling of the whole area since 2000 has confirmed his feelings. As he concluded:

A deteriorated wall in a clear-felled forest; it is a stronger expression of the situation as it is now. I can foresee a time when the wall is completely collapsed, overgrown and possibly only visible as a mound. As such, it could become as strong and powerful as it was when it was first made. (S 2006, AGA)

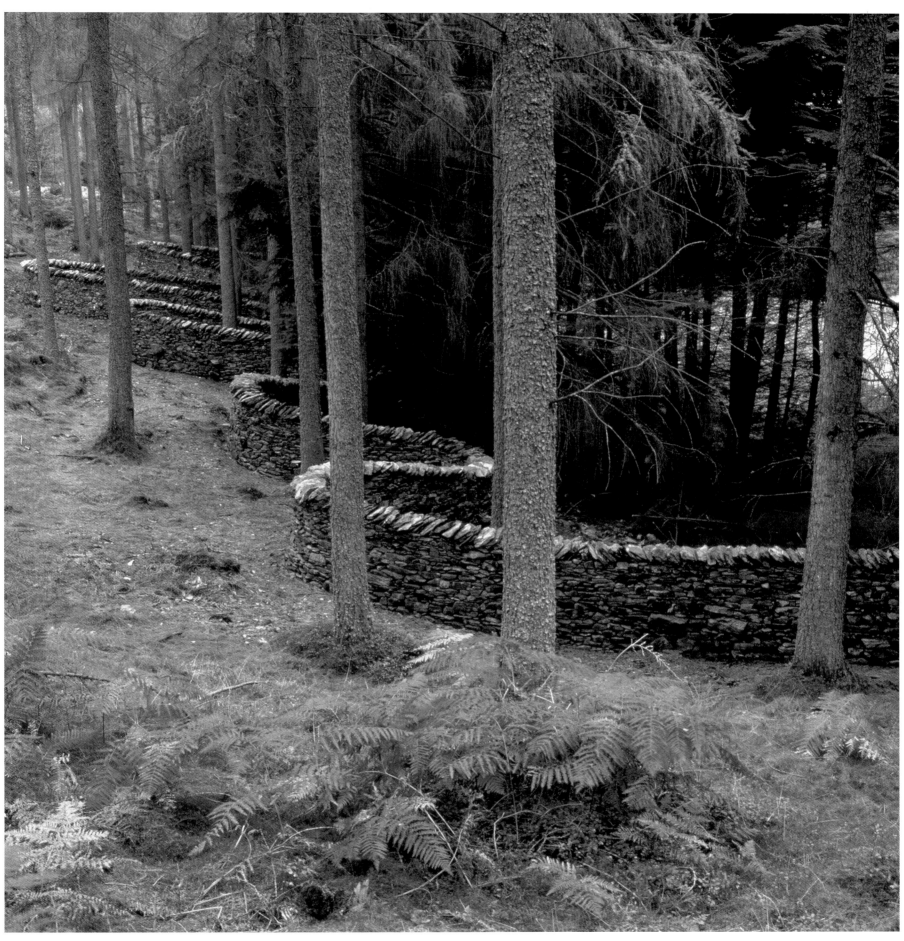

15 CONE, 1991

H c. 5′5″ (1.7 m)

Les Jardins de la Petite Afrique, Monte Carlo, Monaco

Slate from French Pyrenees. Installed February 1991

This cairn was commissioned for the Monte Carlo Biennale of 1991 and installed among the palm trees of the Jardins de la Petite Afrique. In an early statement Goldsworthy said, "I have made three cones during February in France—Toulouse, Monte Carlo and Paris. The material for each comes from a small slate quarry in the Pyrenees. They are of a single source—the same family and related" (s, *Little Africa Cone*, 1991, AGA). The other two cairns—in Toulouse and Paris—were for temporary exhibitions.

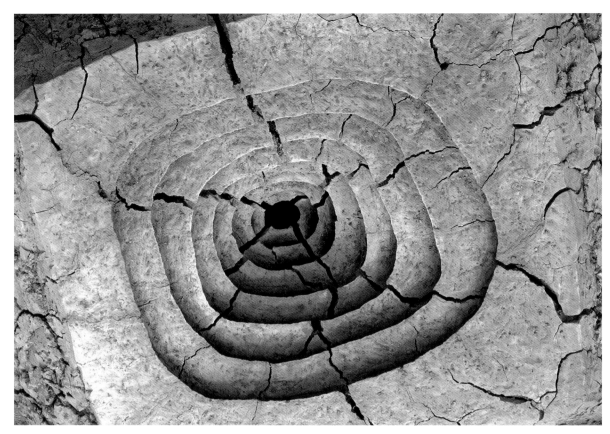

16

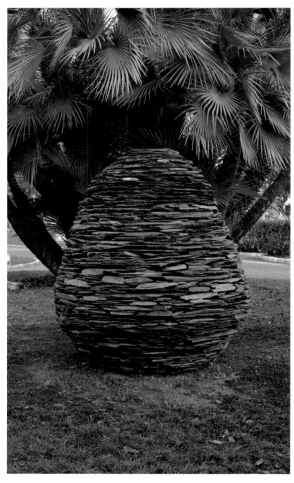

15

16 SEVEN HOLES, 1991

H 4′3″ (1.3 m), W 13′1″ (4 m), D 13′1″ (4 m)

Greenpeace UK, London, UK

Clay sourced from ground outside the building, and building debris. Installed April 1991

Retty Eliades and other Greenpeace staff members

Literature: Goldsworthy 1994, 34–36; Friedman, in Goldsworthy 2000b, 192

Seven Holes was the first permanent installation that Goldsworthy made specifically in response to the physical fabric of a building and the uses to which that finished building is put both physically and conceptually. It is also the first installation for which he used raw materials made visible and accessible by works on the building; in this way, he sought to connect the building very directly with the materiality of its footings. On an initial visit, Goldsworthy noticed yellowish clay in the ground, which had been exposed during excavation. In a proposal to Greenpeace shortly after that visit, Goldsworthy wrote:

I want the work to touch the nature upon which the building stands; drawing the eye deep into the ground. A contemplative work, to be looked into from a pausing place on the stairs of an intensely active building. I hope it becomes … a reminder that nature is here too. (PS 1990, AGA)

The resulting work, *Seven Holes*, comprises seven large, squarish clay structures, each sited at various locations across the lower ground floor on the north side of the building and containing finely edged holes of decreasing size, one dug within the other, that appear to regress into infinite space. A sufficient quantity of clay was extracted from the building ground, and was made workable by volunteers kneading it. Goldsworthy used it wet, adding no binding element. With each, he began by constructing the smallest, central hole, then stage by stage, building outward. He concentrated on working the edges of each layer of the recess, and then built up the form around it. He recalls using other building debris, such as bricks, to bulk out and bank the clay around the hole.

Cracks and fissures began to appear in the Greenpeace clay structures as they dried. This was not part of Goldsworthy's initial intention for the piece, and on a few occasions, he traveled to London to fill in the cracks and "repair" the work. However, he began to realize that the cracking stabilized after a certain point, and that the process and resulting effects were themselves interesting; he subsequently acknowledged the cracks as a part of the work.

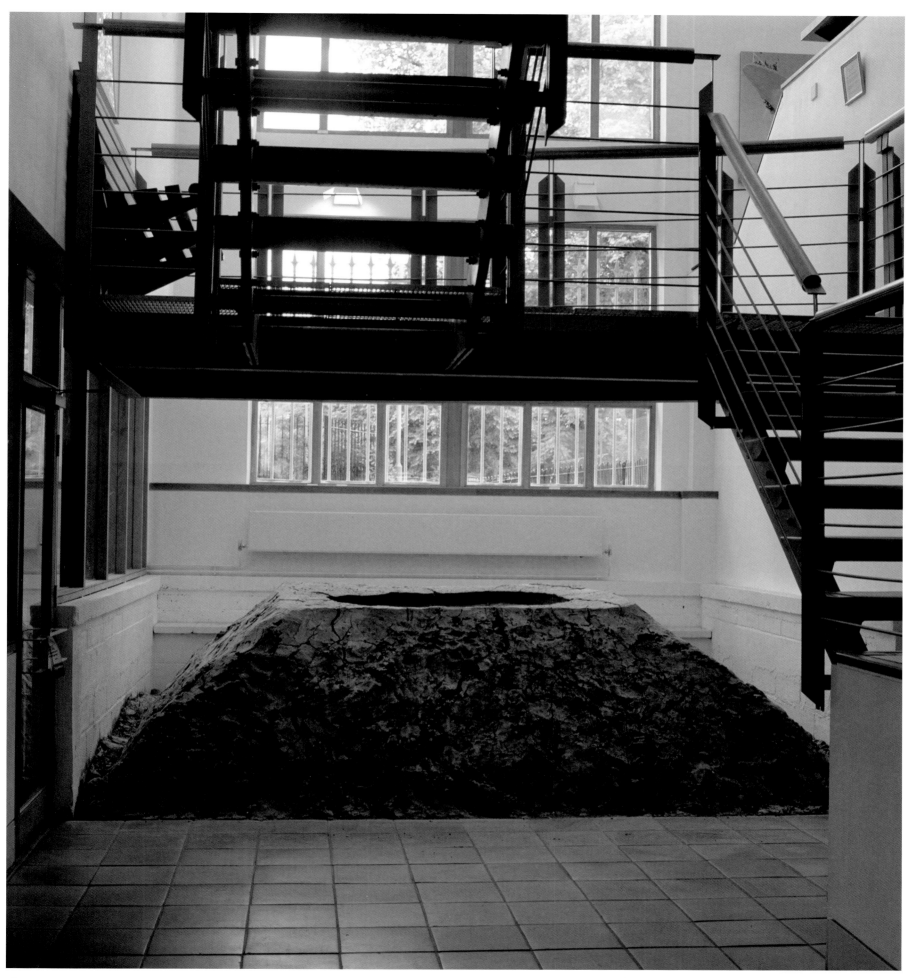

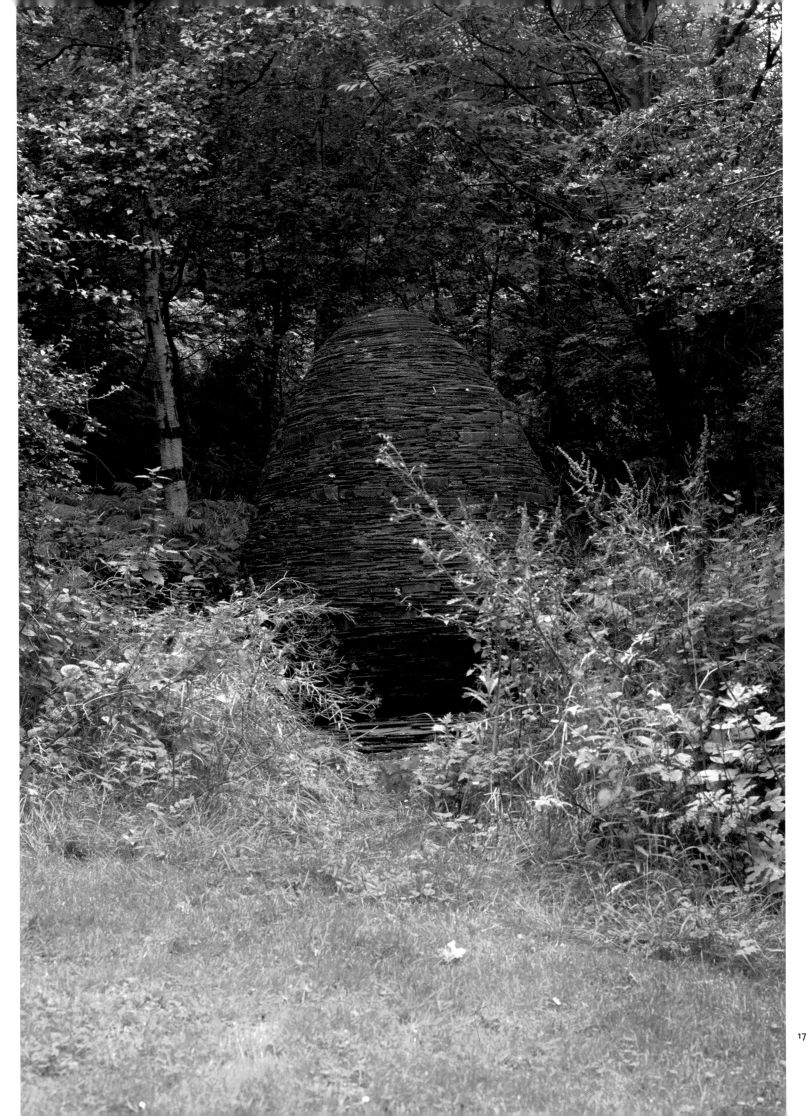

17 CONE, 1991

H 10' (3 m), ∅ at widest point 5' 9" (1.8 m)

Gateshead Council, Riverside Sculpture Park, Gateshead, UK

Rusted scrap steel. Installed in Pipewellgate, Gateshead, summer 1991

Literature: Causey, in Friedman and Goldsworthy 1990, 140; Goldsworthy 1994, 34–36; Friedman, in Goldsworthy 2000b, 192

Cone is the first of this type of cairn that Goldsworthy built as a site-specific commission for an outdoor context. It was commissioned for an urban public park, which runs along a formerly industrialized stretch of the south bank of the river Tyne at Pipewellgate in Gateshead. Goldsworthy was first invited to Gateshead in the mid-1980s and initially made three proposals, of which drawings and copies of drawings exist (D.1986.2–5, AGA): a group of "orange steel" cones situated near the Queen Elizabeth II Bridge (D.1986.5); a large-scale "sheet metal" or "industrial/earth" arch sited near Redheugh Bridge (D.1986.2–4); and a long "walk/single track earthwork through the trees" at Pipewellgate (D.1986.5). The arch and earthwork proposals did not proceed, although the latter subsequently came to fruition as the *Lambton Earthwork* (cat. 9) in County Durham in 1988. Goldsworthy reprised the proposal for a group of five cones for Pipewellgate in summer 1990, eventually building one cone the next year.

 Cone is somewhat anomalous in Goldsworthy's oeuvre, as it is the only instance in which he used metal as his primary material for a permanent commission. However, his use of steel was very much informed by the history of the site; the area of the park in which Goldsworthy located the work was previously a foundry. For him, the site had a palpable rawness, as much in its neglected and overgrown guise as for the aggressive industrial processes and human labor that marked it in the past. For him, the steel was emblematic of the connection between the rawness of nature and of man's use of it; "steel," as he wrote, "retains a quality of the earth from which it comes" (1994, 35).

18 THREE SANDSTONE CAIRNS, 1991

Each cairn: H c. 3' 9" (1.1 m)

Dumfriesshire Educational Trust, Gracefield Arts Centre, Dumfries, UK

Gatelawbridge red sandstone. Installed 1991

Literature: Friedman and Goldsworthy 1990, 87; Friedman, in Goldsworthy 2000b, 192

Exhibition: Hand to Earth 1990

Goldsworthy included these three cairns in his touring exhibition *Hand to Earth*. He installed them in the grounds of the Gracefield Arts Centre in Dumfries after the last of the exhibition's destinations. They are the only existent example of this kind of cairn, built using large round slabs of sandstone of decreasing size.

19 BLACK SPRING, 1992

H 3' 11" (1.2 m), ∅ 16' 10" (5.1 m)

Botanic Gardens of Adelaide, Adelaide, Australia

Parachilna slate from the Flinders range, eucalyptus, and wattle. Installed February 1992

Literature: Goldsworthy 1994, 112–113; Friedman, in Goldsworthy 2000b, 194

For his first two major public commissions outside Britain, Goldsworthy built enclosures. Those two structures, made for Adelaide in Australia and for Île de Vassivière in France, respectively, were both partners to works that Goldsworthy had already built in Scotland. The Adelaide enclosure forms a southern hemisphere counterpoint to the *Slate Dome Hole*

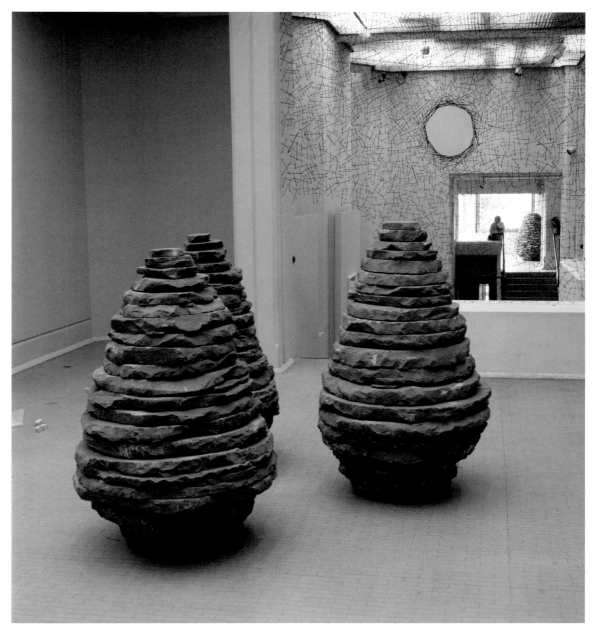

18 *Hand to Earth*, Leeds City Art Gallery

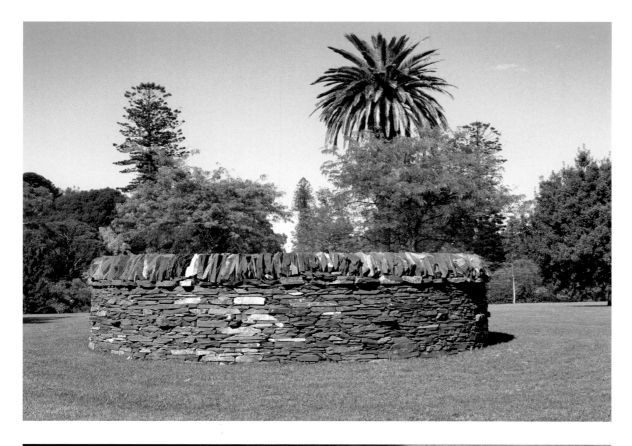

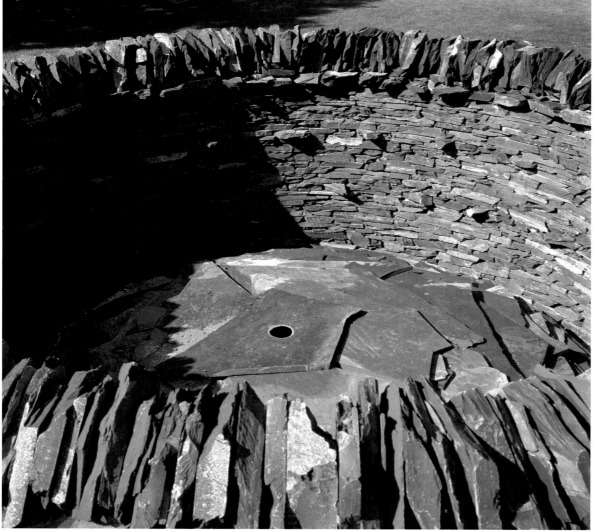

(cat. 13), which Goldsworthy built in the Royal Botanic Gardens in Edinburgh. Pairing and repetition are frequent in Goldsworthy's work, usually involving the recurrence of form or structure, but also encompassing a performative aspect on Goldsworthy's part as well. Many of Goldsworthy's commissioned works are conceptually linked by his own travels.

Black Spring was constructed two years after *Slate Dome Hole*, for the opening of Goldsworthy's *Hand to Earth* exhibition at the Botanic Gardens of Adelaide. He decided to return to the ideas and form of the Edinburgh work for the commission in Adelaide, largely because of the similarity in contexts and as a means of connecting them.

20 TWO FOLDS, 1992

Overall: L 295' 3" (90 m)
Each fold: H 5' 3" (1.6 m), ⌀ 49' 3" –55' 9" (15 –17 m)

Centre International d'Art et du Paysage, Île de Vassivière, Limousin, France

Fieldstone sourced locally. Installed April 1992

JS, PD

Literature: Causey, in Friedman and Goldsworthy 1990, 141; Goldsworthy 1994, 114 –115; Friedman, in Goldsworthy 2000b, 192 (dated as 1991)

Goldsworthy was first invited to submit a proposal to Île de Vassivière in 1990 at the suggestion of David Nash. A 70-hectare island, partly wooded, partly farmed, Vassivière is situated in the middle of a sizable man-made lake. The lake and island were created in 1949 with the building of a hydroelectric dam across the river Mauld; the flooding of the valley entailed the submersion of no less than eight villages. It is clear from sketches and notes made during his initial visit in April 1991 that Goldsworthy was drawn to the shoreline as a palpable marker of Vassivière's history. He recorded a number of ideas for possible projects, all of which incorporate the notion of counterpoint between shore and inland. At the end of his first day, he noted: "made quite a good work with dry and damp sand—this has gone to an idea for permanent work— 2 large stone cairns—one on the shore—one in the wood—the one of the shore will stay bare stone whilst the one in the wood will become mossy" (SD 32, AGA). Goldsworthy also discovered the remains of a wall that would once have defined a field, and he

made small sketches of an S-shaped, two-chambered fold, in the manner of the 1988 *Give and Take Wall* (cat. 7). In this instance, he included in one a tree trunk; in the other, a boulder, as well as a rough sketch for a separate tree fold. At the conclusion of his visit, he elaborated further ideas thus: "woodland and shoreline cones; lake, shore, stone, wood, fold; entrance — similar to Hooke" (SD 32, AGA).

Goldsworthy went on to elaborate two of those ideas into proposals — woodland and shoreline cones and lake, shore, stone, wood, fold. He took the latter forward, constructing *Two Folds* a year later in April 1992. The first circular enclosure begins in the wooded glade of the island, unfurling around trees and then running the short distance down to the shoreline and looping into the water to form the second fold. Goldsworthy noted of Vassivière: "I have not worked in a place so suddenly altered — the shock of which can still be felt — a place in which nature has been so changed yet where nature is still strong" (s, *Walls*, in PD, compiled by Steve Chettle, *Sheepfolds Project*, 1994, pages 7–8, AGA, here and following). As he elaborated, *Two Folds* "encloses and contrasts two spaces. The differences in space, feeling and light within each enclosure underscore the changes that have taken place."

The shore/water fold was built first, when the water levels were low. Goldsworthy has noted that the levels rose as the wall was built, and that part of the shore fold was submerged by time they finished the entire work. Although he rebuilt or restored old derelict agricultural buildings in Digne-les-Bains, *Two Folds* is the only occasion in France in which Goldsworthy built or extended a wall or enclosure along the line of a previous structure. Goldsworthy is keen to note that it is not a nostalgic or sentimental gesture. More important, in the context of Île de Vassivière, the gesture is an isolated one: "A wall in Britain becomes part of a network that nourishes and maintains the wall, without it there isn't the need or purpose to keep it in order." No longer part of a functional agricultural network of walls, the Vassivière folds will, in time, become not only physically, but also conceptually cut off. Consequently, as Goldsworthy has foreseen, it "will collapse and in its own turn become evidence of an island just as the previous wall spoke of a valley and fields." This inevitability is heightened by natural tensions that underscore the work: "Water will erode the wall on the shore and tree roots will undermine the woodland enclosure. The tension between lake and land (what was before and how it is now) will also work on the wall." Although he has said he was not aware of it at the time of conceiving the work, Goldsworthy's

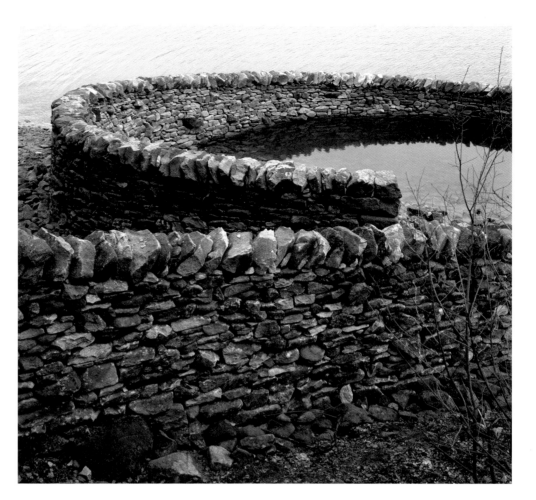

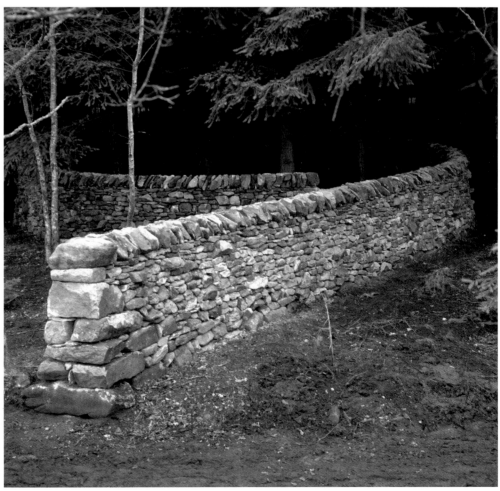

construction of two sheepfold structures is indeed appropriate insofar as the name "Vassivière" itself is derived from a medieval French term meaning "sheepfold," indicating that at some point in the history of the area, sheep farming formed an important part of the economy.

21 CONE, 1992

H C. 5' (1.5 m)

Dumfriesshire, UK

Red sandstone from Gatelawbridge Quarry, Thornhill, Scotland. Installed 1992

Literature: Goldsworthy 1994

This cairn was the first privately commissioned work that Goldsworthy undertook in Dumfriesshire, preceding its large millennial counterpart (cat. 66) by eight years.

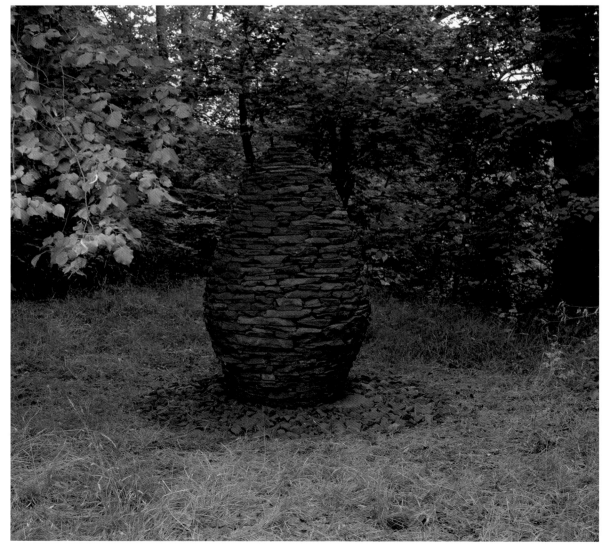

21

22 FLOODSTONES CAIRN, 1992

H 15' (4.6 m), ∅ 24' (7.3 m)

Private Collection, Pennsylvania, US

Field and gravel-pit boulders. Installed November 1992

JS, Don Hausler, Rick Rogers

Literature: Causey, in Friedman and Goldsworthy 1990, 140; Goldsworthy 1994, 37, 46–47; Friedman, in Goldsworthy 2000b, 192, 194

Goldsworthy uses the term "cairn" to refer to two types of stone forms, the cone shape and the pyramidal pile. *Floodstones Cairn* is the second cairn of the latter type (the pile) that he built to be a permanent structure. These cairns, he has suggested, are more rooted in and dependent on place and "less self-contained" than their cone-like counterparts.

This work was originally constructed next to a river within the grounds of a house in Illinois that was built in 1951 by Mies van der Rohe. Goldsworthy

was invited there in 1989 to make a proposal for a permanent work. Following a visit in November of that year, he first put forward an idea for a row of stones, one for each year of the house's existence, the sizes of which would be determined by the levels of the annual floodwaters that afflict the area. Andrew Causey described Goldsworthy's proposal for this site as

more conceptual…than usual for him, in the sense that a set of external facts, the height of the flood, regulates the art precisely. The facts, however, are ones that also govern the house, its elevation from the ground, and its environment, and are therefore a representation of place in the way all his works are. (1990, 140)

Goldsworthy later proposed instead to construct a large cairn that would specifically mark the 100-year flood that occurred in 1954. He felt that this type of cairn form would most successfully convey "a feeling of the weight, power and volume of a river in flood" (1994, 37). He built the cairn to the height that the floodwaters reached on that occasion—12 feet. Goldsworthy then had the annual high water levels incised in horizontal bands onto the cairn's stones at the appropriate height. Included are the years 1983 to 1987 (excluding 1985), 1991 to 1993, and 1996 to 2002 (excluding 1998).

This cairn is exceptional among Goldsworthy's larger site-specific works in that he did, after much consideration, subsequently relocate it. Goldsworthy made the decision that *Floodstones Cairn* should remain with its specific owner, and the work was moved to Pennsylvania. In August 2003 the cairn was rebuilt there, on a site that Goldsworthy chose not far from *Room* (cat. 23), an installation he had built for the same collector. The cairn was, however, built to a new height of 15 feet—the floodwater height achieved on 18 July 1996.

23 ROOM, 1992

H 12' 6" (2 m), ∅ c. 26' (7.9 m)

Private Collection, Pennsylvania, US

Fieldstone. Installed November 1992

JS

Literature: Goldsworthy 1994, 118; Friedman, in Goldsworthy 2000b, 192; Reina Sofía 2007; Yorkshire Sculpture Park 2007, 30

Goldsworthy was invited by the owner to propose a work for the grounds of a house designed by Frank Lloyd Wright. Goldsworthy first visited the property in Pennsylvania in November of 1989, and his sketch-book diary (SD 25, AGA) for that time contains a pre-liminary pencil sketch for *Room*, accompanied by the following text:

an idea for [the property]—a space in the woods—walls without corners—walls with no roof—wood (trees) in stone (walls). A place…a human space with an earth atmosphere—a complementary space to the house…. The sculpture will have a rawness and toughness that the house does not.

Goldsworthy sited *Room* in a wooded area of the grounds, in a clearing populated by a small cluster of thin-growing trees. He built the fold to enclose the thin-growing trees, and the enclosure wall is regulated by five narrow breaks that frame the trees within. In making the decision to title this work *Room*—as opposed to fold or enclosure—Goldsworthy seems to invoke both human presence and human habitation. As his 1989 diary notation suggests, he clearly wanted

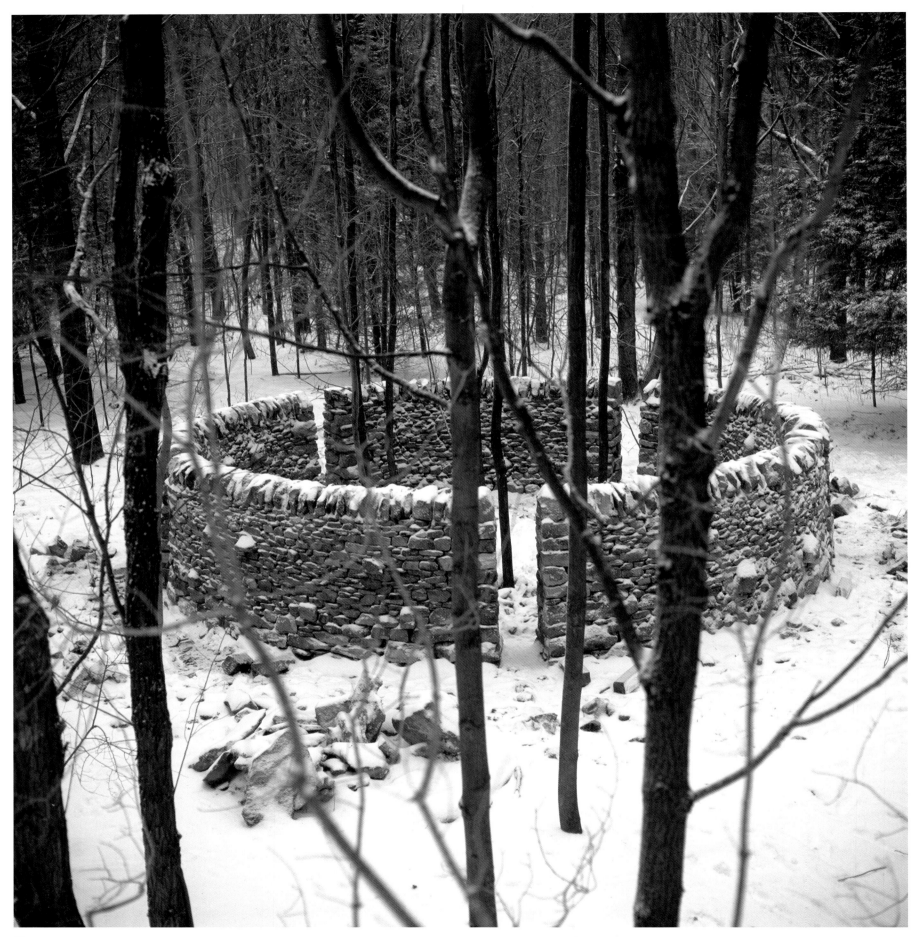

to connect it with the house, and he used stone from around the estate, of the same kind used to build the house itself. Insofar as he clearly conceived it to be an external room, *Room* is closely related to *Two Folds* (cat. 20), for which Goldsworthy elaborated the enclosure as a formal device for making rooms to contain different spaces.

24 ROCK FOLD, 1993

H external 4' 11" (1.5 m), ⌀ external 28' 7" (8.7 m)

Private Collection, Barfil, Dumfriesshire, UK

Fieldstone and bedrock. Installed February 1993

JS and students from Carlisle College of Art

Literature: Goldsworthy 1994, 108 – 109; Friedman, in Goldsworthy 2000b, 195 (listed as winter); Yorkshire Sculpture Park 2007, 60, 63

The first fold that Goldsworthy made in 1993 focused on the inherent physicality of the land, in this instance evoking the agricultural as a superimposition upon the geological. When Goldsworthy first visited Barfil, a farm property in Dumfriesshire, he was drawn to small hints of bedrock visibly breaking through in the surrounding fields. He noticed that there were no obvious, sizable outcrops of rock, but realized that those small, exposed areas suggested larger areas of bedrock lying just below the surface. He decided to unearth a section of the bedrock and to build a drystone enclosure around it. Choosing to excavate an area that sits on a gradient, and is just hidden from the view of the

farmhouse, Goldsworthy intended the fold to provide an aperture into the land.

Rock Fold is the first instance in which a formal process of excavation — on this occasion digging and scraping to reveal the bedrock — provides a performative core to the work. Excavation is, for Goldsworthy, clearly related to the hole: "What is a black hole but excavation?" (Yorkshire Sculpture Park 2007, 66). However, the process of exposing and enclosing has developed in Goldsworthy's practice, and *Rock Fold* is an early precursor to works such as the 2005 *Stone House* (cat. 103). The bedrock has undergone a process of acclimation: the exposed surface has mossed over and the raw quality rapidly softened where it proved to be extremely friable. Goldsworthy would like to work the idea again, on another site, with a harder bedrock.

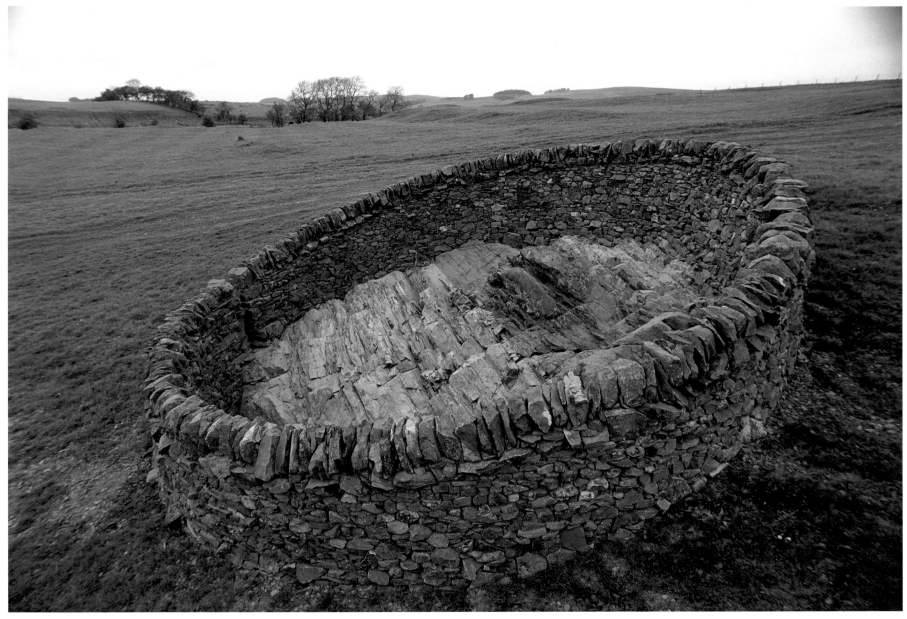

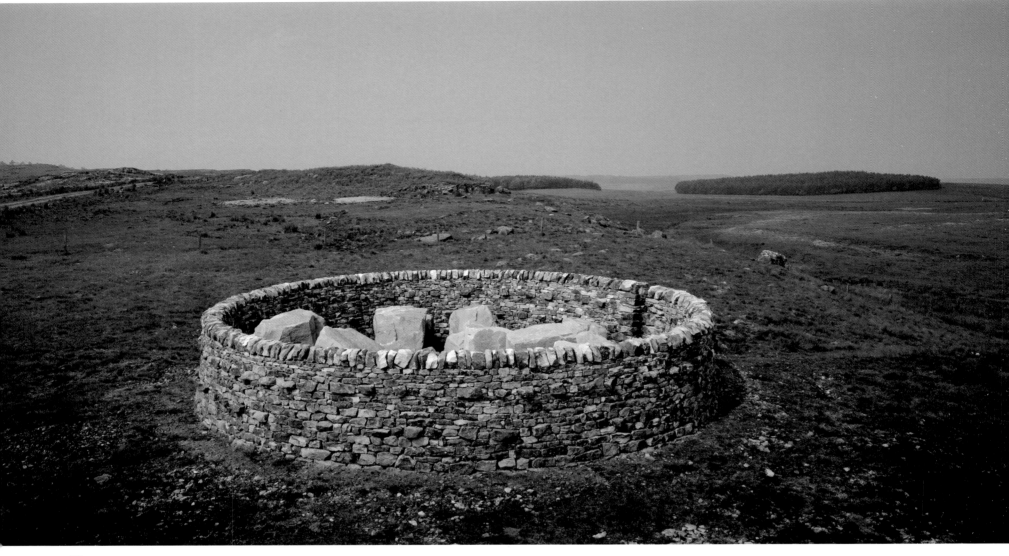

25 STONE GATHERING, 1993

H 6' 6" (2 m), ⌀ 29' 5" (9 m)

Collection of The Right Hon. The Viscount Devonport, Ray Demesne, Kirkwhelpington, Northumberland, UK

Eight sandstone boulders and walling stone from High Nick Quarry, Northumberland. Installed spring 1993

JS, PD

Literature: Goldsworthy 1994, 107; Baker, in Goldsworthy 2000a, 18–19

Stone Gathering is the second drystone enclosure in 1993 that Goldsworthy built specifically for an agricultural setting. On this occasion, he sited it on rough, open, grazing ground near a farm. It also anticipates the Sheepfolds Project that Goldsworthy later advanced in Cumbria, and was the first of many wall, fold, and house structures into which he has incorporated larger boulders or raw stone blocks. With later works, Goldsworthy sourced the stone mostly from surrounding fields. However, here he selected irregular, square-cut blocks from a local quarry and brought them to the site.

The wall is taller than is standard for agricultural walling, and the entrance into the fold is significantly narrower. These factors amplify the strong sense of the unexpected and of latent energy, which Goldsworthy intended for this work. A view over the wall (at 6½ feet high) into the enclosure is seriously inhibited, and sizable boulders are only encountered after entry. When first installed, the boulders were a pale, buff color and had the rawness of freshly quarried stone. Those qualities initially provided a point of contrast with the fieldstone used in the wall and lent Stone Gathering a sense of dissonance. It has muted over the years, as the boulders have acclimated, and fieldstone and boulder have become more visually harmonious. Goldsworthy installed the boulders fairly close together and consequently gave them a herded quality. Henry Moore wrote of rocks that they "show the hacked, hewn treatment of stone, and have a jagged nervous block rhythm."[7] Something of that nervousness is manifest in the blocks in Stone Gathering, which recall the nervous skittishness of penned sheep. As Goldsworthy noted, the work draws together the energy of both stone and animal.

26 CORNER CONES, 1993

H c. 5' 9" (1.8 m)

Private Collection, France

Limestone. Installed April 1993

Literature: Goldsworthy 1994, 38–39; Friedman, in Goldsworthy 2000b, 195

Corner Cones was the first occasion on which Goldsworthy used limestone rather than slate to build the cone form. Goldsworthy sited these cones in the four corners of a square garden on a private property in France. He intended that they be visually linked, marking as they do a pathway through the garden.

27 CONE, 1993

H c. 5′ 9″ (1.8 m)

Royal Botanic Gardens, Edinburgh, UK

Ballachulish slate. Installed summer 1993

Exhibition: Hand to Earth 1990

This cairn was first installed in the Royal Botanic Gardens as part of Goldsworthy's exhibition *Hand to Earth*, which was shown there in 1990. Following the completion of *Hand to Earth*'s tour, Goldsworthy returned to the gardens to permanently install the sculpture on the grounds.

28 WOOD THROUGH WALL, 1993

H 4′ 3″–4′ 7″ (1.3–1.4 m), W 67′ (20.4 m)

Private Collection, New York State, US

Fieldstone and wind-fallen tree sourced from site. Installed November 1993

JS

Literature: Goldsworthy 1996, 6, 54–55; Goldsworthy 2000a, 42; Friedman, in Goldsworthy 2000b, 195; Reina Sofía 2007; Yorkshire Sculpture Park 2007, 34–35

Wood through Wall constitutes a benchmark within Goldsworthy's early permanent commissions. It initiated in his larger-scale work an intense and poetic exploration of the physical and historical continuities and discontinuities that exist between agricultural and post-agricultural contexts. The invitation that led to the creation of *Wood through Wall* was the first that Goldsworthy had received to work in New York State in the United States. On a preliminary visit to the property in June 1993, Goldsworthy noted the remnants of drystone walls within the surrounding woods — walls that would once have enclosed fields that were farmed. Now largely post-agricultural and

26

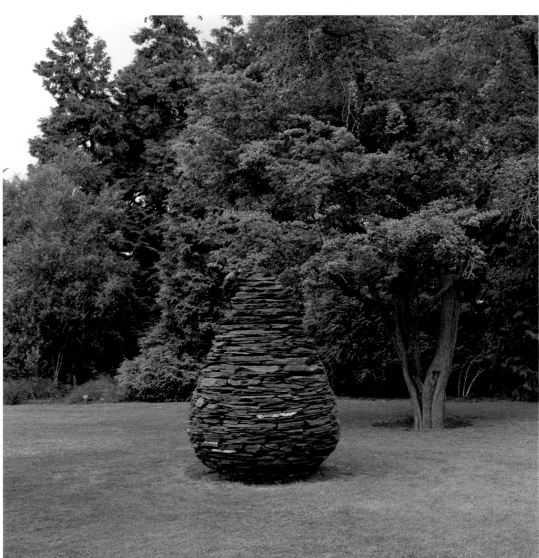

27

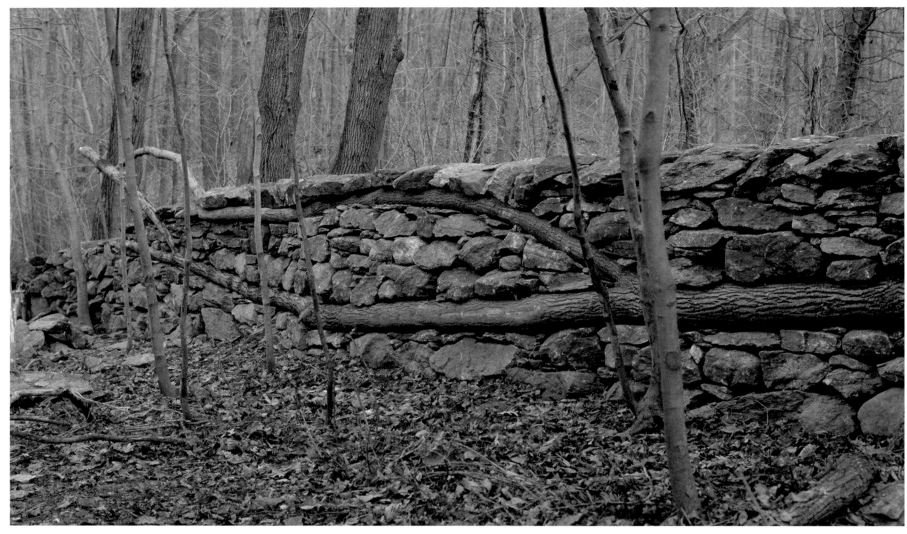

28

heavily reforested, that area, particularly in the wider context of northeastern states, has proved influential to Goldsworthy, and has enabled him to conceptually propel forward many of the concerns that "the wall that went for a walk" (cat. 14) proposed. For Goldsworthy, behind each successive claiming of the land (either for subsistence or for regeneration) lie powerful human gestures—cutting, stripping, stacking, dividing, planting, tending, reaping—all of which bear sculptural effect in the shape of walls, fields, crops, and so forth. As one predominant land use cedes to another, it leaves in its wake numerous physical accretions, which become decontextualized in the onset of the next.

The reforestation that Goldsworthy saw in New York State, as compared with the farming landscape of Cumbria in northern England, elicited in him a growing sense of the shock that the aggressive denuding of the land for agriculture must have entailed:

The tension between tree and wall is evocative of the historical tension between a forested landscape and a farmed landscape.... You realise this very forcibly when you walk in a wood that was once a field. I've been in re-forested areas thick with briars and thorns. These are abrasive places, not easy to walk through. You get a powerful sense of the struggle of clearing that wood, but also the power of growth to regenerate and reclaim that field. "Secondary forests", as they are called, are also a reminder of how much devastation occurred to the land when it was cleared for fields. (Yorkshire Sculpture Park 2007, 35)

Along the length of derelict drystone wall that Goldsworthy discovered, he noted the still-visible remnants of a gate opening. Within the grounds of the property he also found a tree that had been felled by a recent storm. Proposal drawings (private collection, documented in slide, AGA) that he made at the time are inscribed "Field Gate. A proposal for ... New York, 1993," and they indicate that he wanted to rebuild the wall, complete with opening, and to embed the felled tree into the wall, cutting it at either side of the

entrance. By so doing, Goldsworthy wanted to retain the shock that can be provoked by the sight of a single prone tree. He also wanted to manifest the aggressive action of the "cut" in the wall, evoking the issue of clearance, and the powerful actions and effects bound up in that process. The cut in the wall additionally elicits a performative engagement on the part of visitors insofar as they enact the "cut" each time they walk through the gap.

Goldsworthy purposefully built *Wood through Wall* as a time-based work, and it exists in an increasing state of powerful tension to the extent that the untreated tree is in a gradual process of decay. Eventually the tree will deteriorate, and by so doing, it will compromise the structural integrity of the wall. As such, Goldsworthy built into the wall a profound irony. The initial making of the wall formed part of the agricultural drive that entailed the clearance of considerable tracts of woodland across New York and New England. In its present incarnation, however, the wall was made dependent upon the strength of the tree.

29 CLAYWORKS, 1993–1994

Dimensions not available

Runnymede Sculpture Farm, Woodside, California, US

Clay from the site. Clay works fired on site in a temporary kiln 6–18 June 1994. Installed 12–13 June 1995

Barry Gregson, Mary Maggini

Literature: Goldsworthy 1996, 17, 42–43; Friedman, in Goldsworthy 2000b, 196

Exhibition: Breath of Earth 1995

Goldsworthy first visited the Runnymede estate in May 1992. His initial thoughts, he recalled, had focused on the idea of "Frightened Mountains," a series of cairns built along a trail with small stones and previously proposed for Laumeier Sculpture Park, St. Louis, Missouri. However, while he felt the idea was appropriate to California, "stone is not really what Runnymede is about" (PS, 10 March 1993, AGA, here and following). At the time of his first visit, Goldsworthy also removed some clay that he found in the ground there and molded it into a small circular form, which he fired on return to the United Kingdom. It is this form that constituted the crux of his proposal, which required making about thirty large versions of the test piece from Runnymede clay: "They will be about 24"–30" in diameter. They will be dried in the sun to intensify the cracking. Some may fragment in the firing. This is acceptable…most will be solid and strong, despite the cracks."

This is the first and only occasion for which Goldsworthy produced clay works using raw extracted clay that would be fired outdoors (at Runnymede in this instance) prior to reinstallation at the sites of extraction. He adumbrated the working process thus:

[E]xtract pure clay from Runnymede Farm and distill clay into a pure, clean medium free of ; gravel, dirt, rocks and organic matter. Wedge clay into a consistent mouldable material for Andy's approval. Construct forms to be dried, slow fired in an on-premises hand-built kiln and then re-installed to the excavation location.

Goldsworthy and ceramist Barry Gregson returned to Runnymede in May 1994 and produced the circular forms during that time. The resulting clay works were included in Goldsworthy's *Breath of Earth* exhibition at the San Jose Museum of Art in 1995; they were returned to their sites of extraction and installed following the exhibition's closure.

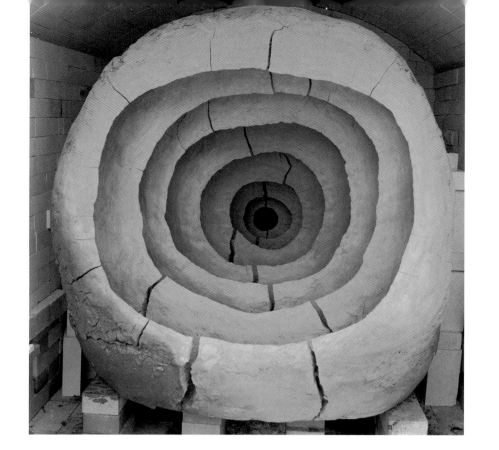

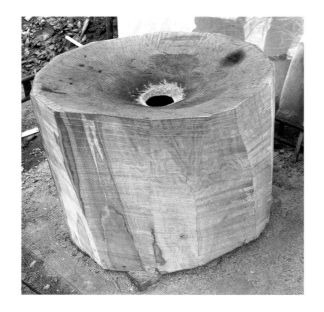

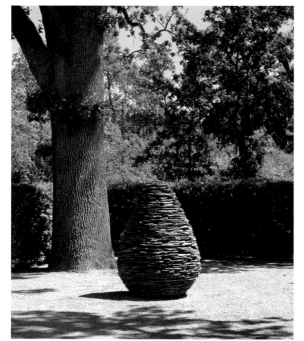

30 top **31** bottom

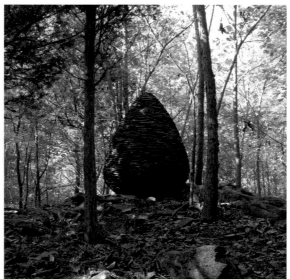

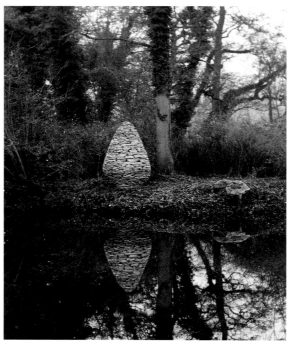

32 top **33** bottom

30 HOLE, 1995

H 2′ 9″ (.8 m), W 3′ 3″ (1 m)

Private Collection, Stockholm, Sweden

Wood. Installed early 1995

31 CONE, 1995

Dimensions not available

Private Collection, California, US

Slate. Installed 14–16 June 1995

32 BUCKHORN CONE, 1995

H 5′ 5″ (1.7 m), W 4′ 7″ (1.4 m)

Private Collection, New York State, US

Recycled roofing slate. Installed September 1995

33 CONE, 1995

H 7′ (2.1 m), ∅ 5′ (1.5 m)

Private Collection, Oxfordshire, UK

Cotswold walling stone. Installed December 1995

34 REDMIRE FARM FOLD, MUNGRISDALE, 1996 (SHEEPFOLDS PROJECT)

H 5′ (1.5 m), ∅ 22′ 3″ (6.8 m)

Commissioned by Cumbria County Council, with funds from the Arts Council of England, UK

Walling stone sourced locally. Built 8–12 January 1996

JS, SA, and Newton Rigg College, Penrith, students and staff

Literature: Goldsworthy et al. 1996, 25–30; Goldsworthy et al. 1998; Goldsworthy 2007, 54–57

Redmire Farm Fold was the first of some forty-five sheepfolds that Goldsworthy rebuilt and renovated across the six districts of Cumbria County between 1996 and 2009, as part of his extensive *Sheepfolds Project.* It is one of two such wide-ranging endeavors to which Goldsworthy committed himself in the late 1990s, the other being the ongoing *Refuges d'Art* project in the Réserve Géologique de Haute-Provence in France. Both constitute Goldsworthy's most multilayered and sustained responses to place, forming what Goldsworthy has called linked commissions that encompass territorially diverse areas, multiple communities, numerous landowners, and land rights. He conceives of both as single, aggregate works, the many structures of which are bound by an overarching integrity.

Both projects are rooted in what are for Goldsworthy presiding concerns: the human presence in the landscape and the ongoing processes of physical and conceptual inscription that are enacted upon and layered into the land. In northern England and the Scottish Borders, Goldsworthy's interests have coalesced in particular around hill-farming communities, the tenuous relationship they negotiate with the upland territories they inhabit and work, and the shifting fortunes that have beset their specific systems of land use and habitation.

Steve Chettle, at the time public arts officer for Cumbria County Council, first approached Goldsworthy in 1993 with a view to developing a major proposal for Cumbria for the 1996 Year of the Visual Artist. As Chettle recalled, "Andy's response was to propose a hundred sheepfolds for Cumbria. This was a massive proposal, but also highly appropriate. Cumbria has been shaped largely through its sheep-farming history" (PD, compiled by Steve Chettle, *Sheepfolds Project,* 1994, page 5, AGA). Structures for sheltering sheep are evident across Cumbria, and historically have been ubiquitous,

but, as Goldsworthy indicated, the absence of working folds is emblematic of shifting patterns of farming. Goldsworthy's interest in rebuilding folds was not a simple reinstatement or a nostalgic gesture, but focused on the fold's continued meaningfulness as a bearer of function and of values, and as an agricultural artifact and site.

Goldsworthy and Chettle consulted first edition as well as current maps in order to identify historic and existing sheepfold, pinfold, and washfold sites. Although initially located in contexts formed by agricultural activity, many of those contexts had altered considerably, reflecting changes and continuities in living and working patterns across Cumbria. What most decisively determined the scope and pace of the

Sheepfolds Project, however, were the landowners, parish councils, farmers, community groups, and commoners associations, and the processes of consultation that were not always favorable in outcome. Indeed, the project underwent a period of hiatus, precipitated by licensing issues. It was further complicated by the outbreak of foot and mouth disease in 2001.

Redmire Farm Fold was the first structure built under the umbrella of the *Sheepfolds Project*. Paired with *Field Boulder Fold* (cat. 35), this first work was constructed where a fold had previously stood, and is formally very simple. At 5 feet, the wall stands higher than traditional folds and has a visible batter. Historian Michael Turner noted, "[T]here are numerous ways in which the actions of man have been fossilised in the

present-day landscape—the cultural landscape."[8] This statement resonates with Goldsworthy's conception of the fold as a performative space, an arena for elemental, economic, and symbolic processes. *Redmire Farm Fold* evokes this potency:

[T]he fold [becomes] a forum for something, the idea that something has happened in it: not just leaving an object but leaving a story or an idea, space charged with the memory of things that have happened there. When I'm in a fold making things, my mind goes back to the motions of what a farmer would do there....I feel that it's such an intense space. I think that's why I'm so attracted to the enclosures, because of that intense atmosphere inside. (PS 1995, AGA)

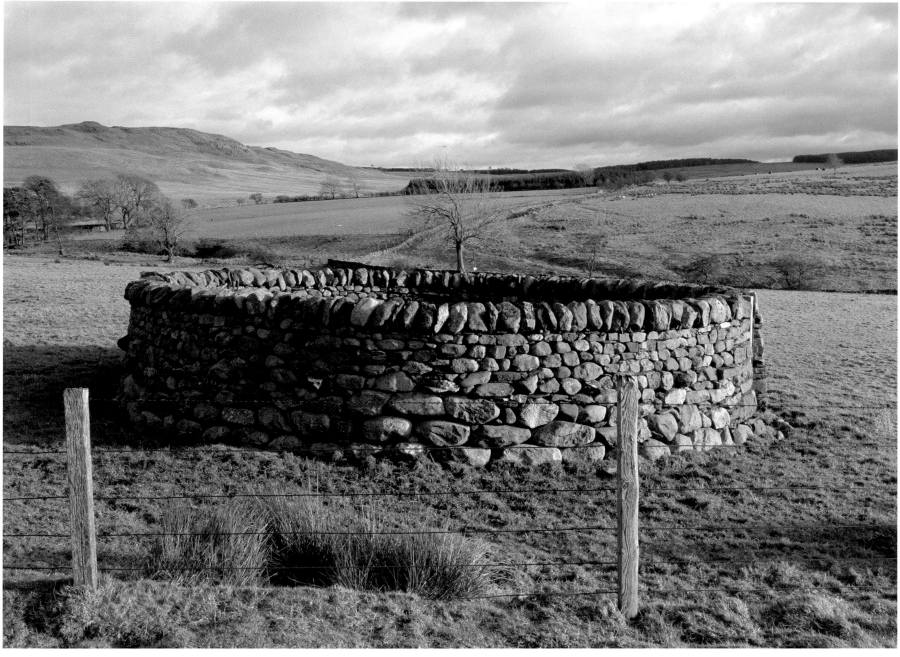

35 FIELD BOULDER FOLD, MUNGRISDALE, 1996 (SHEEPFOLDS PROJECT)

Total fold: H 6' 7" (2 m), ∅ 50' (15.2 m)
Interior fold: H 5' (1.5 m), ∅ 21' 6" (6.6 m)

Commissioned by Cumbria County Council, with funds from the Arts Council of England, UK

Walling stone, granite, and greywacke boulders sourced locally. Built 12 January–15 February 1996

JS, SA, and Newton Rigg College, Penrith, students and staff

Literature: Goldsworthy et al. 1996, 31–37; Goldsworthy 2007, 54–57

Field Boulder Fold is the second of the two folds that Goldsworthy completed at Redmire Farm, Mungrisdale, in January 1996. Unlike the first work (cat. 34), which stands on the site of a previous sheepfold, the second is located a short distance away, on a new site, and is secreted within a pile of large boulders that had been ploughed from the ground and gathered in the corner of a nearby field.

Goldsworthy did not initially plan a pair of folds for Mungrisdale. He and Steve Chettle determined from maps that a sheepfold had stood on the farm, although no structure was existent. While on a site visit to the farm in 1995, Goldsworthy noticed the large pile of boulders heaped in the corner of one of the fields for eventual use in wall repairs. In response, he proposed using that pile as the source for rebuilding the sheepfold and developed three possible versions. His drawings include one for a square fold, which he proposed to set onto boulders, another for a circular enclosure with a cairn inside it, and a third for a circular fold surrounded by boulders around its outside perimeter. Of the latter proposal—the one that he went on to develop—Goldsworthy noted:

I have seen these piles of stones many times before… gathered from a field, made into a pile, waiting to become a wall.… The stones have been dragged out of fields through the process of ploughing or drainage.… The fold will sit in an irregular heap of stone, more irregular than the [proposal] drawing.… It will appear as a pile from a distance. (PS, *Mungrisdale*, AGA, here and following)

However, Goldsworthy subsequently decided that he did not want to disturb the pile by relocating it across to the sheepfold site. Instead, he conceived the idea for a second fold that would be built within the pile, which would remain in its location at the corner of the field. Thus, Goldsworthy was able to deal with the "sculptural integrity" of the pile itself, "to show the structure that lies within these apparently random piles," which for him is "an expression of farming rhythms." The boulders were left in situ, and a 360-degree excavator moved them around to accommodate enough room at their center so that a fold could be built inside. He created the distinct sense that the fold is growing out of the pile or that the pile is producing a wall. Either, as Goldsworthy suggested, is in effect the true purpose of such piles. *Field Boulder Fold* not only provides a primer for its freestanding companion fold *Redmire Farm Fold*, but also, indeed, appears as if it might be the source.

36 RAISBECK PINFOLD CAIRN, 1996 (SHEEPFOLDS PROJECT)

Fold: H 4' 6"–5' 2" (1.4–1.6 m), ∅ 28' (8.5 m)
Cairn: H 6' 1" (1.9 m), ∅ 4' 4" (1.3 m)

Commissioned by Cumbria County Council, with funds from the Arts Council of England, UK

Walling stone. Fold and original cairn built May 1996. Cairn vandalized and rebuilt 1997

SA, Michael Appleby

Literature: Goldsworthy et al. 1998, 31–37; Goldsworthy 2007, 62–63

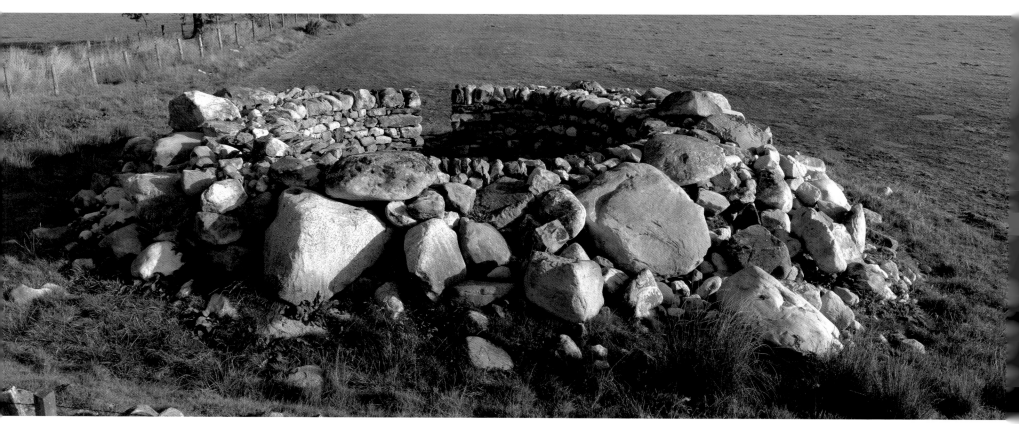

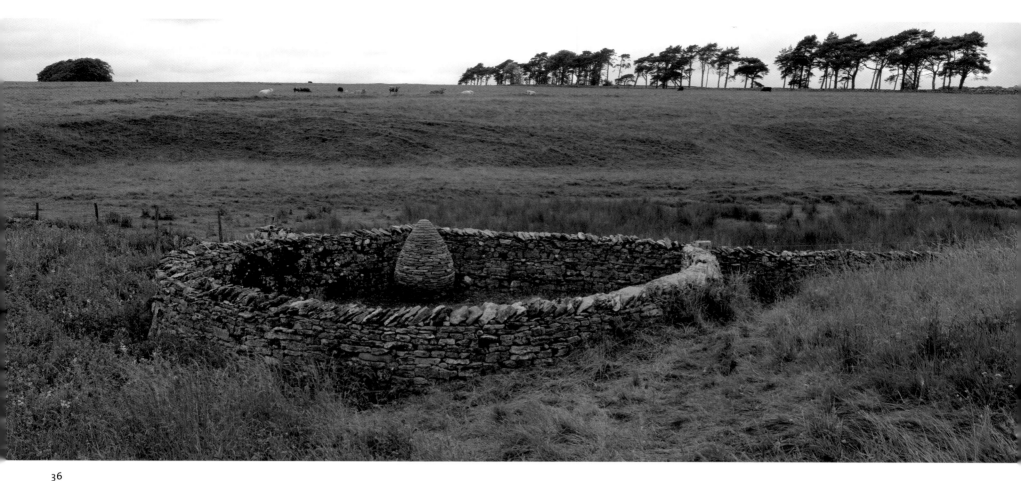

Raisbeck Pinfold Cairn is the first pinfold structure and cairn pairing to be built as part of the *Nine Pinfolds*, a subsidiary of the *Sheepfolds Project*. *Nine Pinfolds* was initiated at an early point in the larger project and derives from the Nine Standards, large stone structures of indeterminate date and irregular form, which are sited upon Hartley Fell overlooking the Eden Valley of East Cumbria. Goldsworthy discussed the significance of these structures for him and the formal development of his own cairns (see cat. 5). *Nine Pinfolds* presented an "opportunity…to take the cairn back to its origins and to place it in counterpoint and dialogue with the Nine Standards" (2007, 59). It also enabled him to work with pinfolds specifically, as folds located not out on the open fell or on farmland, but within villages: "The Standards are dramatic monuments to the high ground; my cairns will be monuments for the valley and village life" (2007, 59).

Between 1996 and 2004, Goldsworthy managed to complete six pinfold-cairn pairings, falling short of the planned nine. He decided to retain the title *Nine Pinfolds* to indicate that the project incorporates those that failed to be realized as much as those that were realized. This particular project certainly held personal significance for Goldsworthy, living as he did in the Eden Valley in the early 1980s, and an emotional connection is especially vivid in the works that he built there. The emotionalism that permeates Goldsworthy's development of and subsequent writing about the project is often cited as evidence of a benign sentimentalism in his work. Yet, as Kay Anderson and Susan Smith suggested, "to neglect emotions is to exclude a key set of relations through which lives are lived and societies made."[9] Indeed, they added that "emotional relations tend to be regarded as something apart from the economic," an insight that is particularly illuminating in relation to the *Sheepfolds Project* generally and to *Nine Pinfolds* specifically. Anderson and Smith referred to "emotional geographies" that can be accessed, for example, "through settings where the emotional is routinely heightened." Goldsworthy's own personal history within the Eden Valley certainly rendered it an emotionally heightened space. In a sense, the *Sheepfolds Project* presents a confluence of such geographies, which accumulated around "the fold" and around particular folds. The negotiation of those geographies is just one of the factors that necessarily inflected what the project was ultimately able to achieve.

37 CONE, 1996

H 5′9″ (1.8 m)

Private Collection, Stockholm, Sweden

Slate. Installed June 1996

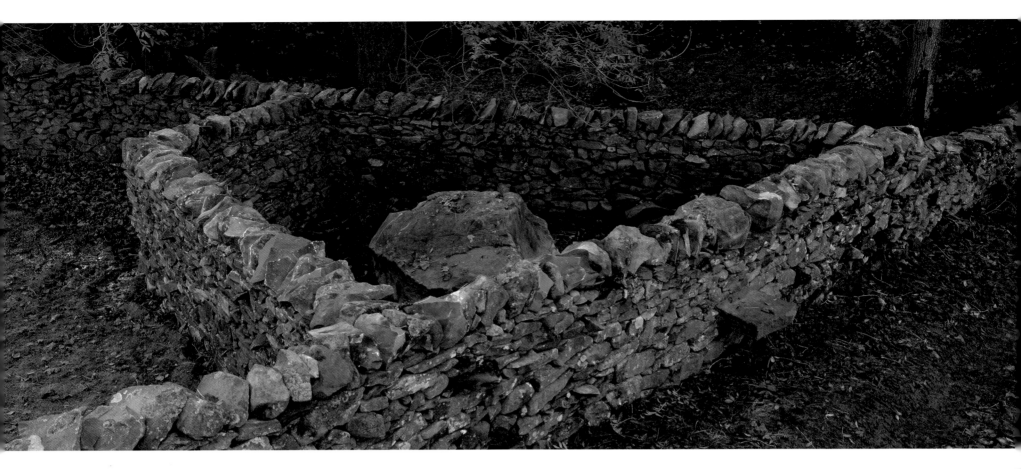

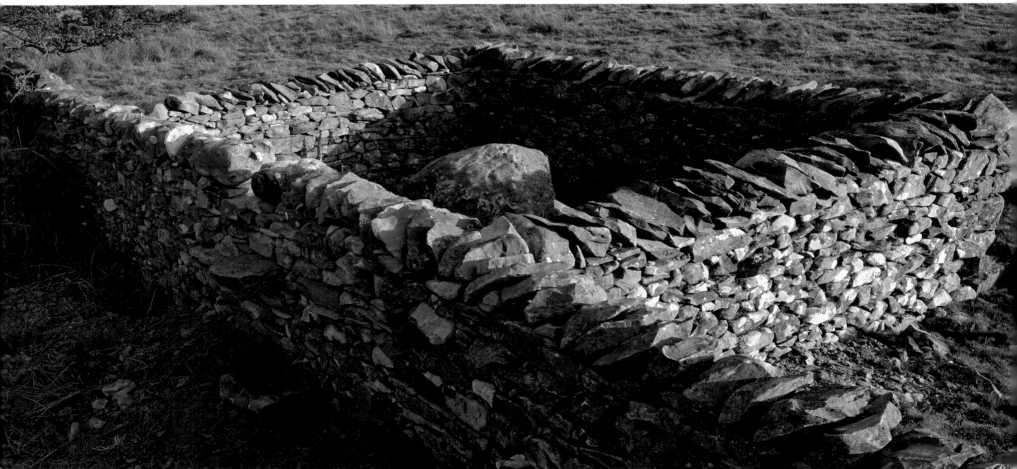

38 DROVE STONES, 1996
(SHEEPFOLDS PROJECT)

16 folds and 16 boulders, dimensions vary
Folds: approximately H 4′–4′8″ (1.2–1.4 m),
W 12′4″–15′ (3.8–4.6 m), L 10′8″–16′ (3.3–4.9 m)
Boulders: approximately H 2′1″–5′ (.6–1.5 m),
∅ 5′–9′5″ (1.5–2.9 m)

Commissioned by Cumbria County Council, with funds
from the Arts Council of England, UK

Walling stone and boulders sourced from surrounding
fields. Built 1–14 August 1996

SA, KA, David Gardner, Steve Harrison,
Willie Law, Graham Milburn, Joss Robinson

Literature: Goldsworthy et al. 1998, 31–37; Goldsworthy
2007, 64–83; Yorkshire Sculpture Park 2007, 39, 55,
58–60, 62

Goldsworthy's earliest proposal drawings for these
folds date to autumn 1994, just following his first
visit with Steve Chettle to Fellfoot Road in Casterton
in Cumbria. Those drawings are Goldsworthy's first
visualization of the sequence of sixteen folds that
are collectively titled *Drove Stones*. In a statement of
1995, Goldsworthy said of Fellfoot Road:

I have never seen such a concentration of folds. These
small, simple enclosures are connected to a walled track,
like rooms attached to a corridor. I would like to make
a work that answers the rhythm of these repeating
sheepfolds. (2007, 64)

Fellfoot Road provided Goldsworthy with a ready-
made spine of small, regularly shaped folds. Some
were still in use, while others were not. Goldsworthy
decided to rebuild those that had fallen into disuse
and enclose large glacial boulders, moved from
the surrounding fields, within them. Goldsworthy
described *Drove Stones* as "a distillation…of what
already exists," in this instance of "stone, walls, field
and farm" (2007, 75). That distillation is critical to the
experience of the work:

[T]he track that links the folds and the spaces between
them, is as important as the folds themselves. Fold, then
field, fold, then field: it sets a rhythm in the sculpture
that is beyond just the stone of which it is made. It is
about the movement of walking, about space. (Yorkshire
Sculpture Park 2007, 55)

Although *Drove Stones* is unified as a single work by
a linear and rhythmic integrity, no less than eight
separate parties own the fields that abut the track and
in which the folds are situated. The spatial and visual
connections that exist between the folds belie the
logistical coordination that the work required, the dif-
fering economies of each farm or estate, and the at-
times emotive process of shifting the boulders. Golds-
worthy evoked the tension inherent in moving animals
from field to field or down a road. The energy of the
herd or the flock is unpredictable and prone to disper-
sion. Folds and walled tracks channel that energy, or
else contain it. Clearly, for Goldsworthy, the moving
of stones is an analogue to moving animals, both
processes being sites of resistance—animal or stone
requiring physical persuasion.

39 THREE ROADSIDE BOULDERS, 1996

Overall: L 60′ (18.3 m), H 3′4″ (1 m)
Each recess: H 7′ (2.1 m), L 13′ (4 m), D 13′ (4 m)
Each boulder: ∅ c. 3′ (.9 m)

Private Collection, New York State, US

Fieldstone, slate slabs, glacial boulders, and maple
trees. Installed 31 August–14 September 1996

SA, GW, JA, WN

Literature: Goldsworthy 2000a, 16–17 (repr.); Baker, in
Goldsworthy 2000a, 9–19; Goldsworthy 2000b, 192

Goldsworthy was first approached about the possibility
of undertaking a commission "for a stone wall work"
in New York State in January 1994. He had recently
completed *Wood through Wall* (cat. 28), at another New
York property, and was particularly responsive to an
invitation by which he could extend his engagement
with post-agricultural northeastern states (especially
New York and New England) and their artifacts. Golds-
worthy made two site visits to the property, the first in
March 1995 and the second in May 1996. On his initial
visit he clearly decided to work with the long stretch
of wall at the front of the property, which separates it
from the road. He also decided "to make something"
visible from the roadside "that uses the idea of passing
by, of travel, yet does not become an opportunity for
showing off the sculpture" (PS, 1996, AGA, here and
following). Goldsworthy produced a proposal in April
1996, just ahead of his second visit:

I propose to insert in the wall three chambers. The back
wall of the chamber will be approximately the same
height in each, but because of the different ground level
as the wall goes away from the entrance along the road,
the chambers will appear to be sunk deeper into the
ground. In the back wall of each chamber will be embed-
ded a large round boulder. I've always liked the way
the boulders are described as growing, rising out of the
earth…the piece will have a hidden quality about it.
The stones will be set back, sunk down and have a quiet
reticent feeling as well as being on a road.

Goldsworthy noted that his impetus for this
proposal was a work he had recently made on the
Dumfriesshire coast in Scotland comprising three short
freestanding walls, each with a stone embedded in
its center. However, the conception of *Three Roadside
Boulders* was also coincident with Goldsworthy's
development of the *Sheepfolds Project*, and his decision
to use excavated boulders such as those he had viewed
along the roadside during his first visit was certainly
informed by the latter. During site visits to Cumbria
throughout 1995, Goldsworthy noted: "Sometimes
large boulders are left stranded. There is something
strange about these boulders—it begs the question
of why they are left." In fact, Goldsworthy arrived to
begin construction on *Three Roadside Boulders* shortly
after completing *Drove Stones*, and that transition from
the Cumbrian to the northeastern United States con-
text seems to have enacted a distinct re-registering of
the processes of disinterring and abandoning boulders.

Critic Kenneth Baker has compared Goldsworthy's
use of boulders in this instance to Carl Andre's place-
ment of thirty-six boulders of varying size in a public
space in Hartford, Connecticut, a work known as *Stone
Field Sculpture,* 1977 (2000a, 18). Baker noted of Andre's
piece "a wry subtext" aimed at the freighted iconogra-
phy of Plymouth Rock:

Andre is a native New Englander who knows it was tradi-
tional for New England Hamlets to adorn their town
squares with boulders.…Each such boulder is a symbol
of Plymouth Rock, the legendary disembarkation point
of the pilgrims who settled the Massachusetts Bay Col-
ony in the early 17th century. (2000a, 18)

Goldsworthy's use of boulders sits within a different,
less ironic, register of New York's and New England's
history of settlement. Attending the acclimation of
European settlers to the region, cultural geographer
Denis Cosgrove has suggested, was a "conflict of land-
scape images" between the "utopias sustained by

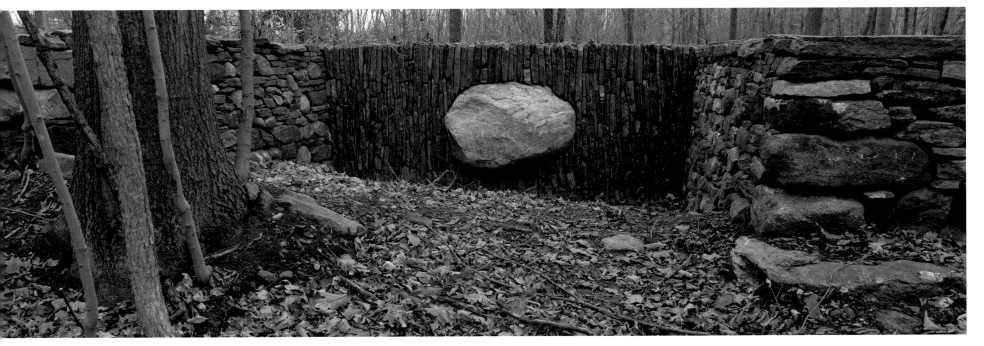

39

those who viewed from afar and the more practical image of wilderness to be tamed by those who materially confronted the environment."[10] For Goldsworthy, the boulder is certainly emblematic of the adoption of "practical attitudes" by those who faced the physical task of clearing land and establishing the physical infrastructure of settlements. The placement, or rather levitation, of the boulders within the wall also draws on the economy of myth that the earliest "practical shapers" generated about the land in response to physical occurrences they could not explain: As Goldsworthy noted, early European settlers often thought that stones were literally growing out of the land, "because ground frost would just push more and more of them to the surface each year" (2000a, 15).

Three Roadside Boulders is of course a perimeter wall to a residential property. Boulders are no longer extracted from the ground to produce usable fields, then abandoned. Rather, they are excavated, along with earth, to make foundations for housing. Often as not, they are removed and crushed as part of the demands of a new visual and spatial order.

40 JACK'S FOLD, 1996–1997 (SHEEPFOLDS PROJECT)

H 4′ (1.2 m), ⌀ 24′ 7″ (7.5 m)

Commissioned by Cumbria County Council, with funds from the Arts Council of England, UK

25 tons of walling stone supplied by Harold Hodgeson, Casterton. Installed in Barbondale 3 April 1997, and in St. Albans late September 1996

SA, KA

Literature: Goldsworthy et al. 1998; Goldsworthy 2007, 88–91.

Exhibition: Jack's Fold 1996

Goldsworthy first formulated the conceptual basis for Jack's Fold in July 1996 in response to an invitation from the University of Hertfordshire (where he was a guest senior lecturer) to host a Sheepfolds exhibition in its Margaret Harvey Gallery. Goldsworthy's proposal was to "take materials from Cumbria to Hertfordshire where a sheepfold would be made as part of the Sheepfolds exhibition at St. Albans and then returned to Cumbria where it would become a permanently sited sheepfold" (PS, Jack's Fold, AGA). As he elaborated:

[T]he reason for making a hundred folds was to identify not only the spaces the folds occupy, but the spaces between them, the links between different places in a landscape and the themes that flow through them. The British landscape does not stop at the borders of one county, it is connected and there are, historically, strong commercial links between every part of Britain.

Jack's Fold, like the Drove Arch Folds that followed soon afterward, developed Goldsworthy's long-standing interest in the practices, structures, and routes associated with livestock export and import, which have historically defined a major facet of agricultural life across Cumbria. Both Jack's Fold and the Drove Arch Fold sequence have their genesis in agricultural economic cycles that have historically underpinned drove routes and market centers. They provide the first occasions whereby Goldsworthy was able to ground major permanent stoneworks in relation to those specific concerns. Indeed, the notion of traveling stone raised by these works is coincident with Goldsworthy's first visit to Montreal and his early conceptualization of the large Arch, for which tons of stone reenact a transatlantic economic transit.

The stone for Jack's Fold came from a derelict wall belonging to Casterton farmer Harold Hodgeson. The stone was transported to St. Albans, where it was used to build the fold. Half of the fold was installed inside the glass-fronted gallery, the other half outside, so that the structure appeared to bisect the floor-to-ceiling window. The fold is named in memory of Jack Chettle: his son Steve Chettle was an originator of the Sheepfolds Project with Goldsworthy and its commissions manager until 2000. Jack Chettle himself was born in St. Albans, but had spent much time in the Lake District, his own personal journeys providing a counterpoint to the fold's.

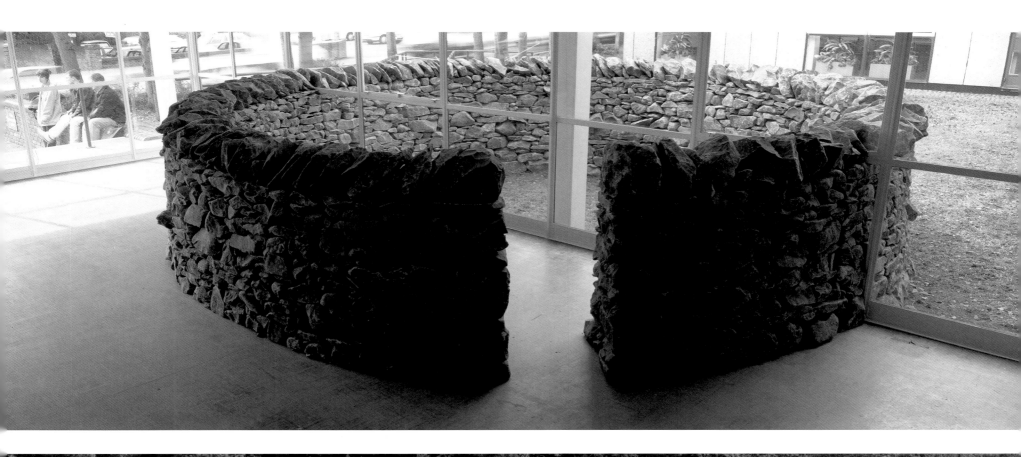

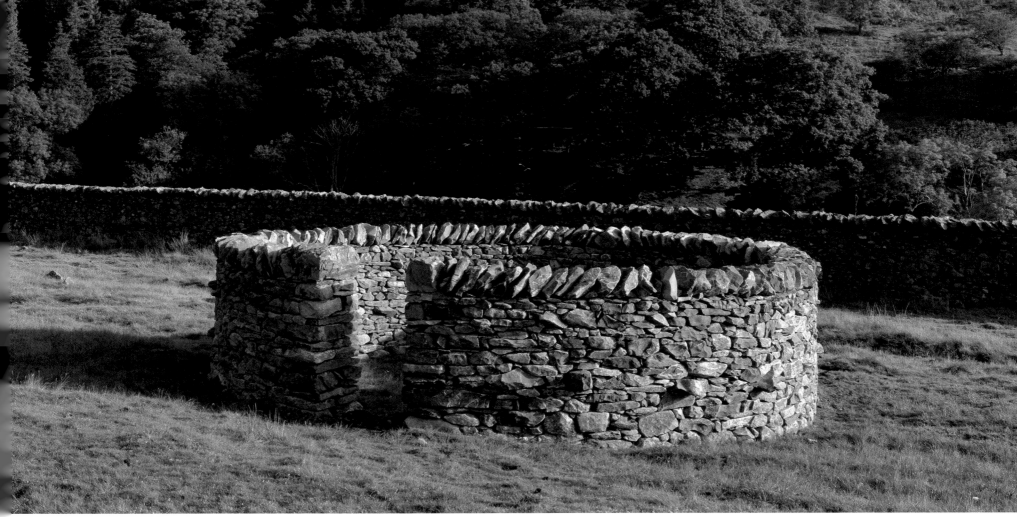

top, St. Albans; bottom, Barbondale

41 CLAY WALL, 1996

H 14' (4.3 m), W 17' (5.2 m), D 2' 5"(.7 m)

Haines Gallery, San Francisco, California, US

Clay. Installed November 1996

Peter Klove

Literature: Friedman, in Goldsworthy 2000b, 199

Exhibition: Wood 1996

108

Clay Wall was built for a temporary exhibition in 1996. It was at the time a particularly experimental work for Goldsworthy. He had previously installed two clay floors: the first, a porcelain clay floor entitled *Hard Earth*, shown at Turske Hue Williams Gallery in London in 1991, and the second, a red Drumlanrig clay floor at the Gallery of Modern Art in Glasgow in March 1996. However, *Clay Wall* is the first attempt that Goldsworthy made at the installation of a vertical surface of fresh clay that would adhere to, but crack, on the wall. Fourteen years later, the original wall still stands, and has survived at least two seismic events.

 The raw clay that Goldsworthy has used to coat walls and floors, and latterly rooms, provides a particularly reactive membrane, which responds often "violently" to its immediate climactic conditions, in such a way that the surfaces can appear agitated. The fissures that the drying and cracking cause are of course indexical of those processes. However, the impact of the fissures also seems in excess of their material cause, and they can elicit from the viewer a visceral reaction.

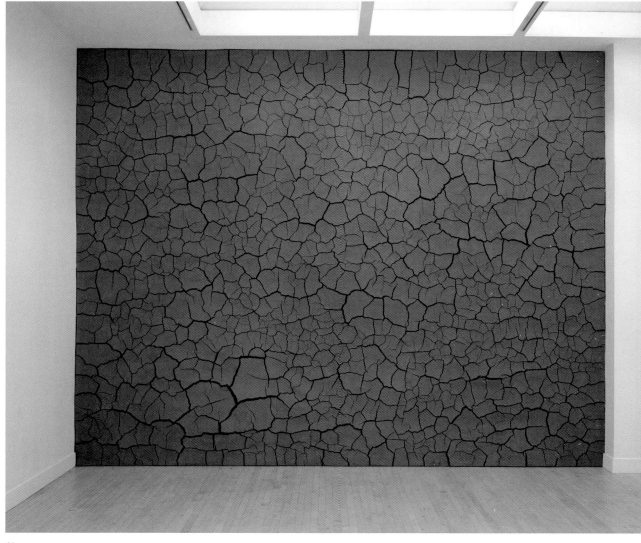

41

42 OUTHGILL PINFOLD CAIRN, 1996
(SHEEPFOLDS PROJECT)

Fold: H 4' (1.2 m), ⌀ 22' 6" (6.9 m)
Cone: H 6' (1.8 m), ⌀ 4' 3" (1.3 m)

Commissioned by Cumbria County Council, with funds from the Arts Council of England, UK

Buff sandstone and walling stone. Installed late November 1996

NM, SA

Literature: Goldsworthy 2007, 84–85

Goldsworthy and Chettle began negotiations for *Outhgill Pinfold Cairn* with the incumbent authority,

Mallerstang Parish Meeting, in 1995, and minutes from a meeting on 23 November 1995, indicate the following:

> **Lengthy discussion took place with regard to the Pinfold. Its historical background, together with its apparent reduction in size were outlined. The meeting agreed that the Pinfold should be rebuilt and voted unanimously in favour of the principle behind the "Sheepfold Project." It further agreed that the size and shape should be negotiated between Mr S. Chettle and the adjoining owners and that the outcome should be reported to the March 1996 Parish Meeting. (village records)**

Goldsworthy built the cone in late November 1996, and the Mallerstang Parish Meeting noted its completion on 5 December. The minutes of the same meeting reveal two other issues, which mediated the creation of the *Pinfold Cairn* at Outhgill. Firstly, negotiations were "still continuing regarding the re-building of the Pinfold," with particular reference to its shape. Part of the pinfold land had been absorbed into the deeds of the adjacent property, and its existing proportions

were, as a consequence, relatively rectangular. Historic maps reveal that the fold had originally been circular. A proposal drawing of 1996 shows Goldsworthy's intention of rebuilding the fold as circular. However, it did not prove possible to reconstitute the original fold shape, and the fold, which was largely structurally intact, retained its rectangular proportions. Aside from one wall, which was rebuilt in 1998, there have been no modifications to the fold, as found by Goldsworthy and Chettle.

 Secondly, the pinfold at Outhgill stands on common land that was not listed in the *Register of Common Lands* (1965). Indeed, the Land Registry designated it as having "no known owner," a status quo frequently found to be the case with small village greens. As noted by parish meeting minutes in December 1997, the Cumbria County Council had to indemnify the Mallerstang Parish Meeting by means of a "defective title" insurance policy against the possibility of a true owner of the fold or land coming to light and disputing the presence of the *Cairn*.

43 CLAY HOLES, 1997

H aboveground 1–2' (.3–.6 m), D below ground
3' (.9 m), ø at base 7'4" (2.2 m), ø of hole 5' (1.5 m)

Getty Research Institute, Los Angeles, California, US

Clay. Installed May 1997. Deinstalled in 1999

Peter Klove

Literature: Goldsworthy 2000b, 198–199

Goldsworthy first visited the new Getty Research Institute—part of the campus of buildings designed for the J. Paul Getty Trust in Brentwood, Los Angeles, by architect Richard Meier—in June 1995. In a letter to Cheryl Haines of 3 July 1995 (AGA), Goldsworthy noted:

The site was described to me by Tom Rees whilst I was doing the installation at San Jose. At the time I was making a clay work in the wall of the museum. The image of this work kept coming to mind during Tom's description.... The version at the Greenpeace HQ in London was initially proposed to be set into the ground, so that it was a visual and physical link with the earth below the building. Unfortunately we were unable to do that because of the water table.... The site at the Getty Center will allow the work to bond with the earth that

lies below, form where it comes. I can think of nothing more appropriate than a vortex for the center of a circular building; a focus for its energy.

Goldsworthy visited again in October 1995; he located sources of clay around the building site and made several small clay maquettes, although the final form remained somewhat indeterminate. The terms of the commission were finalized in January 1997. Having initially considered holes built in a graduated fashion in the side of a pyramidal clay pile so that they would face the viewer, Goldsworthy decided upon a series of holes constructed in a flat-topped clay form, somewhat consistent with the Greenpeace holes (cat. 16), and illuminated by the light provided through the oculus. He noted: "I hope that the sculpture will act as a continuation of the general feel and form of the building as it focuses onto this central point." (S, April 1997, AGA)

The processed clay was rolled into coils that Goldsworthy then added piece by piece starting at the bottom. The better, malleable clay was used around the edges of the holes, and the rougher clay and soil were mixed with small stones and compressed into the pile. As anticipated by Goldsworthy, the form began to crack—the fissures becoming "visual paths leading down to the centre of the hole" (S, April 1997, AGA).

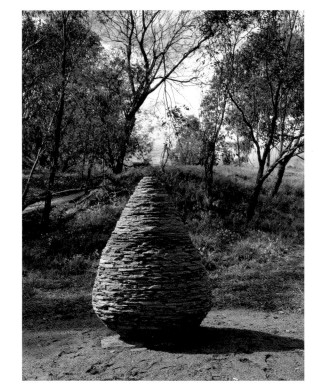

44

44 HERRING ISLAND CAIRN, 1997

H 6'3" (1.9 m), ø at widest point 4'7" (1.4 m)

Herring Island Environmental Sculpture Park, Melbourne, Parks Victoria, Australia

Castlemaine slate. Installed 25 August–
11 September 1997

Literature: Friedman, in Goldsworthy 2000b, 192

This cairn is one of two site-specific works that Goldsworthy built for Herring Island, an environmental sculpture park, 2.8 hectares in size, which is situated on the Yarra River, near Melbourne. Goldsworthy was invited to build a work for the park in 1997, but actually completed two: "one predicted, anticipated, the other not."[1] The "predicted, anticipated" (S 1997, AGA) of those two works was *Herring Island Cairn*. Goldsworthy had not visited Herring Island prior to arriving in August of that year, and decided to build a cairn as a means to respond directly and immediately to the context:

[T]he cone is very much a rooting piece. Making it is a crash course in getting to know the place.... Although the idea is the form which is in my mind as I arrive, in the making, it does become part of the place because it is never quite the same as the idea I brought there. (S 1997, AGA)

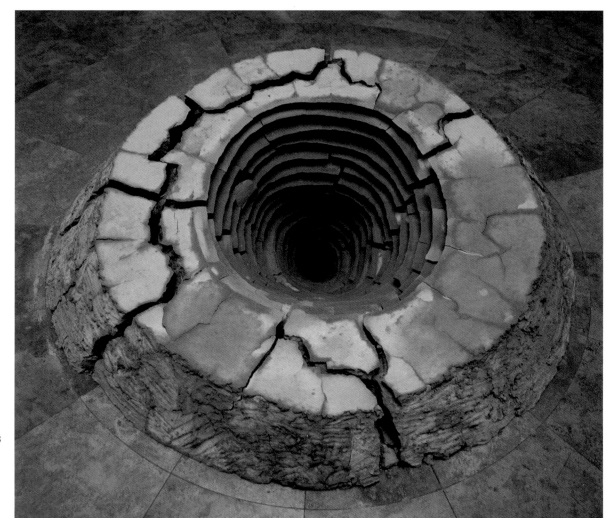

43

45 STONE HOUSE, 1997

Wall: H 6′ 5″ (2 m), **W** 9′ 7″ (2.9 m), **D** 4′ 6″ (1.4 m)
Cavity: ⌀ 3′ (.9 m)
Stone: H 1′ (.3 m), ⌀ 2′ 7″ (.8 m)

Herring Island Environmental Sculpture Park,
Melbourne, Parks Victoria, Australia

Dunkeld sandstone. Installed 25 August –
11 September 1997

Literature: Friedman, in Goldsworthy 2000b, 192

Stone House is the second, not "anticipated," work that
Goldsworthy built at Herring Island. It comprises a
short, sandstone wall built with stone laid vertically
into a banking, into which Goldsworthy placed a large
rounded red sandstone boulder. The boulder is visible
through a round aperture in the front of the wall.
Goldsworthy himself (S 1997, AGA) noted a "roughness
and rawness" in the work, qualities that he attributed
to the particularly intuitive nature of its construction.
It has its genesis in concepts that Goldsworthy was
developing throughout the spring of 1997 for a series
of permanent works for the Réserve Géologique
de Haute-Provence in Digne-les-Bains, France. Golds-
worthy's sketchbooks at that time show working
drawings for a series of shallow openings or entrances
that would be cut into the mountain face, by the
roadside, and into which single stones or small cairns
would be placed. At the quarry he visited to source
new stone for *Herring Island Cairn* (cat. 44), Golds-
worthy noticed a red, roundish boulder, sitting among
rubble, and decided to use it in a second work for Her-
ring Island. It prompted the only realization of those
initial ideas for Digne-les-Bains, wherein Goldsworthy
enclosed a stone within a small chamber.

Though fairly modest, *Stone House* has proved
to be an important work. It marked the inception of
two sequences of projects in particular that have been
among Goldsworthy's most original. The first of those
is the group of freestanding, upright walls, made in
stone, into the front of which are built openings or
chambers. The second sequence relates to the enclos-
ing (rather than the embedding) of boulders and larger
stones (and eventually trees) within house structures.

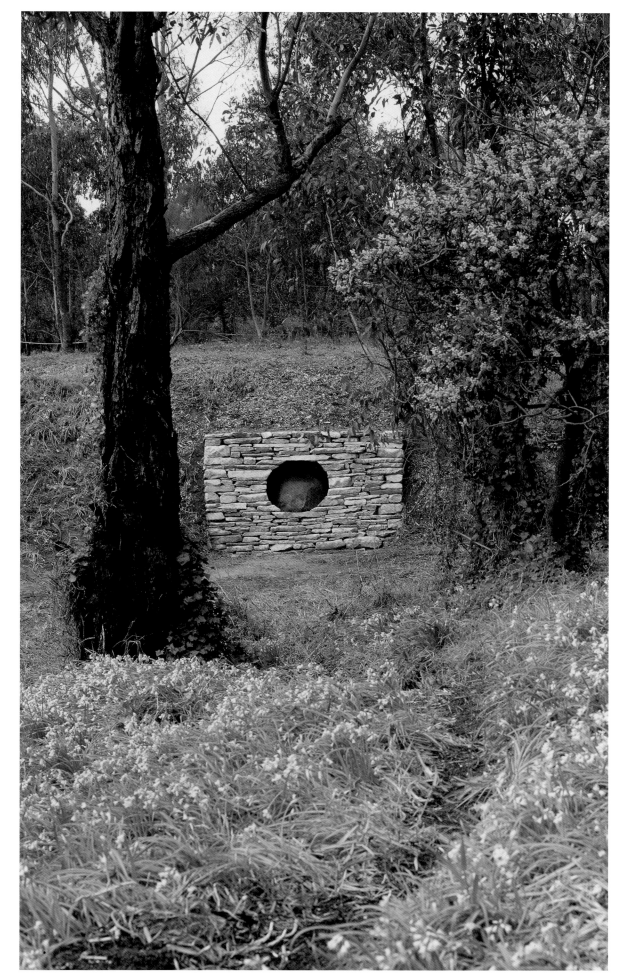

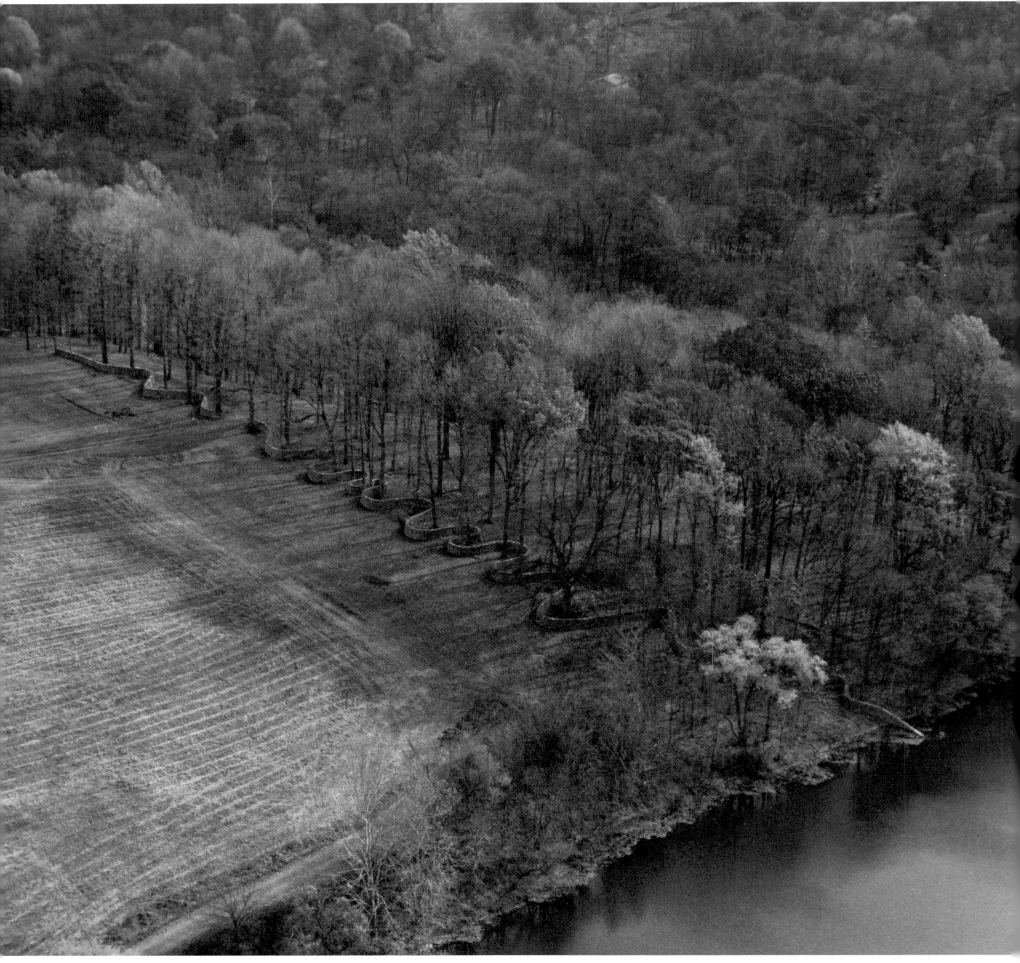

46

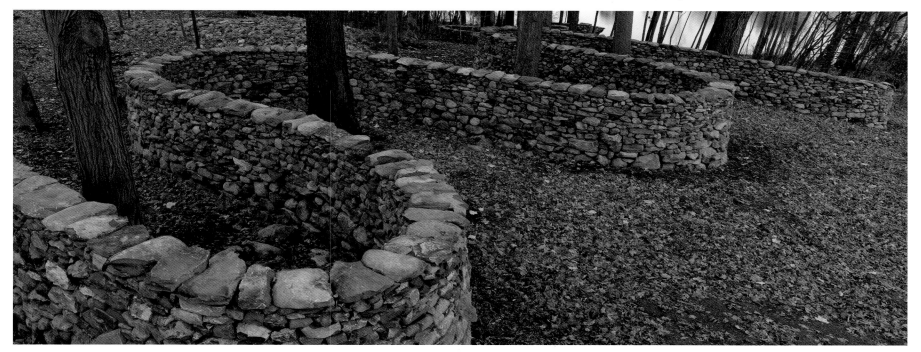

46

46 STORM KING WALL, 1997–1999

L 2,278′ (694.3 m), H 5′ (1.5 m)

Storm King Art Center, Mountainville, New York, US

Eastern section built September 1997. Western section built September–October 1998. Final completion September 1999. Inaugurated 20 May 2000

SA, GW, JW, MH, MN

Literature: Goldsworthy 2000a, 8–19, 20–22, 28–31, 34–35, 42–51, 56–64, 70–91; Goldsworthy 2000b, 199, 200, 201; Yorkshire Sculpture Park 2007, 34–36, 42

Goldsworthy first visited in June 1995, and noted in a letter of 3 July 1995 (AGA): "I particularly liked the rectangular wood that has a derelict wall around its perimeter" (C, 3 July 1995). His first proposal, to be located in that area, was a "walled enclosure within the wood, echoing the perimeter wall." The wall, he suggested, could be as high as 6 feet, "so that you could not see inside until you enter. On entering you would find it full of large boulders." David Collens, then curator, wrote to Goldsworthy again in August 1995, indicating that a new area would possibly soon be available and inviting Goldsworthy to visit in the autumn to see it. Indeed, following that second visit—during which he found the remnants of a former field boundary wall—Goldsworthy proposed building a new wall, estimating its possible length at 300 yards:

I am always looking for lines that are already there, rather than imposing new ones. I like the resonance to the history of a place by making an old line new again, changing the line in the process, in response to the changes that have made the place as it is now. (PS 1996, AGA)

Although initially more modestly conceived, *Storm King Wall* is of seemingly epic proportion and was built over three successive autumns. Its path negotiates various topographical features, including the line of trees that speak of its original construction, as well as a lake. It is, as Goldsworthy suggested, a line drawn out of the place itself, such as its history of use has determined it.

Storm King Wall clearly elaborates Goldsworthy's engagement with the material legacies of colonial deforestation, as practiced by European settlers to establish a specific agricultural economy. These interests are evidenced in his earlier *Wood through Wall* (cat. 28), and equally ground *Storm King Wall*. Of the latter, Goldsworthy wrote: "The original wall was made when the forest was cleared, from stones ploughed out of the field which it marked off and enclosed" (2000a, 28). Yet, *Storm King Wall* provided a context for Goldsworthy to shift the focus of his attention from the making of the cut as a historically resonant and spatially dynamic gesture to the drawing of the line. *Storm King Wall* does indeed instantiate a boundary between field and forest, and is evocative of the distinctions that the original wall itself produced. Yet as Goldsworthy indicated, despite its initial purpose as a rigid if contested instrument of field and property division, the wall "provided the

shelter which allowed tree seeds to germinate and eventually grow alongside or even within the wall itself. In the end, the wall collapsed, leaving a straight line of trees as evidence of where it had been" (2000a, 28). Indeed, Goldsworthy's wall constitutes a line that is underpinned by a compelling sense of yield, as testified by its numerous curves and folds.

This yield has its own complex historical grounding, by dint of necessity, within the colonial binary of "forest-field." As William Cronon pointed out, because of soil exhaustion exacerbated by deforestation, grazing, and ploughing,

lands cleared for crops frequently had to be turned back to pasture or woods less than a decade after their first planting.... In this colonial farmers were no different from their Indian predecessors: Indians too had moved their fields from place to place. But colonialists tried to incorporate Indian practices in a much different system of agriculture and property boundaries.[12]

If clearance precedes division historically, and the cut always precedes the line, *Storm King Wall* destabilizes that order. It does so quite differently from its Cumbria counterpart "the wall that went for a walk" (cat. 14), the material integrity of which remains tied to the continued fluctuations in its surrounding topography. The visibility of "the wall that went for a walk" as a line remains locked in a dynamic relationship with the cut, the area around it now clear-felled. The wall at Storm King, however, manages structurally to transmute the gesture of the cut into that of the fold.

47 ELEVEN ARCHES, 1997

Each arch: H 2′ (.6 m), S 3–4′ (.9–1.2 m)

Private Collection, Poundridge, New York, US

Stones from the creek. Installed September 1997

PM, NM

Literature: Goldsworthy 2000a, 88–89; Goldsworthy 2000b, 191

Goldsworthy built this group of eleven low-lying arches, each spanning the distance between two stones along a creek bed in autumn 1997, while working on the first phase of construction of the *Storm King Wall*. He suggested that *Eleven Arches* is more like an ephemeral work—a piece that "will change over time" (c, from Mary Sabbatino, 11 March 1997, AGA)—for it was made with a certain amount of flexibility. The stones for the arches, found on site, were lightly and roughly chiseled, and built over piles of logs that were then removed.

48 GLENLUCE STONES, 1998

Slate wall: H 7′ 6″ (2.3 m), W 3′ 6″ (1.1 m)
Stone column: H 6′ (1.8 m), W at widest point 1′ 8″ (.5 m)

Private Collection, Dumfriesshire, UK

Roofing slate sourced from property. Weather-rounded granite and whinstone boulders from Luce Bay. Installed February–March 1998

Literature: Friedman, in Goldsworthy 2000b, 200

Glenluce Stones is installed in the former entrance to a disused thrashing mill, part of a range of farm buildings on a coastal estate in Scotland. On visiting the site, Goldsworthy was intrigued by the large, blocked doorway, which stands almost 8 feet tall, and he was keen to site a work there that would allude to the history of the building and also make reference to the coastal context. He dovetailed those various elements in a proposal for a graduated column of stones, sourced from the surrounding coast, which would be embedded into a wall of dry-stacked slate built in the doorway. The balanced stone column operates across a range of contexts in Goldsworthy's work as an abstract representation of growth, multiplicity, and energy. It is also a structure that Goldsworthy strongly associates with the coast, and prior to this work, he had built numerous temporary balanced columns using rounded boulders on shorelines in Skye, northwest Scotland, and Japan.

Glenluce Stones is the first incorporation of the stone column into a permanent work, and it can be considered a primer for later works incorporating balanced columns, such as the 2004–2005 *Stone Houses* (cat. 104). In this smaller work, however, balance is not real, but implied. The boulders sit directly upon each other and protrude in high relief, but are held in place by the slate. Goldsworthy did not use mortar in the piece.

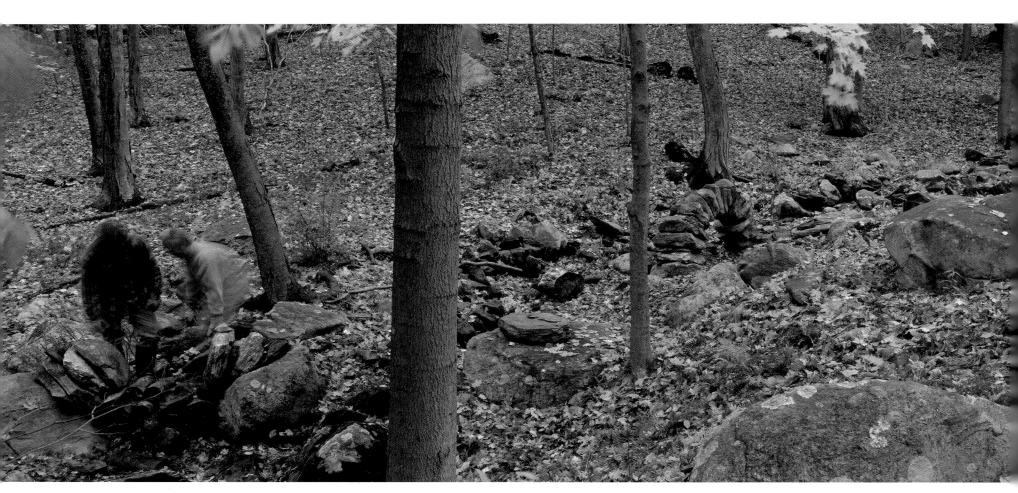

47

49 SLATE CAIRN AND CHAMBER, 1998

Cairn: **H** 5′ 11″ (1.8 m), **W** 4′ 1″ (1.2 m)
Chamber: **H** 10′ (3 m), **W** 10′ 11″ (3.3 m), **D** 5′ 10″ (1.8 m)

British Airways Art Collection. Curated by Artwise Curators, UK

Slate from Little Langdale, Cumbria. Cairn built March and chamber April 1998

SA

Literature: Goldsworthy 2000b, 192

In April 1997, Goldsworthy made his first site visit to the new British Airways headquarters, designed by Niels Torp and still under construction. Initially Goldsworthy contemplated the possibility of installing a large stalk screen in front of a full-length four-story glass wall, slanted 24.6 degrees, but ultimately he demurred, suggesting that "the structure to the windows…would kill off the delicacy of the stalk [screen]" (c, to Susie Allen, 7 May 1997, AGA). Following another visit in August of that year, Goldsworthy appears to have proposed an alternative that would involve taking "a line for a walk through the structural members of the roof. This line would have been constructed from lengths of wood, one joined to another" (c, to Bob Ayling, 16 December 1997, AGA).

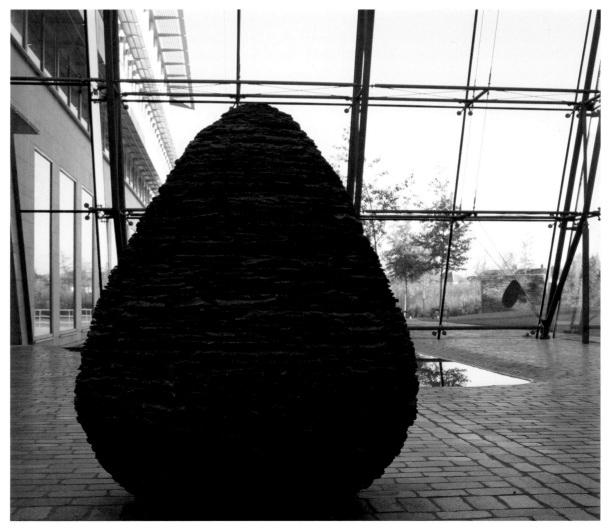

The proposal for a "Cairn and its home" appears to have emerged in December 1997 (AGA), with Goldsworthy outlining a two-part work that comprised a cairn and a counterpart wall with a cairn-shaped chamber or opening built into it. Goldsworthy subsequently suggested that the resulting work, *Slate Cairn and Chamber*, developed from *Stone House* (cat. 45), which he built on Herring Island in Australia just prior to the construction of this work. However, where the Herring Island wall appears to ingest a foreign stone, in this work the putative stomach of the wall—the cairn—is separated from its "home." That separation evokes principles of absence and presence, of home and travel, and the physical residues and emotional bonds that operate between those factors. He even briefly proposed that he build five cairns and five chambers over five years, with the possibility that the cairns be built in other countries and the chamber elements be built as a long wall "with the join between one year and the next being visible" (c, to Susie Allen, 18 December 1997, AGA).

Finally, Goldsworthy constructed one cairn and wall/chamber pairing. He was particularly concerned that the pairing should have "its own self-contained internal space, yet [make] a link between the inside and outside that transcends the visual interferences that may be placed between the two," and consequently relocated the wall/chamber during the construction process to a site nearer to its cairn counterpart.

50 ENCLOSURE, 1998

4 walls, each: H c. 9' 10" (3 m), W 1' 8"–2' (.5–.6 m), L internal 15' 1" (4.6 m), external 17' 5" (5.3 m), ⌀ of circle 5' 7"–5' 11" (1.7–1.8 m)

National Museum of Scotland, Edinburgh, UK

Recycled Edinburgh roofing slate. Built April–May 1998

Neil Rippingdale and team

Literature: Goldsworthy 2000b, 10; Friedman, in Goldsworthy 2000b, 200

Goldsworthy was invited in 1996 to propose new works for the National Museum of Scotland, Edinburgh, which would respond to its collections and its new building. In an initial proposal statement (June 1997, AGA) Goldsworthy suggested:

What I try to do is find a connection between the outside and the inside. A building is after all only earth reworked. A building has its own nature, the nature of the way the building is used and in a museum, the nature of the objects it contains. Over the past three years I have been presented with opportunities to work with buildings that are in the process of construction. I have become fascinated [with] the spaces behind or within a wall or floor. The idea of embedding works into the fabric has become [something] I wish to pursue.

As he later described, "I had hoped to place work in the floor so that people could walk on top and over them" (c, to Gordon Benson, 17 December 1997, AGA), installing as many as twenty-three "objects" in that manner. However, that proposal hit insurmountable technical difficulties by December 1997, and Goldsworthy considered other possibilities, finally conceiving, in January 1998, a group of works for the museum's Early People gallery.

Enclosure, the first of those works to be installed, comprises four large curving slate walls that enclose vitrines containing objects related to hunting, gathering, and growing food. As Goldsworthy said of the work and the interrelation it created with the objects: "the walls are simple and large, so that you don't look through a case with objects to another object, but to a landscape. A surface that can be seen within and outside of the case" (s, 18 August 1998, AGA). He also spoke of "qualities of light, time and the feeling of protection" that he wanted to invest in the space, as well as a sense of "seasonal connection." Into each of the slate walls, Goldsworthy incorporated a large circle, similar to his early *Slate Stack* (cat. 6). However, the circle in each wall "is turning" insofar as Goldsworthy varied the directional placement of the slates. As Denis Cosgrove noted:

[C]ertain, unalienated conditions of our lives on earth form consistent motifs for cultural production....The

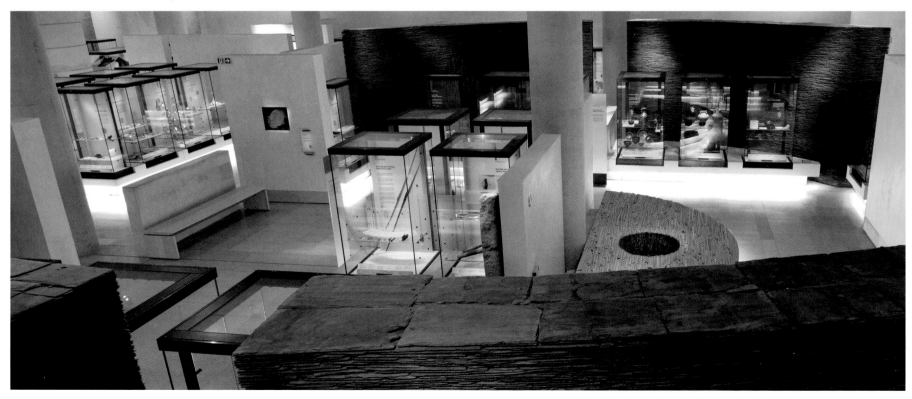

116

seasonal changes of nature…form an obvious structural reference in a culture dominated by the success or failure of food production.[13]

Indeed, such "structural reference" seems to take on particular relevance with *Enclosure*.

Unlike most of Goldsworthy's stacked slate walls, which are freestanding and self-supporting, these walls are built around an inner wall structure and fixed with mortar. The sense of enclosure is enhanced by Goldsworthy's decision to include a work on a plinth that would be situated at the entrance of the space. The small work entitled *Hearth*—comprising pieces of light-colored wood laid on a flat area and featuring a burnt circle in the center—alludes again to the process of settlement and to the fire or hearth as the focal point for its onset. Nearby, Goldsworthy later installed a small, stacked bone work, composed of a whale skeleton. Another work, *Ballachulish*, incorporates a carved wooden female figure in the museum's collection that is 1.4 meters high and dated 725 to 500 BC. It was found buried in a peat bog covered with the remains of a wickerwork structure. Goldsworthy built a wooden structure, referencing the wickerwork, around the back of the figure. The central placing of the upright figure, protected by a chamber, anticipates works such as *Clougha Pike Chambers*, *Chapelle Ste Madeleine*, and *Refuge d'Art, La Forest* (cats. 64, 76, 123).

51 CLAY WALLS, 1998

Wall 1: H 7′ 9″ (2.4 m), W 21′ 5″ (6.5 m)
Wall 2: H 7′ 10″ (2.4 m), W 28′ 11″ (8.8 m)
Wall 3: H 14′ 6″ (4.4 m), W 24′ 3″ (7.4 m)
Wall 4: H 14′ 6″ (4.4 m), W 14′ 3″ (4.3 m)

National Museum of Scotland, Edinburgh, UK

Drumlanrig clay. Installed May 1998

PM, AMcK

Literature: Goldsworthy 2000b, 10; Friedman, in Goldsworthy 2000b, 200

With the second commission that he realized for the Early People gallery of the National Museum of Scotland, Goldsworthy expanded upon several of the concerns manifested in his clay works in London and Los Angeles. On this occasion, the process of revelation was less an act of exposing a raw material to be used than a reference to the process of archaeological excavation that underwrote a sizable proportion of the museum's artifactual collection:

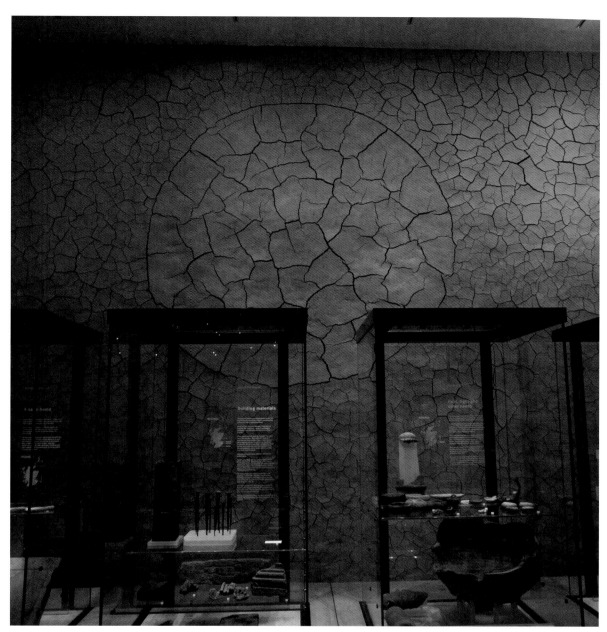

51

The archaeological context given by the NMS collections made me think of differences in surface that are caused by things buried below.…Many of the objects in the museum have been buried in the ground, before rediscovery often giving indications of their presence by sending signs to the surface. Where something is buried, plants will grow differently. There may be a different colour of earth. In drought, when the ground is laid bare, variation in form, colour and texture tells us what lies below. (s, 18 August 1998, AGA, here and following)

Goldsworthy installed a sequence of four clay walls in the Early People gallery, which, as planes of earth, very literally "extend the building into the earth." Using unrefined red Drumlanrig clay, he embedded within the clay walls "forms" (for example, a circle)

and pigments (ironstone) that accreted to or influenced the clay surface as the walls dried. To achieve this effect, partitions were constructed in front of the walls, with shaped recesses built into them. Thus, Goldsworthy could vary the depth levels of clay he applied, which in turn influenced what occurred on the surface during the drying and cracking process. With one, Goldsworthy incorporated a rather irregularly shaped circle: "the circular wall is evocative of settlement, the houses of which were predominantly circular. So often I have come across no building, but the indication of foundations." With another of the clay surfaces, he applied a "stain of deeper red…extracted from the clay itself, from red ironstones that are found in [it]." As he continued, "Many resources were discovered by reading signs such as stains that indicated the materials that lay below."

52

52 MONTREAL ARCH, 1998

H 15′ 2″ (4.6 m), S 29′ 5″ (9 m), D 4′ 2″ – 7′ 2″ (1.3 – 2.2 m)

Cirque du Soleil Collection, International Headquarters, Montreal, Canada

99.6 tons of Locharbriggs red sandstone. Installed 25 – 28 May 1997

ES, BN, GG, GR

Literature: Goldsworthy 2000b, 60 – 69, 198; Friedman, in Goldsworthy 2000b, 200

Conceptually and physically, *Montreal Arch* represents a considerable amplification in Goldsworthy's exploration of the arch form and in his interest in the social history surrounding the quarrying and transaction of stone. It is the first large-scale, freestanding arch that Goldsworthy made, bringing into massive fruition a form with a long prior history in his work and presenting something of a summa of its trajectory in his oeuvre thus far. Goldsworthy noted:

My arches are raw, roughly hewn, fresh from the quarry, not yet dressed or tamed. They connect architecture with its origins. . . . Movement in stone has become increasingly important to me. . . . I draw parallels between the movement and flow of nature and the movement and flow of people. Stone and people making a journey together is for me a powerful statement of change, but also to our connection to the land, the great upheavals that have occurred to both. (PS, Montreal Proposal, 1996, AGA)

Goldsworthy was initially invited by Cirque du Soleil to visit the site of its new headquarters and studio in Montreal in September 1995. He was able to visit in autumn 1996. He described his reaction to Montreal as "totally fascinated," and he put two proposals forward that drew upon preexisting ideas (C, to Claude Brault, 25 September 1996, AGA). The first of those was "Red Hill," derived from an idea he had initially developed for Flevoland, The Netherlands, in 1990, but which, in this case, would be built in a former quarry-turned-refuse dump. The second, for a "large, possibly 10 feet tall stone arch of the same stone that came across in the ships as ballast and [was] eventually used in some of the buildings of Montreal," drew upon the history of the physical origins of parts of the city. During an early visit to Montreal, Goldsworthy noted seeing red sandstone buildings such as Benjamin Tooke House, for which the stone was sourced from quarries in Scotland and northern England.

Both proposals were considered simultaneously for a short while, although the Red Hill proposal was suspended fairly soon. The arch, Cirque du Soleil project manager Claude Brault wrote (C, 13 November 1996, AGA), would be a "good indicator of Cirque's ubiquity." Goldsworthy did not specify potential sites for the arch during that first visit, and he briefly considered having it pierce the new Cirque du Soleil building, standing half in and half out. This idea was, however, put to one side and Goldsworthy began to elaborate the arch proposal further as a freestanding work.

Planning for the construction of *Montreal Arch* commenced in January 1997. Working with LG Mouchel & Partners, an engineering firm in Dumfriesshire, Goldsworthy began to develop a blueprint for the arch. Certain factors were open and would be determined by engineering constraints. As Goldsworthy noted (C, to Claude Brault, 10 January 1997, AGA) in the early stages, for instance, "there are obvious limitations to how large an arch can be made, but I am now looking [at] the possibility of a 15 – 20 [foot] span." However, it was clear that the site of construction would be Locharbriggs Quarry, and for Goldsworthy this took on a particular relevance: "[I]t looks as if I will make the arch in the quarry in Scotland before dismantling it and shipping it to Montreal. This also I think is an important element to the piece that the arch has stood here as it will stand in Montreal" (C, 10 January). As initial questions regarding production arose, Goldsworthy was clearly advancing his sense of how the arch should look and feel, noting:

[The engineer] would be happier if the stone is cut into pre-determined shapes. . . . Myself and the quarry master would prefer to construct the arch using the naturally flat tapered bed stone as it comes out of the quarry. I want the arch to stand slightly upright, not just [as] . . . a semi-circle which to me looks too low and lacks the energy that I want. (C, to Claude Brault, 5 February 1997, AGA)

The planning and construction of the arch proved to be fraught in the early stages, Goldsworthy also not-

ing on 5 February, "I don't know if engineering theories are capable of explaining the stability of what I intend to do." By the end of the month, however, the engineers had developed an "arch geometry which we believe will be structurally stable" (C, K.G. Asher to Eric Sawden, 17 February 1997, AGA). The initial blueprint was signed off on that March: it would include thirty-eight stones, and its internal height would measure 15 feet to the keystone. Goldsworthy began choosing stones in May and anticipated initiating production in June. It was, however, suspended until November of that year, after the first phase of the construction of the *Storm King Wall* (cat. 46).

Production of the arch began in Locharbriggs Quarry on 28 November 1997 but was interrupted several more times. The arch's scale was reduced again in February 1998, and it was finally completed on 31 March. The arch as installed was then subjected to a pressure test on April 23, during which process Goldsworthy observed, "It felt close to my ephemeral work which is so often take[n] to the edge of collapse. My larger permanent works are taking on qualities and tensions that were previously present only in the ephemeral works" (2000b, 67). In contrast to the slow progression of its production, the work was shipped to and installed in Montreal with relative speed.

53 WATER CAIRNS, 1998

5 cairns, each: **H** 7′ 3″ (2.2 m)

Commissioned by Ville de Digne-les-Bains with funds from European Program Leader 2, Conseil Général des Alpes de Haute-Provence, and Conseil Régional PACA

Pale limestone from carrière de Revest-St-Martin and water. Installed in Musée Promenade de St-Benoît July 1998

SA, GW, JW

Literature: Goldsworthy et al. 1998, 18–19; Goldsworthy 2002, 8–9, 122–124; Goldsworthy et al. 2008, 154

Water Cairns was the first permanent commission that Goldsworthy undertook for the Réserve Géologique de Haute-Provence in Digne-les-Bains. When the cairns were built in 1998, Goldsworthy's relationship with the Réserve Géologique and the Musée Gassendi was already three years old. Guy Martini and Nadine Gomez first invited Goldsworthy to exhibit work in Digne-les-Bains in May 1995 and arranged a residency for him in July of that year.

Correspondence (AGA) shows that Martini and Gomez first raised the idea of a "permanent installation in the geological center" either during or immediately following that residency in July 1995. Goldsworthy responded that September with a proposal (C, to Gomez and Martini, 19 September 1995, AGA) for a project entitled "La Maison de Pierres," which comprised a number of small cairns that would be installed in circular cavities in the walls of the park's *restanques* or drystone retaining walls, and would "stretch between the town of Digne and the Centre." Ensuing discussions between Goldsworthy, Martini, and Gomez clearly proliferated a number of possible ideas for permanent works by Goldsworthy within the reserve's territories. During a visit that Martini and Gomez made to Penpont in February 1997, they discussed at least five separate projects. Martini subsequently listed them as "the cairns along the trail, the 'mark' to indicate that there is something to read, the 'thing' to indicate a reserve stop, the entrance doors, and the water cairns on the trail going to the geological center" (C, 20 March 1997, AGA).

This was the first mention of a series of water cairns for the Musée Promenade de St-Benoît, along the walk that connects the reserve's headquarters to the museum in the Digne town center. The idea for water cairns was not new for Goldsworthy. He first elaborated the concept in an interview in 1996 in relation to the *Sheepfolds Project*:

I have an idea for four or five piles of stones within sheepfolds, and inside each pile will be a sound chamber into which water from a nearby stream will be directed.... There will be the sound of water in a place where you can't see water—and if I make that five times, I'll have five different sounds. (1998, 18–19)

Certainly, the connection between water and cairn has long been potent for Goldsworthy, and he has made numerous cairns, such as *Floodstones Cairn* (cat. 22), in proximity to rivers. However, that relationship was particularly pertinent in Digne, not least because of *Cairn de Digne*, the ephemeral cairn that Goldsworthy built near the river Bès on 14 July 1995, and to which he added a successive layer daily for nine days. Goldsworthy continued to experiment with this idea of layering or secreting things within cairns, and during their visit in February 1997, Goldsworthy showed Martini and Gomez a recent ephemeral work in which he had hidden a small arch, made late in 1996, by building a cairn around it.

The number of cairns initially was left open and might have included as many as ten (C, from Guy Martini, 8 May 1997, AGA). In July 1998, Goldsworthy built five. He diverted water from neighboring streams toward the sound chambers of four of the cairns. With them, the water is heard and not seen. With the fifth cairn, the water again appears aboveground.

53

54 HUTTON'S ROOF, 1998

4 stones, each: **H** 2′7″–2′8″ (c. .8 m), **W** 3′11″–4′3″ (1.2–1.3 m), **ø** of hole 1′6″ (.5 m)

National Museum of Scotland, Edinburgh, UK

Locharbriggs red sandstone. Extracted, cleaved, and carved 31 August–18 September. Installed November 1998

Literature: Goldsworthy 2000b, 10; Friedman, in Goldsworthy 2000b, 200

In addition to the group of works that Goldsworthy installed in the Early People gallery, he was invited by the museum to propose an installation for its new roof terrace. As early as April 1996, Goldsworthy was discussing the idea of siting on the roof a group of large "torn stones," greywacke boulders that would be exposed to high temperatures in a kiln to the point that their surface would split and their interior appear liquid, and in which state they would then cool and harden (c, Meeting notes, 4 April 1996, AGA). Goldsworthy had begun experimenting with the firing of rocks rounded by water erosion in 1989, in dialogue with the interrelated concepts of heat, stone, movement, and fusion found in the geological theories of James Hutton. Hutton was an influential member of the Scottish Enlightenment, along with the economist Adam Smith and the philosopher David Hume,[14] and his *Theory of the Earth* was first published in the United Kingdom in 1788. Indeed, the context of the National Museum of Scotland amplified the original reference to the Edinburgh native Hutton: "He was the first to talk of all stone being in a continual state of movement and change. The partially melting stones were intended to express some of that movement" (c, to Gordon Benson, 25 June 1998, AGA).

Goldsworthy did fire numerous large boulders. In a letter to Hazel Williamson (c, 22 March 1998, AGA) he noted, "the firing came to temperature.... The stone began to crack and tear and suddenly went almost molten, one part of it collapsing." However, with the fragility of the fired boulders apparent, and in view of the possible vulnerability of the stones if exposed to the elements over time, Goldsworthy ultimately redirected the project. He proposed instead a work comprising between five and ten "carved" red sandstone blocks, sourced from Locharbriggs Quarry:

The stone at Locharbriggs was deposited by wind blowing the sand. It has been laid in layers and can be cleaved along the grain into slabs. The stones will be split this way into between five and seven slabs. In each slab a hole will be carved which when the stone is reconstructed will align in order of descending size so that the holes lead the eye into the centre of the stone. (PS, Hutton Roof Commission, 27 May 1998, AGA)

Goldsworthy offered the following conceptual continuity between the two projects: "holes now replace tears as entrances to the landscape within the stone" (c, to Gordon Benson, 25 June 1998, AGA). It is also conceivable to express that continuity in Huttonian terms. As historian Roy Porter suggested, "the marks of elevation borne by existing rocks — folding, fracturing, contortion, faults" had partly enabled Hutton to deduce that "expansive forces of heat" not only formed new rock strata, but were "responsible for their elevation."[15] The sandstone blocks emphasize that natural economy of geological regeneration, not least where Goldsworthy utilized those very "marks of elevation" as the basis for the work. Something of that elevation is registered in the successive layers of the cleaved sandstone blocks.

Goldsworthy eventually completed four carved blocks for the roof. After correspondence with the architect of the building, it was decided that the blocks would be aligned with the four cardinal points of the compass to "co-ordinate and harmonise with the building and at the same time make links to the land, time, light and season" (c, 25 June). Goldsworthy also proposed a work in counterpoint to *Hutton's Roof* — a water cairn or water boulder for the basement of the museum, similar in principle to those he had made in Digne-les-Bains. A spring was located on the site, and Goldsworthy thought it might possibly be diverted under a stone or stone structure that might amplify its sound. This work was not realized.

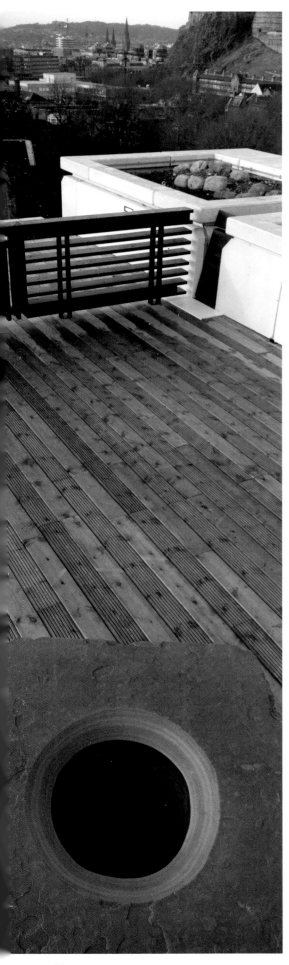

55

55 OAK BALL, 1998

H 5′ 11″ (1.8 m), ⌀ 6′ 10″ (2.1 m)

Private Collection, Brussels, Belgium

Scottish wind-fallen oak. Installed 2 December 1998

Literature: Friedman, in Goldsworthy 2000b, 200

Exhibition: Être Nature 1998

Despite early proposals for stacked wood cairns
(cat. 20), and several interior stacked wood spheres,

Oak Ball was the first stacked branch form that Golds-
worthy installed as a permanent work in an outdoor
context. In so doing, he made the form entirely subject
to the passage of time and effect as conferred upon
it by its surroundings. Indeed, *Oak Ball* and subsequent
stacked branch works (cats. 71, 81, 95, 109) are some
of Goldsworthy's most time-based. They slowly but
inexorably stage an uncompromising process of decay.
That process is made all the more compelling as the
form resists those effects, producing real tension in its
structure.

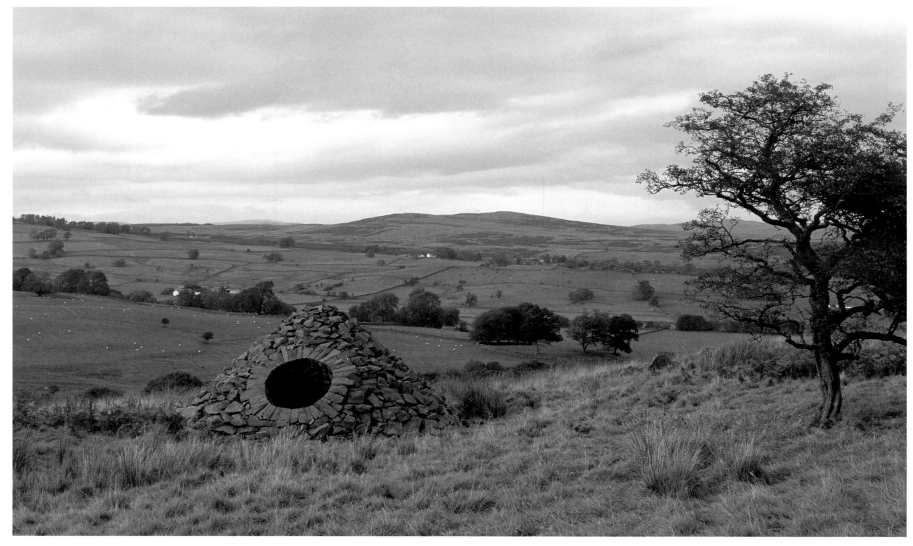

56

56 DUNESSLIN CAIRNS, 1999–2001

Each cairn: H 10' (3 m), ⌀ 20' (6.1 m)
Each cavity: ⌀ 4–6' (1.2–1.8 m)

Iain & Zara Milligan, Dumfriesshire, UK

Whinstone from Morrington and Tynron Quarries in Dumfriesshire. Installed January–March 1999, August–September 2000, and September 2001

AMcK, MN, ES, Thomas Melinsky, Simon Philps, Stuart Higgins

Literature: Goldsworthy 1996, 46–47; Goldsworthy 2000b, 23–24

Goldsworthy was first invited to visit Dunesslin in 1996 and make a proposal for a work. Shortly thereafter, he proposed a cairn about 6 to 8 feet high, which would feature a circular or barreled recess that would "contain within it a growing tree" (c, to owner,

20 August 1997, AGA). Possibly the first design for a cairn with a circular recess appears as a rough pencil sketch on the front of one of Goldsworthy's sketchbook diaries dating to December 1988 (SD 22, AGA). Goldsworthy first built it as a structure in July 1994, around a grown olive tree in Fornaluix, Majorca, Spain, and soon after he developed several project proposals for stone walls or cairns with circular recesses from which trees spring. Goldsworthy proposed a tree and cairn for a sheepfold at Kentmere in Cumbria, as part of the *Sheepfolds Project*, but it was never undertaken. The *Dunesslin Cairns* remains the only permanent incarnation of this structure to date, with the exception of a smaller version that Goldsworthy built at his home in Scotland. The tree/cairn, he has suggested, was entirely appropriate to the Dunesslin context, shaped as it is by "the geology, weather and farming" (DN, 5 March 1999, AGA).

Though he completed three cairns, Goldsworthy was initially commissioned to build only one. The mak-

ing of the first cairn, for which he undertook all the principal stonework himself, proved to be physically arduous. Goldsworthy chose to make the work with whinstone, a particularly hard stone that is difficult to cut or to work. As he noted: "The form is simple but the method of construction is one of the most complex and subtle that I have ever worked with. This has been made more difficult by the nature of the stone" (DN, 5 March). With the first cairn, Goldsworthy did not use cutting machinery, although he did with the second and third cairns. He began each cairn by constructing the hole or barrel first, and then the circular arch that supports it. Goldsworthy noted at the time that he was not sure whether to "construct the interna hole by laying stones on top of each other, or constructing arches" (DN, 8 March 1999, AGA). He decided to layer the stone, a decision that, he recalled, gave the stonework at the back of the hole "a strange wall-like quality," which in turn produced dislocating optical effects that Goldsworthy liked:

There is a visual tension between the exterior stone and the interior stone, in that the stone of the hole looks as if it is in the far distance or is hovering somewhere behind the hole. It looks disconnected. If I had made it as arches, the structure would have been evident and connected to the exterior.... It is like looking at a river of stones behind the hole, flowing in the back. (DN, 8 March)

Once the construction of the hole was completed, Goldsworthy built the pyramidal bulk of the cairn around it. He observed, with the first cairn, that this process proved more demanding and interesting than he had anticipated. Working to avoid "shoulders" appearing in the exterior stonework around the hole, Goldsworthy made the outside of the cairn rough and textured. With the completion of the first cairn, the proposal that Goldsworthy build another two was put forward—one to be constructed in 2000, and the other in 2001. Goldsworthy selected the sites for the next two cairns in July 1999, and he linked all three by designating a walk from one to the next. The first cairn was planted with a hawthorn shortly after its completion, as were the second and third cairns. Goldsworthy removed the trees in 2002 and 2003, however, as he came to feel that they were out of scale with the holes and ultimately not necessary.

57 LOGIE CAIRN, 1999–2000

H 15' (4.6 m), ∅ 28–30' (8.5–9.1 m)

Private Collection, Aberdeenshire, UK

Dressed granite, sourced from the site, and mica schist. First part installed 29 March–10 April 1999, and second part 21–24 July 2000

GW, JW

Literature: Goldsworthy 2000b, 11–12; Goldsworthy 2004, title page

In 1999, Goldsworthy made three half-built sculptures, which he finished in the course of 2000. Each of the three commissions arose quite distinctly, but contemporaneously. Goldsworthy was initially invited to make a proposal for "sculpture in stone" for a private estate in Aberdeenshire late in 1996 (C, from owner, 22 January 1997, AGA). The owners were developing parkland between their house and the nearby river, and wished to have some sort of sculpture commemorating the millennium.

The conceptual basis—for a work whose construction spans the millennium—was established during Goldsworthy's first visit to Logie in April 1997. Of the forthcoming millennium, he noted, "I like the idea of that moment being somehow embedded in a work that contains elements of both centuries." In that vein,

Goldsworthy proposed building a large cairn, completing the first half in 1999 and the second half with the onset of 2000. He elaborated: "a thin gap would be left between the two halves which would be evocative of the passage of time" (C, to owner, 29 April 1997, AGA).

Goldsworthy sited the cairn on the Hill of Logie, and intended that the gap through the cairn would only be visible from two sides. As he suggested in *Time*, "From everywhere else, the cairn will be perceived as being whole and solid" (2000b, 11). He wanted visitors approaching the cairn to be confronted with what he called a slice of light, and he therefore oriented the gap to maximize the impact of the open sky behind.

The building of the cairn in two halves, with a completely even, vertical gap, presented some technical issues, not least in ensuring two things: firstly, the angle of ascent of stone on both sides should read as continuous, and secondly, the two solid sides constituting the gap should be entirely flush. To remedy the second of those concerns, the first half of the cairn was built to a timber profile, against which the stones were placed. The profile was jointed in a manner similar to the stud partitioning in a house so that Goldsworthy and his assistants could visually check that all stones were well bedded and not sitting on any high points. The second half was constructed without the use of the profile.

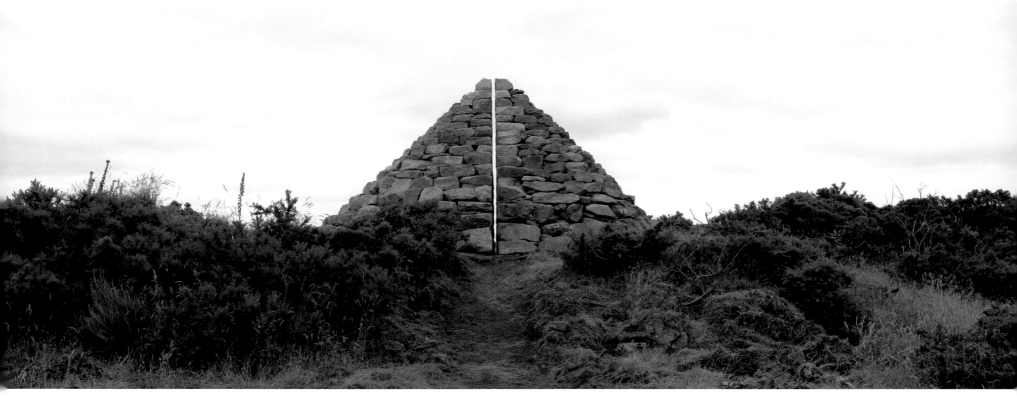

58 RIVER OF EARTH (RIVIÈRE DE TERRE), 1999

H 17' (5.2 m), **W** 29' (8.8 m)

Collection Musée Gassendi, Digne-les-Bains, France
(see page 71)

3,500 kilos of red Dumfriesshire clay. Installed
June 1999

AMcK, Brian Dick, Ian Vernon

Literature: Goldsworthy 2000b, front cover, 193;
Goldsworthy 2002, 45–49, 123

The commission for *River of Earth* has its origins in the second collaborative project that Goldsworthy and the choreographer and dancer Régine Chopinot of the Ballet Atlantique, La Rochelle, France, initiated in June 1998. For the design of *La Danse du Temps*, which used the river as a metaphor for the passage of time, both decided that Goldsworthy's contribution should not be overtly sculptural. Instead they agreed he should make a film that could be projected as a backdrop. For Goldsworthy, the brief resolved itself with a plan for "an interior structure that required a constant light source and…[could] be filmed over a period of two weeks" (2002, 45). By June, he further elaborated the concept, suggesting that he could install a clay wall and film it as it dried and cracked, relating notions of fluidity, change, and time.

Working in Digne weeks later, Goldsworthy realized that it was the ideal place to make and film the work; on 17 July 1998 he created *River clay worked into the cliff face* on the Bès River. Fortuitously, Nadine Gomez proposed that he use a large wall in the recently renovated top floor gallery at the Musée Gassendi. Goldsworthy utilized the same process of construction and installation for *River of Earth* that he had developed for the 1998 *Clay Walls* (cat. 51) in Edinburgh. The Digne wall is considerably larger in scale, however, and the installation took two-and-one-half weeks to complete. As with the walls in Edinburgh, a wooden partition was constructed across the wall with the desired form cut out — in this instance, a river form horizontally across the middle of the wall — and coated with a cement mix to create a good adhesive surface for the clay.

Goldsworthy elected to use clay dug straight from a pit at Drumlanrig, near his home in Dumfriesshire. Since the clay is distinctively red, the drying process had a stronger visual force with the change of color from wet to dry. The work revealed itself slowly as it dried over a two-week period. The process was filmed by Thomas Riedelsheimer and Dieter Sturmer. With the subsequent inception of the *Refuges d'Art* project in 2002, *River of Earth* became the starting point for the Refuges Walk, and, in effect, Musée Gassendi constitutes the first *Refuge d'Art*.

124

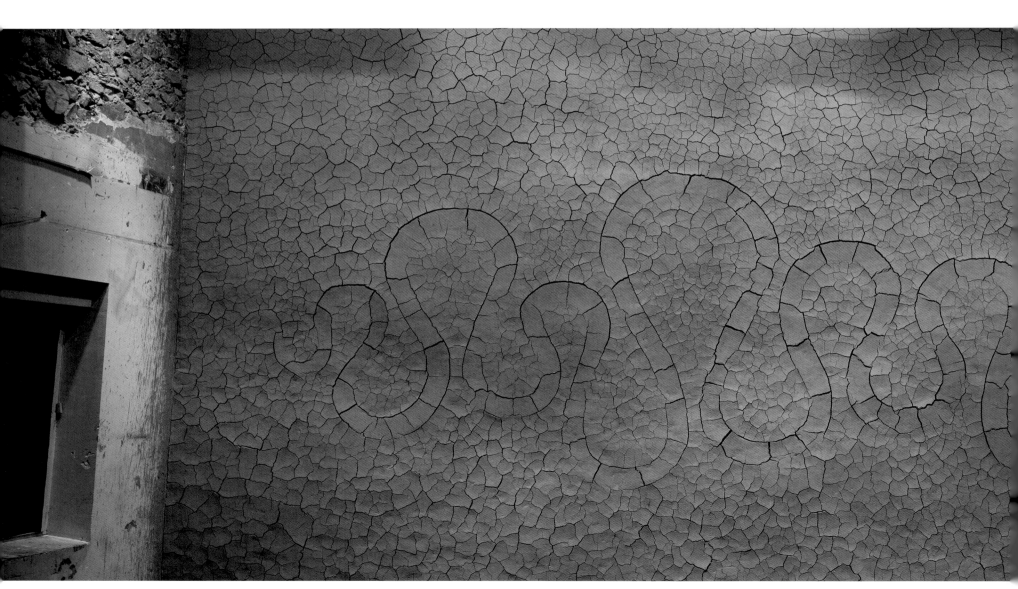

58

59 SENTINELS (LES SENTINELLES), 1999–2001

Sentinel, vallée du Bès, Les Clues de Barles, D900a, 1999
Sentinel, vallée du Vançon, Authon, D3, 2000
Sentinel, vallée de l'Asse, Tartonne, D219, 2001

Each cairn: H c. 10′ 2″ (3.1 m), ⌀ 7′ 5″ (2.3 m)

Commissioned by Réserve Géologique de Haute-Provence and Musée Gassendi, Digne-les-Bains, France (see page 71)

Pale limestone from carrière de Revest-St-Martin. Installed June 1999, April 2000, and April 2001

Literature: Goldsworthy 2002, 100–109; Goldsworthy et al. 2008, 60–65, 78–83, 116–119, 154–158

Goldsworthy, Guy Martini, and Nadine Gomez initiated the notion of possible "entrance doors to the reserve territory" in late 1996, and they continued to use the

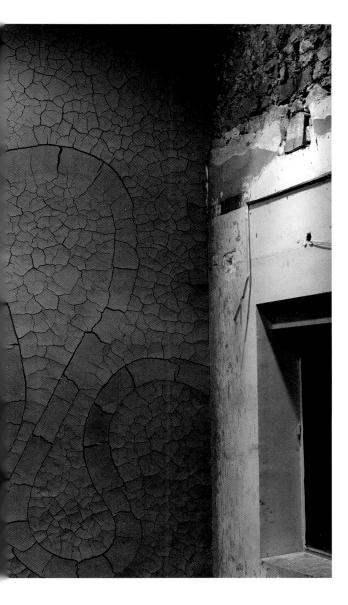

term "entrance door" in their correspondence throughout early 1997 (C, from Martini, 8 May 1997, AGA). Accordingly, Goldsworthy developed a series of ideas in which holes or entrances would be cut into roadside mountain walls and boulders then placed within them. The term *"sentinelle"* was first used by Gomez — referring to the cairn that Goldsworthy was then making on Herring Island in Melbourne — in correspondence dating to 23 September of that year (AGA). In subsequent correspondence, both Martini and Gomez used *sentinelles* rather than entrance doorways.

By summer 1998, Goldsworthy had developed a proposal to site a large roadside cairn in each of the three valleys that define the reserve — les vallées du Bès, du Vançon, and de l'Asse. Each cairn would act as a guardian or sentinel to its valley and as a journey marker, and all three would be formally, conceptually, and functionally connected. Interestingly, in an early proposal for his large 2001–2002 *Three Cairns* project (cat. 75), Goldsworthy referred to three cavities that would act as counterpoints to the cairns: "In the town of Digne itself will be the three cavities, the negative spaces" (PS, *Three Cairns*, AGA). The cavities were never realized, and as Goldsworthy has subsequently intimated, the valleys themselves are the cavities. However, while siting the cairn at Authon, Goldsworthy and Martini developed the idea of linking the three *sentinelles* by means of a walk through the mountains and between the valleys. Initially, they intended to complete the *sentinelles* at Authon and Tartonne during the same visit in 2000, in order to inaugurate a "three cairn walk" in 2001. As Goldsworthy noted, shortly thereafter, "I think we should take the opportunity to make a cairn in 1999, 2000, and 2001. This way we also make a line through time" (C, 7 September 1997, AGA).

The siting of the cairns in each of the valleys took place by car. The first to be sited was the cairn in la vallée du Bès in July 1998. Sites for the second cairn at la vallée du Vançon, and the third in la vallée de l'Asse were selected in June 1999. For la vallée du Bès, Goldsworthy already knew Les Clues des Barles well. While driving with Martini and Gomez, Goldsworthy noticed a small refuge that had been cut into the mountainside, obscured by a curve in the road, where workmen who built the road could rest. Goldsworthy was drawn to the idea of protection already invested in the site:

I never believed that I could make a cairn in the Clues De Barles.... We had in fact found a site further up the valley beyond Barles. It was on our way back that, out the corner of my eye, I saw the small recessed area where the cairn now sits. I said nothing for a few kilometres, suppressed the idea. Eventually I asked Guy Martini, who was driving, to turn around and go back.... When we reached the site, it was so obvious that this was the place. This was confirmed by finding two cut holes in either side of the recessed area, in which a beam had once been placed, to support a roof, which would have sheltered the people who made the road. When I dug the foundations, I found a rusty shovel and evidence of fires. (2008, 78)

The *Sentinel* in la vallée du Vançon was sited on a hairpin bend of route D3, near Authon. The third, in la vallée de l'Asse, proved to be the most difficult to place. Goldsworthy eventually chose a roadside site at Tartonne, next to a large Scotch pine and a milestone.

Certainly, in terms of Goldsworthy's cairns, the three *sentinelles* are the most resonant in terms of matching site to method to materials to form:

[T]he construction of laying one stone upon another is not unlike laying one bed upon another. It becomes almost a geological process in which the stone is returned to its state when it lay as bedrock. It's a mass that's not inflexible, but one that will bend and settle, and more, over time. It's a process close to growth. Each stone adds another layer to the work, and piece by piece the form emerges...rooted internally, in the structure itself and isn't merely superficial. (2002, 105)

The construction of the *Sentinel* at Authon in April 2000 was almost jeopardized by initial hostility within the local community toward the presence of a sculpture on the designated site. Goldsworthy has since spoken of the "strong attachment" that the communities in and around the reserve have to the land:

I was quite aware of that. A similar situation had occurred in Cumbria when I was doing the *Sheepfold Project*. Having to talk and explain to them about the sculpture, and having to be questioned, and to defend yourself in these situations. It's not very pleasant, I don't enjoy it, but I rise to the challenge of it. (2008, 155–156)

Subsequently, at Authon and Tartonne, the *sentinelles* have been appropriated into their respective communities. Inasmuch as Goldsworthy intended them as guardian sculptures, they are themselves now protected by those communities.

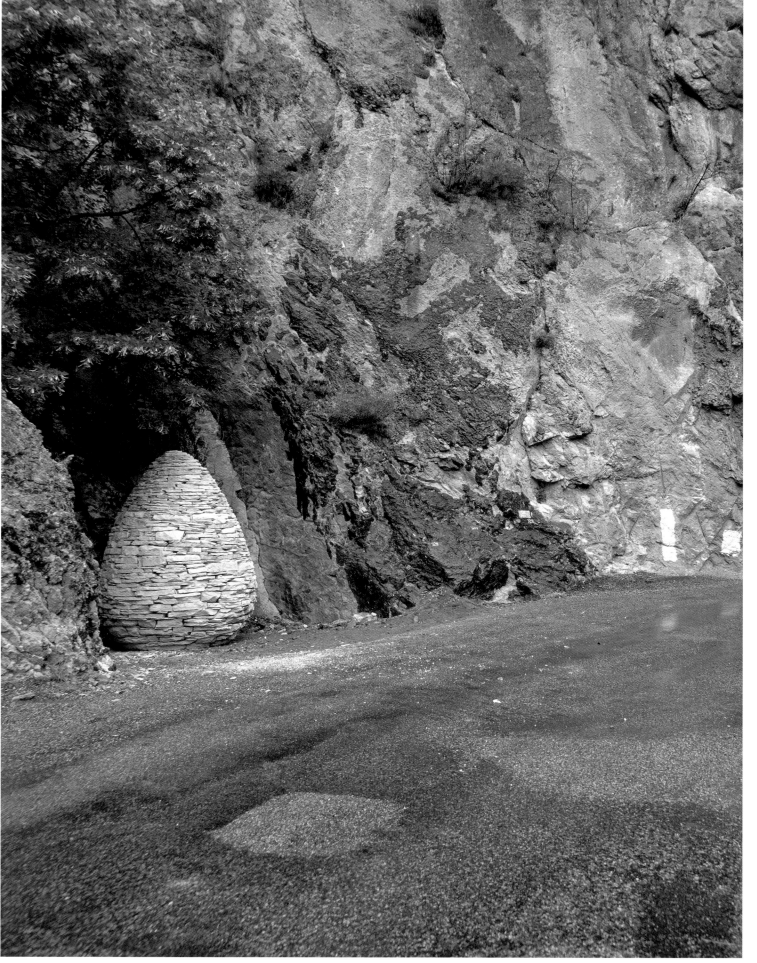

59 above, Bès; right top, Vançon; right bottom, l'Asse

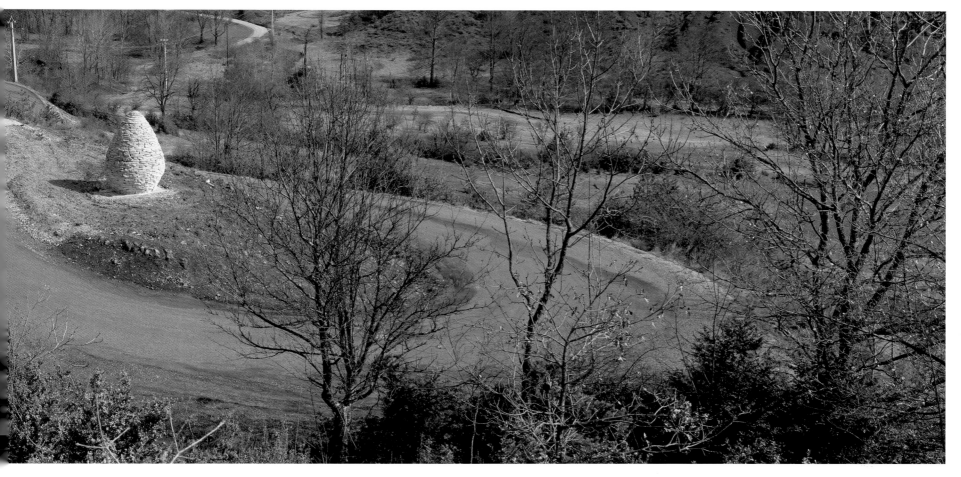

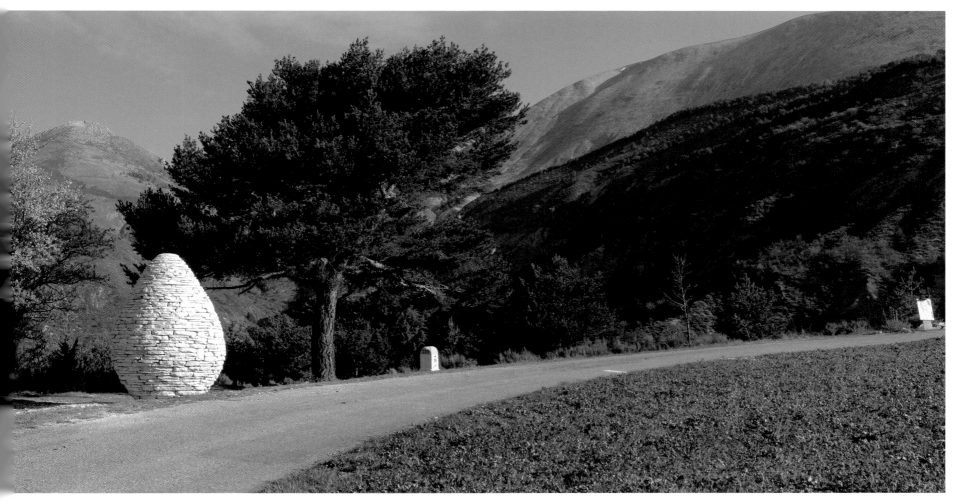

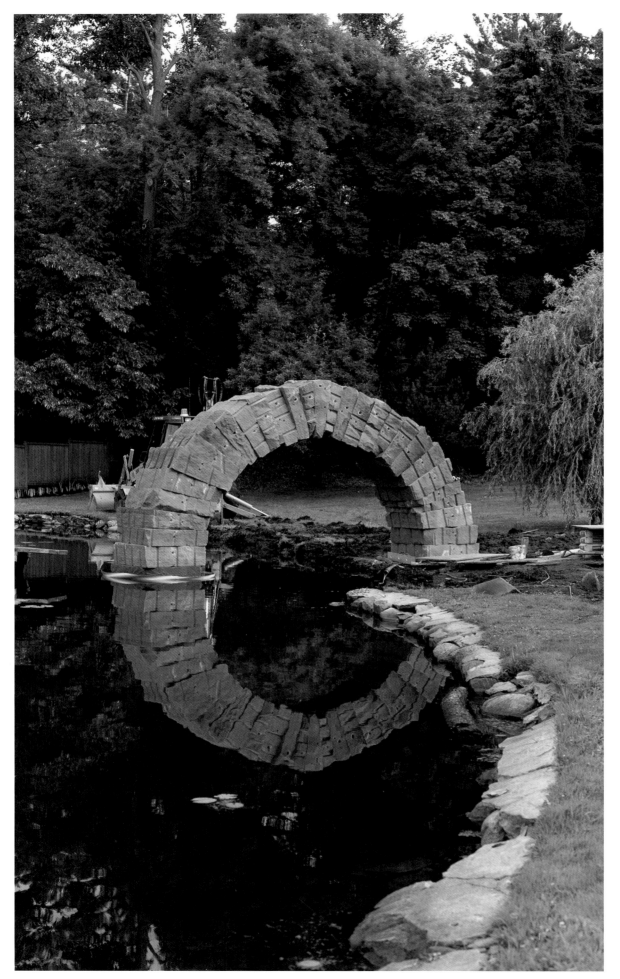

60 ST. BRUNO ARCH, 1999

H from ground level 6′ (1.8 m), from bottom of lake 11′ (3.4 m), S 12′ (3.7 m)

Collection of Guy Laliberte, St. Bruno, Canada

15 tons of Locharbriggs red sandstone.
Installed 1–4 July 1999

GG, GR, BN, SA, GW, JW, MN, David Harris

Literature: Goldsworthy 2000b, 60–69, 198

The possibility of inviting Goldsworthy to make a work or "intervention" in Montreal, at the residence of the director of the Cirque du Soleil, was first made in October 1997 (C, from Claude Brault, 31 October 1997, AGA). At that time, Goldsworthy was developing concepts for a series of arches, and he later referred to an idea for one "that steps from land into water" (S, *St. Bruno Arch*, 2000, AGA). He proposed that he build just such an arch on the edge of the lac du Moulin at mont St-Bruno following a visit there in autumn 1998.

The *St. Bruno Arch* was constructed at Locharbriggs Quarry in spring 1999, concurrently with the *Millennium Arch* (cat. 62). While it and the Cirque du Soleil arch (cat. 52) weigh almost 100 tons each, the *St. Bruno Arch*, at less than a third of their size, weighs "just" 15 tons. However, it retains the same raw, rough-hewn qualities exhibited by the larger two. Installing the arch, one foot on land and the other in the lake, required particular attention be paid to the foundations. The foot of the arch that falls into the lake is actually some 5 feet longer, to compensate for the drop down to the lake floor.

The *St. Bruno Arch* is the first of the arches, and of Goldsworthy's commissioned works in general, to engage his long-standing interest in the juncture between land and water. The context of lac du Moulin offered relatively calm conditions wherein the arch, viewed from a distance, appears to form a complete circle; it also makes reference to Goldsworthy's earlier explorations of the 360-degree arch, including such works as *Touchstone North* (cat. 12).

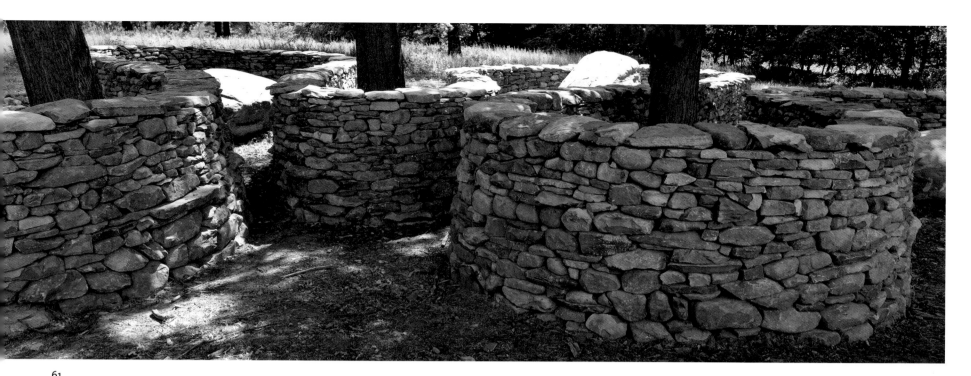

61

61 FOLDED WALL, 1999

H C (1.3 m), L 554' (168.9 m)

Private Collection, Orange County, New York State, US

Fieldstone. Wall marked out May and built July 1999

SA, GW, JW, AMcK

Literature: Goldsworthy 2000a, 12; Goldsworthy
2000b, 202

Goldsworthy first visited the site on which Folded Wall
now sits in October 1998, during the second building
phase of the Storm King Wall (cat. 46), and the two
commissions are clearly linked. Folded Wall is the third
of Goldsworthy's sinuous, curving agricultural walls,
built in response to its immediate environment, and
indeed it appears to synthesize ideas that he devel-
oped in early 1988 for Mossdale Farm in the Yorkshire
Dales. On that occasion, Goldsworthy devised two
possible serpentine walls: in one version boulders
would be placed into the folds of the wall; in the other,
trees would be planted in them. The latter of those
appeared later as "the wall that went for a walk"
(cat. 14) and as the Storm King Wall. Folded Wall inte-
grates both elements, alternately enclosing tree, boulder,
tree, boulder, and so on. Given that the title of this
work suggests the coalescence of "wall" and "fold,"
Goldsworthy has elsewhere differentiated the two:

**There is a difference between a wall and a fold. The
fold is an enclosed space, like a microcosm of the field.**

The *Storm King Wall*…is a line, it draws space—draws
the place wherein it's made. Drawing is a good word
to describe many aspects of making a wall. (Yorkshire
Sculpture Park 2007, 41–42)

62 MILLENNIUM ARCH, 1999–2000

H 19' (5.8 m), S 32' 8" (10 m), D 7' 7" (2.3 m)

Robert Hiscox, Wiltshire, UK

99.6 tons of Locharbriggs red sandstone.
First half installed 1–11 September 1999, and
second half 26–30 May 2000

AMcK, GG, GR, BN

Literature: Goldsworthy 2000b, 14–15; Friedman,
in Goldsworthy 2000b, 202

The *Millennium Arch* is one of the three large sculp-
tures that Goldsworthy left half built across the turn
of the millennium. It was the second of the three
begun in 1999, and the first completed in May 2000.

Goldsworthy was first approached in April 1997
about making a sculpture to mark the turn of the cen-
tury. The intended site, an estate in Wiltshire, includes
an Iron Age camp, the workings of which are still visible.
It is also documented in *The Anglo Saxon Chronicle* at
AD 923, and the owner has since suggested that this
commission was very much about leaving a mark for

AD 2000. His anticipation of the millennium was very
much in temper with Goldsworthy's and coincided
with the proposal Goldsworthy was already develop-
ing for *Logie Cairn* (cat. 57) in April 1997.

Goldsworthy was overseeing the construction
of *Montreal Arch* (cat. 52) at the time of his first site
visit to Wiltshire. Throughout the period of conceiving
and making *Montreal Arch*, Goldsworthy had devel-
oped proposals for at least five other red sandstone
arches, "all of which connect one thing to another"
(s, *St. Bruno Arch*, 2000, AGA), and between which there
would be a strong conceptual bond. That link would
be established by the repetition of form, and by Golds-
worthy's desire that they each be produced with stone
from the same source—Locharbriggs Quarry, Dumfries-
shire. For Goldsworthy, the stride of the arch is a spa-
tial gesture, linking two contexts either physically or
psychically; but *Millennium Arch* is more temporal in
conception. For the Wiltshire estate, he suggested an
arch with one-half built in 1999: "I think the moment is
less significant than those that exist [on] either side of
it. It is the flow of time that interests me far more than
an arbitrary moment" (c, to owner, 20 April 1997, AGA).

Millennium Arch was built in its entirety in
Locharbriggs Quarry in the first half of 1999, using
extensive scaffolding rather than a former. It was
then dismantled, and half was shipped to the Wiltshire
estate for installation. The second half was stored
at the quarry and taken to Wiltshire in spring 2000.
It has weathered considerably, with lichen growing
on its north side.

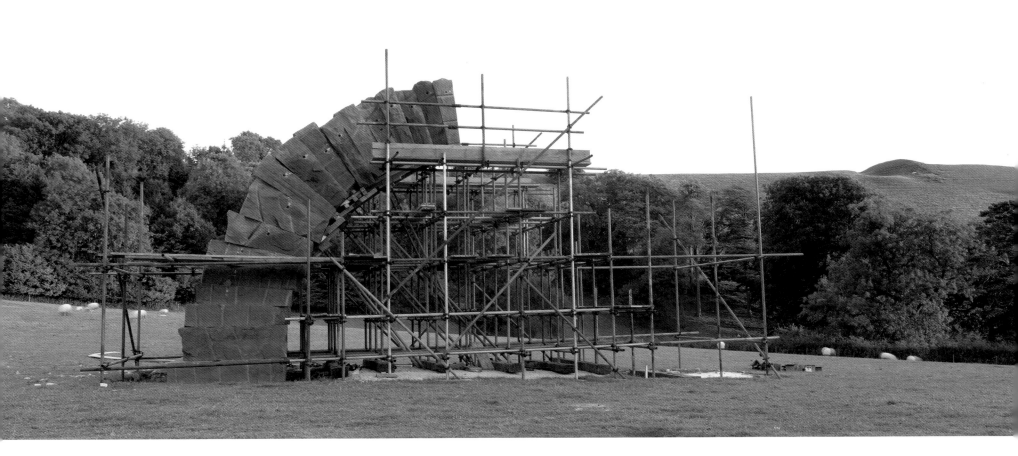

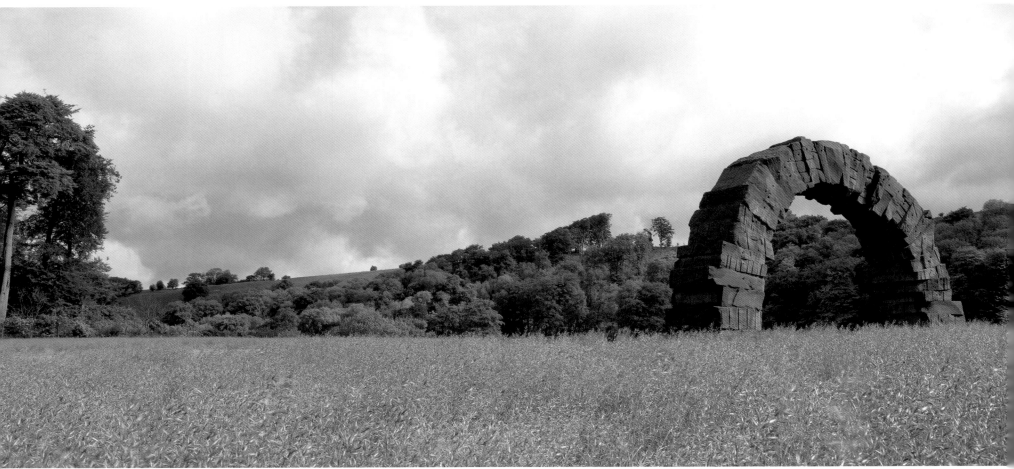

63 MILLENNIUM CAIRN, 1999–2000

H C. 12′ (3.7 m), ø 24′ (7.3 m)

Private Collection, California, US

Hy-desert regular and thin-set flagstones (¾–1½ inch thick) from Atascadero, California. First half installed November 1999, and second half 13–19 October 2000

AMcK

Literature: Goldsworthy 2000b, 12–13; Friedman, in Goldsworthy 2000b, 202

Millennium Cairn is the last of the three works that Goldsworthy started in 1999 and completed in 2000. It is closely related to Logie Cairn (cat. 57), the first half of which was built in Scotland eight months previously. Both were built in much the same manner: the first half constructed against a profile; the second, built by eye. As distinct from the two halves of Logie Cairn, between which he left a gap, Goldsworthy built this cairn so that the second half butted up against the first and created what is called a running joint, which extends through the work vertically from apex to base. Such a joint is often taken to be a sign of a poorly built wall, as Goldsworthy suggested, "in a properly made, seamless wall, each stone should cross the joints of the stone below, though a trained eye can, even then, often make out the join where one day's work ended and the next began" (2000b, 12). In the context of California, however, the seam itself

took on geological implications, referring to the fault line that runs through the state. For this cairn, Goldsworthy chose a flat-bedded stone, which was sourced from a nearby quarry. The stone was hard, and, as Goldsworthy recalled, "difficult to work" (2000b, 12). The horizontality of the stone, placed layer upon layer, accentuates the vertical line of the join. It also placed added pressure on Goldsworthy and the wallers to get the ascent of the angles entirely accurate, so that the cairn would read as if it had been built as one entity rather than in two parts.

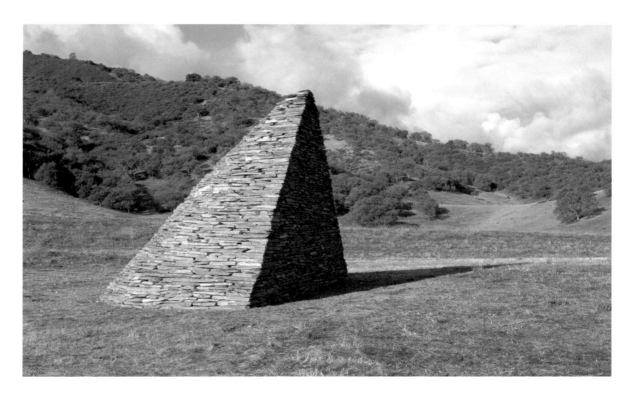

64 CLOUGHA PIKE CHAMBERS, 1999–2001

Wall: H 9′ 6″ (2.9 m), W 6′ 6″ (2 m), D 5′ (1.5 m)
Chamber: H 6′ (1.8 m), W 2′ (.6 m), D 3′ (.9 m)

Private Collection, UK

75 tons of millstone sourced from the site. Installed 22–28 November 1999, 11–21 September 2000, and December 2001

AMcK, ES

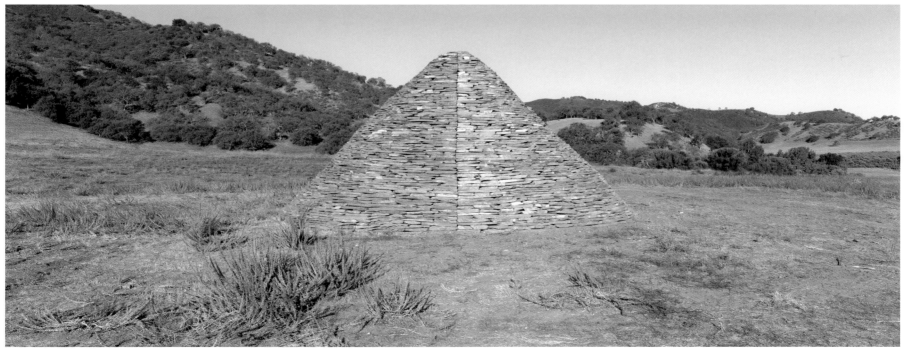

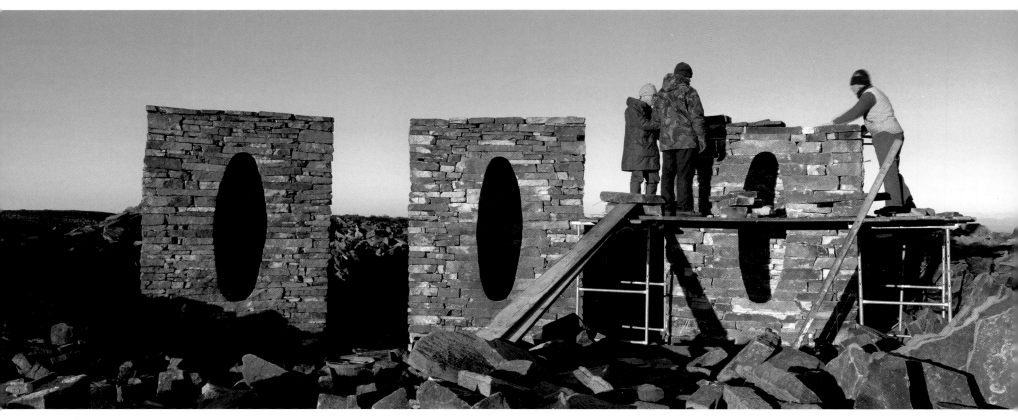

64

Literature: Goldsworthy 2000b, 12–14; Friedman, in Goldsworthy 2000b, 202

Correspondence suggests that when invited to make a work for Clougha Pike, Goldsworthy initially considered proposing a cairn that would feature a running joint through its middle. He developed that idea for *Millennium Cairn* (cat. 63), and instead proposed a freestanding, upright wall, into which he would build an elongated chamber approximately 6 feet high that visitors would be able to enter. Goldsworthy proceeded to construct three such chambers at Clougha Pike, in three phases between 1999 and 2001, and they present the inception of one of the most conceptually rich and evocative strains in his work. The formal simplicity of the three chambers and their supporting walls belies the abundance of reference that informs their structure, their relationship to their site, and their participatory element.

The *Clougha Pike Chambers* derives from a very particular synthesis of formal, autobiographical, and agricultural references. Frequently, Goldsworthy's elaboration of forms such as the arch or the cairn is tied to his own presence in a phenomenological sense and to his journeys to the various sites, for which many structures stand as markers. However, as Goldsworthy has revealed, the site at Clougha Pike touched

upon his own personal narrative, being within sight of where he had worked outdoors as a student. As such, a sense of his own remembered presence, counterpointed with his extended absence, imbued the formal conception of the work.

The formal trope for the chamber originated in Goldsworthy's familiarity with a series of graves carved into the bedrock in the grounds of a small church nearby. Those concavities suggested the shape of the chamber and its evocation as a space for an absent body. Also influential for Goldsworthy were the numerous limekilns distributed across the region's fields: ground-based, semicircular spaces cut into rock outcroppings and used to burn lime. As Goldsworthy noted:

I believe that people's response to the sculptures will be primed by these structures. Initial responses may be that [they are] structures connected with mining or farming. To find a space that may have been for the fire of a kiln or the working of an animal, but is in fact a space for a person, will turn this negative space into one of memory and presence. (c, to owner, 15 March 1999, AGA, here and following)

Goldsworthy was also drawn to the history of use and the physicality of the site. Built on a heap, it formerly functioned as a quarry from which stone for the various agricultural structures was sourced. Initially Golds-

worthy considered building the chambers into cairns, linking them briefly to the type of structure that he developed for the 1999–2001 *Dunesslin Cairns* (cat. 56). However, Goldsworthy felt that the chambers "would lose connections" to the fragmented walls, piles of quarried stone, and surrounding farm buildings. As he noted in March 1999, the slim, vertical wall for the chamber would be "the strongest conceptually and visually, but also structurally, which is important for a work that will be stepped in and out of."

The three walls sit 5 yards apart from each other, embedded into the spoil heaps so that they appear to rise out of the ground. The chamber opening in each wall faces east and under certain lighting conditions appears to hover. The construction of all the chambers was particularly physically demanding. As with the *Dunesslin Cairns*, Goldsworthy did all the primary stonework himself. In bitter November conditions, he noted that, of the first structure,

the chamber became a coat of stone that I wrapped around my body to give me shelter from the elements and, although forced by a busy schedule to carry out construction in difficult conditions, I would have not wished it otherwise. The rawness of the weather imparted to the work a sense of need and protection. (2000b, 16, 19)

65 MEGAN'S FOLD, 1999–2000 (SHEEPFOLDS PROJECT)

H 4′6″ (1.4 m), **W** 15′1″ (4.6 m), **L** 20′ (6.1 m)

Commissioned by Cumbria County Council, with funds from the Arts Council of England, UK

Fieldstone. Installed late December 1999 and January 2000

SA, GA

Literature: Goldsworthy 2007, 108–109

Goldsworthy first proposed making a "Millennium Fold" or "Two centuries fold" in summer 1999, not long after completing the first half of the *Logie Cairn* (cat. 57) in Aberdeenshire in Scotland (see D.1999.1, AGA). Similarly to the *Logie Cairn*, which Goldsworthy conceived as a single structure to be built in two halves spanning the turn of the millennium, he noted an idea for a fold work: "½ fold built in 1999, the other ½ in 2000. No fold site yet" (*Sheepfolds* memo, by Steve Chettle, August 1999, AGA).

Goldsworthy began looking for a site in early autumn 1999, but by late October had still not located a suitable fold. Steve Allen, who had begun working with Goldsworthy in 1996, suggested a possible location on a farm then belonging to his uncle, near a gate where sheep are loaded up. No fold had previously stood on the proposed site; however, Goldsworthy was attracted to the idea of building an entirely new

fold for a specific need and use. Goldsworthy visited Yew Tree Farm in November when working at Clougha Pike, and by late November had sent a proposal drawing to Steve Allen. Goldsworthy contemplated building a round fold, but decided upon a rectangular one, largely in response to its location near the field gate. As with *Millennium Cairn* (cat. 63), the first half of which Goldsworthy completed just prior to undertaking *Megan's Fold*, he elected to join the two halves of the fold with a straight running joint or seam. There is only one running joint, which is visible on the short wall of the fold, opposite the position occupied by the gate into the fold.

Goldsworthy initially intended to name the work "Millennium Fold," and it was also occasionally referred to as "Bretherdale Fold." He decided, however, to name it for Steve Allen's daughter, born on 1 January 2000 as the first half of the fold was being completed.

66 PENPONT CAIRN, 1999–2000

H 9′8″ (2.9 m), ⌀ 7′5″ (2.3 m)

Penpont Community Council, Dumfriesshire, UK

15 tons of Locharbriggs red sandstone, donated by the quarry. Installed 23 December 1999–28 January 2000 on land farmed by Jim and David Kirkpatrick. Foundation stone put in place by Glen Davidson. Machines supplied by Lloyds Tractors, and stone transportation by Walter Marchbank

AMcK, Wallace Gibson, Glen Davidson

Literature: Friedman, in Goldsworthy 2000b, 202; Goldsworthy 2004, 6–17

The minutes of a meeting of the Penpont Community Council on 6 December 1999 (AGA) record its support for the building of a red sandstone cairn on a "slight eminence near Stepends Farm." The cairn stands just to the east of Penpont, the Dumfriesshire village in which Goldsworthy has lived for twenty-two years. Commissioned by the village, at the suggestion of Neil Mackay, to commemorate the millennium, it also acts as Goldsworthy intended, as a sentinel or guardian to the village. As such, it is closely linked to the protective role that he invested in the three *sentinelles* (cat. 59) of the Réserve Géologique de Haute-Provence in France.

Two early drawings (D.1987.3 and D.1987.4, AGA) show groupings of five or more red cairns in distinctively hilly settings: one features a group of cairns built upon what appear to be constructed mounds. Small pencil studies show that Goldsworthy was clearly interested in the relationship between the rounded bases of the cairns and the rounded promontories on which they would sit. Something of these ideas appears to be present in his siting of *Penpont Cairn*. Goldsworthy has remarked that the cairn's prominent placement and elevation are unusual for him, and that his preference is for more discreet locations. However, after placing the sizable foundation stone on 23 December, he noted,

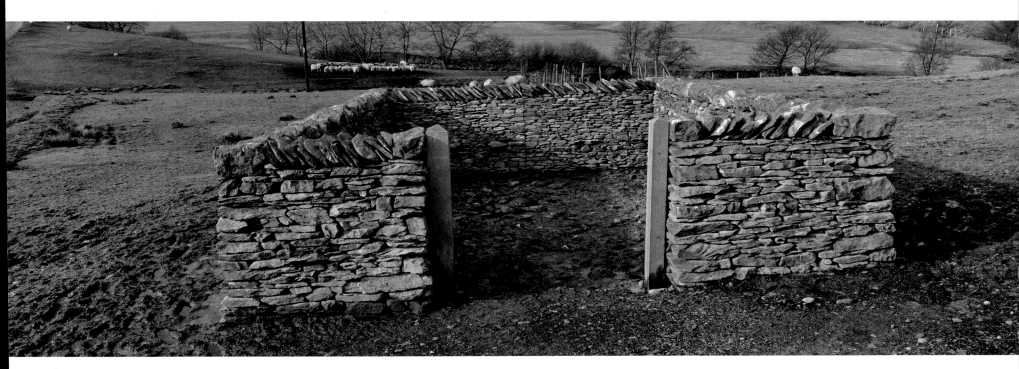

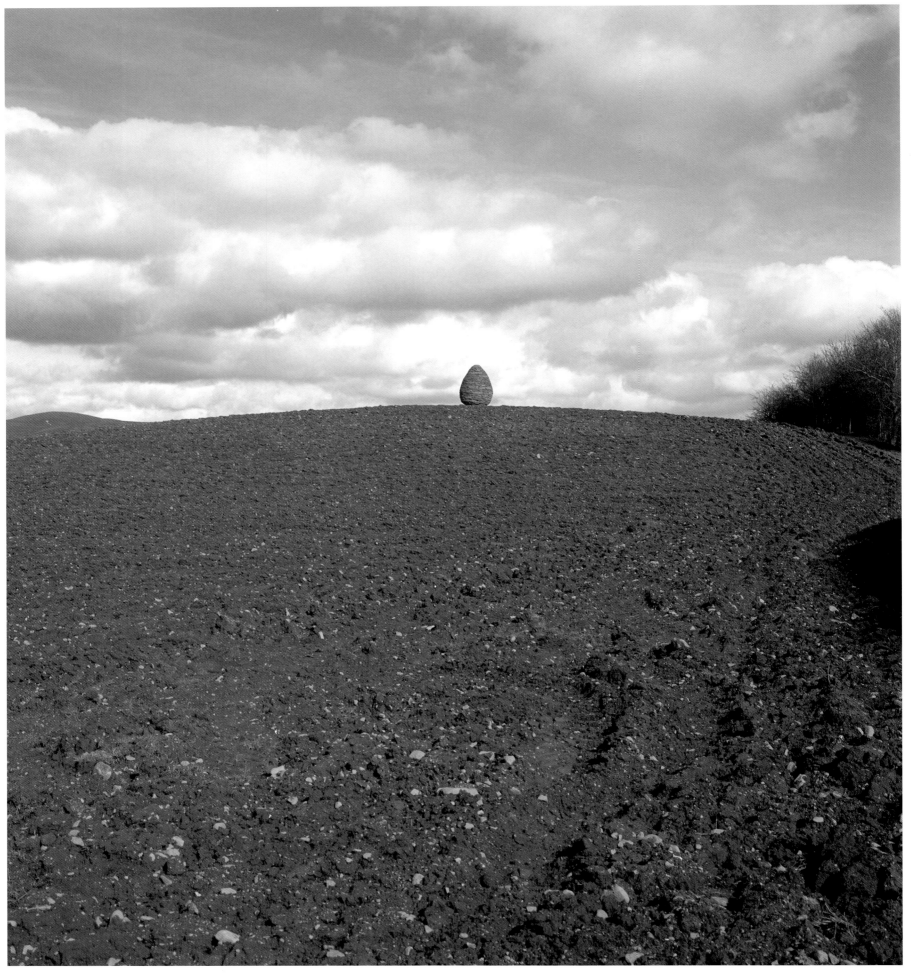

I decided to bed the stone half in and half out of the ground. This will raise the cairn by a foot, so that when viewed from the road, the bottom will appear to be sitting directly on the hilltop — a joining of two rounded forms. (2004)

The farm is, of course, a working environment, and Goldsworthy has continually subjected his works to the terms or conditions of the farming context; he has also relied on the care of landowners and farmers to support and care for many of his structures.

67 TWO OAK STACKS, 2000

Each stack: Ø 10′ (3 m)

Private Collection, Richmond, Massachusetts, US

Wind-fallen Scottish oak, with native Massachusetts hardwoods filling the center. Installed Massachusetts 14–18 May 2001. Each weighs 6 tons

Literature: Goldsworthy 2000b, 202

Exhibition: Storm King 2000

Goldsworthy first constructed *Two Oak Stacks* in May 2000 for his exhibition at Storm King Art Center in New York. He located one of the oak spheres in a gallery space, and the other outside, on a lawn. He built both to a diameter of 10 feet, using twisted oak branches brought from Dumfriesshire, Scotland, but has recalled being struck by how the contexts — one in the open and the other enclosed — modified the sense of scale and density of the form.

When permanently siting *Two Oak Stacks*, Goldsworthy looked for locations in which he would be able to physically link but counterpoint the two sculptures. He decided upon a small clearing, situated next to a dense woodland, and constructed one sphere in the clearing and the other 50 yards away just beyond the start of the trees. Though very close together, the two spheres elicit very distinct feelings from the visitor. The first, sitting in open ground and visible on approach, has the benefit of space and perspective, and its form and structure can be apprehended as a whole. The second, enclosed and hidden within the woodland, is more compressed and constrained, and the visitor's focus is thrown onto and into the network of woven oak limbs.

In terms of their condition, the sphere in the clearing has lightened in color and settled slightly. By contrast, the sphere located just inside the woods has been subject to more activity: moss and fungi have grown on some of the limbs, and the structure has begun to decay.

68 MOUNTJOY TREE FOLDS, 2000–2001 (SHEEPFOLDS PROJECT)

Fold 1: H c. 4′ 6″ (1.4 m), W 25′ 5″ (7.7 m), L 20′ (6.1 m); *boulder:* H 3′ 6″ (1.1 m), L 8′ (2.4 m)
Fold 2: H c. 4′ 6″ (1.4 m), W 40′ 2″ (12.2 m), L 47′ 6″ (14.5 m); *boulder:* H 3′ 8″ (1.1 m), W 9′ 2″ (2.8 m)

Commissioned by Cumbria County Council, with funds from the Arts Council of England, UK

Fieldstone and glacial boulders from surrounding fields. Boulders moved 5 December 2000. Folds rebuilt January 2001. Trees planted December 2001

SA, GA, NM, Andrew Allen

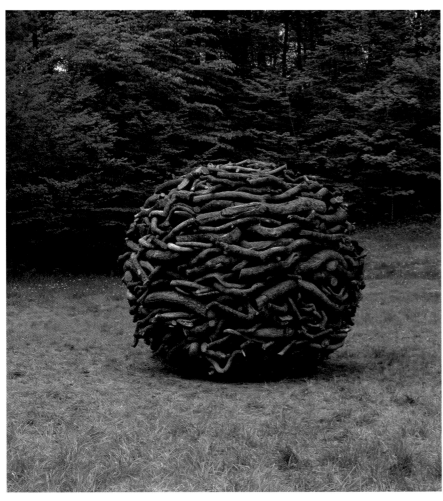

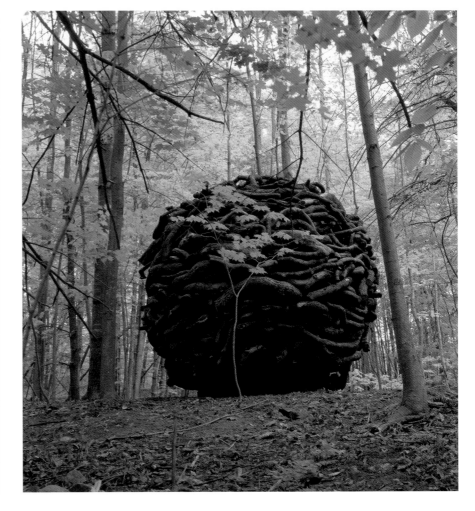

The first mention of Mountjoy Farm in Goldsworthy's papers for the *Sheepfolds Project* dates to 1998, and documentary images of trees growing from stones date from that time. Goldsworthy has recalled that it was the presence of one such rowan tree on the farm that instigated the development of the *Mountjoy Tree Folds*: "I have seen trees in similar positions in other places, but never one as straight and vigorous as this. It is a powerful example of resilience and strength" (2007, 127).

 Mountjoy Tree Folds comprises two separate folds. Each one sits tucked into the corner of a field and has two chambers or rooms. A large boulder, in which a tree has been planted, occupies one chamber of each fold; the other chamber of each fold remains vacant but for wild plant growth. The two boulders were sourced from the immediate area and moved into place using heavy machinery. Goldsworthy vividly recollected their being shifted into place: "it appeared as if the stones moved only when they decided to, and only then after much persuasion" (2007, 127).

 As Goldsworthy has documented (2007, 111), work on the two folds at Mountjoy had to be suspended owing to the outbreak of foot and mouth disease in February 2001. Indeed, for him, the uncompleted folds became witnesses to the devastation that the epidemic caused: "they mark its arrival, presence, and its eventual departure" (2007, 111). Some 2,030 cases were documented across the British agricultural community, with millions of animals lost; Cumbria was the worst affected county. Ian Convery and his coauthors have discussed the outbreak's impact upon "the emotional geographies of livestock farming," "geographies" that they argue were "hugely disrupted and displaced" by the crisis.[16] It is in this context that the latent symbolism of the "stone-tree" emerged much more forcefully:

[T]he Mountjoy trees will perhaps provoke a potent mixture of feelings: hardship, struggle, renewal, fragility, and strength…[which] will articulate something of the emotional struggle of those people living in badly affected areas. (Goldsworthy 2007, 111)

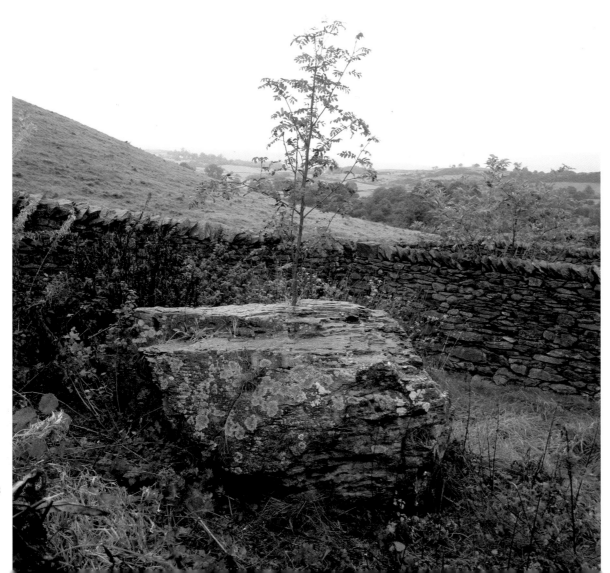

69 BROUGH PINFOLD CAIRN, 2001 (SHEEPFOLDS PROJECT)

Fold: H 4′ (1.2 m), ∅ 22′ 6″ (6.9 m)
Cone: H 4′ 6″ (1.4 m), ∅ 4′ 6″ (1.4 m)

Commissioned by Cumbria County Council, with funds from the Arts Council of England, UK

Buff sandstone donated by Keith Brogden, Ravenseat, Swaledale, and Kevin and Rachel Buckle, Stainmore. Begun in February and completed September 2001

SA, AM

Literature: Goldsworthy 2007, 116–117

Following a five-year pause, Goldsworthy recommenced his *Pinfold Cairn* project (see cats. 36, 42) in February 2001, installing cones at both Brough and Bolton (cat. 70), which he intended to quickly follow with the completion of the folds themselves. The cairns at Brough and Bolton were, however, two of the four structures—along with the two folds on Mountjoy Farm (cat. 68)—for which work had to be suspended owing to the outbreak of foot and mouth disease in February 2001. Thus the folds were completed later than initially planned.

Brough Pinfold Cairn, like *River Stone Fold* (cat. 78), holds particular autobiographical reference for Goldsworthy: he lived in Brough from 1982 to 1985, and his knowledge of the area—and of the Nine Standards on Hartley Fell—and his interest in the sheepfold structure derive from that period of his life. *Brough Pinfold Cairn* is the only one of the pinfolds not to be built or rebuilt upon the footings of an existing or historical pinfold site. Goldsworthy and Steve Chettle initiated research into the possibility that Brough once had a pinfold in 1997. Consulting historical maps of the area, they discovered indications that a circular fold had once stood on ground now built over and adjacent to the school, near the A66 bypass. A proposal that re-sited the pinfold within the grounds of Brough County Primary School was put forward in May 2000, and met with considerable support. Goldsworthy visited in late November of that year, and suggested three possible sites within the grounds of the school. Two of those sites could accommodate a circular fold; the third location required that the fold be rectangular. Goldsworthy and the school agreed to a site where the fold could be round (thus replicating its original shape) and the public could access it.

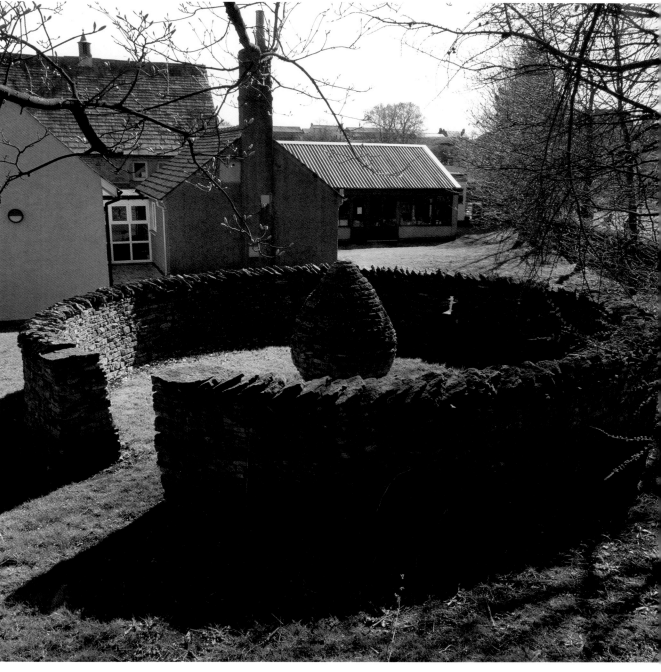

69

The devastation of the foot and mouth outbreak and its coincidence with the *Sheepfolds Project* had considerable impact on Goldsworthy and Dick Capel, the commissions manager at that time. Indeed, Goldsworthy clearly felt the sentinel-like, protective aspects of the cairns at Brough and Bolton were enhanced, and he referred to this symbolism in terms of growth and potential. The building of the fold proceeded in early September 2001, and although cases of foot and mouth continued to appear in the immediate vicinity of Eden Valley until 30 September, Goldsworthy's work was inaugurated on 13 September.

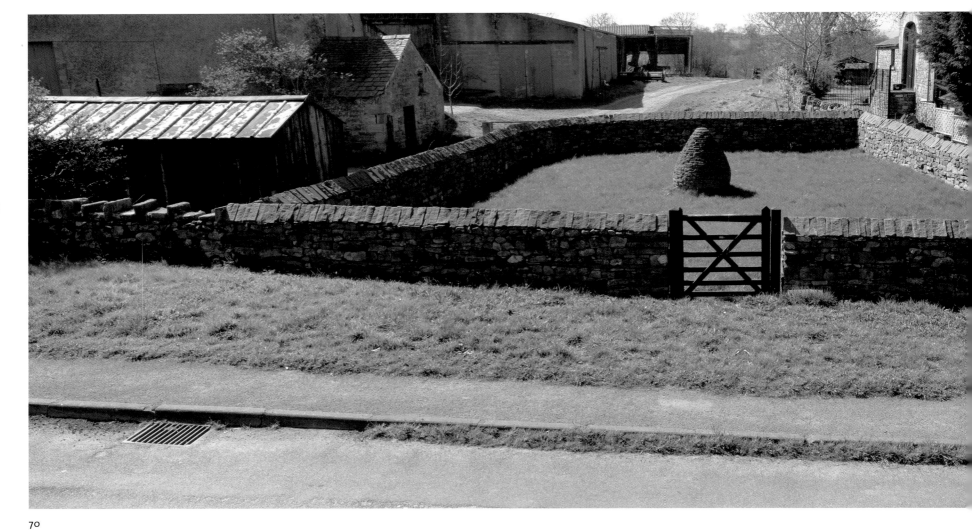

70

70 BOLTON PINFOLD CAIRN, 2001 (SHEEPFOLDS PROJECT)

Fold: H 4′1″ (1.2 m), W 34′ (10.4 m), D 47′6″ (14.5 m)
Cone: H 5′1″ (1.5 m), ⌀ 4′1″ (1.2 m)

Commissioned by Cumbria County Council, with funds from the Arts Council of England, UK

Original wall stone and red St. Bees sandstone donated by Stancliffe Stone. Cairn built February 2001. Fold completed summer 2002

Keith and Malcolm Hogg, Colin Bullman

Literature: Goldsworthy 2007, 130–131

The largest of the pinfolds that Goldsworthy rebuilt, the Bolton fold comprises a fairly sizable, square paddock, which is located next to the roadside at the center of the village. It was first suggested as a possible candidate for Goldsworthy's *Pinfold Cairn* project by Vanessa Richards, head teacher of Bolton Primary School, who had supported earlier, unsuccessful attempts by Goldsworthy and Steve Chettle to draw the nearby Cliburn pinfold into the project. The structure of the Bolton pinfold was intact, but in a bad state of repair; following a site visit, Goldsworthy and Chettle scheduled it for landowner research in early February 2000.

Like Outhgill before it, *Bolton Pinfold Cairn* is situated on a piece of common land that was not listed in the *Register of Common Lands*. Chettle researched the ownership of the pinfold land from February through September, at which time the Land Registry established "no known owner." With the Land Registry unable to give ownership to the Bolton Parish Council, it was not certain that the project could proceed. That uncertainty continued to beset Goldsworthy's possible use of the Bolton pinfold site until December, when the Bolton Parish Council decided to register a caution against first registration by any other party, and thus ensure that it would be informed of any claims in the future. Like the Mallerstang Parish Meeting (see cat. 42), the Bolton Parish Council took out a "defective title" insurance policy against the possibility of a true owner of the fold coming forward and disputing the presence of the cairn.

71 HEART OF OAK (COEUR DE CHÊNE), 2001

H 16′ 4″ (5 m), ⌀ 12′ 6″ (3.8 m)

Private Collection, Charente, France

Sessile curved oak branches from the site and surrounding area. Installed April 2001

Literature: Goldsworthy 2004, 88

Heart of Oak was the first large-scale, freestanding woven oak cairn that Goldsworthy built as a permanent commission. It was the first of three works realized that he made on a private property in southwest France. Goldsworthy initially developed the idea for woodland cones as part of a proposal (see cat. 20) for Île de Vassivière, near Limoges in France in 1990. He imagined a group of dense wooden structures—each 3 meters high, clustered and secreted within the heavily wooded island—but eventually completed a different project there.

On 27 December 1999, southwest France was hit by hurricane-force winds. The historic estate, for which *Heart of Oak* was commissioned, was badly affected; approximately 15,000 trees, chiefly oak and chestnut, were lost. Seeking to find positive ways to respond to the destruction, the owners invited Goldsworthy to make a permanent sculpture using the storm-felled wood. Learning that much of the damage

was sustained by mature oak, Goldsworthy recalled immediately proposing a group of cairns that could not only stand as markers and memorials to the devastation, but also suggest renewal. With the approval, in principle, of this idea, he asked that any curved branches be kept for his purpose, and he visited in October 2000 to look over the wood and find a site.

Arriving to install the first of the cairns in 2001, Goldsworthy realized that the length of the oak branches actually permitted him to make much larger cairns than he had anticipated. He decided to make only one cairn, and to scale it up from 3 to 5 meters. The exaggerated curves of the branches also allowed him to interweave and lock the form as robustly as possible. The process of interlocking the curves, particularly at the base, gives the form its strength as a permanent structure. For Goldsworthy, it also connotes growth. In a statement from 1999 (AGA), he noted:

Although some of my works have the quality of being woven, they do not, in fact, use the traditional sense of weaving, in that they bend material into form. For me, the weaving process is closer to growth and layering. Consequently, I would more easily describe those qualities in my work that have been called weaving as stacking. The laying of one upon another and another and another.

The strength that Goldsworthy was able to build into *Heart of Oak* took on added meaning and poignancy as an expression of the resilience of the land.

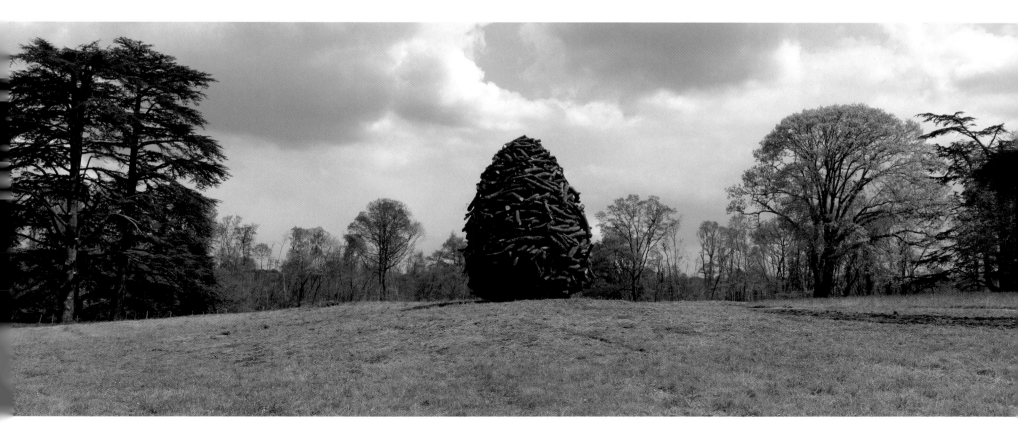

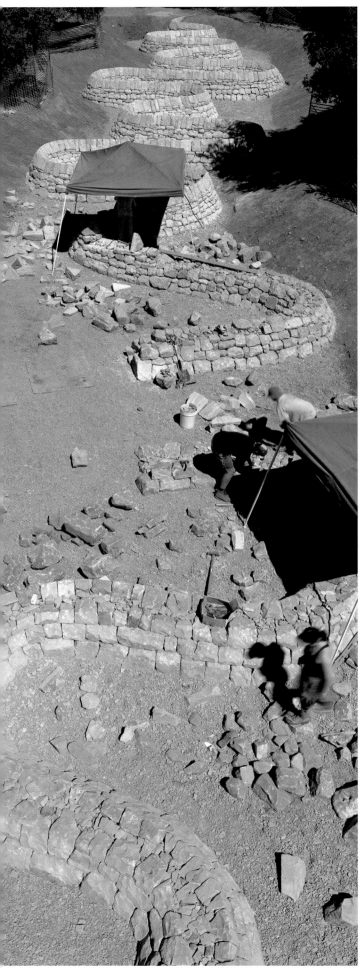

72 STONE RIVER, 2001

H 3′ 6″ (1.1 m), **W** at base 4′ (1.2 m), **L** 320′ (97.5 m)

Cantor Center for the Visual Arts, Stanford University, California, US. Given in honor of Gerhard Casper, President, Stanford University, 1992–2000, by the Robert and Ruth Halperin Foundation (see page 71)

Buff sandstone. Installed August 2001

AMcK, SA, GW, JW, AM, MH, MN, Terence Kane Tierney

Stone River is a 320-foot-long drystone wall, built into an excavated trench (itself some 210 feet long) and sited within the grounds of the Cantor Center for the Visual Arts at Stanford University. Goldsworthy was invited to the center in late 2000, and in December of that year submitted a proposal for *Stone River*, the first of his large drystone wall constructions that are pyramidal in cross section—wide at the base and tapering to a thin edge at the top—and built along a taut curvilinear line.

Although *Stone River* delineates a serpentine line in the manner of "the wall that went for a walk" (cat. 14) and *Storm King Wall* (cat. 46), those earlier works were conceived for settings that explicitly evoke or indeed instantiate the forest-field dialectic. This, the first of Goldsworthy's stone rivers, more clearly recalls *Lambton Earthwork* (cat. 9) as a direct precedent, not least in terms of that work's relationship to its site. Indeed, a pencil sketch of a pyramidally constructed, curving stone wall appears in an early sketchbook diary (SD 22, AGA) and is consonant with Goldsworthy's creation of *Lambton Earthwork* in 1988. Interestingly, *Stone River*'s form often detracts from the importance of its siting as well as the fact that it is built into, and

has a dynamic relationship with, the plane of the ground (as do the two works that follow). The element of excavation is critical to the work. As Goldsworthy noted:

I use excavation far more than [people] think. What is a black hole but excavation? *Stone River* at Stanford is built into the ground. With those works, I excavate first. You feel as though you have revealed or exposed the space, and found something very archaeological. It does bring to the sculpture a powerful sense of "was it something they dug out, was it always there or was it put there?" (Yorkshire Sculpture Park 2007, 66)

In this particular instance, the work's relationship to the ground has a material resonance, as Goldsworthy decided to recycle buff sandstone salvaged from campus buildings destroyed in the 1906 and 1989 earthquakes, and piled in the campus' so-called boneyard. The reinterment of the stone, freed from architectonic function, to a horizontal plane was critical:

[T]he digging of the sculpture into the ground will return the stone to the land—not as waste or infill, but with some of the life and energy it had when it once lay as bedrock and then as a building. (PS, December 2000, AGA)

Its evident connection of stone to ground notwithstanding, the sculpture's title *Stone River* proposes a further link, that between water and stone, and establishes an interconnection between the three— stone, earth, and water. Goldsworthy's desire to superimpose or find the qualities of water in stone is grounded (at least in part) in the geological reality that much bedrock was a seabed at some stage. He himself has cited sources such as Norman Nicholson's "Beck": "Not just the water— / The stones flow also," allusions that

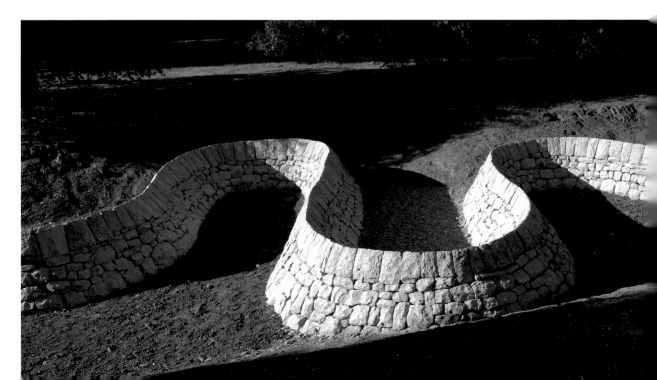

73

Nicholson builds up in the course of the poem.[17] In addition, watercolors by British surrealist painter Paul Nash, such as *Stone Sea* and *Wood Sea*, both 1937, have also influenced Goldsworthy. *Stone Sea* is just one of several works that Nash made while living near Swanage on the east Dorset coast, an area in which there is a prevalence of agricultural stone walls, built with limestone remnants from the fields and nearby quarries. In Nash's drawing, the stone wall looks like the crest of a wave making landfall, or else assumes the force of a stream in spate, forging its course. Stone figures water—taking on its power and vigor. Indeed, the curving form of *Stone River* recalls the curving line of the wall and promontory in Nash's *Swanage Sea Wall*, 1934, in which it is difficult to determine what is wall and what is sea.

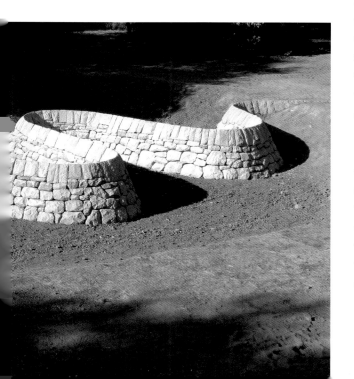

73 MELMERBY WASHFOLD, 2001 (SHEEPFOLDS PROJECT)

Fold: H 3′–5′3″ (.9–1.6 m), W 50′3″ (15.3 m), D 28′4″ (8.6 m)
Dubstone: H 1′8″ (.5 m), W 4′2″ (1.3 m), D 2′8″ (.8 m),
Ø 1′4″ (.4 m)

Commissioned by Cumbria County Council, with funds from the Arts Council of England, UK

Locharbriggs red sandstone. Completed September 2001

SA, GA

Literature: Goldsworthy 2007, 118–123

Melmerby is one of the two washfolds that Goldsworthy rebuilt in the second stage of the *Sheepfolds Project*. It was first identified for inclusion in the early stages of the project, although drawings made by Goldsworthy in April 1996, which show a dubstone submerged in water, may possibly have been for a washfold at Troutbeck. However, drawings from early 1997 clearly refer to Melmerby and were possibly executed following a site visit that Goldsworthy made in February 1997.

Melmerby Washfold is located on privately owned land opposite the village green, which is managed by Ousby Parish Council and still used for controlled grazing. The fold—a two-chamber structure, rectangular with curving walls—was active until the 1930s. At the time of Goldsworthy's first visit, the structure had almost entirely disappeared. In a statement dated March 1997, Goldsworthy noted:

Until this project, I wasn't familiar with washfolds. Around where I live…the folds are usually circular and not attached to a river or stream….It has been interesting to find this new (for me) use of the sheepfold. It's also presented new problems. Sheepfolds attached to washfolds are much more complicated, many chambered. It is easier…for me to respond to the simple square or circular fold—these are like empty boxes waiting to contain something….Empty spaces. Washfolds have a different feel. There is a sense of flow through the fold, sheep going in one end, working their way through chamber to chamber and out the other. The point of departure has become important to me, where the sheep leaps out of the fold. (S, March 1997, AGA, here and following)

Goldsworthy decided to mark that point of departure by siting a dubstone just below the fold, on the bank of Melmerby Beck, in the curve that would have been used for washing and dipping the flock. The dubstone is made with five slabs of red sandstone, placed one on top of the other, with increasingly small holes carved into them; it reprises the stacked, red sandstone units of *Hutton's Roof* (cat. 54). By locating the dubstone in the beck, Goldsworthy wanted it to become a focus for "the movement and energy of the fold." It is also one of the first times that Goldsworthy elaborated the possibilities of the "hidden sculpture," noting that the dubstone would

soon silt up with mud and disappear. This too interests me, especially in the context of the memories of things that have taken place at that washfold and in the pool. Here I am making something that will also become a memory, but is not entirely lost either.

After a hiatus, from late 1998 to mid-2000, work continued on the washfold at Melmerby. The site was excavated in 2001, at which time the exact foundations of the fold were revealed. Goldsworthy had wanted the fold to be completed before the dubstone was installed. However, this method did not prove practicable, and the dubstone was set in place on 13 September, while the wall was half built. Goldsworthy returned to dam the stream and submerge the dubstone for the first time on 25 October with Dick Capel.

74 CONE, 2001

H 5' (1.5 m), W 4' 3" (1.3 m)

University of Hertfordshire, UK

Slate. Installed December 2001

Goldsworthy was visiting senior lecturer in the School of Art and Design, University of Hertfordshire, in 1996, and has subsequently worked with students from the school on a number of projects, including *Midsummer Snowballs* (London, June 2000) and *Night Path* (cat. 79). He installed this cairn on the campus, during a period of residency in December 2001.

75 THREE CAIRNS, 2001–2002

6-part work, installed in 3 museums. Limestone from Weber Stone, Stone City Quarries, Des Moines

Neuberger Museum of Art Purchase College, New York, US

H 8' (2.4 m), ∅ 6' 6" (2 m)

Installed November 2001

ES, Jacqueline Skilkoff

Museum of Contemporary Art San Diego, La Jolla, California, US

H 8' (2.4 m), ∅ 6' 6" (2 m)

Installed January 2002

ES, JE

Des Moines Art Center, Des Moines, Iowa, US

Cairn: H 8' (2.4 m), ∅ 6' 6" (2 m)

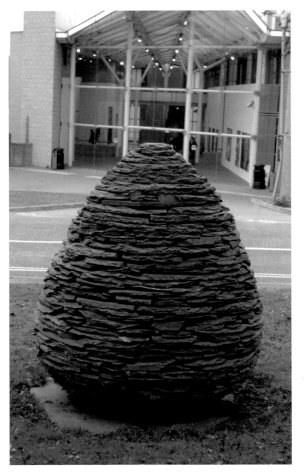

74

Each wall: H 13' 2" (4 m), W 14' 5" (4.4 m), D ½" (1.2 cm)
Each chamber: H 7' 11"–11' 2" (2.4–3.4 m), ∅ 9' 2" (2.8 m)

Installed May–July 2002

ES, SA, WN, GW, JW, AM, MH, JE, Josiah Updegraff, Andrew Loudon, Darren Woolcock, Valerie Knowles, Sam Chermayeff, Chad Elliot, Micah Hammac, David Pearson, Nick Manders

Literature: Goldsworthy 2004, 92–125

Exhibition: Three Cairns 2002

Unfolding over a period of two years from August 2001 until August 2003, *Three Cairns* is one of Goldsworthy's most ambitious commissions to date. It involved no fewer than six different sites across the continental United States, a three-part ephemeral project, three exhibitions, and the construction of six massive limestone structures, all of which Goldsworthy dovetailed into a single, monumental work. Within his oeuvre, *Three Cairns* coalesces a broad matrix of visual, conceptual, temporal, elemental, geographic, geological, formal, material, and social connections. Goldsworthy made his first visit to Des Moines in September 1999 at

the invitation of Susan Lubowsky Talbott, formerly director of the Des Moines Art Center, who wished to discuss the possibility of his undertaking an ephemeral project. Goldsworthy made that visit with the preconception of the Midwest as center; his initial response was very much informed by a long-standing fascination with it in relation to America's two coasts:

I am very interested in using the idea of the centre of the country and its relationship to the east and west coasts. I want to define and explore these relationships by making a construction on the east and west coasts that would act as a marker to these places, but at the same time show some of the differences. For this to work, I feel a sculpture of similar form is necessary. Only by showing the same will we be made aware of the differences in the way that I want. (PS, AGA)

Goldsworthy's early response manifests some of the thinking that lay behind the first *sentinelle* he completed in Digne-les-Bains in France. Almost immediately. Goldsworthy proposed to Lubowsky Talbott that, although the project should retain an ephemeral element, it should have a permanent aspect. Referring to the 1998 *Slate Cairn and Chamber* (cat. 49), he noted:

Des Moines offers an opportunity to make three of those works of a much larger scale. There would be three walls with cavities and one cone in its cavity. The other two cones would be on the east and the west coast in the grounds of a museum there. (PS, AGA)

Consequently, two further venues became involved—the Museum of Contemporary Art San Diego at La Jolla in 2000, followed by the Neuberger Museum of Art in New York State. Four parts of *Three Cairns'* permanent rendering do, indeed, sit in Greenwood Park on the grounds of the Des Moines Art Center. This site installation includes three boxlike freestanding walls; each "box" contains a cairn-shaped chamber and faces a single large 8-foot-high cairn. Two other cairns, of the same dimension and stone, reside on alternate coasts.

Three Cairns is a work of continental scope that draws a metaphorical latitudinal line across the United States. Denis Cosgrove suggested that, "America is in some respects an articulation on a continental scale of the landscape idea, an articulation which embodies the different sets of experiences of practical shapers and theoretical designers" (SFSL 1984, 162). It is possible to read the ephemeral and permanent elements of *Three Cairns* as overlaying those "different sets of experiences." On the one hand, this project was to that

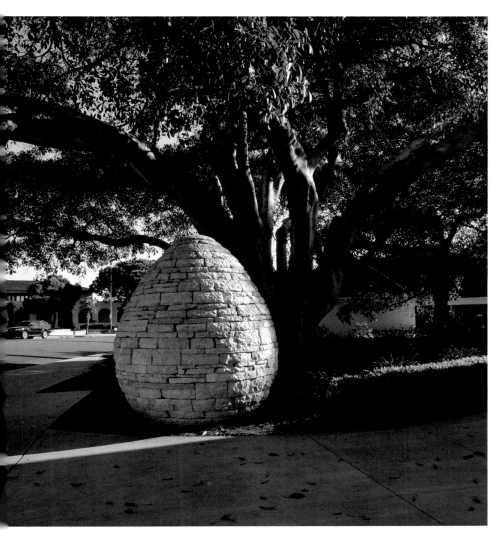

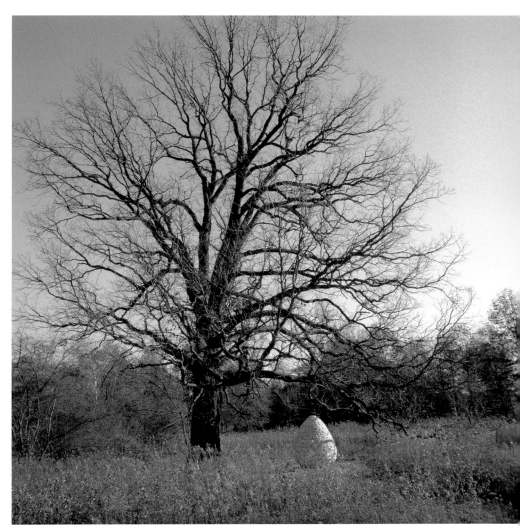

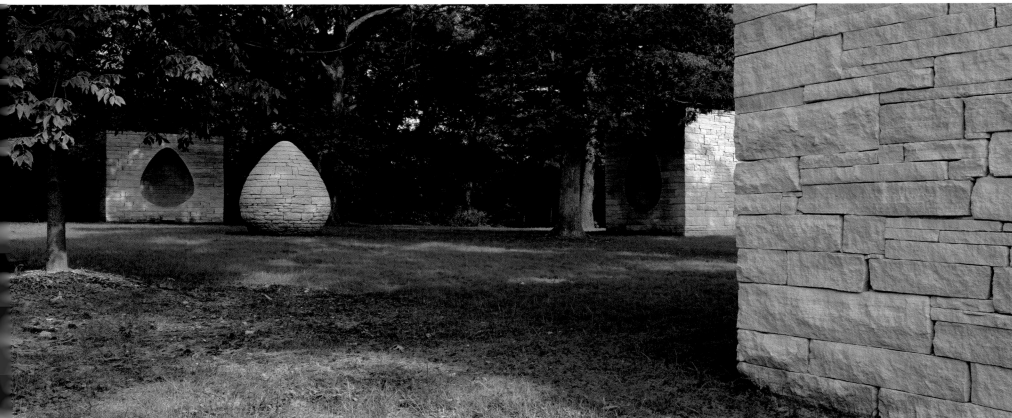

top left, California; top right, New York; bottom, Iowa

date the only instance in which Goldsworthy had employed mathematical calculations for the building of cairns, and insofar as the cairn appears briefly to become a measurable, quantifiable unit, the permanent structures would seem to reference schemes of "land survey, division and settlement" (SFSL 1984), such as were imposed in a westward movement across the United States, most systematically from the time of Thomas Jefferson's Land Ordinance Act of 1785. The two "absent" cairns serve as reminders of the displacement that such visions required; often a phenomenon of the experience of displacement is to search for the familiar and recognizable, or to seek to re-create it. On the other hand, the three temporary cairns—two built for the tides, at Pigeon Point, Half Moon Bay, in California and New Rochelle in New York, respectively, and the third, a prairie cairn, built at Grinnell College in Iowa and subject to a controlled burn—speak of the shifting fortunes of that westward settlement, instantiating some of the basic elemental conditions that would have been commonly experienced from point to point.

76 REFUGE D'ART, CHAPELLE STE MADELEINE, 2002 (REFUGES D'ART)

Wall: H 11′ 11″ (3.6 m), W 10′ (3 m)
Chamber: H 6′ 11″ (2.1 m), W 2′ 4″ (.7 m)

Commissioned by Réserve Géologique de Haute-Provence and Musée Gassendi, Digne-les-Bains, France (see page 71)

Pale limestone from carrière de Revest-St-Martin. Installed April 2002

Architect: Éric Klein

JW, Hugh Hill

Literature: Goldsworthy 2002, 51–61; Yorkshire Sculpture Park 2007, 56; Goldsworthy et al. 2008, 40–51, 162–167

Of his early visits to Digne-les-Bains, Goldsworthy recalled being drawn to "the huge number of old derelict buildings in which there were such interesting spaces" (Yorkshire Sculpture Park 2007, 55). The conception of the *Refuges d'Art* project dates to 1999, when Goldsworthy had completed the first *sentinelle* and was in the process of siting the second. He and Guy Martini first discussed the possibility of a route or walk through the mountains that would directly link all three cairns:

In terms of connecting the three *Sentinelles* by means of a walk, I didn't have my conception of the network of connections that exist between the three valleys. I remember Guy going to find a map to see, and he came back and said, "Yes, we have a circle." (2008, 157)

The *Refuges d'Art* project, which is still unfolding, is substantial in scope and ambition—that is, in the geographical, geological, and emotional terrain that it endeavors to cover. In its broadest sense, it demonstrates the centrality of the notion of the domestic within Goldsworthy's practice—the domestic being rooted in the principle of settlement and the many economies and investments in and of place that it involves. The area around Digne has witnessed much displacement in the twentieth century, as communities long established on mountaintops have progressively relocated to the valleys. It is this foothold that is the purchase for *Refuges d'Art*, and indeed the house or "refuge" is its unit. As literary theorist Robert Pogue Harrison suggested, "the retrieval and perpetuation by which humankind creates a memory and opens its future take place primarily within the human house."[18]

"In the beginning," Nadine Gomez recalled, "we thought that perhaps someone, not necessarily Andy, could determine the route of the walk" (2008, 158–159). Following the completion of the *sentinelle* at Authon in spring 2000, Goldsworthy was taken to see a derelict property above the town of Thoard:

I knew that we had to start with a modest work. I could see that if I chose to rebuild a large, complicated property, the whole project would not happen.…I remember seeing the little chapel…on the hill in the distance. I went straight across the field to it, because I couldn't see any road.…It was also perfectly sized for the first work, being a single room.…The good thing about that day was it really reinforced that I had to go and walk. (2008, 157)

Goldsworthy returned on several occasions over the next year, accompanied by his then-wife, Judith, walking many prospective routes and locating possible properties. By the end of 2000, Goldsworthy had formed a clear vision for numerous buildings, as demonstrated by the number of proposal drawings that he produced.

For *Chapelle Ste Madeleine*, Goldsworthy decided to integrate a stone chamber recess—first used at Clougha Pike (cat. 64)—into the fabric of the chapel, situating it where the altar would have been. Underscored at Clougha Pike in part by Goldsworthy's own biographical referencing, the use of the chamber is here amplified by its situation in the chapel:

The building is on a very spectacular site, with expansive views of the valley below. You see the building from the village, it's in the sky, and then you get up there, and find the chamber, you go into a very internal space. I wanted the Refuge to focus on the internal view, not the extraordinary external one, and how we reflect that in the human condition. It is a message about looking inward, into yourself. I wanted to make the chamber as a further room, a human-shaped form for people to step into. I'd like to think that the chamber will collect the memories of the people who will step into it. You can feel the presence of people in the building. The project is about that: the houses, the works, hopefully they'll get richer the more time people spend with them. (2008, 160–161)

In his exploration of the concept of house, Pogue Harrison invoked Henry David Thoreau, particularly Thoreau's reference to the "burrow"—the primitive cellars dug into the earth over which houses would once have stood. In Walden, Pogue Harrison noted, Thoreau "speaks of such burrows as the grave markers of the vanished houses that once populated the surrounding woods" (DD, 42). Goldsworthy's stone chamber, it could be said, operates within this sense of the burrow as an originary space and as just such a marker to vanished communities and economies of dwelling.

77 WARCOP PINFOLD CAIRN, 2002 (SHEEPFOLDS PROJECT)

Fold: H 4′ 1″ (1.2 m), W 24′ 7″ (7.5 m), D 20′ 4″ (6.2 m)
Cone: H 5′ 9″ (1.8 m)

Commissioned by Cumbria County Council, with funds from the Arts Council of England, UK

Red sandstone. Cairn built April 2002. Fold completed October 2002

SA

Literature: Goldsworthy 2007, 134–135

Drawings dating from the late 1980s reveal that Goldsworthy had long wanted to make a "red fold," built in the round, using sandstone. He did make a round red fold for his exhibition at Storm King, New York, in 2000—a fold that, as he later said, felt like it had "gone to America for sanctuary" (2007, 89). To date, the only red fold (built entirely of red sandstone) currently extant is the pinfold cairn at Warcop, which is of squarish proportions.

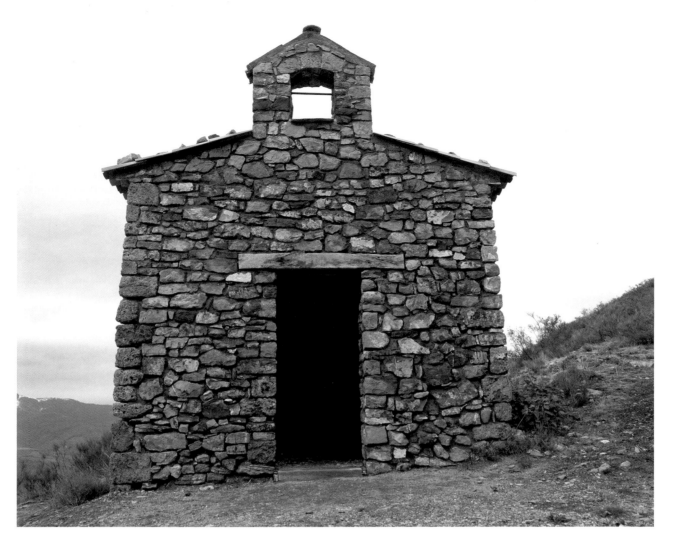

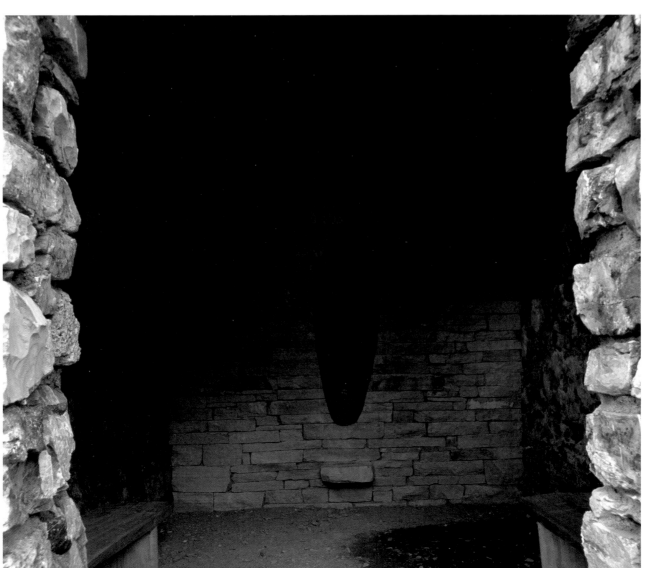

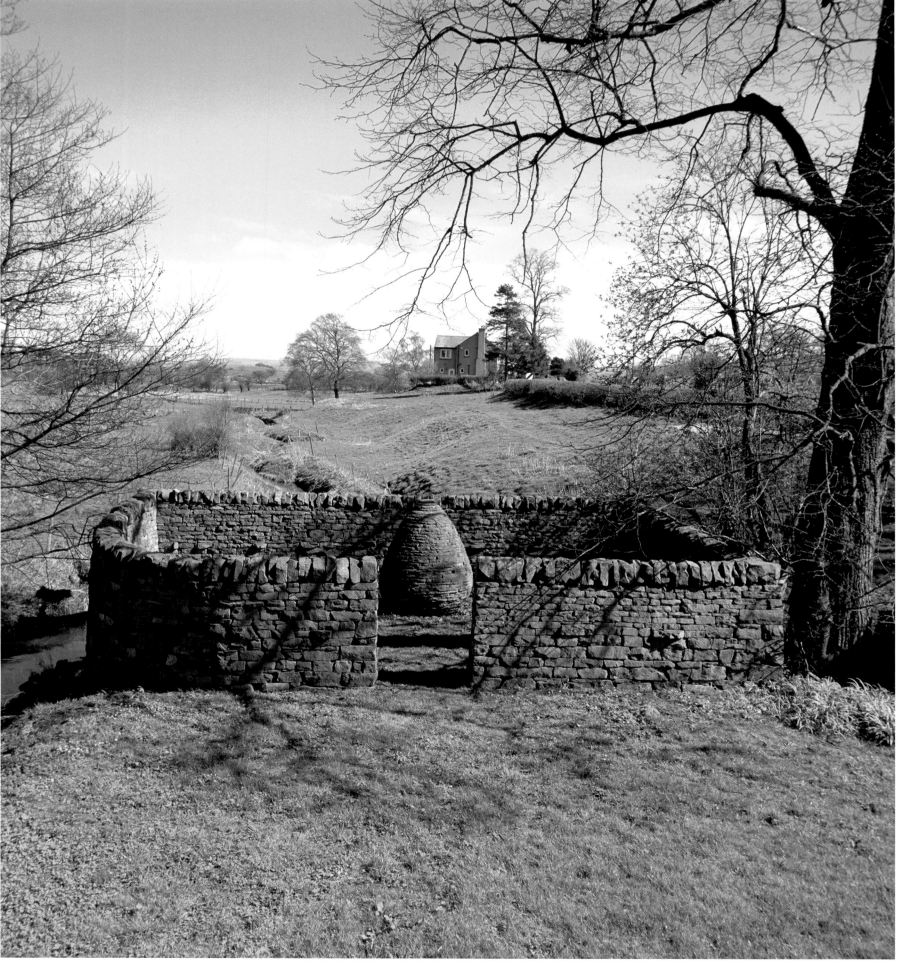

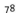

78 RIVER STONE FOLD, 2002
(SHEEPFOLDS PROJECT)

Fold: **H** 5′ (1.5 m), **W** 50′ 11″ (15.5 m), **D** 45′ (13.7 m)
Sculpture 1: **H** 3′ 6″ (1.1 m), **W** 2′ (.6 m)
Sculpture 2: **H** 3′ 6″ (1.1 m), **W** 2′ (.6 m)
Sculpture 3: **H** 4′ 6″ (1.4 m), **W** 2′ 6″ (.8 m)

Commissioned by Cumbria County Council, with funds from the Arts Council of England, UK

River stones sourced from Swindale Beck, and stone from Keith Bragdon, Swaledale Quarry. Installed May and August 2002

SA, AM, Andrew Loudon

Literature: Goldsworthy 2007, 132–133

The fold at Dead Man Ghyll comprises two fairly large chambers and sits by the roadside in the uplands above Brough, near a small stream that flows into Swindale Beck. Goldsworthy first visited Dead Man Ghyll as a possible *Sheepfolds Project* site in 1996, although minutes from later project meetings suggest that research into the ownership of the land began in February 2000. The land on which the fold sits is privately owned but is registered as common land.

Goldsworthy's early proposal drawings for the work show that he intended to include small sculptures in the walls of one of the chambers, reprising a group of freestanding sculptures he made in 1982 on the banks of Swindale Beck:

I made a series of balanced stone works which I called Riverstone Thoughts. My reason for this was that they appeared to me like thoughts, turning the idea over in my mind as I worked....I propose to re-build the fold and in a secondary chamber build into the wall versions of the Riverstone Thoughts—one in each side of the four-sided enclosure. (PS, AGA)

The incorporation of balanced stone structures into walls as symbolic or personally commemorative "reliefs" also recalls *Glenluce Stones* (cat. 48), yet *River Stone Fold* seems particularly self-referential. "Can we," as Owain Jones queried, "recollect past emotional—spatial experiences for the purposes of some attempt at representation?"[19] It would appear to characterize Goldsworthy's endeavor with *River Stone Fold*, in which he eventually placed three votive sculptures that seem to aspire to some kind of self-representation.

79 NIGHT PATH, 2002

L c. 9,842′ 6″ (3,000 m)

Commissioned by the Pallant House Gallery, Chichester, the National Trust/Petworth House, Lord and Lady Egremont, and Leconfield Estate with the support of the Arts Council of England, UK

Pulverized chalk supplied by Duncton Minerals Ltd. Installed February–March 2002. Inaugurated 24 June 2002. Maintained 2002–2003 by Sue Wagstaff, Nick Taylor, and students from Northbrook and South Downs Colleges

ES, John Baker, Hugh Dickenson, Neil Humphries, Tim Jemmet, Paul Kingswell, Mark Ralph, Jumbo Taylor, Nick Taylor, Steve Wadey, David Wort

Literature: Goldsworthy 2004, 153–166; Dorment, in Goldsworthy 2004, 152

Comprising a 3-kilometer path made from pulverized chalk, which weaved its way through the extensive grounds of Petworth Park in Sussex, *Night Path* was conceived as a temporary installation. It was the second of two works commissioned from Goldsworthy by

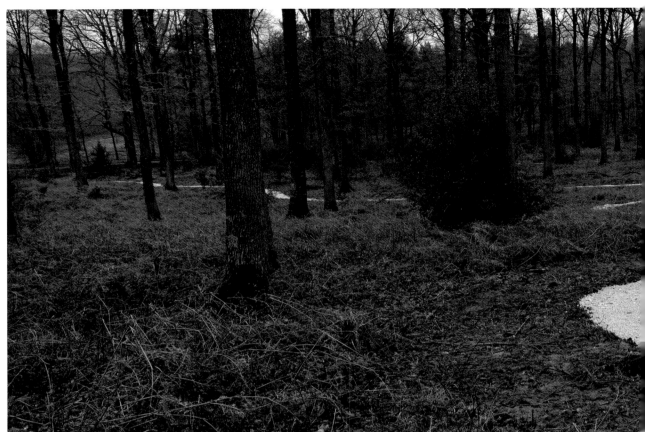

79

Stefan van Raay for the *Strange Partners* project (see cat. 80) and was opened to the public three nights every month, around the full moon, from June 2002 to May 2003. Part of the work has, in the years since, been privately maintained.

Goldsworthy recalled making his first works at night in the early 1980s, chiefly in order to take advantage of the lower temperature when building ice works. "I have made many works," he noted, "sometimes under moonlight, at other times in complete darkness or during dusk or dawn. Inevitably I became interested in night itself and began making works for and about night" (2004, 153). Prior to *Night Path*, Goldsworthy had used chalk to make a large-scale work "for the night" on one other occasion. That work, *A Clearing of Arches: For the Night*, 1995, comprised eleven quarried chalk arches that Goldsworthy installed at the Goodwood Sculpture Park, not far from Petworth Park. Clustered together and viewed in moonlight, the arches emitted a pale, somewhat eerie glow. Goldsworthy originated the idea for a "dark" path, or a walk of chalk to be experienced at night, at Goodwood following the installation of the arches: "I think the idea of an extension of the arches to be seen at night in the form of a path to be walked is one that I find particularly interesting" (C, to Michael Hue-Williams, 5 January 1998, AGA).

Goldsworthy first proposed the idea for a moonlight path in collaboration with Sandra Drew of Stour Valley Arts as early as 1996. In early correspondence, Goldsworthy referred to the work as "Taking a chalk line for a walk" (C, Michael Hue-Williams to Sandra Drew, 6 January 1997, AGA), which he initially conceived as being up to 3 miles long and 3 to 4 feet wide. The original location earmarked for the project was King's Wood in Challock, Kent. Goldsworthy tried out a small area at King's Wood in August 2000, where, though now overgrown and difficult to find, his test work is still discernable. King's Wood, however, is an ancient woodland site, and following concerns voiced in relation to this status, it was decided in January 2001 that the project would not be realized in the North Downs. The possibility of creating the path in the South Downs was explored by Stefan van Raay (with whom Goldsworthy was already developing *Chalk Stones* for the *Strange Partners* project), and in summer 2001, he introduced Goldsworthy to Lord and Lady Egremont with a view to realizing *Night Path* at Petworth House.

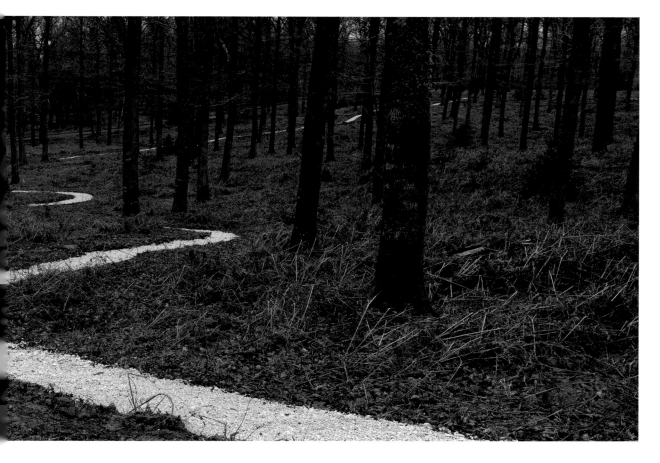

80 CHALK STONES, 2002

14 boulders, each: ⌀ c. 6–7′ (1.8–2.1 m)

Commissioned by the Pallant House Gallery, Chichester, and the South Downs Conservation Board with support of the Edward James Foundation, West Dean, and the Arts Council of England, UK

Chalk from Duncton Minerals Ltd. Installed June 2002

ES, AMcK, Sue Wagstaff, Nick Taylor

Literature: Yorkshire Sculpture Park 2007, 64

Chalk Stones comprises fourteen chalk boulders, quarried and carved at Duncton Quarry in Sussex, England, thirteen of which Goldsworthy installed at various points on the West Dean and Cowdray Estates in the South Downs in Sussex, linked by a 5-mile walk. The fourteenth stone is sited in the grounds of the Petworth Estate. The work was commissioned as part of *Strange Partners*, a project initiated by Stefan van Raay, director of Pallant House Gallery, Chichester, and supported by a partnership comprising Pallant House, South Downs Conservation Board, The National Trust, West Sussex County Council, Chichester District Council, Leconfield Estate, and West Dean and Cowdray Estates.

Van Raay contacted Goldsworthy perhaps as early as 1998 to discuss a "possible project between Chichester and Midhurst/Petersfield in the South Downs," for which Goldsworthy put forward the idea of a "trail of cairns; each showing the geological changes on a breaking point" (c, from Stefan van Raay, 25 February 2000, AGA, here and following). He then approached Goldsworthy again early in 2000, aware that Goldsworthy was developing a moonlight path (see cat. 79) with Stour Valley Arts, and suggested that he might be interested in linking the two commissions: "one in the Western part of the South Downs and one in the Eastern part of the North Downs."

Goldsworthy spent the 1999–2000 winter preparing the sizable snowballs that he installed at various locations in London on 24 June 2000. He suggested situating large chalk boulders throughout the South Downs, to be chanced upon by passersby, in much the same manner as were the snowballs. He visited the South Downs in June 2000, after completing the installation of *Midsummer Snowballs*. Although a memorandum following that visit (c, from Stefan van Raay, 30 June, AGA) suggests that the cairn idea was "not forgotten,'" Goldsworthy developed the proposal for "chalk stones," noting:

Goldsworthy intended to lay out the path so that the visitor would be drawn into and guided through the darkness. He wanted the visitor's experience to be one in which touch and hearing would become acutely sensitized: "By day we are spectators but at night we are enveloped by the dark—the division between ourselves and place becomes obscure. Form becomes less defined. The experience is more introspective" (PS, *Night Walk*, AGA). The route itself was marked out and installed from February to March 2002, and it traversed four distinct areas of the Petworth estate: the oak wood, the pine wood, the chestnut coppice, and the parkland. Goldsworthy noted that the sensory quality of the walk varied considerably between those sections of the walk, which is darkest and most disorienting under the pine canopy.

The work is most often referred to as *Moonlit Path*, a title initially used by Goldsworthy, which has encouraged focus on its lunar element. For Richard Dorment, reviewing it in the *Daily Telegraph* (London), it brought to mind Japanese artist Yoshitoshi's series of woodcuts *One Hundred Aspects of the Moon* (Goldsworthy 2004, 152). Goldsworthy himself published photographs of the path in 2004 under the title *Night Path*. He did so in part, he suggested, to play down the romanticizing of the work. To photograph it at night, Goldsworthy had to allow for exposure times ranging between eleven and forty-four minutes. The resulting images are beautiful tonal studies that constitute some of Goldsworthy's most subtle and suggestive photography. They do indeed support Dorment's suggestion that "artists as different as Chopin, JM Whistler and Debussy would have recognised at once that [*Night Path*] is, in essence, a nocturne" (Goldsworthy 2004, 152).

Had the path been installed in the more prosaic woodland in Kent where Goldsworthy tested an area, the more romantic readings of the work might have been repressed. Designed by Capability Brown, the landscape lends considerable atmosphere to *Night Path*. The experiential scope of the work was perhaps best summed up by Dorment as one that oscillated between the elatory and the unnerving:

To see a landscape by moonlight is rare in an age of sodium street lamps and brightly lit houses. At its simplest level, Goldsworthy's project connects us with something elemental in ourselves, some instinctive fear of the night, and awe of the moon, worshipped by ancients in the form of Hecuba or Diana. (Goldsworthy 2004, 152)

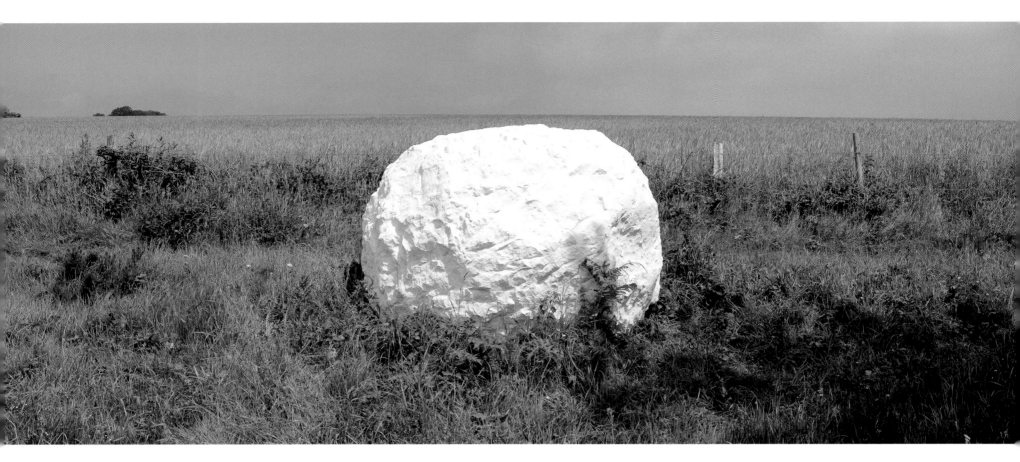

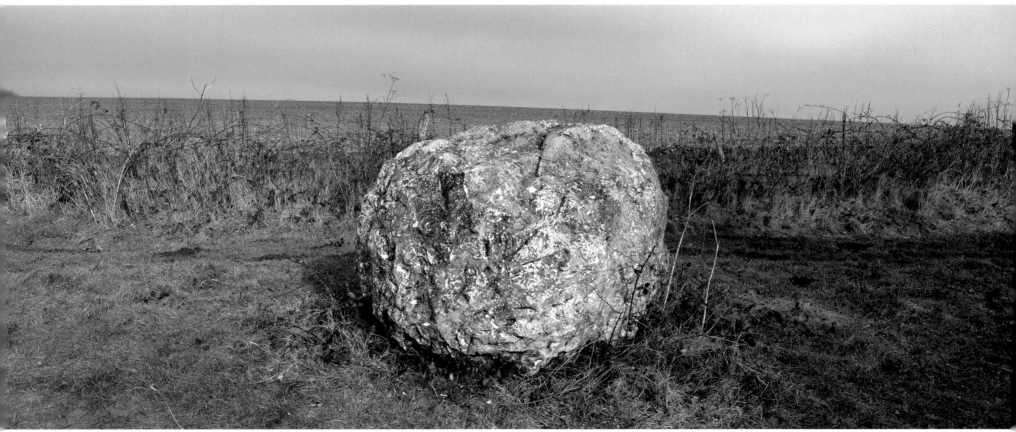

80 top, 2002; bottom, 2006

[C]halk is a huge mass of material in the Downs and yet it is largely hidden. Where it does make an appearance, in the cut of a road or the face of a quarry, it looks strange and unreal, as if it doesn't belong....It has the appearance of a wound. (PS, *Chalk Stones*, Sussex Downs 2001, AGA, here and following)

Chalk Stones is, in effect, a time-based work, insofar as Goldsworthy intended that the chalk boulders respond to their setting, changing and ultimately decaying. Thus, *Chalk Stones* offers a temporal recalibration rather than a durable rendering of *Midsummer Snowballs*. The acclimation of the boulders (evolving from glaring white to murky, mossy green), their increased secretion in their settings, and their anticipated life span (measured in years rather than days) fit into Goldsworthy's long-standing interest in "the many things that make the landscape rich in events and constructions that when new were a shock, but over time have become accepted and to some extent no longer seen." As he noted, "it will be interesting to see, after the initial shock of the chalkstones, if [they] will also become accepted as belonging to the places in which they are put."

Goldsworthy made at least three trips to find locations for the chalk boulders. The first was in summer 2001, and Goldsworthy's initial preference was to site the stones in the Bignor Roman Villa area of the Downs. By December, however, Goldsworthy and Van Raay decided to contact the major estates of West Dean and Cowdray, both of which proved extremely accommodating, and the final locations were selected in February 2002. Goldsworthy had initially thought that he would have to form the chalk stones through a process of compaction. While visiting Duncton Quarry in December 2001, however, Goldsworthy and the project manager Eric Sawden learned that the quarry was able to extract large blocks of chalk that could be carved into shape. The maximum size of block that Duncton was able to extract thus determined the diameter of the stones. Goldsworthy and Sawden began work in the quarry in February 2002, and the stones were stored on the Petworth Estate until their installation in June.

81 OAK CAIRN, 2002

H 16' 4" (5 m), ⌀ 12' 6" (3.8 m)

Private Collection, Charente, France

Sessile curved oak branches from the site and surrounding area. Commissioned 2001 and installed August 2002

Literature: Goldsworthy 2004, 88

Oak Cairn was the second of three works commissioned for a private estate in the southwest of France. It and *Pool of Light* (cat. 82) were commissioned as Goldsworthy was completing the installation of *Heart of Oak* (cat. 71). He proposed another cairn, which would have the same proportions as *Heart of Oak* and use the remainder of the storm-fallen oak branches.

However, he elected to build this cairn within a long woodshed that adjoins the field in which the first cairn was made. As with *Two Oak Stacks* (cat. 67), Goldsworthy intended *Oak Cairn* to be a foil for *Heart of Oak*—one sculpture sheltered and protected, the other exposed.

Goldsworthy was also interested in establishing a link between the estate's history of selective wood farming, and the sudden and substantial felling wrecked by Hurricane Martin at the end of 1999. The shed, which measures 100 meters, had long been used by the estate to store old sawn timber. By installing the cairn in the shed, still home to wood detritus, a certain counterpoint was achieved between wind-fallen and harvested, between the often indiscriminately destructive force of nature and the measure of human cultivation and habitation.

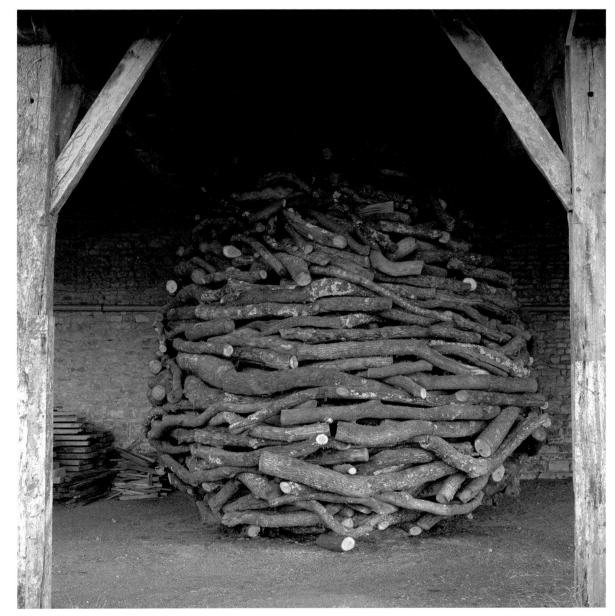

81

82 POOL OF LIGHT, 2002

H 1′ 5″ (.4 m), W 36′ (11 m), L 72′ 1″ (22 m), ⌀ 22′ 9″ (6.9 m)

Private Collection, Charente, France

Cleft chestnut logs. Installed August 2002

Yves Rondinaud, Serge Choisy, Bruno Gerbaud, Katie Budge

Literature: Goldsworthy 2004, 88 – 91

Pool of Light is the third commission that Goldsworthy completed in Charente in France. For this work, Goldsworthy used chestnut from the estate that had been brought down in the storms of 1999 and then split into logs for use as firewood. A low, horizontal, rectangular staging area situated in front of the château was built to dimensions that correspond to those of the center of the house. Onto that terrace-platform, Goldsworthy laid and arranged the split logs, the majority of which he laid diagonally across the horizontal plane. At the center of the rectangle, Goldsworthy isolated a circle and placed the logs therein at a 90-degree angle to the others. With the passage of the sun over the south-facing terrace, the variation

in light activates the variation in the laying of the wood. In effect, the edges of the split logs create a sensitized surface, responsive to changing light conditions throughout the day. Early in the morning, the central circle appears to be dark, with the surrounding wood appearing light. In the late afternoon, this effect is reversed, and at times of even (as opposed to angled) light, there is no differentiation.

Goldsworthy's technique of laying the logs is derived from the method he has used to build upright slate stacks such as *Enclosure* (cat. 50) wherein he differentiated a central form (frequently a circle or barrel) from the horizontal stacking by setting slate vertically or diagonally to it. Goldsworthy's title *Pool of Light* invokes the notion of reflection and the reflective capacity of water, and relates the work to an ephemeral precursor that Goldsworthy made in June 1999 near the river Bès at Digne-les-Bains, while working outdoors with the dancers from the Ballet Atlantique. *Pool of Light* can also be related to Ben Nicholson's few large-scale, exterior reliefs, specifically his marble wall at Sutton Place, Surrey, which he installed in 1982 near a small pond in order to engage notions of reflection and mirroring.

83 CORNER CAIRN FOLD, 2002 (SHEEPFOLDS PROJECT)

Fold: H 4′ 3″ (1.3 m), W 25′ 3″ (7.7 m), L 51′ 2″ (15.6 m)
Cairn: H 8′ 2″ (2.5 m), ⌀ 14′ 1″ (4.3 m)

Commissioned by Cumbria County Council, with funcs from the Arts Council of England and Yorkshire Dales National Park, UK

Fell and river stones from remnants of derelict fold. Installed late August – September 2002

SA, AM, Martyn Hall, Andrew Pratt, Des Metcalfe

Literature: Goldsworthy 2007, 136 – 141

Corner Cairn Fold is situated on Brant Fell, a sizable piece of common land within the Howgill Fells. Goldsworthy made his first site visit to view the derelict washfold up at Brant Fell early in 2001. With the outbreak of foot and mouth disease in February, he was not able to visit again until much later in the year, and that walk up to the fold was the last he was able to take in Cumbria for several months. Goldsworthy subsequently proposed rebuilding the washfold and

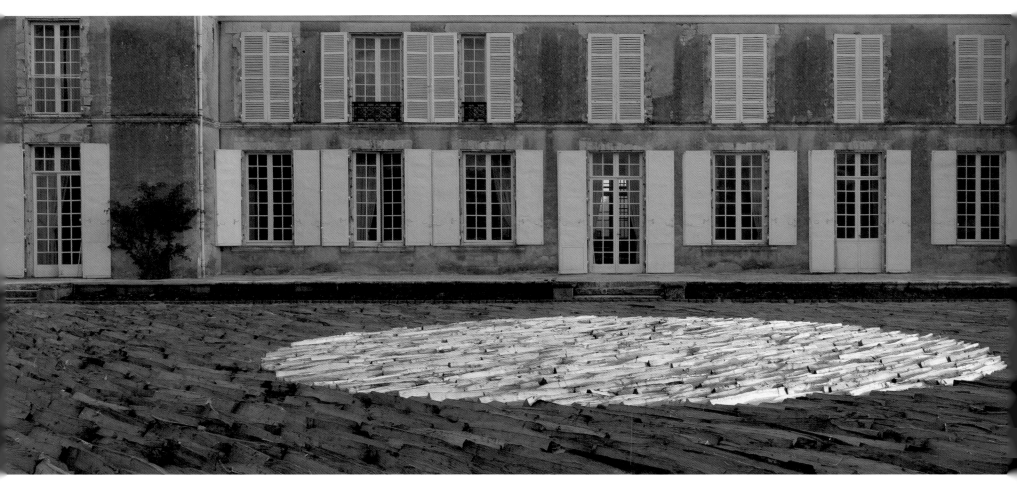

152

82

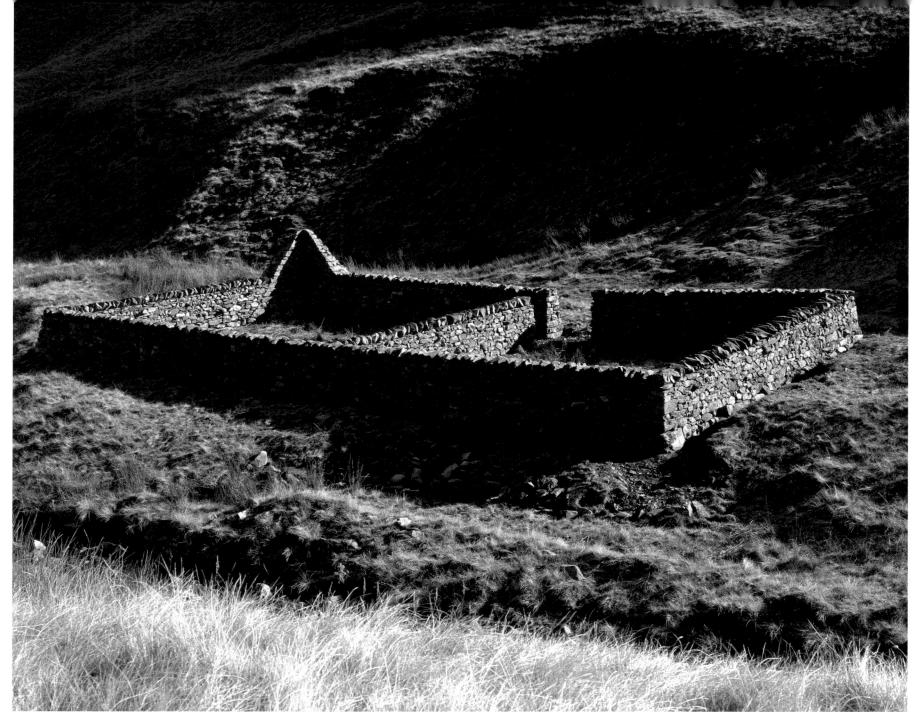

83

building, in one of the chambers, a 6- to 7-foot-high cairn inside the fold or nearby that he would clad with washed fleeces. The fleeces would then be set on fire or left to disperse in the wind:

[The wool's] disappearance will be evocative of the loss of sheep....Empty fields stand as potent and disturbing witnesses to the departure of the sheep. I would like the cairn to have a similar quality. I realise that burning wool may appear insensitive at this moment, but fire was central to [the] way in which the problem was tackled. (Goldsworthy 2007, 136)

Permission for *Corner Cairn Fold*'s plan, however, was required from Yorkshire Dales National Park—a process entailing consultation with various interested parties.

The response to Goldsworthy's proposal from those parties was mixed: the so-called heritage aspect of rebuilding the sheepfold could be accepted, but there was a strong objection to the fleece cairn as likely to cause offense. Furthermore, no cases of foot and mouth occurred on the Howgill Fells, and it was felt the location of a memorial there would be inappropriate (2007, 136–137).

Goldsworthy ceded to opinion and instead elected to build a pyramidal cairn in one corner of the washfold, with the corner of the fold appearing to cut an angle out of it. The new proposed fold represented not "the farmer's perspective on foot and mouth but my own" (2007)—the cut or absence referring to the year the *Sheepfolds Project* lost to foot and mouth. Yet

for those afflicted by the culling of animals on farms that the outbreak necessitated, the sheer immensity of death involved "transcended the loss of the material...and became also the loss of the conceptual," while it "transgress[ed] the emotional geographies of the farm as the place of livestock management and the abattoir as the place of livestock death, because death was in the wrong place, at the wrong time and on the wrong scale."[20] Despite Goldsworthy's insistence that *Corner Cairn Fold* does not represent "the farmer's perspective" on the outbreak, it is precisely that latter loss—"the conceptual"—that it embodies. "In the wrong place" itself, *Corner Cairn Fold* may be viewed as a monument to those transgressions of place, scale, and emotion.

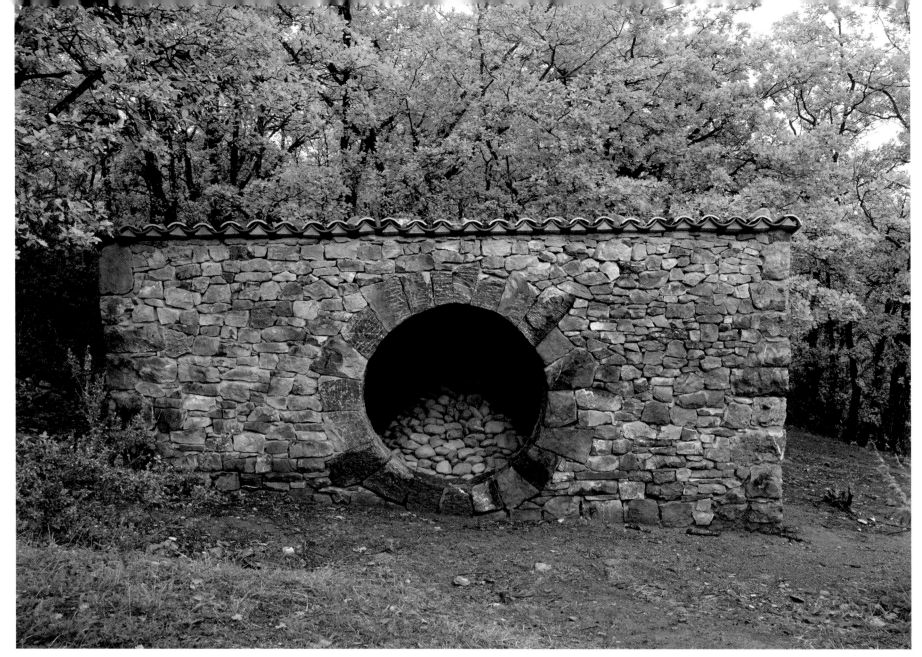

84

84 REFUGE D'ART, LES BAINS THERMAUX, 2002 (REFUGES D'ART)

Entrance: ø 4′ 11″ – 6′ 11″ (1.5 – 2.1 m)
Cairn: H 4′ 3″ (1.3 m), ø 6′ 11″ (2.1 m)

Commissioned by Réserve Géologique de Haute-Provence and Musée Gassendi, Digne-les-Bains, France (see page 71)

Dark gray limestone found on-site, and pebbles from the river Eaux-Chauds. Installed November 2002

Architect: Éric Klein

ES, SA, GW, JW, AM, MH

Dedicated to Antoine Gomez

Literature: Goldsworthy 2002, 97–99; Goldsworthy et al. 2008, 124–125

Refuge d'Art, Les Bains Thermaux comprises a low, rectangular building, into the sidewall of which Goldsworthy built a 360-degree circular arch that frames a large stone cairn. Where previously, he had used the circular arch as a freestanding form, here Goldsworthy integrated it into an architectural setting and brought it into relationship with the pyramidal cairn form. Goldsworthy first explored the combination of wall, circular arch, recess, and cairn on a smaller scale in an ephemeral work that he built into the embankment of the river Bès on 15 July 1995. He initially proposed making it a permanent form, as part of a series entitled Les Maisons des Pierres, for the walls of the Musée Promenade de St-Benoît in 1997. Goldsworthy had intended with that proposal that visitors might add or remove stones from the cairns as they embarked upon or returned from their journeys.

Such a work was not realized on that occasion, but this refuge provided the opportunity for

Goldsworthy to integrate the circular arch, recess, and cairn more successfully. Les Bains Thermaux includes only one cairn, which is considerably larger in scale than what Goldsworthy intended for the walls of the Musée Promenade. At Les Bains the circular arch is no longer an aperture though which to look or to reach with the hand; it is a point of entry and exit for the body. This refuge was initially conceived as one of a pair, with the second, identical work at La Comberge. That work, which would have constituted the first refuge, will not be built. However, it indicates that Goldsworthy initially anticipated the pair to reflect the circularity of the Refuges Walk.

Goldsworthy has imagined that those who start and complete the Refuges Walk will add stones to the cairn at Les Bains Thermaux; he has also speculated that perhaps a point will come when the house will be entirely full of stones.

85 CORNER STONE FOLD, 2002 (SHEEPFOLDS PROJECT)

H 5′ (1.5 m), **W** 32′3″ (9.8 m), **D** 17′8″ (5.4 m)

Commissioned by Cumbria County Council, with funds from the Arts Council of England, UK

Walling stone from derelict fold, and boulders sourced from farm. Installed late November– early December 2002

SA

Literature: Goldsworthy 2007, 142–143

An owner of a farm in North Cumbria contacted Goldsworthy and Dick Capel directly in the latter stages of commissions for the *Sheepfolds Project*, inviting Goldsworthy early in 2001 to view a derelict rectangular fold. It stood fairly close to the farmhouses, and Goldsworthy, after making a series of site visits there, noticed several large boulders that had been incorporated into the footings of some of the farm buildings. Goldsworthy has long had a fascination with buildings built around bedrock or boulders such as those he first viewed in Digne-les-Bains in France. Interestingly, Goldsworthy's proposal for *Corner Stone Fold* also made reference to one of the initial proposals

Goldsworthy made in 1995 for *Field Boulder Fold* (cat. 35). It is possible that the Mungrisdale folds were in Goldsworthy's mind, for they are located relatively nearby (s, Potts Gill, AGA, here and following).

Goldsworthy agreed to rebuild the fold, with the proposal that he would place a large boulder in each of the four corners, like foundation stones:

I have always been interested in corner stones. They have a structural importance that gives them a conceptual significance also. I eventually decided to rebuild the fold with a large stone in each corner... this idea was confirmed.... For a stone used in such a prominent and importance place, I am intrigued that it has been left oversized and boulder like. The rest of the stone work shows an ability to work the stone into a more regular shape.

Goldsworthy commenced work on the fold in late November 2002, upon return from Digne-les-Bains, and it was completed shortly thereafter.

86 SLATE FOLD, 2003 (SHEEPFOLDS PROJECT)

Fold: **H** 5′1″–6′6″ (1.5–2 m), **W** 60′8″ (18.5 m), **L** 60′1″ (18.3 m), **D** 1′4″ (.4 m)
Slate wall 1: **H** 6′6″ (2 m), **W** 10′8″ (3.3 m), **ø** 4′4″ (1.3 m)
Slate wall 2: **H** 5′10″ (1.8 m), **W** 10′7″ (3.2 m), **ø** 4′3″ (1.3 m)
Slate wall 3: **H** 6′4″ (1.9 m), **W** 10′9″ (3.3 m), **ø** 4′5″ (1.3 m)
Slate wall 4: **H** 5′10″ (1.8 m), **W** 11′2″ (3.4 m), **ø** 4′4″ (1.3 m)

Commissioned by Cumbria County Council, with funds from the Arts Council of England, UK

Blue slate donated by Burlington Slate, and fieldstone from surrounding area. Slate works built March and fold completed June 2003

SA, GA, AM, AL, Dan Sumner

Literature: Goldsworthy 2007, 146–149

Goldsworthy first visited Tilberthwaite to look for sheepfold sites in April 1996, and he made two proposal drawings for two different sites at that time. One of those proposals was for a wall that would run along the base of a fell with a series of small round folds built at intervals and enclosing large boulders. That proposal shared a number of features with *Drove Stones* (cat. 38), which Goldsworthy was then preparing to build and which was situated along Fellfoot

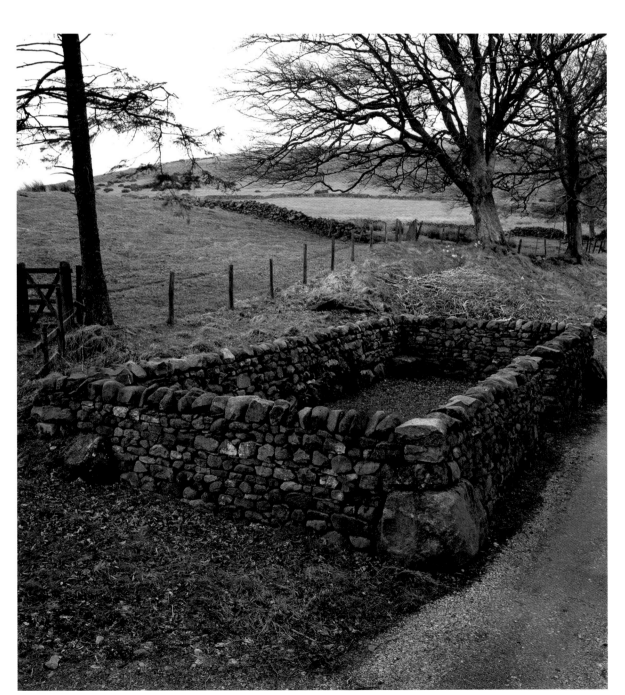

Road at Casterton in 1996. The second proposal differed considerably and was developed for a large, single square fold, adjacent to a disused slate quarry. Goldsworthy had made several early proposals for folds containing slate, such as Dunnerdale. Attracted to its "sharp, aggressive side," Goldsworthy noted:

It also cuts light: it is both dark and light depending on which way it catches the light....In each side of the fold, I would embed a slate circle within a square so that it would act like a clock...not unlike the four snow circles I made at the North Pole. It would act like a time piece. (PS, AGA)

Goldsworthy elected to proceed with the second proposal. However, the ownership of the fold took some time to establish. Work was eventually able to begin on-site in March 2003. The four square slate walls were built first, with blue slate quarried locally. As on previous occasions, Goldsworthy differentiated the direction of the slate laid in the central circle from that surrounding it. In *Slate Fold*, each slate circle is laid at a different angle and responds to lighting conditions according to its position in the fold and the manner in which the slate was stacked. Once the slate structures were completed, the fold walls were rebuilt using fieldstone from the surrounding area. It is the largest of the folds to be rebuilt within the fold.

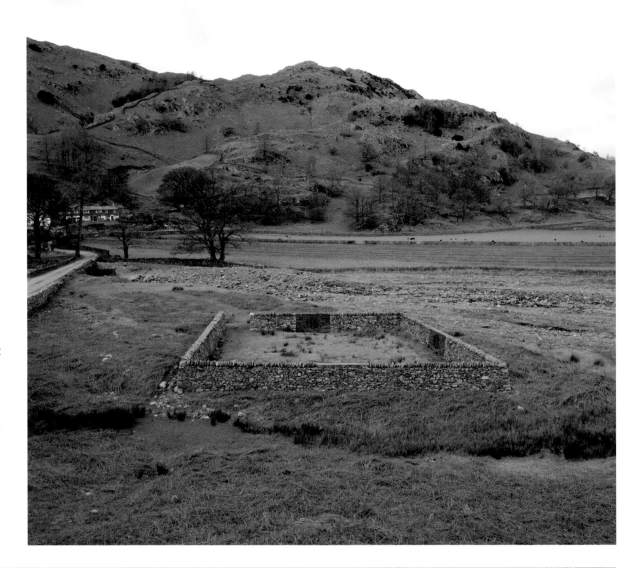

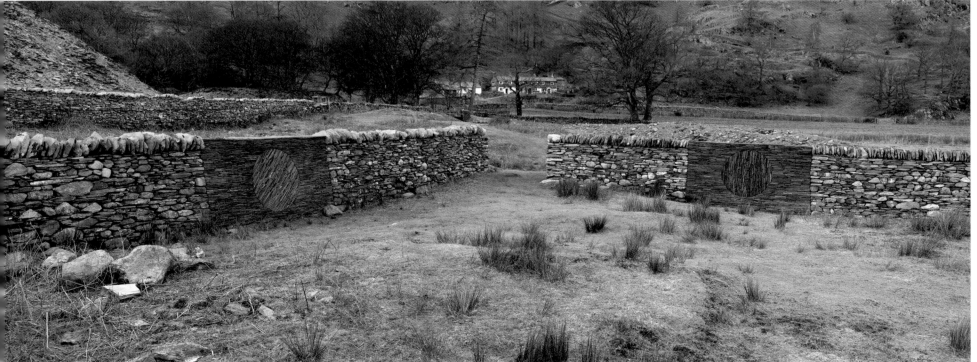

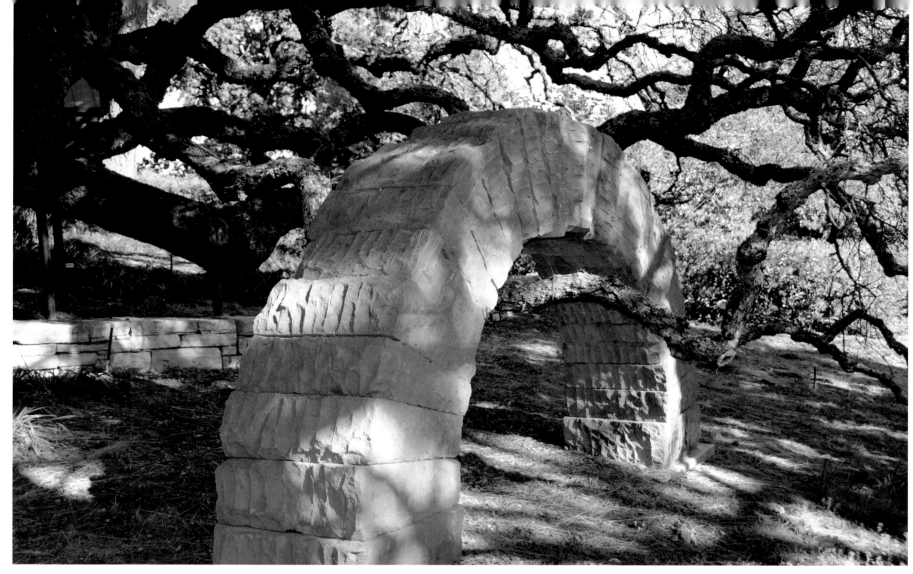

87

87 DOW ARCH, 2003

H 6′9″ (2.1 m), S 12′4″ (3.8 m), D 2′ (.6 m)

Private Collection, California, US

5 tons of Locharbriggs red sandstone. Installed
April 2003

ES, GW, JW

This arch was built in Dumfriesshire early in 2003. It
was subsequently shipped to California and installed
"striding" over a long, low-lying branch of a tree.

88 DROVE ARCH HUT AND TOBY'S FOLD, 2003 (SHEEPFOLDS PROJECT)

Arch: H c. 5′3″ (1.6 m)
Fold: H 4′8″–4′10″ (1.4–1.5 m), W 17′5″ (5.3 m),
D 19′11″ (6.1 m)

Commissioned by Cumbria County Council, with funds
from the Arts Council of England, with additional
financial support from family and friends of Toby
Grimwood, Craven District Council, and the Yorkshire
Dales Millennium Trust, UK

Locharbriggs red sandstone (arch) and limestone,
sandstone, and walling stone sourced locally (fold and
hut). Completed March 2003

NM, Jeff Metcalfe, Steve Harrison

Literature: Goldsworthy and Craig 1999; Goldsworthy
2000b, 199; Goldsworthy 2007, 144–145; Yorkshire
Sculpture Park 2007, 43–45

Goldsworthy recalled that he felt it was important
that "some aspect of the *Sheepfolds Project* began out-
side Cumbria, went through Cumbria, and ended up
out of Cumbria" (Yorkshire Sculpture Park 2007, 43,
here and following). He also wanted the project to
incorporate routes determined by movement—what
he called the "economic river of animals"—as well
as the folds and enclosures that give that movement
structure and rhythm. This found focus in the network

of "roads, walls and lines," or "drove roads," along
which, as Goldsworthy explained, "livestock, usually
sheep and cattle, were taken to market, often ulti-
mately leading to London."

The resulting *Drove Arch* project took place over
twelve days, from 7 to 18 June 1997: Goldsworthy jour-
neyed south, following the trajectory of a historic
drove route. Starting at Spango Farm in Dumfriesshire,
he and assistant Nigel Metcalfe (with Katy Hood) con-
structed, dismantled, and reconstructed a small red
sandstone arch at twenty-two locations, eleven of
which related to derelict sheepfolds; they concluded
their journey near Kirkby Lonsdale. Ten of the eleven
derelict fold stances, at which the arch was erected,
have since been restored (with the exception of Thun-
derstone, Shap). The arch is now permanently housed
in *Drove Arch Hut*, a rebuilt stone hut at Thornton-in-
Lonsdale, which is on the North Yorkshire and Cumbria
border. Next to it, a twelfth working sheepfold has
been constructed and dedicated to the memory of
Toby Grimwood, who worked as an assistant to Golds-
worthy on a project at Goodwood Sculpture Park in
the south of England.

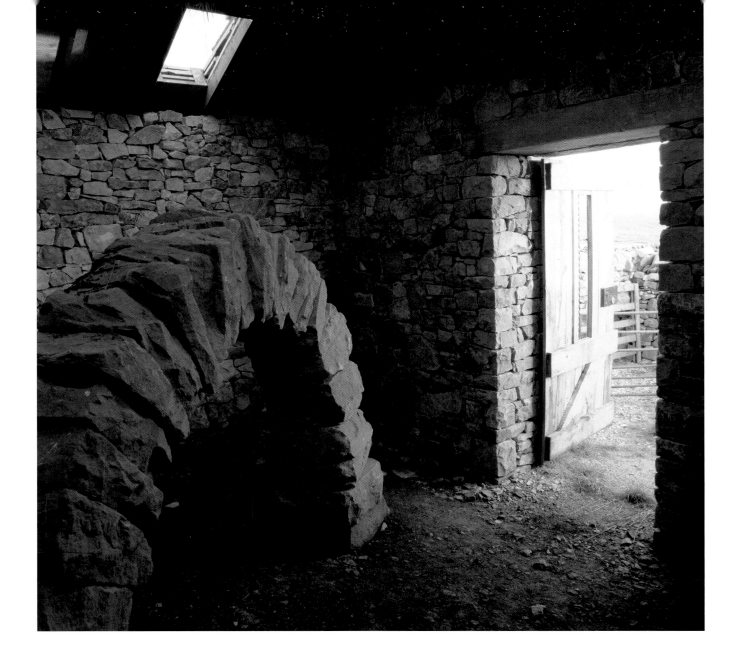

158

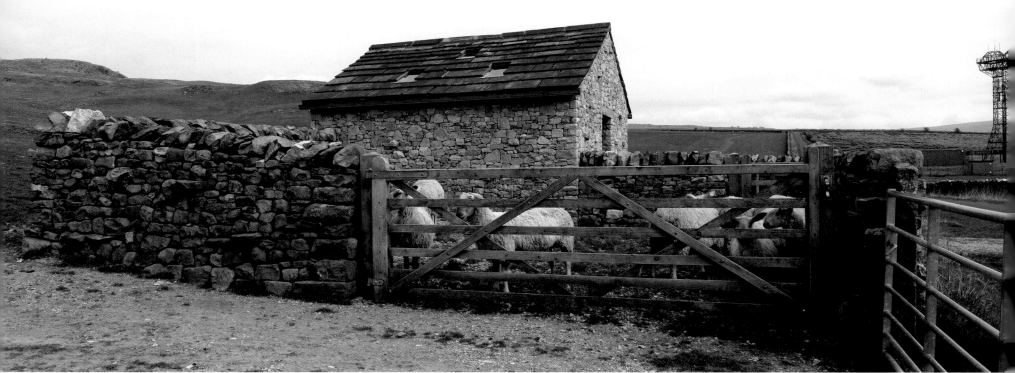

88

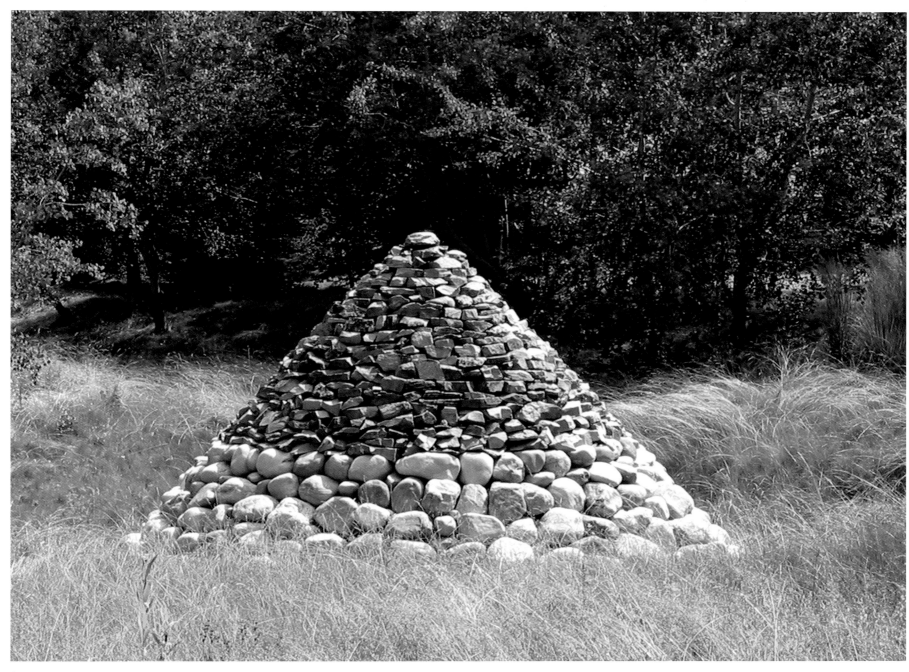

89

89 FLOODPLAIN CAIRN, 2003

H 12′ (3.7 m), ⌀ 22′ (6.7 m)

Private Collection, Western US

75 tons of river rocks 6–20 inches thick.
Installed July–August 2003

SA, GW, JW, AM, MH

Goldsworthy first visited the grounds of a private resi-
dence in July 2001. Then in the process of being built,
the residence now sits within view of a river on a
100-year floodplain, which consequently determined
aspects of the property's development. A floodplain

is the area adjacent to a river, creek, lake, stream, or
other open waterway that is subject to possible flood-
ing when there is significant rainfall. If a property is
situated on a 100-year floodplain, there is a 1-in-100
chance in any given year that it will flood. In the
United States, flood areas are marked out on flood
insurance rate maps, and Goldsworthy used the con-
tours and levels delineated in them as his starting
point for developing proposals for the property.

In a letter to the owners (c, 30 January 2002,
AGA) Goldsworthy referred to an idea for a "geological
cairn" to mark the maximum height of flooding waters
within the floodplain. Whereas *Floodstones Cairn*
(cat. 22) referenced the history of flood levels actually

achieved in the vicinity of a river in Illinois, this cairn is
essentially predictive, based on the floodplain designa-
tions. Goldsworthy considered siting it near the river,
as he had *Floodstones Cairn*. However, he eventually
located the cairn close to the residence, constructing
it in an excavated area 4 feet deep so that the greater
part of its bulk would sit below grade. Large boulders
make up the bulk of the form, with smaller stones
used at 6 feet to indicate the floodplain. Though they
are mapped, floodplains are not fixed and can change
according to broader forces, erosion for instance. As
constructed, *Floodplain Cairn* becomes a marker of the
use and regulations to which the land it occupies was
then subject.

90 FLOOD LINE, 2003

H aboveground 4–6' (1.4–1.8 m), L 235' (71.6 m)

Private Collection, Western US

Quarry rubble. Installed July–August 2003

In the same 30 January 2002 letter to the owners (AGA, see cat. 89), Goldsworthy described a second work relating to the floodplain, but referencing instead the contours rendered on the flood insurance rate maps. A carved stone edge following the predicted flood line would be set directly into the ground. Goldsworthy deliberately left the specifications of this work loose until he arrived to create it. Thus, the work took on and still retains the quality of a drawing.

90

91

91 TREE LINE, 2003

H average 12–14' (3.7–4.3 m), L 217' (66.1 m)

Private Collection, Western US

232 aspen saplings. Installed July–August 2003

Goldsworthy installed a third work for these owners (cats. 89, 90), which comprises a row of planted, close-growing aspen trees that will in time form a cagelike screen alongside a road that leads through the property. The title *Tree Line* evokes the visible residue lines that often remain on rows of trees situated within flood-plains or close to riverbanks, and which indicate the height that waters reached. Goldsworthy selected the aspen for *Tree Line* because this relatively fast grower will form a dense screen.

92 GARDEN OF STONES, 2003

Garden: 4,150 ft.² (385.5 m²) with 18 boulders
Largest: H 7' (2.1 m), L 9' 6" (3 m), C 24' 6" (7.5 m)
Smallest: H 4' (1.2 m), L 4' ½" (1.2 m), C 14' 8" (4.5 m)

Museum of Jewish Heritage — A Living Memorial to the Holocaust, New York City, US

Glacial granite boulders from Vermont, each containing a dwarf oak. Commission organized by Public Art Fund, New York. Installed August–September 2003. Trees supplied by Ken Asmus, Oikos Tree Crops, Michigan. Garden tended by Charles Day

JE, Gerri Jones, Ed Monti, Tom Whitlow, Miriam Pinkser, Karen Edelstein

Literature: Goldsworthy 2004, 58–74; Yorkshire Sculpture Park 2007, 61–62

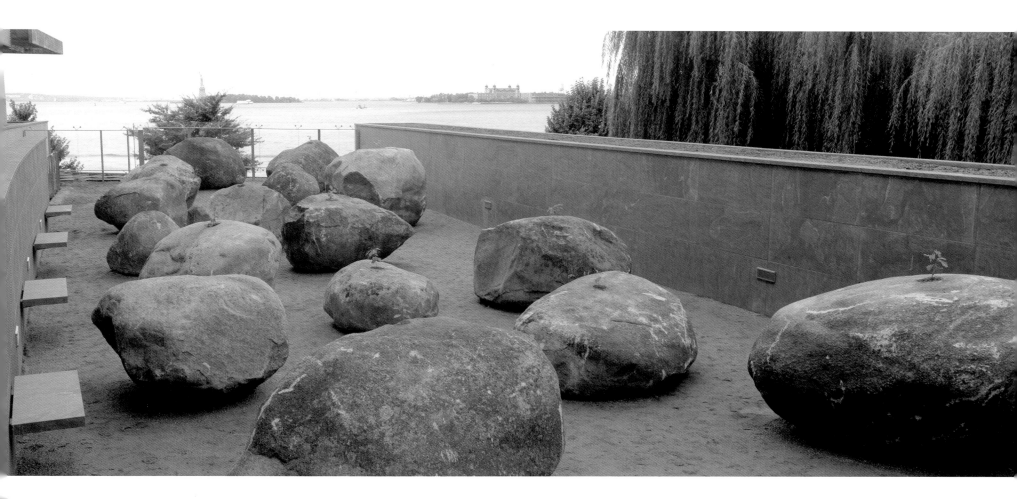

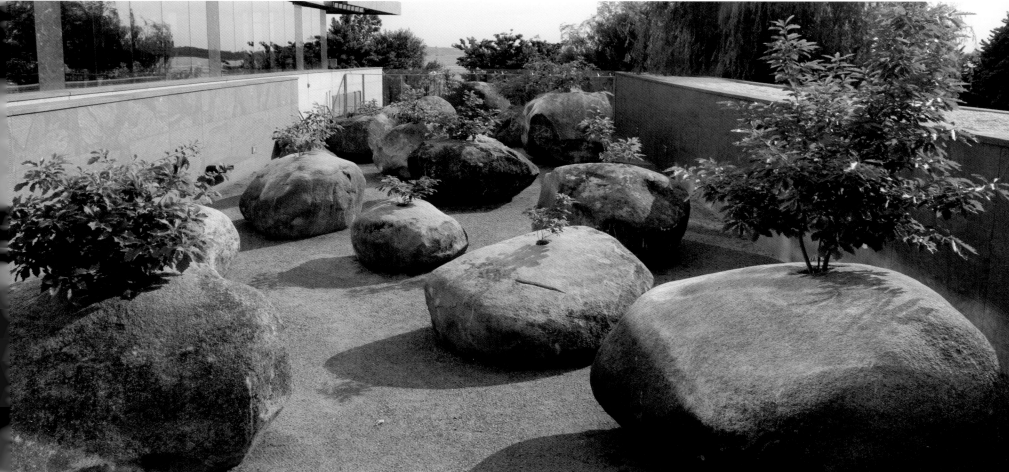

92 top, 2003; bottom, 2009

In early 2002, the Museum of Jewish Heritage in New York City invited Goldsworthy to submit a proposal for a garden or living memorial to the Holocaust to be sited in their building at Battery Park in downtown Manhattan. The site was a longish, open area, accessible via the museum's top floor and overlooking the Hudson River. In response, Goldsworthy developed two proposals. The first, a "Garden of Shadows," would have required the installation of large flat-topped stones, upon which people would lie in the rain to leave a "shadow." For Goldsworthy, who has produced such shadows many times over, their making requires a self-imposed vulnerability. In this instance, such an act would become one of empathy and communion, as well as an expression of the evanescence of human presence.

For the second proposal, which was taken forward, Goldsworthy proposed sourcing a number of large granite boulders, hollowing them out, and planting saplings in them. He evolved the idea from the sight of ubiquitous small trees growing out of stone buildings or from stranded rural outcrops. By transposing it to the context of the museum, Goldsworthy might seem to bestow an implausibly weighty emblematic burden upon what is often an improbable or accidental manifestation of life. Yet, the survival of such trees is of course an extraordinary feat of life sustaining itself under what would seem to be hostile or impossible conditions. Indeed, his proposal for *Garden of Stones* was closely linked to Goldsworthy's two earlier folds at Mountjoy Farm in Cumbria (cat. 68). Where, with those folds, the survivor-tree presents an allegory of the agricultural endeavor understood as a definitive human struggle, with *Garden of Stones* the trees epitomize the ability to survive and endure even in the most destructive of circumstances. The combination of tree and stone and the act of tree planting as a recuperative, even therapeutic, action have an obvious pedigree in the form of Joseph Beuys' *7000 Oaks*. Whereas Beuys' extraordinary project bore a profoundly conceived ecological mission combined with a visionary social program, Goldsworthy's has a specific historical reference, toward which it has a redemptive injunction. The critical trajectory of Beuys' project was "the transformation of all of life, of society, and of the whole ecological system."[21] Goldsworthy's work reminds viewers that the human ability, whether individual or collective, to prevail in the face of extreme and enforced privation and destruction is ultimately of an elemental order.

That premise permeated Goldsworthy's development of the project. In discussing his decision to use granite boulders, which he located in Vermont in late 2002 and early 2003, the dramatic timbre of Goldsworthy's writing embraced the geological and agricultural in contiguous elemental history:

These glacial boulders have had a long and at times, violent past — both natural and man-made. Granite originated in fire at the earth's core and rose to the surface, where it has been split, carried and worn down by glaciers. Farmers pulled out whatever they could to make fields, blasting those that they couldn't remove.... Underlying the pastoral calm and beauty of a field is the destructive or creative violence of stones and trees being ripped out to make farmland.... They have a history of movement, struggle and change — appropriate associations, I hope, for a Holocaust memorial garden. (2004, 63)

Furthermore, Goldsworthy elected to use a heat method to hollow out the boulders. Over a number of months, quarryman Ed Monti used propane to burn out the core of boulders. As Simon Schama proposed, Goldsworthy's decision to favor this method drew out powerful resonances and introduced a sense of catharsis: "Fire cleans as well as sculpts. Shooting flames at granite not only re-enacts primordial geology, but converts the incinerations of genocide into the flames of sanctification" (Goldsworthy 2004, 59).

The boulders were installed at the museum in late August 2003, and dwarf oak (*Quercus prinoides*) saplings were planted on 16 September 2003 by Holocaust survivors and their relatives, as well as relatives of those lost. Indeed, the sense of endurance that Goldsworthy anticipated for the installation has been amplified beyond his initial expectations, as the trees have taken several "generations" to gain a firm hold. One tree does survive from the first planted group. Thriving now, it will grow, as will the other seventeen, to approximately 15 feet. In time, the trees will begin to exert pressure on their respective stones, and in so doing they will convert their own current forbearance. It is conceivable, if unlikely, that the trees will break the boulders — the relationship between tree and stone is one of vital tension that makes the feat of survival, endurance, and transcendence more acute and potent.

Four additional boulders planted with dwarf oak reside at Cornell University in Ithaca, New York, where Goldsworthy was Andrew D. White Professor-at-Large from 2000 to 2008.

93 REFUGE D'ART, FERME BELON, 2003 (REFUGES D'ART)

Overall: **W** 22' 4" (6.8 m), **L** 36' (11 m)
Each arch: **H** c. 5' 3" (1.6 m), **W** 7' 7" (2.3 m), **D** 2' 11" (.9 m)

Commissioned by Réserve Géologique de Haute-Provence and Musée Gassendi, Digne-les-Bains, France (see page 71)

33 tons of limestone from carrière de Revest-St-Martin. Installed 26 October – 6 November 2003

Architect: Éric Klein

ES, SA, GW, JW, AM, MH

Literature: Goldsworthy 2002, 88 – 90; Goldsworthy et al. 2008, 104 – 111, 168

Refuge d'Art, Ferme Belon is situated at Draix in the Forêt Domaniale de Haute-Bléone. It is a former farmhouse, in the basement of which Goldsworthy installed eleven interweaving limestone arches. It was the third building renovated as part of the *Refuges d'Art* project, and the fourth installation created.

For this stage of the Refuges Walk, Goldsworthy initially proposed rebuilding a derelict barn in nearby Archail. The Archail barn was square, with a lower and upper level. In response to those factors, Goldsworthy decided to build a massive stone cairn that would sit centrally in the building and occupy both floors, with each floor revealing only a partial view of the whole cairn. Administrative complications led to the withdrawal of the Archail barn, and the local authorities at Draix put forward Ferme Belon. A disused farmhouse, it also offered two levels, and Goldsworthy initially thought he might still realize a large cairn that could be accessed from the two floors. The farmhouse, however, had very different proportions. It also had a tragic history — as a site of Resistance activity — and Goldsworthy bound that history into the conception of a new proposal. He noted, "Although the sculpture was not intended as a memorial, it lent itself to the idea" (2002, 89).

His proposal to install the eleven limestone arches in the dark basement recalls a group of chalk arches of similar proportions, which he exhibited as *A Clearing of Arches* on the grounds of Goodwood Sculpture Park, England, in 1995. Indeed, the dimensions and atmosphere of the farm basement bring to mind the ground floor of his old studio, where Goldsworthy subsequently permanently installed the 1995

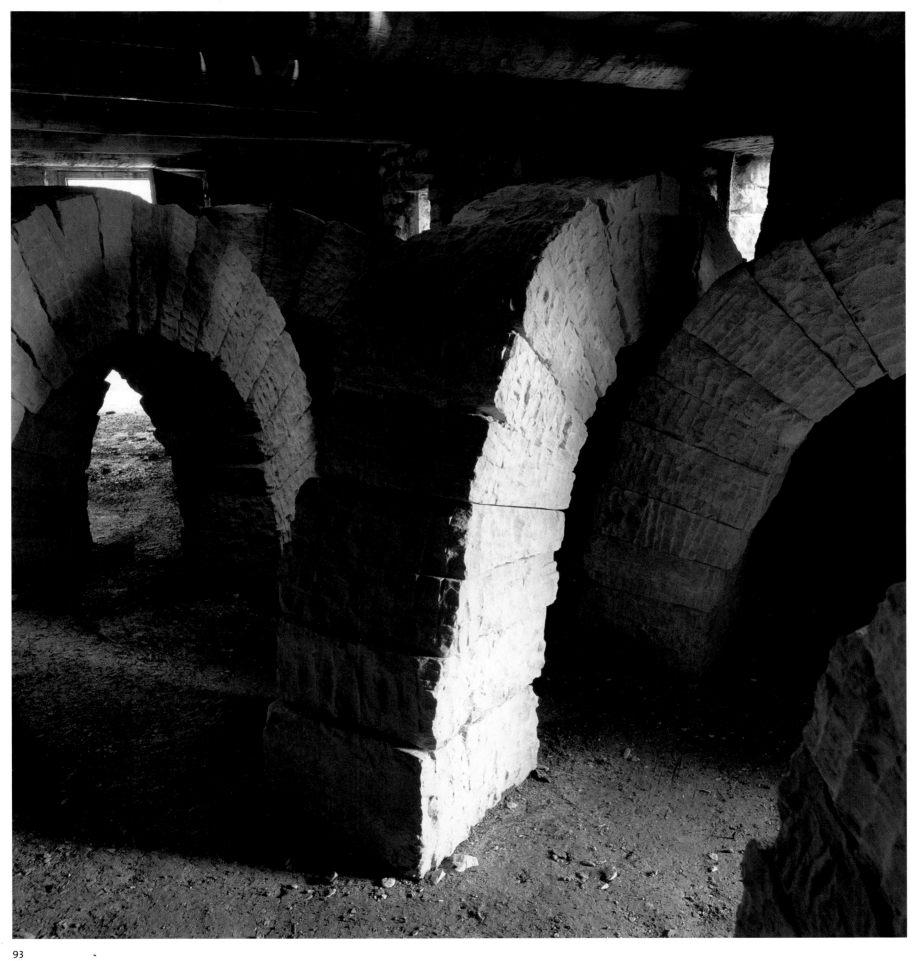

Goodwood arches. However, the installation at Draix not only retained the sense of concealment of the Archail proposal, but also, for Goldsworthy, amplified it through the farm's former use as a hideout, the basement's atmosphere, its low ceiling, and few windows.

Within the confines of the basement, the arches intersect and overlap and create a sense of movement that fills the space. Goldsworthy's choice of pale stone contrasts with the subdued darkened space and gives the arches a sense of virtual presence, of being negative shadows. Goldsworthy himself referred to them as "architectural ghosts" (2002, 89).

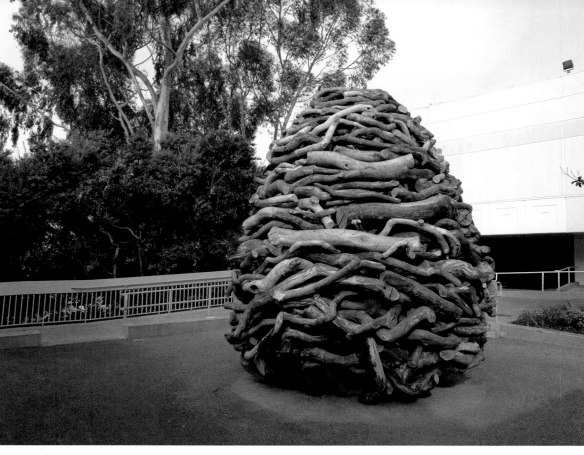

95

94 CAIRN AND BOULDER, 2003

H 10' (3 m), ⌀ at base 12' (3.7 m)

Herbert and Ann Burger, Massachusetts, US

Locharbriggs red sandstone from Scotland and granite boulder sourced locally. Installed December 2003

JE

This pyramidal cairn is built up in layers of flat-trimmed stone, similarly to *Millennium Cairn* (cat. 63). *Cairn and Boulder* extrapolates on three cairns that Goldsworthy installed at Galerie Lelong in New York between January and March in 2003, with each negotiating such various structural factors in the gallery

space as columns or doorways. Here, Goldsworthy included a boulder protruding from the side of the cairn, creating a strong contrast between the red of the sandstone and the pale grayish color of the granite boulder. This disjunction extends to the texture—the worked stone as compared to the rawness of the boulder—and lends the work a sense of chance or suspension, as if the boulder had just fallen into the cairn.

95 SCRIPPS CAIRN, 2004

H 12' 10" (3.9 m), ⌀ at widest point 10' 11" (3.3 m)

The Scripps Research Institute, La Jolla, California, US

Scottish oak and eucalyptus. Installed January 2004

ES, JE, Dustin Gilmore, Elisabeth Ehrenberg

Exhibition: Three Cairns 2002

The oak for this cairn had to be transported from the United Kingdom to California because of the prevalence of sudden death oak syndrome, caused by *Phytophthora ramorum* and affecting several oak species in coastal areas of California. The Scottish oak had to be debarked prior to shipment, and the use of nude branch limbs produced a muscular quality in this work that is more pronounced than in cairns constructed with branches that retain their bark. The debarked branches have increasingly silvered since installation and appear to have an almost metallic cast.

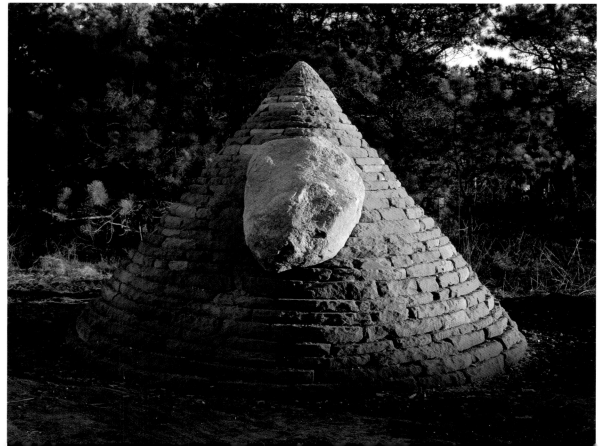

94

96 CROSBY RAVENSWORTH PINFOLD CONE, 2004 (SHEEPFOLDS PROJECT)

Fold: H 4'–4'3" (1.2–1.3 m), W 23'7" (7.2 m), D 18'8" (5.7 m)
Cone: H 5'3" (1.6 m), ⌀ 4'3" (1.3 m)

Commissioned by Cumbria County Council, with funds from the Arts Council of England, UK

Salterwath limestone donated by Cumbria Stone (cone), and walling stone sourced from original wall and surrounding fields (fold). Built February 2004

ES, SA

Literature: Goldsworthy 2007, 150–151

Although initially proposed in 1997, the pinfold at Crosby Ravensworth was the last of the eventual six pinfold cairns to be built. In documentation for the *Sheepfolds Project* (AGA) dating between 1998 and 2000, there is mention of "two folds" and "two cones" for Crosby Ravensworth. This proposal seems to have remained in play until September 2000, when a notation made by Goldsworthy indicated that he would proceed with only one fold and cone.

The ownership of the pinfold site took some time to establish. Chettle enlisted the assistance of the local headmaster in early 2000, and a diocese in the Church of England was identified as landowner shortly thereafter. A license was signed by the Diocese of Carlisle and by the tenant farmer in July 2002. However, work did not proceed until February 2004. The pinfold was, for the most part, in fairly good structural order, although it had been subsumed into the field behind it. Goldsworthy reinstated the back wall that separates the pinfold as a structure from the neighboring field, and built the cone using limestone donated by the local quarry. The slabs of stone provided for the *Cone* were sawn top and bottom, and they give it a distinctive quality not unlike the slab *Cones* that Goldsworthy installed on the grounds of Gracefield Arts Centre, Dumfries.

97 STONE RIVER, 2004

H 3'1"–5'10" (.9–1.8 m), W at base 5'9"(1.8 m), L 783'1" (238.7 m)

Private Collection, Berkshire, UK

482 tons of buff sandstone. Installed 4–18 April, 10–30 May, and 7–28 June 2004

ES, SA, GW, WN, JW, AM, MH, Hugh Hill, Andrew Pratt, Austin Thistlethwaite, Martin Gibson

Goldsworthy was invited to view the grounds of a private property in spring 2003. He subsequently proposed making the second of his "stone rivers" in a man-made lake, whose water level is controlled by a dam. At one stage Goldsworthy proposed continuing the sculpture beyond the lake on the far side into one of the surrounding fields, but, ultimately, he contained *Stone River* to the bed of the lake. The act of submerging works and the attendant impact upon the submerged work's visibility have long interested Goldsworthy. Self-contained within a controlled circumstance, the work becomes, however, much more about the light and surface. Goldsworthy also drew the line out in plans, which he did not do with the Stanford work (cat. 72):

I normally would not draw out a plan for a sculpture preferring to draw it as it is being constructed. In this instance...I felt the need to work out more precisely the length, shape and layout.... [D]rawing the sculpture on paper first could produce a far more fluid and rhythmic sculpture. (c, to owners, 20 February 2004, AGA, here and following)

The process of controlling the revelation of the body of the work is crucial with *Stone River*. It is a work of some mass that is demonstrably transformed by the presence of the water. The stone apex can, for instance, appear as nothing more than a drawn line that "articulates the whole of the lake surface." For the purposes of construction, the lake was drained, and *Stone River* was built in three stages in spring and early summer 2004. The level of the top edge is entirely consistent, particularly as it might need to be read as flush with the level of the water.

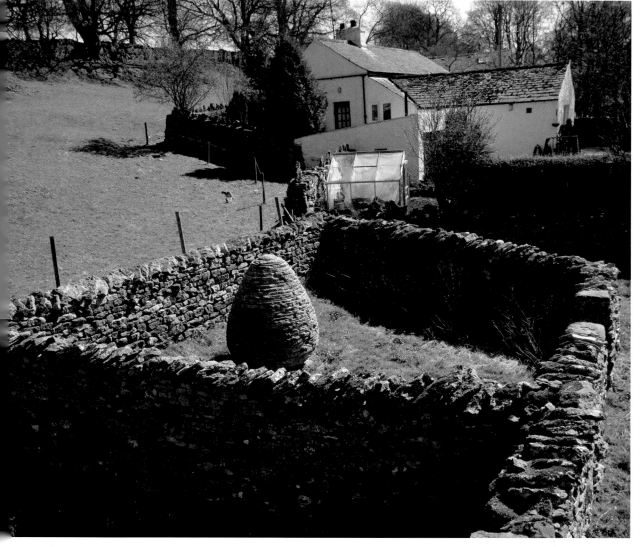

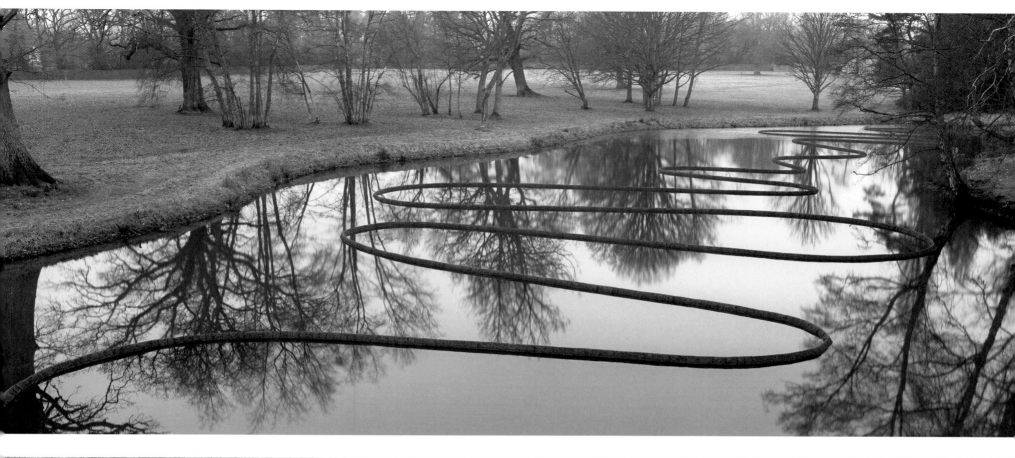
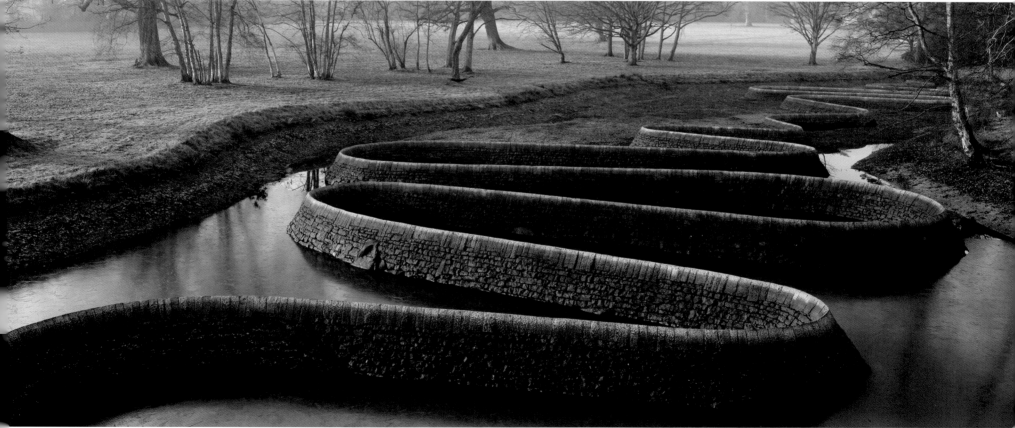

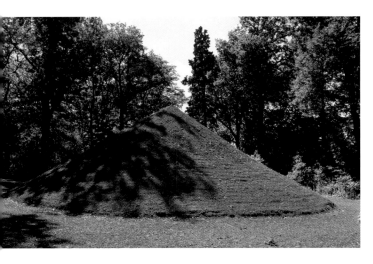

98

98 BRACKEN MOUND, 2004

H 21′3″ (6.5 m), ⌀ 5′9″ (1.8 m), SA 3,380 ft.² (314 m²)

Private Collection, Berkshire, UK

Earth and bluebell bulbs. 70 bulbs per square meter.
Installed June 2004

Goldsworthy first proposed and created this work as
a "blue hill" (C, to owners, 28 June 2000, AGA, here and
following) comprising a large, artificially constructed,
conical mound of earth, densely planted with 21,980
bluebell bulbs. Its aim was "to turn as intense a blue as
possible during the season of the bluebell flower." He
briefly contemplated having an interior core of stone,
but considered that it might make the soil too dry for
the bluebells to grow.

Initially called *Bluebell Mound*, it was the first hill
of color that Goldsworthy realized, and amplifies the
exploration of color that he has long conducted in his
ephemeral work. Goldsworthy's desire to "work actively
with colour" on a large scale has been long-standing,
and he first originated the concept in 1990 for a proj-

ect in Flevoland, The Netherlands. In the Flevoland pro-
posal, which he never realized, Goldsworthy envisaged
a series of "twenty-meter high, artificial hillocks," to
be built roadside, which would be exclusively and
thickly planted with a red foliating tree or shrub, possi-
bly *Cornus* (dogwood) (PS, *Five Hills*, Flevoland proposal,
January 1990, AGA). In autumn, the hills would mani-
fest a thick, matte, primary red growth, which would
appear almost unnaturally concentrated, even violent.
The conical hills would counterpoint the flatness of the
landscape, and Goldsworthy has since suggested that
he anticipated spacing them out evenly along a
stretch of 20 miles. Causey also noted the importance
of light to the proposal, which placed two of the hills
"so that they are illuminated, when seen from the road,
by the rising or setting sun" (1990, 140).

Goldsworthy continued to incubate the idea for
a color hill throughout the 1990s, unsuccessfully pro-
posing the red hill in several contexts. His commit-
ment to realizing the work was strengthened, however,
by his observation of a hillock near his home that was
denuded of broom, which then grew back particularly
vigorously. Goldsworthy first proposed a planted
mound for this commission in 2000, to be built as a
single hill within the grounds of a private garden prone
to brilliant bluebell growth. Built four years later, the
mound was constructed in a clearing surrounded by
densely grown rhododendrons and approached via
a pathway. At the same time, Goldsworthy also built
another work—*Rhododendron Cairn*—inside the
house itself. Interestingly, Goldsworthy had initially
considered the possibility of planting bracken along-
side the bluebell bulbs so that the hill would turn
green and then brown/orange, with seasonal change.
He returned to this particular idea in 2009 and
decided with the owners that the mound should be
replanted with bracken and thus "change colour from
season to season" (C, from Michael Hue-Williams to
owners, 12 June 2000, AGA).

99 WICHITA ARCH, 2004

H 12′8″ (3.9 m), S 22′7″ (6.9 m), D 4′ (1.2 m)

Ulrich Museum of Art, Wichita State University,
Kansas, US

Approximately 30 tons of limestone from
Cottonwood Quarry, and Australian elm tree.
Installed 20–29 October 2004

ES, BN

Unlike its North American counterparts in Montreal
and Grand Rapids, the *Wichita Arch* does not originate
from Locharbriggs Quarry in Dumfriesshire. It is the
first large-scale, freestanding arch to be quarried and
built in the United States, and to be made with lime-
stone as opposed to red sandstone. In this choice of
material, the arch is related to the set of eleven small
limestone arches that Goldsworthy quarried and built
for the *Refuge d'Art, Ferme Belon* (cat. 93) in Digne-les-
Bains, France.

Goldsworthy has long related movement of
stone and of people on both literal and metaphorical
levels—both crossing the seas, as ballast and passen-
ger respectively, and both taking root in the place
where they land. The sea transportation of the stone
for the arches in Montreal and Grand Rapids thus also
takes on conceptual importance. With the use of lime-
stone, however, Goldsworthy recast the associations
between arch, sea, and movement in more geological
terms, insofar as limestone was once the seabed. Like
those quarries near Des Moines, which Goldsworthy
used in the *Three Cairns* (cat. 75) project, the quarries
surrounding Wichita provide tangible evidence of a
less landlocked past. Visiting Cottonwood, he encoun-
tered a horizontal bed of stone, about 8 feet deep,
extending in every direction beneath the ground.
Goldsworthy's interest here was in the transition of

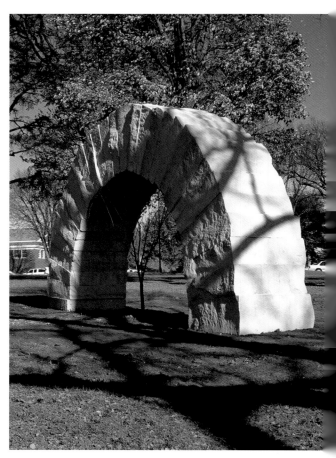

99

stone from horizontal bed into arch, from ground to articulated form.

As opposed to other arches that Goldsworthy built around existing trees, *Wichita Arch* was completed before an Australian elm was planted beneath it. With time, the tree will grow around the arch, and Goldsworthy is keen to see how it will negotiate the stone structure.

100 REFUGE D'ART, COL DE L'ESCUICHIÈRE, 2004 (REFUGES D'ART)

Overall: H 10′ 8″ (3.3 m), W 12′ 3″ (3.7 m)
Calcite lines: W ⅕–⅖″ (.5–1 cm)

Commissioned by Réserve Géologique de Haute-Provence and Musée Gassendi, Digne-les-Bains, France (see page 71)

Black limestone with calcite veins, sourced near site. Installed November 2004

Architect: Éric Klein

SA, GW, JW, AM, MH, Jean Raux

Literature: Goldsworthy 2002, 77–79; Goldsworthy et al. 2008, 96–101, 164

Goldsworthy's initial proposal differs from his final vision for the small two-room structure situated along the Col de l'Escuichière. Originally, he conceived it as part of a group of three refuges, each incorporating installations comprising burnt wood. He intended to install a large stacked ball of dark wood limbs that would fill almost all the available space in one of the two rooms. As he suggested, the relationship between wood and village in this particular area was robust and "complex," serving a range of economic purposes; for instance, "oaks were grown for the making of charcoal and the coppiced landscape is a result of that use" (2002, 77). As Irène Magnaudeix indicated, the nature of that relationship is manifest in the naming of parts of the area along the ridge: "Embois is an area whose name simply means 'in the wood,' and 'La Blache' is a medieval coppice, while 'Le Defens' indicates a forest whose use was regulated in the Middle Ages" (2008, 99). Goldsworthy clearly intended for the proposed group of three refuges to speak of one of the most basic functions we seek in a house: warmth. In his initial proposal, Goldsworthy noted: "The burning of wood for warmth lies at the heart of a building that's lived in" (2002, 77).

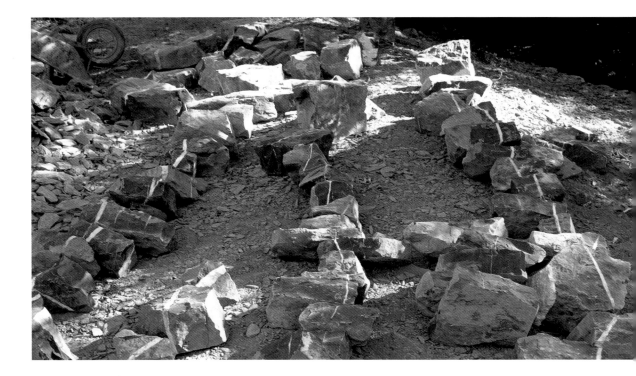

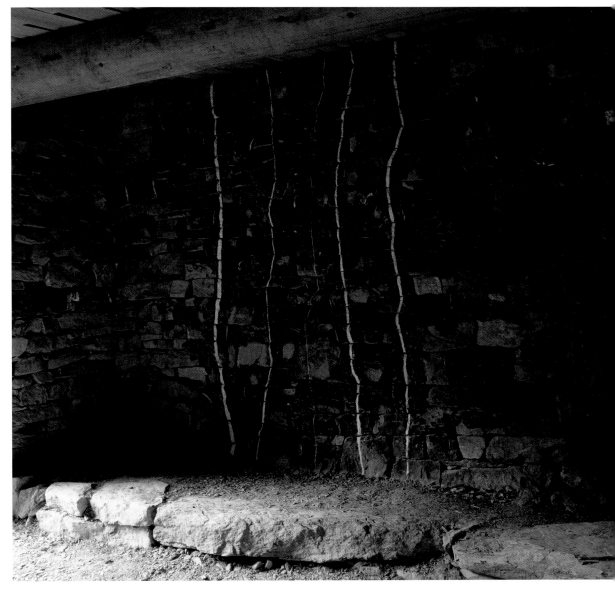

100

During a subsequent site visit, Goldsworthy altered his proposal for the refuge, developing it in a simultaneously more graphic and geological direction. He had noticed thin lines of calcite in the rocks along the col, and decided to embed drawings, made by aligning lines of calcite found in fallen rock rubble, into the walls of the two rooms. In proposal sketches, Goldsworthy elaborated several possible formations, using one wall or indeed all four. The first room of the house was rebuilt in 2004, and Goldsworthy integrated thin lines of calcite running from floor to ceiling into a single wall. It is the first of the refuges to establish a strong visual connection between interior and exterior: the lines of calcite inside the refuge appear at first glance as natural as those in the rock face. However, the specificity evident in how the calcite is aligned and the sense of balance and rhythm in the lines reveal that they are the product of human agency. The result is an especially fine and elegiac work, which proposes that the space of the room is a drawing itself.

101 ROOF, 2004–2005

Overall: H 74′ 1/16″ (22.6 m), W 151′ 4 3/8″ (46.1 m), D 42′ 11 13/16″ (13.1 m)
Each dome: ∅ 27′ (8.2 m)

National Gallery of Art, Patrons' Permanent Fund, Washington DC, US

425 tons of slate from Buckingham, Virginia. Installed November–December 2004 and January–February 2005

JE, SA, GW, JW, AM, MH, Gerri Jones, Jane Padelford, Katherine Schiavone, Danna Kinsey, Barrett Thornton, Bennett Grizzard

Literature: Putman, in Goldsworthy 2007, 16–17

In 2003, Goldsworthy was invited by the National Gallery of Art in Washington DC to make a sculpture on the occasion of the twenty-fifth anniversary of its East Building. He proposed a series of interlocking slate domes cumulatively titled *Roof* that would occupy the rather slender location of the former Japanese Garden and serve to connect the interior and exterior spaces of the I. M. Pei building:

[I]nstead of being on top of a building, my "roof" would connect … to the ground below — a juncture somewhere between architecture and geology. … At the center of the dome would be a black hole — a portal through which the viewer's mind will be drawn into the ground. This would be the inverse of the oculus which sometimes occupies the center of the dome. Instead of looking upward to the light, the view would be downward and dark — whilst being opposites, both deal with the same substance of light and space. (PS 2004, AGA)

Conceived as such, Goldsworthy's proposed union of dome and ground seems to offer a reenvisioning of what Frank Lloyd Wright called the "the tyrannical dome"[22] — the elevated, crowning structure of much civic and governmental architecture, a predominant feature of the Washington DC skyline, and of particular and considerable economy within the history of American architectural discourse from Thomas Jefferson onward. Wright referred to it as "the great symbol of great authority," adding that "domed or damned was and is the status of official buildings in all countries, especially in ours." What Wright seems to address most specifically in his 1931 Princeton lecture was the elevation of the dome literally and symbolically, its "having got out of the building itself onto stilts," as inaugurated and exemplified in Michelangelo's St. Peter's Basilica in Rome.

Goldsworthy's domes, each with a base diameter of 27 feet, are not entirely inconsistent with the proportions of Neolithic underground burial chambers and thus with the "false" or corbelled stone domes with which such chambers were occasionally vaulted. With *Roof*, one can infer the presence of subterranean structures, to which Goldsworthy's domes might indeed operate as cover. *Roof*, however, does not so much sit on the ground as it becomes the ground. Moreover, it succeeds in reconnecting the dome with its materiality. In effect, the domes form an interlocking landscape of stone — appearing not as symbols of civic virtue but as products or accretions of natural sculpturing processes or forces. Matthew Gandy suggested that "the history of cities can be read as a history of water,"[23] and Goldsworthy was aware of the water sources below the National Gallery of Art. If the nine dark dome holes propose a pure energy below ground, the fusion of domes form an articulated epidermis rising in response to and expressive of that energy — like a terrain of inverse sinkholes. Goldsworthy chose quarried slate, sourced locally and prevalent on the roofs of a number of buildings in Washington. The installation carries a powerful sense of flow, rhythm, and linearity.

170

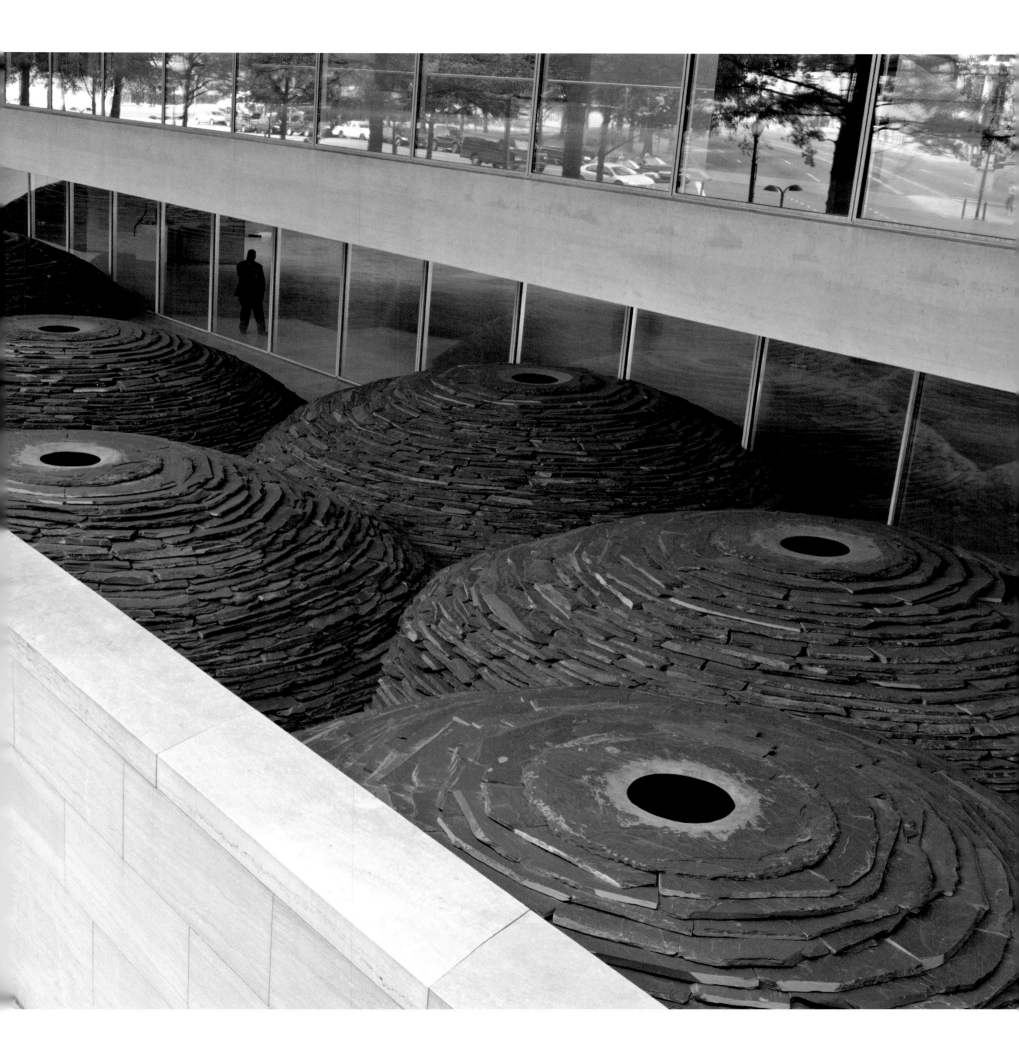

Overall: **H** 2′ 5″ (.7 m), **W** 122′ (37.2 m), **L** 134′ (40.8 m)
Crack line: ⅕–⅖″ (.5–1 cm)

De Young Museum, Fine Arts Museums of San Francisco, Museum purchase, gift of Lonna and Marshall Wais, US

Appleton Greenmoor sandstone. Installation began April and completed June–July 2005

JE, ES, Bernard Gotzhein

Goldsworthy was one of five artists invited to create commissions for the new de Young Museum in San Francisco designed by Swiss architects Jacques Herzog and Pierre de Meuron. Initially drawn to a number of interior spaces, Goldsworthy ultimately elected to work in the exterior courtyard and main entrance. He created a continuous crack—⅕ to ⅖ inches wide (1 centimeter, at widest point) and 134 feet long—that runs through the Appleton Greenmoor sandstone pavers: north from the edge of the Music Concourse roadway in front of the museum, up the main walkway, into the exterior courtyard, and to the main entrance door. Along its path, the crack bisects—and cleaves in two—large rough-hewn Appleton Greenmoor slabs that serve as seating for museum visitors. Although Goldsworthy has long created fissures and cracks directly in the ground, the closest precursor to *Drawn Stone* is the pair of sculptures that he contributed to the British pavilion at the Venice Biennale in 1988. On that occasion, using old pavers found near the site, he cracked the flags in two, reunited both parts with a slight gap between them that read as a crack, and installed them so that the cracks appeared to produce a continuous line.

This commission provided Goldsworthy with the opportunity to work on a large scale in the heart of San Francisco. Goldsworthy has written about the fragility that can be sensed in California (Goldsworthy 1994), and *Drawn Stone* is an amplification of his long-standing interests: firstly, in powerful latent natural energies and forces, and their putative location below ground, and secondly, in the fissures and openings in the earth that manifest those energies, and the demands and impact wrought upon the conception, fabric, and culture of buildings. Geographer Justin Wilford distinguished between what he called "the materiality of natural disaster" and "the material effects of, or response to, disaster."[24] It would be easy to read *Drawn Stone* in relation to the latter, as a

graphical manifestation of the "material effect" of some seismic activity. Goldsworthy's use of an early provisional title for the work—*Faultline*—would seem to confirm such a reading. However, his changing of the work's title, and with it, his invocation of drawing, energy and line, move this work closer to the former. *Drawn Stone* is quite purposefully not a fissure of any particular drama. There is no originating seismic event that it references, and thus the cracked line is not indexical of any specific material effect. However, it was intended to disturb not only our negotiation of space, but also our relationship with the structures and things that articulate, fill, and give meaning to it. According to Wilford, "Natural disasters disrupt the relationship between humans and things, and thereby offer a glimpse of both sides of the dialectic: the differentiation of humans and things alongside their integration" (*EPD*, 659). It is this precise insight that Goldsworthy instinctively sought to stage in *Drawn Stone*. Where Wilford argued that the issue of materiality should not "settle at the moment of catastrophe," but must show that "the material world continues to participate in human meaning," *Drawn Stone* arguably takes up this injunction.

H 12′ 4″ (3.8 m), **W** 26′ 3″ (8 m), **D** 19′ 8″ (6 m)

Private Collection, Richmond, Massachusetts, US

Glacial boulder, Ash fieldstone (mica schist), reclaimed fir and hemlock, and slate from Buckingham, Virginia. Installed 9 May–10 June 2005

JE, SA, GW, JW, AM, MH, Damian DePino, Shern Kier, Ned Shalanski

Literature: Yorkshire Sculpture Park 2007, 62–63, 65

Although it has all the trappings of a small human dwelling in its proportions, its pitched roof, and its window, *Stone House* is the first of Goldsworthy's houses for which the main intended inhabitant is not human. Goldsworthy first proposed enclosing a large boulder within a house for a property at Fiessal near Digne-les-Bains, one of the early proposed locations for *Refuges d'Art*. Indeed, the concept has its roots in *Drove Stones* (cat. 38): "the idea of taking a stone and putting it in a house or fold…led to the far more interesting idea of taking the house to the stone" (Yorkshire Sculpture Park 2007, 62). Here, the house is not located

103 boulder after initial excavation

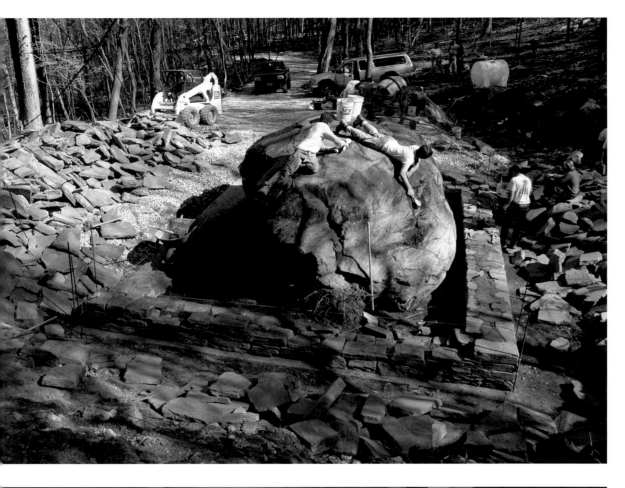

or rebuilt on the footings of a preexisting structure, and thus does not have a direct historical link to human habitation. It was built to fit the proportions of a massive glacial boulder, found half buried by Goldsworthy and excavated.

Robert Pogue Harrison noted, "Nature has shelters, recesses, caves, and burrows, yet it has no houses in which the being (and not only the vestiges) of the bygone is preserved" (*DD*, 39). With *Stone House*, it is as if Goldsworthy tests Pogue Harrison's claim. Indeed Goldsworthy required that the boulder be treated with an intimate consideration that is generally reserved for humans. It was not to deify the stone, but, with the simplest human gestures possible, to attend to the stone's resolute materiality. It was disinterred, cleared, and then properly housed, all within a human economy of care. Thus, *Stone House* is perhaps one of Goldsworthy's most evidently anthropopathic works, and the boulder a deep presence in a preternatural sense.

On entering the house you see the stone, but I hope for one moment that you see it as something alive. It could feel extremely threatening because you can't walk around it. The stone forces you to press yourself between its surface and the wall of the house. The house is very dark; when you first go in you can't see your feet and there may be an animal in there... which adds to this tension, and a feeling that something in that house is alive. (Yorkshire Sculpture Park 2007, 65)

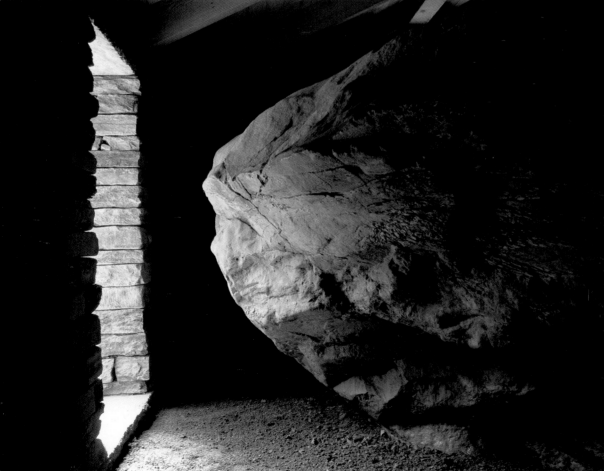

104 STONE HOUSES, 2004–2005

Each dome: H c. 18' (5.5 m), ⌀ 24' (7.3 m)
Each stone column: H c. 16' (4.9 m)
Each wall: H 4' 6" (1.4 m), D 1' 8" (.5 m), ⌀ 36' (11 m)

Private Collection, Massachusetts, US

Granite boulders from Scotland and Massachusetts, black locust, walling stone, gravel, and trees. Installed in New York City April 2004, and in Massachusetts May–June 2005

JE, SA, GW, JW, AM, MH, Gerri Jones, Ned Shalanski, Shern Kier, Andy Lampiasi, Sasha Shumyatsky, William Newton, Tamara Freys, Mary Ann D'Campo

Literature: Goldsworthy 2004, 54–57

Exhibition: Stone Houses 2004

Goldsworthy was first invited to the Metropolitan Museum of Art in New York in February 2003 to propose a sculpture for the museum's Iris and B. Gerald Cantor Roof Garden. In April 2004 he constructed two columns of balanced stones, each 13 ½ feet tall and surrounded by an octagonal dome composed of cedar stacked in a split-rail system. In conceiving *Stone Houses,* Goldsworthy wrote that the work was intended as

a counterpoint to the spectacular view from the roof garden at the Metropolitan Museum—one that looks internally rather than externally and invites the viewer to look into the landscape rather than at it.... [It] will combine two of the strongest elements seen from the roof in Central Park: stone and wood, as well as making architectural references to the surrounding buildings. (PS 2003, AGA)

Indeed, the starting point of Goldsworthy's response to the prospect offered from the roof of the museum resonates with Matthew Gandy's suggestion that "the Manhattan skyline has often been described in terms of metaphors drawn from nature" (*CC*, 2). Whereas Gandy continued by noting the "perception that the scale and dynamism of New York owes more to the raw power of nature than to the prosaic efforts of human labor," it is precisely those factors that Goldsworthy's *Stone Houses* appears to mediate.

In the course of developing the commission for the museum's roof, Goldsworthy visited the grounds of a private property in Massachusetts where he encountered isolated islands of thick abrasive woodland, in the center of which were remnants of stone structures. Goldsworthy felt the context offered in Massachusetts would make an interesting destination for *Stone Houses*, and the projects became nominally linked in his mind. Indeed, Goldsworthy's responses to the two distinct topographies mark out the two stages of this installation. In its Manhattan incarnation, *Stone Houses* notionally rises from a horizontal to vertical state. The granite boulders came from the shoreline of Glenluce Bay, southwest Scotland, and were shipped by sea to New York. The idea of ballast infers an emphatically horizontal state, entailing as it does a lateral distribution of stone or weight. It also evokes the force of gravity in operation, against which human effort is often pitted. British Antarctic explorer Sir Ernest Shackleton memorably recalled having to manage the ballast on the *James Caird*, one of *The Endurance*'s small lifeboats that he and his remaining crew used to reach South Georgia:

The boulders that we had taken on board for ballast had to be shifted continually in order to trim the boat.... We came to know every one of those stones by sight and touch.... As ballast they were useful. As weight to be moved about in cramped quarters they were simply appalling. They spared no portion of our bodies.[25]

The building of the columns on the roof of the museum and the transition of the stones to an upright state required a physical intimacy and effort akin to those that Shackleton recorded. Yet such "prosaic effort" is erased by the apparent effortlessness of the finished columns replete with implications of "growth, reproduction and repetition" (PS 2003, AGA).

In relocating *Stone Houses* to Massachusetts, Goldsworthy decided to add further elements, surrounding the wood domes with stone walls around which a perimeter of trees would be planted. Within this process of embedding and effectively concealing the work, which will occur over time, the original elements now form a nucleus, and the horizontal/vertical counterpoint of the Manhattan installation is supplanted with a concentric structure, suggestive of patterns established in human settlement.

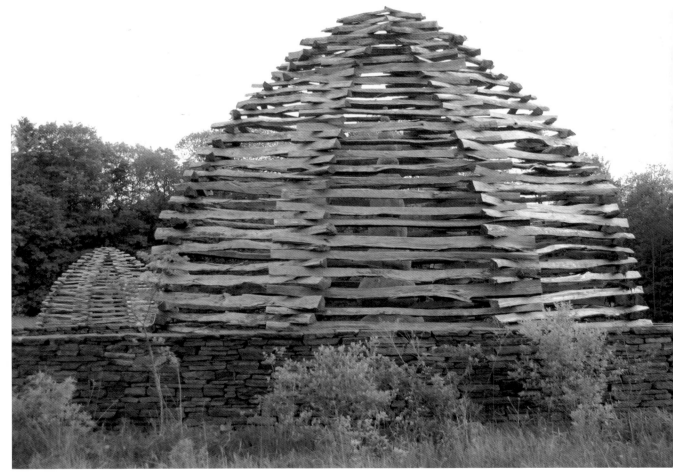

104 top, interior; bottom, exterior

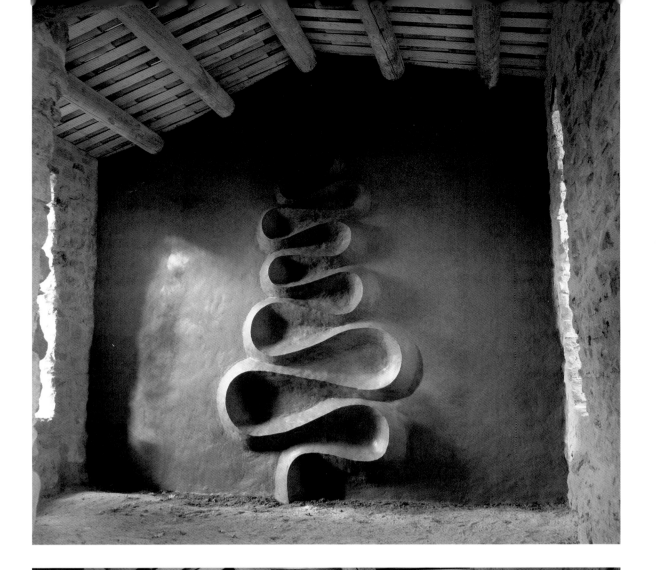

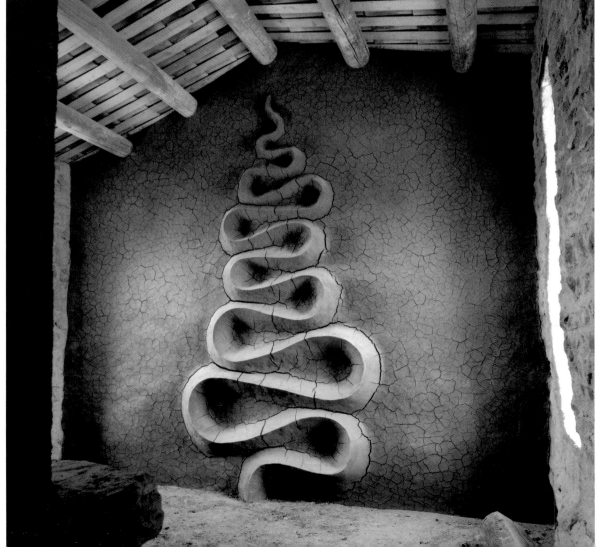

105 REFUGE D'ART, LE VIEIL ESCLANGON, 2005 (REFUGES D'ART)

H 12′ 5″–16′ 3″ (3.8–5 m), W 14′ 1″ (4.3 m)

Commissioned by Réserve Géologique de Haute-Provence and Musée Gassendi, Digne-les-Bains, France (see page 71)

Red clay sourced near site, and human hair. Installed September 2005

Architect: Éric Klein

Bruno Lochon, Jean-Paul Désidéri, Jean-Denis Frater, Jean-Pierre Brovelli, Myette Guiomar, Thierry Beving, Simon Moncoronel, Hugues Chaillan, Patrick Collombon, Lucien David, Brice Etienne, Guillaume Guarino, Christelle Labastire, Josiane Richaud

Literature: Goldsworthy 2002, 84–87; Goldsworthy et al. 2008, 86–93, 162–163, 166–169

Permission to rebuild one of the properties in the abandoned village of Le Vieil Esclangon and to integrate a work into it took four years to secure. As Nadine Gomez attested:

Le Vieil Esclangon belongs to La Javie, and it's a maximum protection area — no construction. At the beginning when we said we wanted to make the *Refuge*, the administrative council said it was impossible. They assumed that [we] were wanting to build a house.... So we said no, it's a work of art. They resisted.... Then it became easier. (Goldsworthy et al. 2008, 166)

The resulting refuge contains an installation that is particularly rooted in its immediate environment. Goldsworthy covered the south wall of the rebuilt house with two thin layers of clay, from which a pyramidal relief element projects into space. While he was covering the wall he constructed the river form, which runs floor to ceiling and required as many as seven or eight thick layers. The clay was sourced directly from the surrounding hills and processed into a workable material on-site. Goldsworthy intended that the wall be activated by light, which influenced his initial thoughts about the inclusion of a single tall thin window to one side of the proposed clay work with a fireplace on the other. However, when the rebuilding of the house began, Goldsworthy decided that two windows on an east-west orientation would create a raking light across the form, and he relocated the fireplace to sit opposite the wall itself.

Interestingly, this is the sole first proposal drawing in which Goldsworthy not only directly featured a fireplace, but also proposed a dynamic relationship between it and the intended work. Though the fire's apparent primary purpose is as a light source, it is also a source of heat. Other refuges, such as the group for the La Combasse area, allude to fire and heat through their inclusion of burnt wood elements, but the literal inclusion of the fireplace in this refuge also evokes the lares — invisible ancestral spirits or household gods that the Romans associated with the hearth and that remained at the center of the house as a source of protection and care. Robert Pogue Harrison noted, "A living space may…be residential and not laral" (*DD*, 51). His distinction between "residential" and "laral" would appear to take on some force in the context of Goldsworthy's project. The buildings that become refuges are not returned to an original functional purpose, such as they fulfilled in their communities. In a very evident sense, they cannot become residential again. Indeed, the *Refuges d'Art* project does not seek to restore former "living spaces" to some kind of structural integrity or to enshrine the memories of those sites in any literal way. Pogue Harrison also quoted the poet Rainer Maria Rilke, who wrote, "[F]or our grandparents a 'house,' a 'well'…their very clothes, their coat, were infinitely more intimate; almost everything a vessel in which they found the human and added to the store of the human" (*DD*, 50). In essence, the refuges become such vessels: the new works incorporated into their physical fabrics make the buildings sites of intimacy once more. For Goldsworthy this effect proposes itself thus: "what has been seen at a distance but is now close at hand — the landscape within the building and in ourselves" (2008, 85).

106 FALLING TREE, 2005

Overall: H 12′ 3″ (3.7 m), W 22′ 6″ (6.9 m), D 16′ 2″ (4.9 m)

Private Collection, US

Fallen oak tree and stone. Installed October 2006

JE, SA, GW, JW, AM, MH, Damian DePino

Literature: Yorkshire Sculpture Park 2007, 70–73

In April 2005 Goldsworthy was first invited to the property on which this work is now located. He returned for a second site visit in June, before undertaking installation in October. He proposed building a house for a large prone oak that had fallen on the steep banking of a creek running through the grounds:

There were lots of oak trees, and one in particular had fallen down. It was next to a creek. It was collapsed on the ground, mostly intact, though there were bits broken off…the place is not just the wood, it's the space. The idea came to me of building a house for the fallen tree. (Yorkshire Sculpture Park 2007, 71)

In several respects, Goldsworthy might well have been drawing on notions of horizontality, openness, and dwelling such as those proposed by Frank Lloyd Wright in his Chicago Institute lectures of 1931 (*FLWW*, 86): "I had an idea…that the planes parallel to the earth in buildings identify themselves with the ground, do most to make the buildings belong to the ground." *Falling Tree* differs somewhat in proportions from the 2005 *Stone House* (cat. 103) or the 2007–2008 *Clay Houses* (cat. 117). It is more discernibly horizontal in emphasis, one might surmise, in order to accommodate as much of the prone tree as possible. It also has a wide entrance, which makes the structure considerably more open. Goldsworthy noted, "[*Falling Tree* and *Stone House*] are both apertures into movement, glacial or decay. They're both about moving" (Yorkshire 2007, 72). Yet, they operate on very different temporal registers. *Falling Tree* is, to all intents and purposes, sheltered rather than housed, lending the sense that its inhabitant has not come to rest but is passing through.

In his lecture, moreover, Wright went on to note, "every house in that low region should begin on the ground — not *in* it, as they then began with damp cellars" (*FLWW*, 86). His correlation of belonging to the ground and beginning on the ground again resonates with *Falling Tree*. To create space for the stonework as he constructed the work, Goldsworthy dug into the steep embankment on which the tree had fallen. Although he suggested that excavation plays a part in the work, "as if you are looking at root[s] or something that has always been there," there is less a sense of the house being rooted in the ground beneath than there is with *Stone House*, or with *Clay Houses*, perhaps because the house keeps the tree in midfall — its various branches and its trunk fused into stonewalls that hold it in a state of suspended animation.

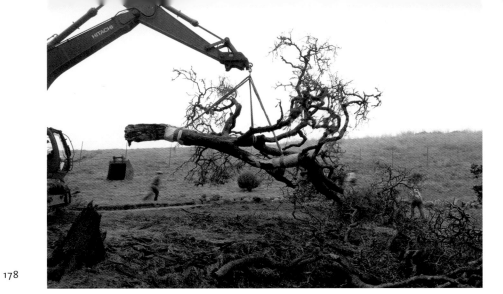

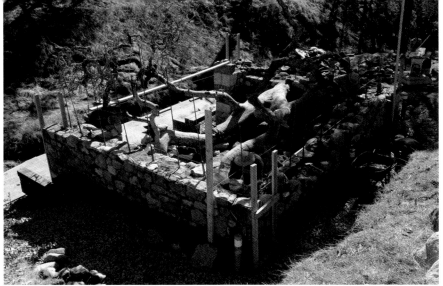

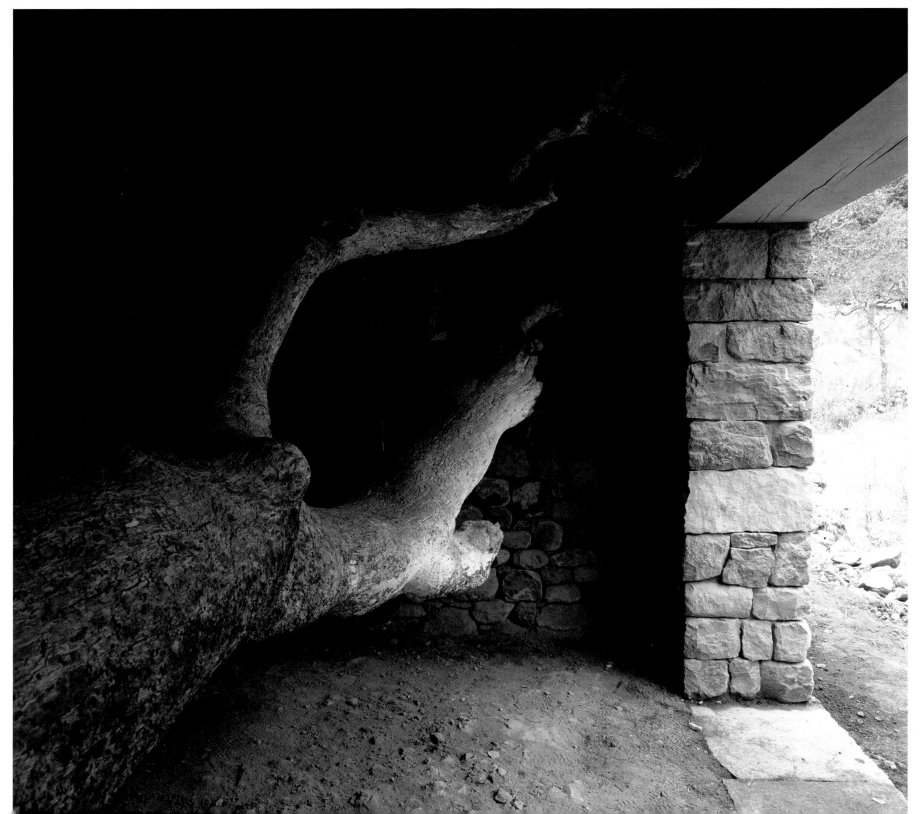

107 GRAND RAPIDS ARCH, 2005

H 18' (5.5 m), S 35' 6" (10.8 m), D 7' 3" (2.2 m)

Frederik Meijer Gardens and Sculpture Park, Grand Rapids, Michigan, gift of Fred and Lena Meijer, US

Approximately 100 tons of Locharbriggs red sandstone. Fabricated in quarry 2001. Installed in Goodwood, Surrey, 2002–2005, and in Michigan October 2005

ES, BN, GG, GR, Martin Gibson, Craig Lauder, Laurence Sneddon, Charlie Graham

This is the third of the large 100-ton arches to be conceived by Goldsworthy and built at Locharbriggs Quarry in Dumfriesshire in 2001. The arch was initially sited at Goodwood Sculpture Park, a temporary sculpture venue in the south of England, from 2002 to 2005. There, the arch was installed across part of the high boundary wall that defines the perimeter of the estate. With one foot of the arch sitting within the park and the other, in a surrounding field, the arch appeared as if it were simultaneously arriving and escaping. It was relocated to a stretch of asphalt road within the grounds of the Frederik Meijer Gardens and Sculpture Park in 2005. Goldsworthy was keen to retain the sense of an arch passing through its environment, not unlike its counterpart, the *Montreal Arch* (cat. 52). He was particularly pleased with the way it appears to sit upon the road surface in Grand Rapids and not sink into it, a factor that enhances its identity as a passerby.

108 ELEVEN ARCHES, 2005

Each arch: H 12' 1" (3.7 m), S 22' 5" (6.8 m), D 3' 9" (1.1 m)

The Farm, Kaipara Harbour, New Zealand

Each arch approximately 29 tons of Locharbriggs red sandstone. Built in quarry June and October, and installed 17 November–17 December 2005

ES, GR, BN, Jerry Carley, John Fitt, Alf Smith, John Reese, Kevin Reese

Goldsworthy was initially invited to the Farm, located 45 kilometers north of Auckland in New Zealand in 1998, and he made his first visit in February 2001. An extensive property encompassing 1,000 acres of grassland and shoreline, the Farm is situated on Kaipara Harbour, the largest harbor in the Southern Hemisphere, and it houses an internationally renowned collection

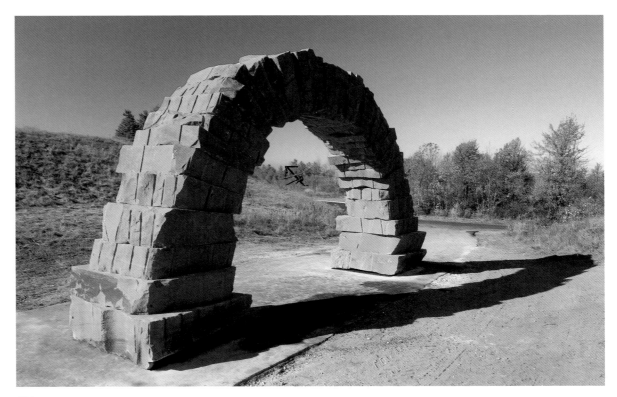

107

of outdoor sculpture on a scale rarely found elsewhere. Goldsworthy noted after that first visit that he "tried to stop looking at the shore," adding "I could have walked out many meters....I envisaged making a serpentine edge in stone, similar to the sand work at the British Museum and the forthcoming stone sculpture at Stanford University" (PS 2001, AGA, here and following). He also referred to several other possible works—such as a "white path" made with crushed shells, which anticipated *Night Path* (cat. 79), and "a huge 20m diameter wood dome and hole"—which finally found fruition in the Yorkshire and Madrid structures that precede the 2008 *Coppice Room* (cat. 118). Goldsworthy also referred to the Farm as "being a perfect home for rejected folds from the 100 Sheepfold project."

By 2002, Goldsworthy proposed a multifaceted project that arose from his "desire to reinstate a wetland area" (C, to owner, c. 2002, AGA): it involved "four land levels," including "a serpentine channel...filled with water" that would be up to 18 meters wide; a road/path that would "define the channel," be approximately 5 meters wide, and sit just above the channel's high-water mark; and islands or viewpoints that would be built with the excavated earth. He made a second visit in 2003 to review sites, and did indeed find a possible location. However, that proposal was superseded in 2005 by another entailing the installation of a group of red sandstone arches on a nearby tidal mudflat:

[T]he placement of the arch in a tidal context will provide it with a sense of arriving or departing. These are appropriate associations given the owner's connection to both New Zealand and Scotland...the changes that occur to the sculpture as the tide ebbs and flows will bring to the work a huge variety of movement and feeling. (PS 2005, AGA)

The eleven arches were quarried, cut, and built at Locharbriggs Quarry in Dumfriesshire, Scotland, and then transported to New Zealand by sea. The tidal mudflat sits on bedrock, and in order to create foundations for each arch, the sand was temporarily excavated back, and shallow concrete foundations laid. A leveler stone was then placed on each concrete pad so that the footings of each arch would seem to sit at sand level. The arches span 50 meters or so of the mudflat. They do not form a true line, as several of the arches are slightly offset. Of his arches, they are the most assertive in their presence, particularly at low tide, when the reach of each arch seems to instantiate an act of appropriation as they march onto land. They are not as rough-hewn as their larger counterparts, and the arch stones are more regularized. When the tide is high, the mass of the arch is dissipated as the line of the form reflects in the water and the silhouette becomes a complete circle.

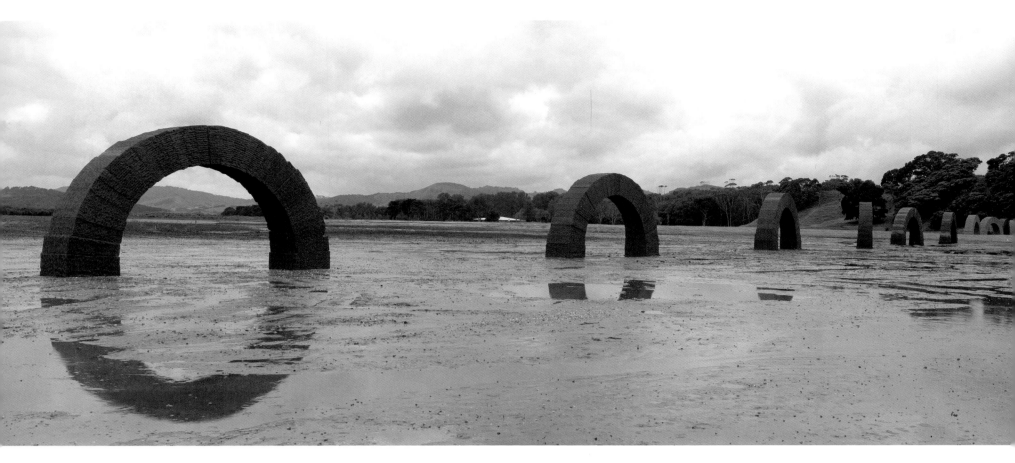

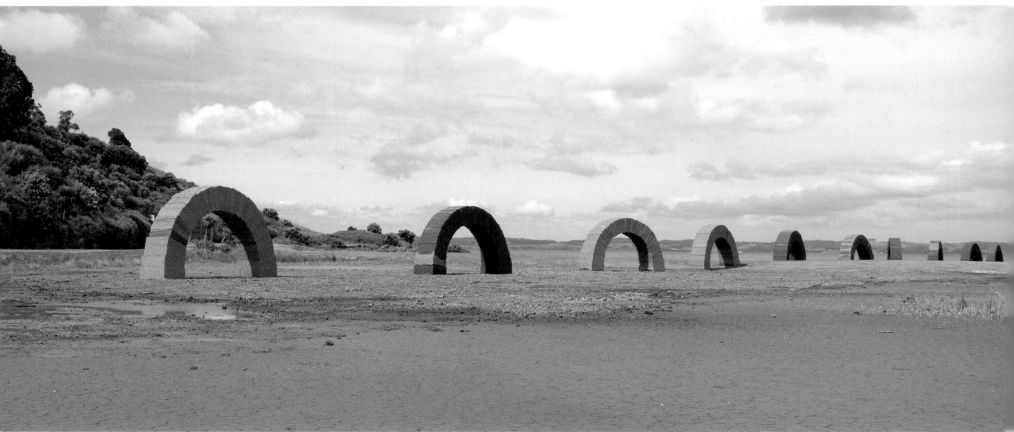

109 OAK CAIRN, 2006

H 14′ 9″ (4.5 m), ∅ at widest point 9′ 2″ (2.8 m)

Private Collection, UK

Wind-fallen oak. Installed February and again
in November 2006

Jolyon Reynolds

Exhibition: Passage 2005

Oak Cairn was originally constructed for Goldsworthy's
exhibition *Passage* at Albion Gallery in London in 2005.
The oak was wind-fallen, and collected from a private
estate in Buckinghamshire. Following the exhibition,
Goldsworthy rebuilt the cairn on the grounds of a
privately owned house, designed in 1897 by architect
Edwin Lutyens and garden designer Gertrude Jekyll.
He used some of the wood from the first installation
and sourced additional material locally. The cairn, which
over time will slowly weather, change, and degrade,
is very visible from the house. Its placement was agreed
upon by the owners, for whom that slow process will
be very apparent and palpable.

110 HANGING TREES, 2006

Each fold, external: W 12′ 3″ (3.7 m), L 25′ (7.6 m),
D 9′ 5″ (2.9 m); *internal:* W 9′ 5″ (2.9 m), L 22′ (6.7 m),
D 9′ 5″ (2.9 m)

Yorkshire Sculpture Park, Wakefield, UK

Felled oak and stone. Installed March 2006

SA, WN, GW, JW, AM, MH, Alan MacKenzie, Iain Stephenson, James Standaloft, Neil Lingwood, Ian Fallon, Sam Clayton, Mark Jacobs

Literature: Goldsworthy 2007, 164, 166, 175–181, 190;
Yorkshire Sculpture Park 2007, 9–10, 12, 78–81, 142–147

Goldsworthy visited Yorkshire Sculpture Park in June
2004 with a view to proposing a permanent, site-spe-
cific work within the grounds, and to developing ideas
for a temporary exhibition for 2007. Long familiar with
the Bretton Estate, Goldsworthy was already primed
to focus on several structural elements of the land-
scape that the sculpture park now encloses: the quarry,
the ha-ha, the gallop, and the lake, among others.
Yorkshire Sculpture Park (YSP), Goldsworthy wrote,

has all the ingredients that make, for me, the British
landscape.... [YSP] has always had to coexist alongside
other "owners"—with the local council, Leeds Univer-
sity, farmers....I do love to rise to the challenge of all the
resistances of a place like YSP. There is a feeling of real
resistance of how to integrate the work into this space.
Here in Britain we have always seemed to coexist with
another institution or another landowner. (2007, 75–76)

Particularly drawn to the historical ha-ha, which sur-
rounds the formal gardens of Bretton Hall, Golds-
worthy focused on the parts of it that were derelict.
As he explained,

[A] ha-ha is a wall within a ditch which prevented ani-
mals and sheep from coming into the garden. At the
same time, it is not visible from the garden, so it feels
as if [it] just flows into the wider landscape...the land-
scape is designed and laid out from this one perspective,
the landowner's perspective.[26]

Goldsworthy referred to the ha-ha as "the interface
between the grounds of the house and the surround-
ing agricultural landscape" (2007, 73). In so doing,
Goldsworthy situated the conception of *Hanging Trees*
within the theoretical terrain that mediates the vari-
ous definitions of land and landscape. Moreover, the
work evokes the "opposing" of a "real" history of the
former to an "ideological" history usually ascribed to
the latter, a strategy that Denis Cosgrove and Stephen
Daniels identified in the writings of John Berger and
Raymond Williams.[27] Goldsworthy has, of course,
worked with the wall and the fold as ideologically
loaded agricultural structures. Yet *Hanging Trees* is,
perhaps, the most direct address that Goldsworthy
has made to the material devices and structures that
actualized an essentially pictorial or visually driven
construction of landscape, such as the ha-ha.

Hanging Trees does evince Goldsworthy's identi-
fication with the "other" view: "I identify with the
farmer in the field, not the landowner in the house.
There is also the view of up close, in your hands, the
grittiness of it, the earthiness of it" (Yorkshire 2007,
74). That is not to say that with *Hanging Trees*, Golds-
worthy produced work that is overwhelmingly rhetori-
cal or programmatic. He initially intended to work with
the ha-ha surrounding the hall, proposing to "inte-
grate something that had to be seen from the other
side; you would have to go over...to look back and
see these works" (Yorkshire, 2007, 75). He considered
works that would offer "a raw frontal view behind

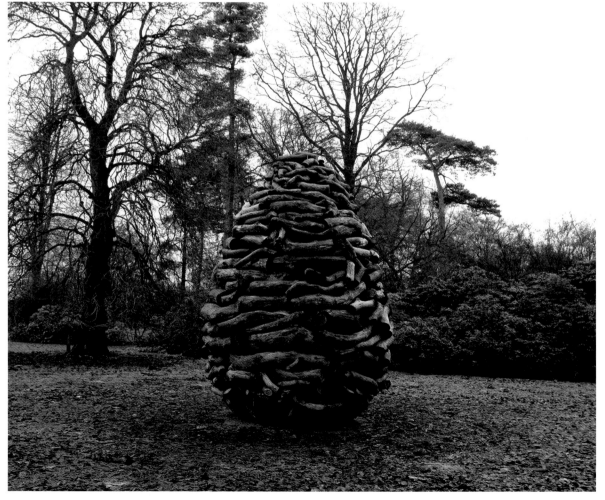

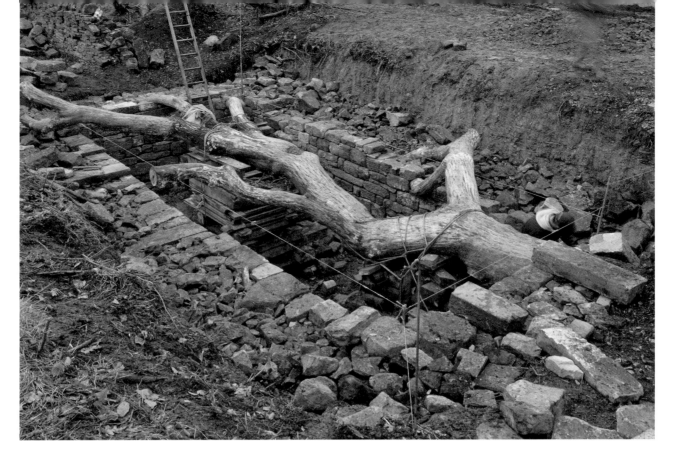

182

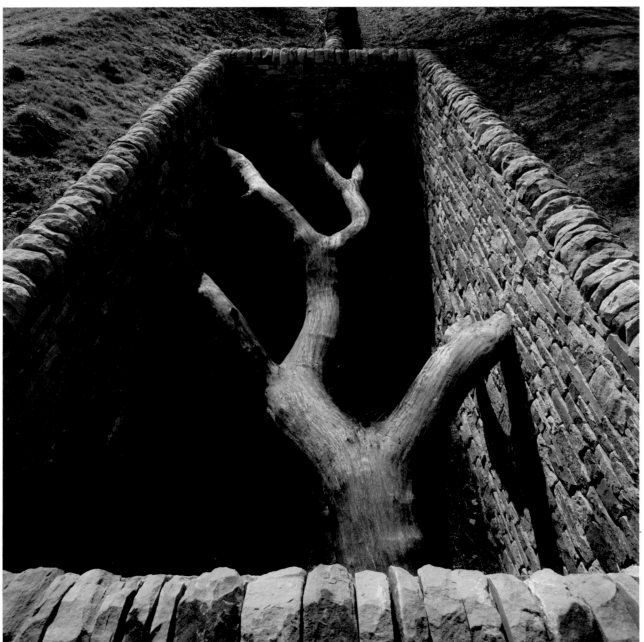

110

which is earth," yet ultimately demurred because of the essentially pictorial viewing conditions that such works would instantiate.

Alternatively, Goldsworthy elected to work with three derelict sections of a stretch of double-sided ha-ha located in a ditch that had been excavated along the brow of Oxley Bank and that now marked the boundary of the sculpture park. Although the ha-ha is freestanding, with either "side" available, Goldsworthy decided to dig into the ground, excavating three pits 10 feet deep, half of which sit within Yorkshire Sculpture Park and half on the neighboring farmer's land. Thus, the "other" view does not entail looking back across, but looking down into. In each of the three pits is a large stone chamber that punctuates a stretch of the wall. Three-quarters of each chamber is subterranean, and each contains a large, prone, floating oak tree. Those oaks evoke the falling body, the body within the earth, not the upright, mobile, rational, external observer.

111 STONE RIVER, 2006–2007

Overall: L 521' 10" (159.1 m), H 5' 7" −½" (1.7 m−1.2 cm)

Aspen Institute, Aspen, Colorado, US. Commissioned for the Doerr-Hosier Center with funds from Bryan and June Zwan

Red sandstone from China, Jordan, US (Colorado), UK (Cumbria). Installation began May 2006, continued July–September, and completed April 2007

JE, SA, GW, JW, AM, MH, Josiah Updegraff, Nick Ketpura, Billy Sallee, Phil Barutha

Goldsworthy first worked with the architect Jeffrey Berkus in 2004 and 2005, when Goldsworthy installed a series of works into the fabric of a private residence that Berkus had designed in Colorado (see page 69, fig. 3). Berkus was also the architect for the forthcoming Doerr-Hosier Center at the Aspen Institute, and Goldsworthy, as an outcome of their successful collaboration, was invited in summer 2005 to develop a work that would integrate not only with the new building's design, but also with its proposed purpose. The Aspen Institute is an extraordinary organization whose stated mission is to help foster values-based leadership and to provide a forum for neutral and balanced debate and discussion on critical world issues. It was estab-

lished in 1950 by Walter Paepcke, a Chicago business-man who brought Bauhaus-trained architect and designer Herbert Bayer to Aspen in 1946. Bayer went on to act as design consultant for the institute from the early 1950s until 1976. In that time, he designed over ten buildings for the Aspen Meadows campus, including the Seminar Building into which he integrated his *Sgraffito Mural* (1952), as well as *Grass Mound* and the *Marble Sculpture Garden* (both 1955). Thus, the development of the campus' architectural fabric and its immediate environment was integral to the development and consolidation of its wider vision.

This ethos was most recently reinforced by the collaboration between Berkus and Goldsworthy, the latter suggesting that it was his first opportunity to respond to both the physical fabric and the mission of a building. Long familiar with the Aspen Institute campus, Goldsworthy proposed building the third of his stone rivers and the most ambitious in terms of its scale: "I have in effect drawn a line through the building, connecting it to its surroundings" (S 2006, AGA). It begins as an edge protruding through the asphalt of the car park and then emerges full form in the excavated area in front of the building. It cuts through the reflecting pool and moves, as an edge, into and through the center of the building interior. It completes its journey at the end of a balcony that cantilevers over the Roaring Forks River. The visual continuity that is established by the line of the wall is perpetuated by the river itself. Goldsworthy also elected to source the red sandstone from various locations around the globe—including the United States (Colorado), England, China, Jordan—and to integrate the stones within the structure of the wall. In this respect, *Stone River* alludes to the continuities that run beneath regional separations and cultural differences not only in the form of geological veins but also as seams of common human values.

111 interior

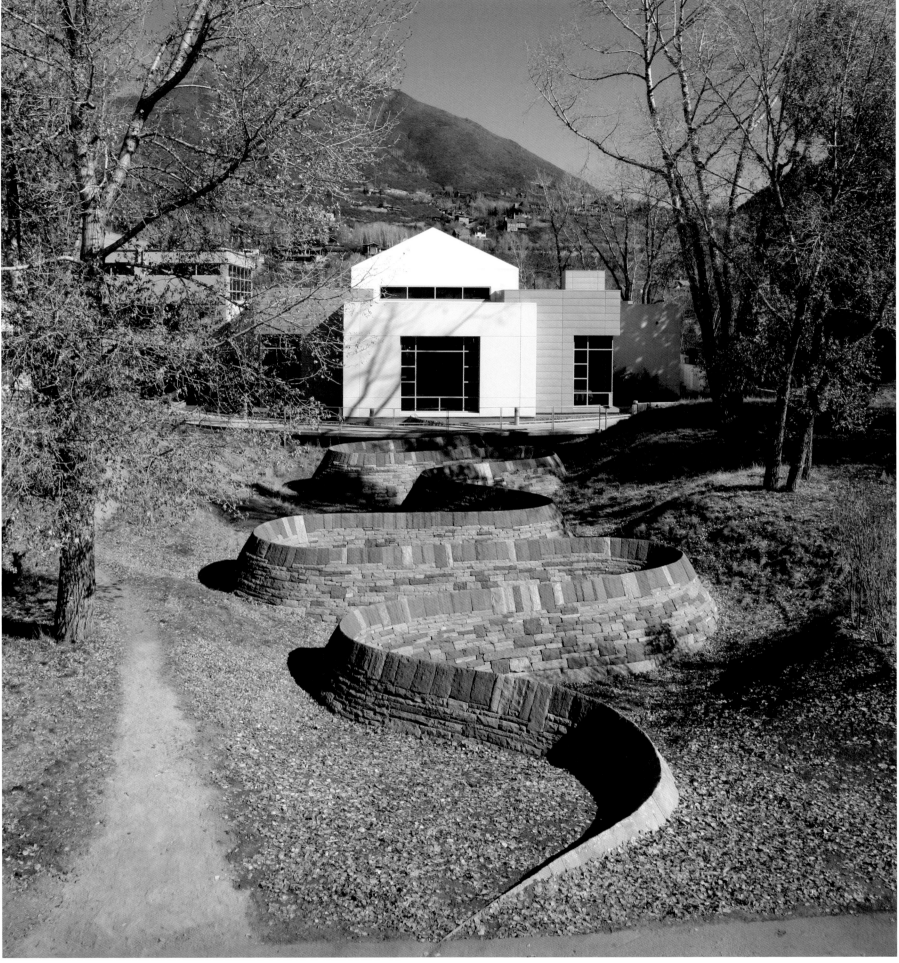

112 ARCH BETWEEN TWO ROCKS, 2006

H 6′ (1.8 m), S with boulders 16′ 4″ (5 m),
without 5′ 9″ (1.8 m), D 1′ 10″ (.6 m)

Private Collection, Nevada City, California, US

Installed July 2006

JE, JW

113 DOME HOLE, 2006

H 2′ 8″ (.8 m), Ø at base 9′ (2.7 m), Ø of hole 8 ½″ (20 cm)

Collection of Jerry Murdock, Colorado, US

Coloradan red sandstone. Installed August–
September 2006

JE

This work is one of several that Goldsworthy was
commissioned to build for a private residence. Six
works are sited inside the house, including *Work for
the Door: Clay and Light*, and were built in summer
2004 (see page 69, fig. 3). *Dome Hole*, the final work
of the commission, is the only one that sits on the
grounds of the property. As a shallow, self-supporting
dome built between several boulders, it forms some-
thing of a vortex drawing them into the ground below.

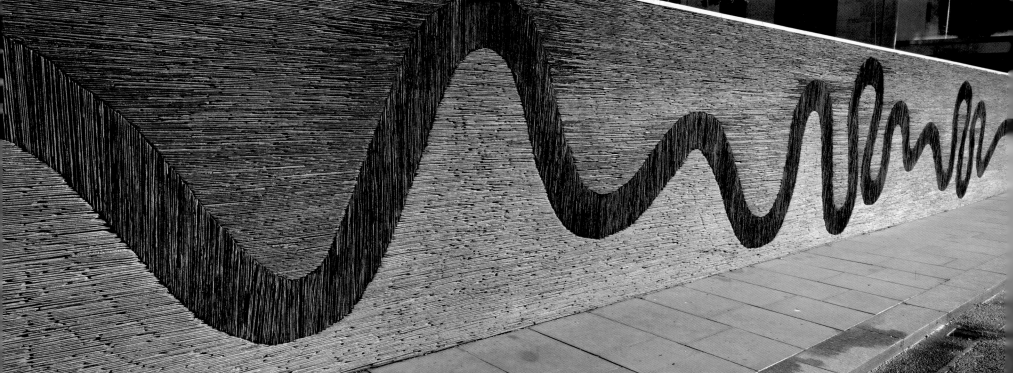

114 SLATE WALL, 2006

H 8' 3" (2.5 m), L 113' 2" (34.5 m)

Commissioned by Grosvenor and Native Land,
London, UK

24,000 roofing slates. Installed 23 October –
25 November 2006

*ES, SA, GW, JW, AM, MH, Edmund Hubbard,
Steve Owens*

Slate Wall is located on Montrose Place, near Belgrave
Square in London. It is built into a 34-meter stretch of
wall facing out on the street. Goldsworthy submitted
a number of proposals for the stretch of wall in 2005,
one of which featured small recesses. He decided to
proceed with the single, unified slate wall and to incor-
porate the river form running horizontally through it.
Like other of Goldsworthy's stacked slate works, *Slate
Wall* was built to respond to the light; the vertical and
horizontal stacking of the slates differentiates how
light operates on the wall's surface at any given time.
It is the first that he built of such length and as an
exterior surface to a preexisting wall.

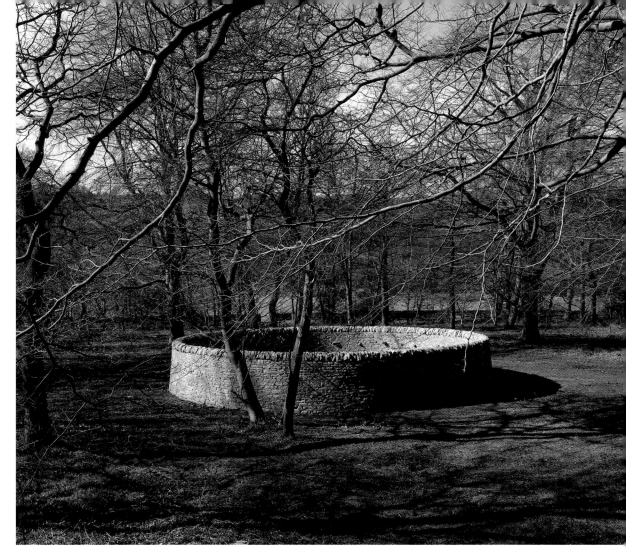

115 OUTCLOSURE, 2007

H 6' 5" (2 m), Ø 26' 2" (8 m)

Yorkshire Sculpture Park, Wakefield, UK

Sandstone. Installed February – March 2007

SA, WN, GW, JW, AM, MH, Neil Lingwood

Literature: Goldsworthy 2007, 187–189; Yorkshire
Sculpture Park 2007, 2–3,148–153

Like *Hanging Trees* (cat. 110), *Outclosure* engages
overtly with the ideological underpinnings of both
landscape and land. The fold structure, which stands
nearly 2 meters tall and has no entrance, is resolutely
implacable: it is an apparently unscalable edifice that
does not yield its contents or internal space to the
viewer. Its placement in the Round Wood, a small
parcel of land not within the ownership of Yorkshire
Sculpture Park, recalls the fact that Goldsworthy's
work often sits on land "owned" by another party and
engages an active acceptance of its presence by that
party. The shape of the structure is informed by the
shape of the wood, itself understood to be artifactual.
 Its title, unusually polemical for Goldsworthy,
very obviously references the historical processes of

115

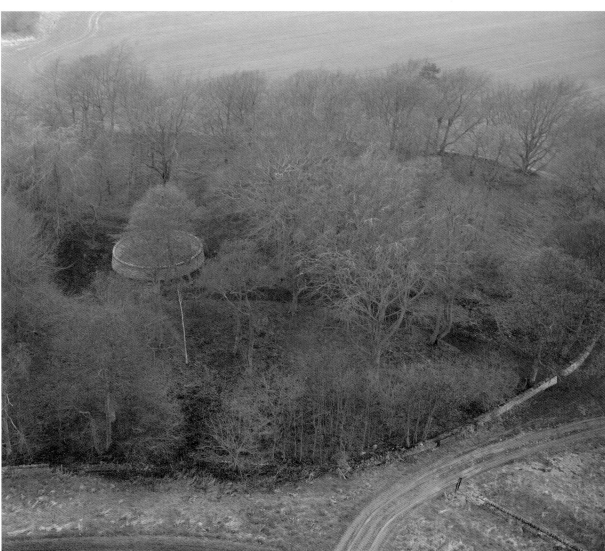

enclosure (or inclosure), which closed off and privatized large areas of land in England, and was legitimized and systematized by various parliamentary acts of the late eighteenth and early nineteenth centuries. The alienation from the land of large parts of the rural population, reliant upon access to it and rights of use, and the reinscription of space that this precipitated, are invested in *Outclosure*. Moreover, as Dell Upton suggested, "Space takes a back seat to imagery in the conceptualisation of landscape."[28] *Outclosure*, standing as a rebuttal of the visual primacy of landscape, encloses space that it refuses to yield to the viewer. "Care for landscape," Upton elaborated, "demands attention to both the seeable and the unseeable, particularly to the relationship between the seen scene and unseen space" (*sus*, 174). Yet, appositely in relation to Goldsworthy's structures and to *Outclosure* in particular, Upton cautioned against the reductiveness that a focus on "the political and economic processes that shape landscape" can precipitate. Those processes are not, he continued, "the final word on its meaning.... This conjunction of seen and unseen, then, draws our attention to the experience of landscape as well as its initial creation" (*sus*, 176).

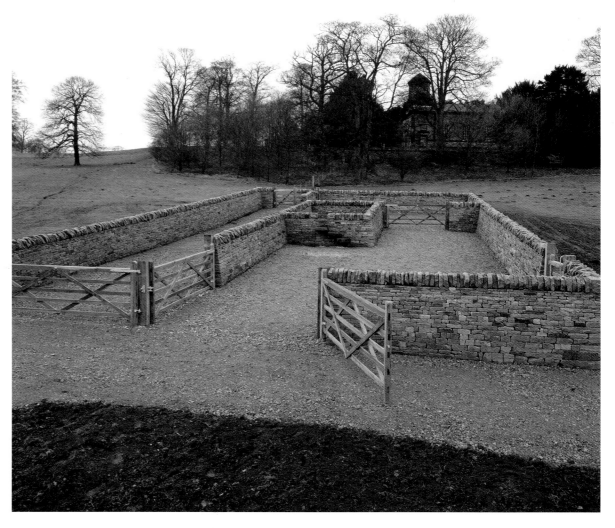

116 SHADOW STONE FOLD, 2007

Overall: H 4′9″ (1.5 m), W 41′ (12.5 m), L 85′3″ (26 m)

Yorkshire Sculpture Park, Wakefield, UK

Fieldstone. Installed February–March 2007

David Griffiths, Nigel Goody, John Billington, Simon Lumb, Alistair Lumb, Christopher Lumb, Clare Midwood, Mark Chesum

Literature: Goldsworthy 2007, 182–186; Yorkshire Sculpture Park 2007, 154–159

As Goldsworthy indicated, he initially proposed shadow folds for the *Sheepfolds Project* in Cumbria:

Shadow Stone Fold has its roots...in the *Drove Stones* [cat. 38] at Casterton, where, on one occasion when it rained, I laid on top of a flat-topped stone in the hope of leaving a shadow. What happened as an opportunistic response to a shower of rain led to the proposal to make a fold containing a stone put there specifically for people to lie on. Lying on a stone where others have lain is a way of linking the presence of one person to that of another. (2007, 177)

Yorkshire Sculpture Park is a unique art institution in that it also hosts a large number of grazing sheep belonging to a neighboring farmer. Goldsworthy proposed rebuilding the existing wooden sheepfold in stone and integrating a large flat-topped "shadow stone" into it. He initially hoped that the stone would sit within the open fold, but following negotiations and discussions with the farmer, the stone was placed in a small internal fold-within-a-fold.

Each house, exterior: H 13' 2" (4 m), W 16' (4.9 m),
L 19' (5.8 m)

Clay House (Holes)

House interior: H 13' 6½" (4.1 m), W 12' 10" (3.9 m),
L 12' (3.7 m)
9 holes, each ring: D 6–9" (15–23 cm)
Largest opening, outermost hole: ∅ 5' 9" (1.8 m)
Total: D 7' 5/8" (2.1 m)
Clay: 58 ft.³ (1.6 m³)

Clay House (Room)

House interior: H 11' 4¾" (3.5 m), W 12' (3.7 m), L 15' (4.6 m)
Total interior surface: c. 1,000 ft.² (93 m²)
Clay: 125 ft.³ (3.5 m³)

Clay House (Boulder)

House interior: H 13' 6½" (4.1 m), W 12' (3.7 m), L 15' (4.6 m)
Clay boulder: ∅ 7' 6" (2.3 m)
Clay: 45 ft.³ (1.3 m³)

Glenstone, Potomac, Maryland, US

228 cubic feet of clay found during excavation on-site,
Scottish Blackface sheep's wool, animal and human
hair, 107 tons of Carderock stone (mica-schist quartz-
ite), roofing slate from Buckingham, Virginia, oak, and
glass. Installed May–June 2007, November 2007, and
April 2008.

Architect: Keith Ross

*JE, SA, GW, JW, AM, MH, Brian Dick, Nick Stansic, Harold
Gray, Gerri Jones, Steven Moseley, Fiona Cundy, Matthew
Ball, John Minnich, Heather Lambert, Ned Shalanski,
Emily Wei Rales, Cicie Sattarnilasskorn, Jennifer Furlong,
Gaby Mizes, Alexandra Small, Dominic Paterson,
Michelle Jubin, Thomas Goldsworthy, Jong Sun Lee,
Jane Westrick, Katie Morton*

Goldsworthy first visited Glenstone in February 2005,
with a view to proposing a large-scale work for the
grounds of the museum then being built. He recalled
noticing the prevalence of reddish clay in the ground
and was also drawn to a particular site down below
the museum, at the bottom of a bank, in a quiet
meadowlike area. Goldsworthy subsequently proposed
building a group of three stone houses, each of equal
size; setting them into the bank; and, inside, construct-
ing installations using clay excavated from the ground.
Of the resulting works, *Clay House (Boulder)* includes
a large rammed earth sphere that Goldsworthy carved
into shape with an axe and then covered with a

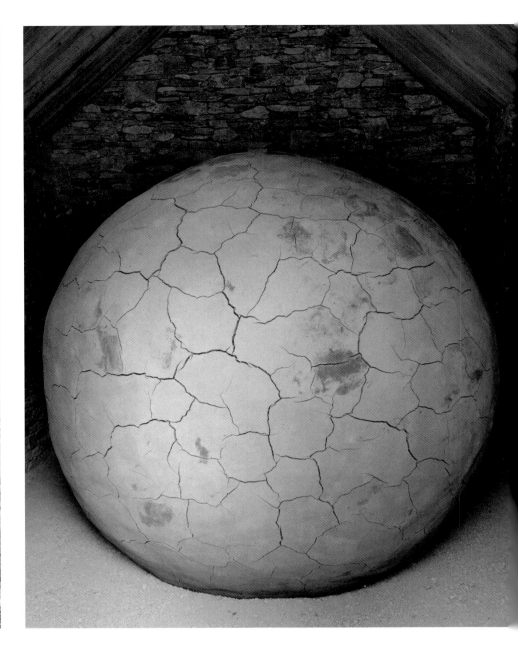

2 ½-inch-thick clay epidermis. With *Clay House (Room)* Goldsworthy covered all available interior surfaces in clay. In homogenizing every plane and angle, horizontal, pitch, and vertical, *Clay House (Room)* immediately recalls Frank Lloyd Wright's dictum, "Let walls, ceiling and floors become part of each other, growing into one another, getting continuity out of it all or into it all, eliminating any constructed features" (*FLWW*, 87). The third work, *Clay House (Holes),* contains a series of recessed clay holes built into its back wall. The "holes," which are built into a concrete box incorporated into the design of the house, give the sense that the wall (if not the whole house) and bank are contiguous.

The relationship between house and clay work is particularly interesting. Goldsworthy himself views *Clay Houses* as a large, single work, yet the title is ambiguous in what it suggests about the dynamic between house and clay: while it implies that clay is the main structural or constituent element of the houses, stone, of course, was the medium used. But neither do the houses seem to simply contain the clay works. As sphere (*Boulder*), circle (*Holes*), and square (*Room*), the three clay works can be seen to constitute archetypal or universal forms, and their respective houses isolate and help to construe them as such. Rendered as they are from a combination of dirt, mud, and hair, they bring to mind Plato's *Parmenides*, in which the youthful character Socrates rejected that such "base" and "worthless" objects as hair, mud, and dirt have "forms."[29] As Plato scholar Kenneth Sayre explained, mud or dirt purportedly "lack determinate properties—in effect are too messy to exhibit deter-

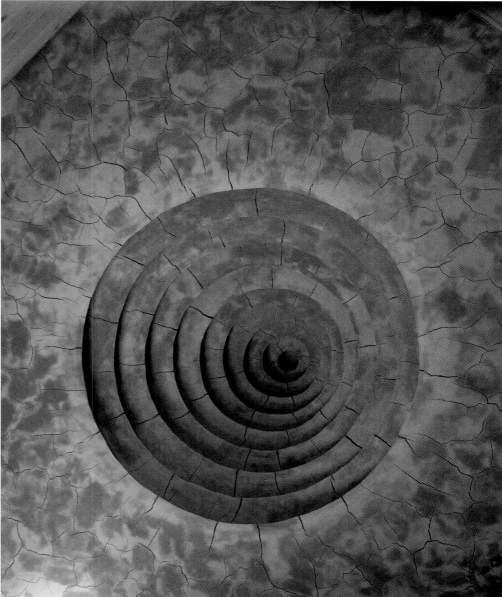

minate structure."[30] In a sense *Clay Houses* imagines a bringing-to-form of those very substances; for all the mess and indeterminacy that the installation of each clay work entailed, what results in each case is a resolved structure of dirt, mud, and hair.

It is equally possible to claim that, with *Clay Houses*, Goldsworthy realized something akin to the "humic" architecture that Pogue Harrison described:

I would expect a humic architecture...to be vertical in the downward and not only in the upward sense, and its rising to be more of an emerging than a soaring. I would expect it to be mortal and metrical, haunted in its visible aspects by the earth in which the existential and historical past ultimately come to rest. (*DD*, 35)

Insofar as they are literally rooted into the surrounding bank and contain the earth of their foundations, *Clay Houses* can said to be "vertical" in the "downward" as well as the "upward." Moreover, the houses are in a peculiar way "haunted" by the earth and by the works that they accommodate. Indeed, *Clay Houses* arguably presents in raw form an architecture that is "mortal"—not in the sense of overtly fragile, but of living and breathing. Each resulting clay work has demonstrably cracked, two have developed a distinctive patina, and all three remain responsive to the climate and conditions. Furthermore, with the addition of human hair the clay as a material contains DNA, and its processing bears evidence of human working. Thus, it speaks very directly of us as connected with the earth.

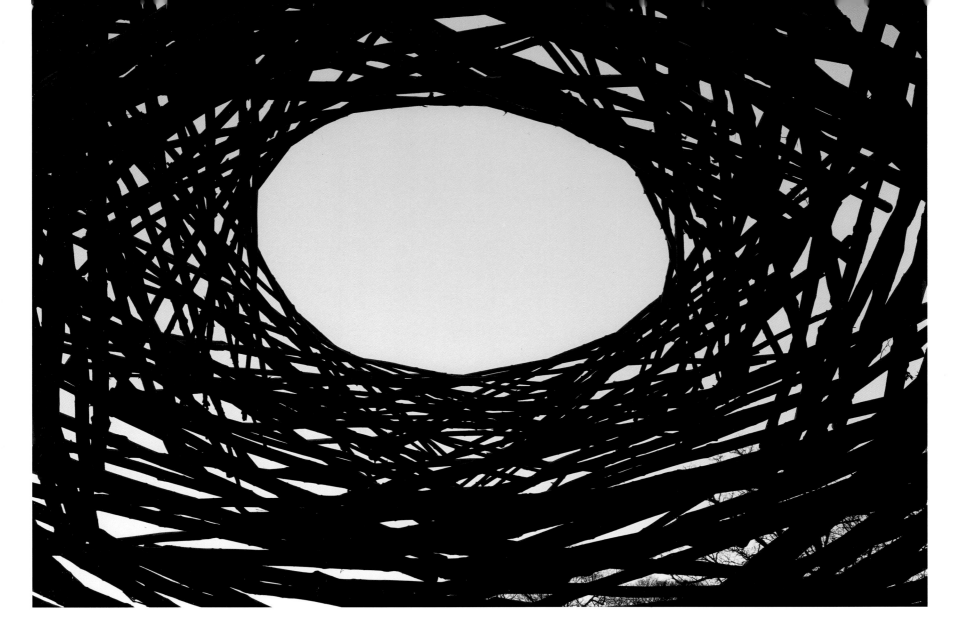

118 COPPICE ROOM, 2008

H 14′ 5″ (4.4 m), ⌀ of dome 29′ 6″ (9 m), ⌀ of oculus 8′ 2″ (2.5 m)

Private Collection, East Sussex, UK

Coppiced sweet chestnut from King's Wood, Kent. Installed February 2008

JE, Sam Clayton, Mark Jacobs

Literature: Reina Sofía 2007; Yorkshire Sculpture Park 2007, 10, 110–119

Coppice Room was first constructed as *Wood Room* for Goldsworthy's 2007 exhibition at Yorkshire Sculpture Park and installed in one of the underground galleries there. In that first context, it was built within the gallery as a hemispherical dome of densely knit coppiced sweet chestnut, nearly freestanding with only a few of its logs buttressed to the walls of the space for support. The focus of the form was its interior, with the limbs of the sweet chestnut wrapping around and overhead to envelope the viewer in a powerful feeling of interiority. The installation was subsequently rebuilt as an entirely freestanding structure on the grounds of a private property.

The logs used first for *Wood Room* and then for *Coppice Room* were sourced from King's Wood, an ancient woodland and coppice in Kent. The choice of coppiced wood was purposeful for Goldsworthy insofar as coppicing is a traditional practice related to woodland management and economics that engages his interest in the "cut" as a historical and ideologically loaded gesture. Moreover, Goldsworthy was keen to maintain a direct relationship between the material as economic unit, its manner of production, and its source. As Raymond Williams wrote in a 1972 essay entitled "Ideas of Nature":

In our complex dealings with the physical world, we find it very difficult to recognise all the products of our own activities. We recognise some of the products, and call others by-products; but the slag-heap is as real a product as the coal.[31]

Primarily, however, Goldsworthy's aim with his recent large-scale domed spaces has been to prompt an intense physical-emotional experience in the viewer. Interestingly, the interiority that Goldsworthy sought to promote as experience with *Coppice Room* becomes dialogic with the proposition of writers such as Pogue Harrison that "we dwell not in the forest but in an exteriority with regard to its closure."[32] Where do Goldsworthy's wood dome spaces sit in relation to such thinking? As Pogue Harrison continued: "To be human means to be always and already outside of the forest's inclusion, so to speak, insofar as the forest remains an index of our exclusion."

Arguably, the more densely constructed *Wood Room* provided a more immersive experience—of the kind that collapses physical and emotional boundaries—than does its exterior analogue. However, Goldsworthy's large domed spaces are intended less as dwellings than as spaces for the perceiving body, acutely attuned to the qualities and resonances of material.

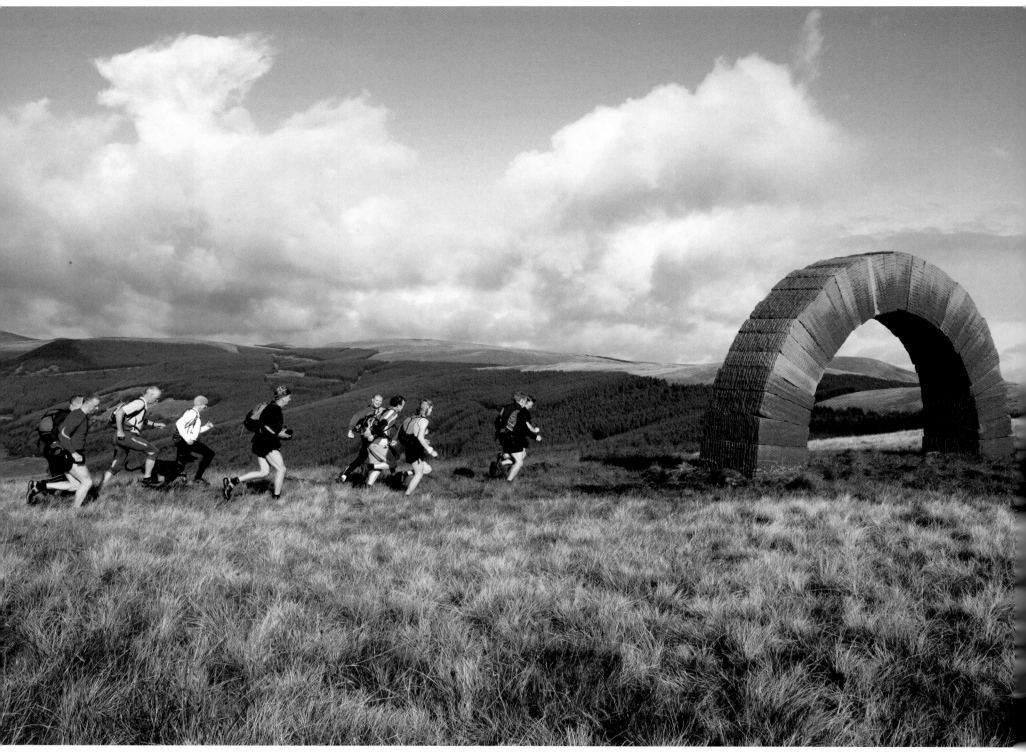

Each arch: **H** 12′ 7″ (3.8 m), **S** 23′ 2″ (7.1 m), **D** c. 3′ 3″ (1 m)

Commissioned by Dumfries and Galloway Arts Association, Cairnhead Community Forest Trust Ltd, and Forestry Commission Scotland (see page 71)

Approximately 100 tons of Locharbriggs red sandstone. Built in the quarry 2005–2006. Installed March–May 2008

ES, BN, GR, AMcK, Wallace Haining, Tam Ewing, Jamie Goldsworthy

Literature: Friedman, in Goldsworthy 2000b, 202; Yorkshire Sculpture Park 2007, 126–129

Striding Arches is the largest permanent work by Goldsworthy found in the Dumfriesshire landscape. He first conceived the idea for a series of "striding" or "running" stone arches, which would number as many as fifty and be installed in the Dumfriesshire hills in the mid-1990s. The arches would mark out the route for a fell run in the Lowther Hills, local to the Drumlanrig Estate. Then, at the suggestion of local farmer David Kirkpatrick and Melville Brotherton of Cairnhead Community Forest Trust, an organization based in nearby Moniaive, Goldsworthy walked a considerable area of the Cairnhead Forest. Drawn to the highly distinctive hillscape, he decided to relocate the proposal there.

Goldsworthy chose to site a large red sandstone arch on the crests of three hills—Colt, Bail, and Benbreck—so that each arch would sit, framed against the sky, on the horizon line. On climbing all three hills, he was struck by the strong visual connection that exists between them: from the top of Bail Hill, a walker can still see the tops of Colt Hill and Benbreck. Despite the visual connections, no route or line links the arches. "The work isn't finished," Goldsworthy stated, "until [a] path has been made. Those arches need a line and the line is as much part of the work as the arches….It is waiting for that to happen. I don't want to be prescriptive about it."[33] *Striding Arches* is the closest association of arch and human figure that Goldsworthy has produced, a connection emphasized by a fell run around the arches made by a group of hill runners led by Goldsworthy's brother John on 28 September 2008. A "line" putatively linked the arches on that occasion, emanating from the runners' release, even exchange, of energy as part of a dynamic physical experience of the environment.

A fourth arch, the so-called *Byre Arch* installed in April 2005, strides out of a previously derelict byre in the Cairnhead Glen.

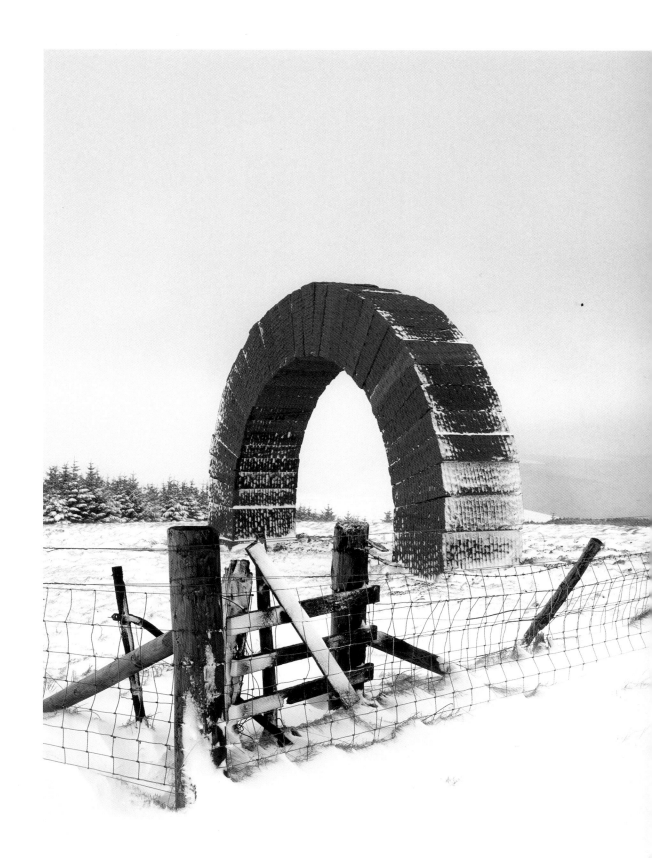

120 CORNELL CAIRN, 2008

H 5'11" (1.8 m)

Cornell University, Ithaca, gift in honor of Maximilian
Arnold Gold, beloved son, Michael O. Gold and Sirje
Helder Gold, Los Angeles, us

Installed April 2008

This cairn was initially installed in Connecticut in
September 1995 at a private residence. It was subse-
quently gifted to Cornell University, where Golds-
worthy installed it in April 2008 in Sapsucker Woods,
near the Ornithology School, following the completion
of his tenure as an Andrew D. White Professor-at-Large
(2000–2008).

196

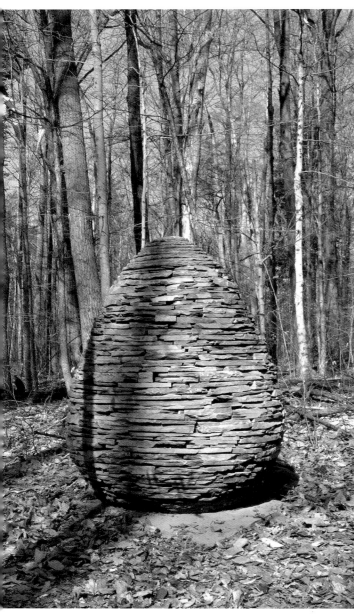

120

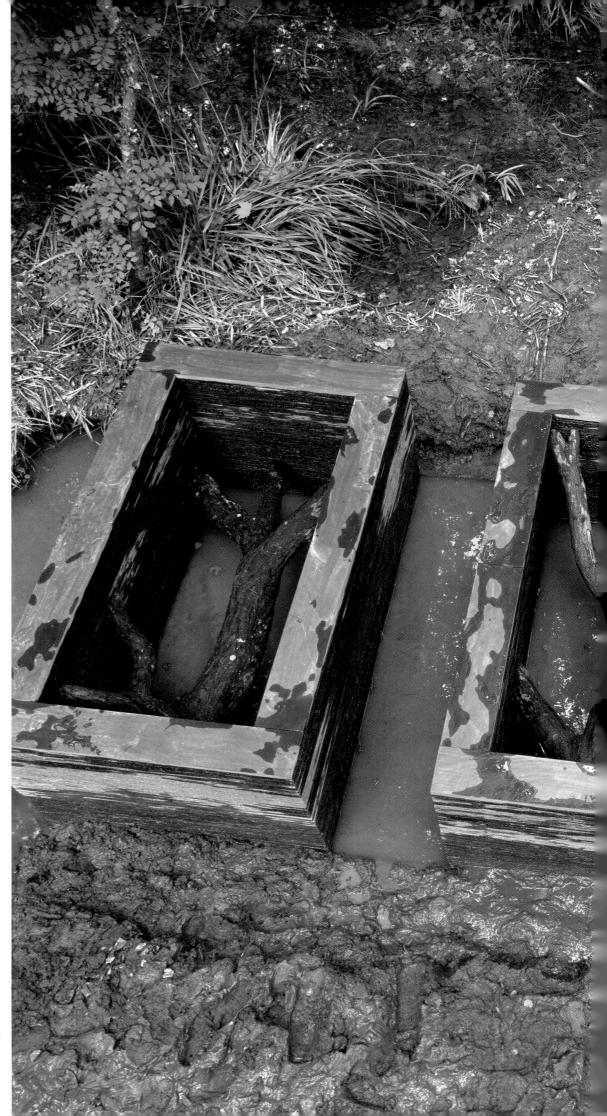

121

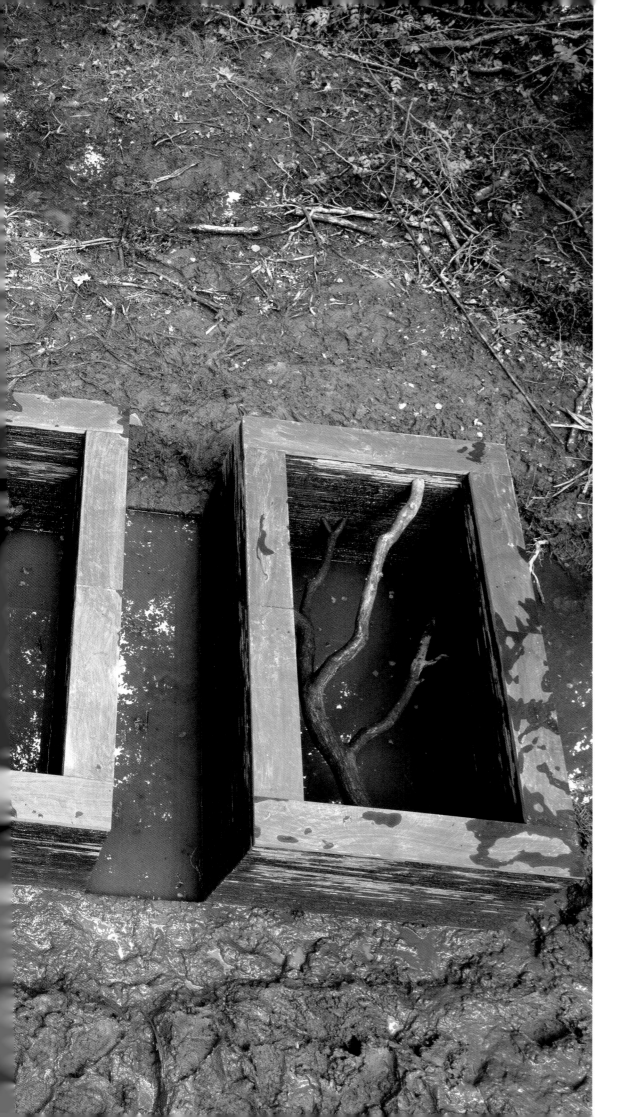

121 REFUGES DES ARBRES, 2008

H 4′6″ (1.4 m), W 3′3″ (1 m), L 6′5″ (2 m)

Private Collection, France

Spanish slate and wind-fallen Scottish oak.
Installed May 2008

GW, JW

Exhibition: *Refuges* 2006

Refuge des Arbres was first installed in Galerie Lelong
in Paris in April 2006 as part of Goldsworthy's *Refuges*
exhibition. The installation comprised four parts: three
slate "wells," into which prone oak limbs were built,
and a clay wall in which a tree was embedded. The
three tree wells were acquired in memory of a private
collector and subsequently installed by Goldsworthy
in the garden of his property in southwest France.

Whereas the slate wells were installed in a line
end to end in Galerie Lelong, Goldsworthy decided
here to install them side by side, bringing a powerful
sense of interment to the work. The garden is prone to
flooding from the neighboring river, and Goldsworthy
installed the wells in a small canal so that water will
flow through the bottom of the structures. The works
were installed during a period of heavy rain, and the
wells and trees were flooded in their entirety during
construction.

122 CLAY WELLS, 2008

*3-part work, linked by a trail 1,142 feet long
Each well, clay surface:* W 10′ (3 m), D 10′ (3 m);
stone structure: W 13′ (4 m), D 13′ (4 m)

Collection of Jeanne and Michael Klein, Santa Fe,
New Mexico, US

Raw clay, stone. Installed July–August 2008

*JE, SA, AM, Andrew Gellatly, John Jones, Steve Peterson,
Johnny Dennis, Paul Schmidt*

Several permanent commissions by Goldsworthy have
displayed a diurnality, some positioned or even created
to respond to the passage of the sun from east to
west. *Clay Wells* constitutes a more developed engage-
ment by Goldsworthy with diurnal rhythms and their
influence on how the terrain (including our own inter-
ventions into it) is visually manifest to us at any given

above, well exterior; right, time lapse

moment. Underpinning this work is the recognition that atmospheric conditions and diurnal rhythms obscure, reveal, amplify, or otherwise mediate how we visually apprehend or physically experience the material world around us. Although these forces are putatively natural, their effects are emphatically cultural.

Clay Wells comprises three large square stone wells, the bottoms of which are covered with raw clay. Lying under each clay floor is a concrete subbase, into which Goldsworthy incorporated a modification: a high-relief circle is in one; the concrete is domed in the middle of another; and the third features concentric circular edges. As with *Clay Walls* (cat. 51), for instance, the substructure in the base of the wells influences what appears on the clay surface. Here, however, the clay surfaces and the images that appear in them are subject to cycles of dehydration and rehydration, as dictated by the patterns of dry and wet experienced in the area within any twenty-four-hour period. The wells are not covered but are exposed to the elements; they are therefore subject to extreme heat, as well as frequent rainstorms coming off the nearby mountains. Extreme dry conditions produce quick cracking in areas of shallow clay, while areas of deeper clay take longer to dry and produce deeper fissures. The clay wells are designed to gather water, under which the "image" produced in the clay by the heat and the drying then disappears, until evaporation begins the drying and cracking process again. Thus, the elements that coalesce to produce *Clay Wells*—clay, heat, and precipitation—will perform an ongoing cycle of self-creation and auto-erasure. The resulting images—the surface variations caused and influenced by the interventions beneath—are ephemeral and invariably partial and imperfect. They are of wonderfully understated impact, and their revelation has less to do with the vagaries of a natural process than with the subtlety of our own visual and experiential acuity.

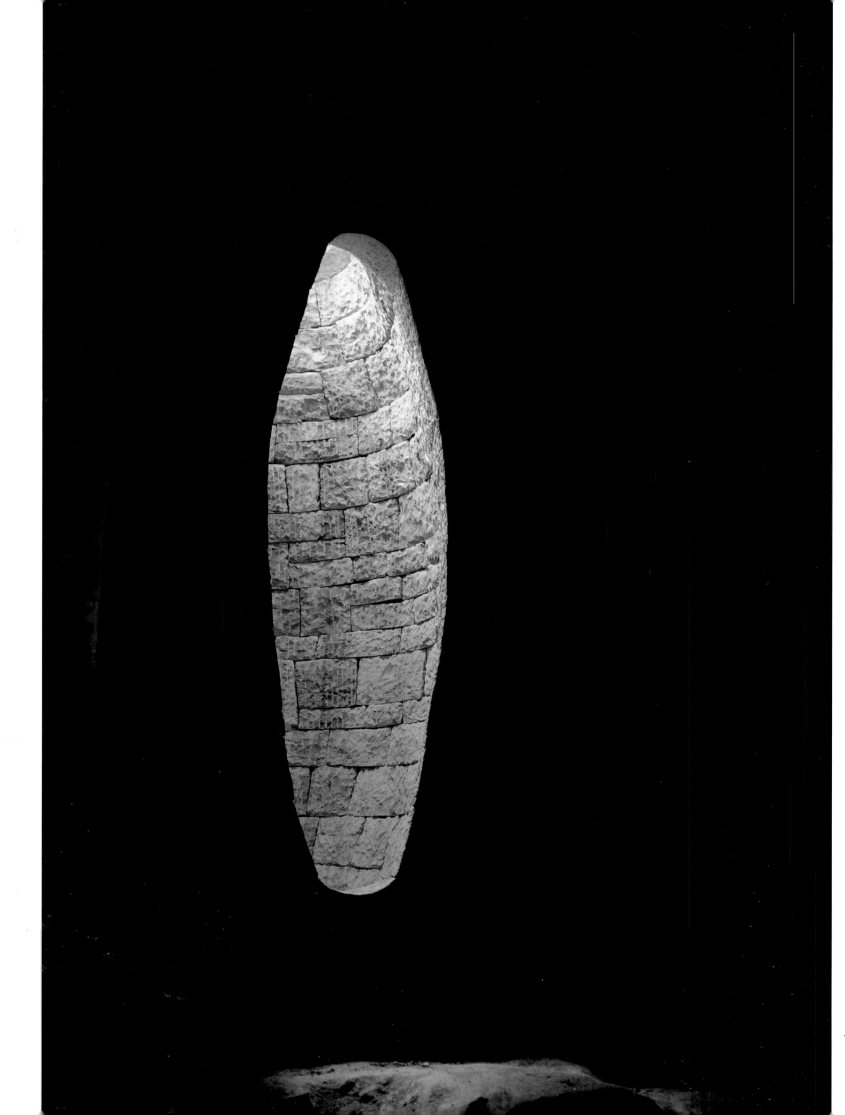

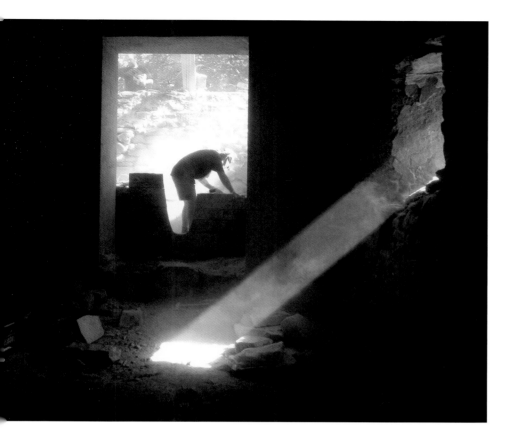

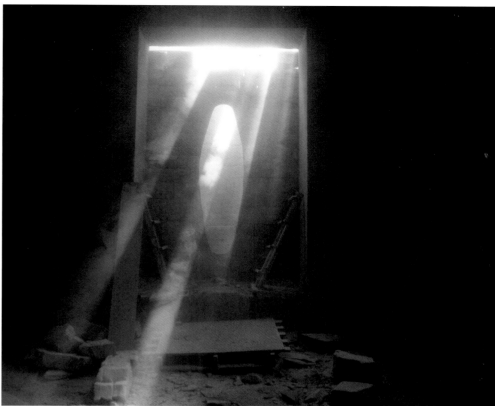

123 REFUGE D'ART, LA FOREST, 2008
(REFUGES D'ART)

Chamber: **H** c. 6′ 10″ (2.1 m), **w** 2′ 4″ (.7 m)

Commissioned by Réserve Géologique de Haute-Provence and Musée Gassendi, Digne-les-Bains, France (see page 71)

Stone sourced from site. Installed 1–18 September 2008

Architect: Éric Klein

JW, AM, MH

Literature: Goldsworthy 2002, 66–67, 73; Goldsworthy et al. 2008, 54–57, 165–166, 168

Of the sites at which Goldsworthy has worked in and around Digne-les-Bains, the abandoned village of La Forest perhaps best evokes the Haute-Provence region as expressed by Jean Giono in his 1953 novella *The Man Who Planted Trees*: "The five or six roofless houses, weathered away by the wind and the rain, and the little chapel with its fallen tower, were arranged like the houses and churches in living villages. But in them no life remained."[34] La Forest, by current standards one of

the more remote *Refuges d'Art* locations, at one time supported a large and possibly wealthy community if the size of the former properties that remain there is taken into account. Indeed, its abandonment is relatively recent, dating to the last century. Then, the cumulative impact of factors such as two world wars and their effect on the young French male population made life in such villages largely untenable.

Goldsworthy visited La Forest early in the development of the route for the project, and he proposed rebuilding the village's small derelict chapel and installing a screen of stalks across its nave. At some point following the construction of the chamber at Chapelle Ste Madeleine (cat. 76), Goldsworthy decided to substitute a stone chamber for the proposed stalk screen. Goldsworthy built the chamber at Chapelle Ste Madeleine from the bottom upward, and he noticed that it was full of light until the final stones were placed on top to enclose it. When completed and viewed from the front, the chamber suddenly appeared to float like a velvety dark opening. Goldsworthy decided to build a counterpoint "light" chamber, which would have an oculus at the top to admit

light. What remained of the two-room chapel at La Forest provided the ideal circumstance to realize the work. The sacristy at the end of the nave was almost entirely derelict and presented the perfect location to site the wall that would contain the light chamber, as Goldsworthy would be able to control the light levels of the nave.

If life in the daily, domestic sense abandoned the village long ago, then the phenomenological memory of that life has not. Philosopher Maurice Merleau-Ponty wrote of the gestures by which we negotiate the world, "In the action of the hand which is raised towards an object is contained a reference to the object…as that highly specific thing towards which we project ourselves, near which we are, in anticipation, and which we haunt."[35] For Goldsworthy, stone is a sensitized, receptive medium, the materiality of which is mediated or haunted by layers of purposeful and incidental human gestures. Goldsworthy used stone found in the debris of partly derelict buildings, and for all the abrasive cutting, grinding, and working of the stone that the creation of the chamber entailed, it is as if he wanted to strip it back and disclose those gestures. The chamber itself is that disclosure.

NOTES

1 Carolyn Forché, "Burning the Tomato Worms," in *Gathering the Tribes* (New Haven, 1973), 4.

2 Joanna Morland, *New Milestones: Sculpture, Community and the Land* (London, 1988), 41–48; see 42, 43 for extracts of Goldsworthy's proposal statement.

3 Richard Cork, "An Historical Perspective," in Morland 1988, 12–13.

4 George Kubler, *The Shape of Time* (New Haven, 1962), 33 (hereafter cited in text as *ST*).

5 John K. Grande, *Art Nature Dialogues: Interviews with Environmental Artists* (New York, 2004), 165–176.

6 "Wall" was published in 1981 in *Sea to the West*. See *Norman Nicholson, Collected Poems*, ed. Neil Curry (London, 1994), 321–322.

7 Henry Moore, *Unit 1*, ed. Herbert Read (London, 1934), 29.

8 Michael Turner, *English Parliamentary Enclosure: Its Historical Geography and Economic History* (Dawson, 1997), 15.

9 Kay Anderson and Susan J. Smith, "Editorial: Emotional Geographies," *Transactions of the Institute of British Geographers*, 26, no. 1 (2001): 8.

10 Denis Cosgrove, "America as Landscape," in *Social Formation and Symbolic Landscape* (London and Sydney, 1984), 170 (hereafter cited in text as *SFSL*).

11 Andy Goldsworthy, "Statement," in *Herring Island Environmental Sculpture Park*, ed. Maudie Palmer and Bryony Marks (Melbourne, 1999), 18–21.

12 William Cronon, *Changes in the Land: Indians, Colonists, and the Ecology of New England* (New York, 1983), 150.

13 "Seasons and Eclogues: Foundations of the English and American Landscape," in Cosgrove 1984, 143.

14 The Scottish Enlightenment refers to a period of flourishing intellectual life in Scotland, putatively dated between 1681 and 1795, which reached across economics, science, and culture. Its ideas were internationally influential.

15 Roy Porter, *The Making of Geology: Earth Science in Britain 1660–1815* (London, 1977), 188–189.

16 Ian Convery et al., "Death in the Wrong Place? Emotional Geographies of the UK 2001 Foot and Mouth Disease Epidemic," *Journal of Rural Studies* 21 (2005): 101.

17 *Norman Nicholson, Collected Poems 1994*, 319–320; "Beck" was also published in *Sea to the West* in 1981.

18 Robert Pogue Harrison, *The Dominion of the Dead* (London and Chicago, 2003), 39 (hereafter cited in text as *DD*).

19 Owain Jones, "An Ecology of Emotion, Memory, Self and Landscape," in *Emotional Geographies*, ed. Joyce Davidson, Mick Smith, and Liz Bondi (London, 2005), 206.

20 Convery et al. 2005, 107.

21 Johannes Stüttgen, *Beschreibung eines Kunstwerkes* (Düsseldorf, 1982), 1. The Beuys' project was inaugurated at Documenta 7 in Kassel, Germany, in 1982, in a plan that called for the planting of seven thousand trees— each paired with a columnar basalt marker measuring approximately 4 feet aboveground—throughout the greater part of the city.

22 Frank Lloyd Wright, "Modern Architecture, Being the Kahn Lectures," in *Frank Lloyd Wright, Collected Writings*, ed. Bruce Brooks Pfeiffer (New York, 1992), 2 (1930–1932): 59 (hereafter cited in text as *FLWW*): "[The dome] has flourished as this symbol ever since, not only in the great capitals of the great countries of the world, but, alas, in every division of *this* country, in every state, in every county, in every municipality thereof. From the general to particular the imitation proceeds, from the dome of the national Capitol itself to the dome of the state capitol. From the state capitol to the dome of the country courthouse … down to the dome of the city hall."

23 Matthew Gandy, *Concrete and Clay, Reworking Nature in New York City* (London and Cambridge, Mass., 2002), 22 (hereafter cited in text as *CC*).

24 Justin Wilford, "Out of Rubble: Natural Disaster and the Materiality of the House," *Environment and Planning D: Society and Space* 26 (2008), 647–662 (hereafter cited in text as *EPD*).

25 Ernest Shackleton, *South: The Endurance Expedition* (London, 2004), 164.

26 For a definition of the ha-ha, see S. A. Mansbach, "An Earthwork of Surprise: The 18th Century Ha-Ha," *Art Journal* 42, no. 3 (autumn 1982), 217–221: "The ha-ha was employed widely in eighteenth-century Britain both as a practical device to keep the lord's grazing animals from the immediate vicinity of the house and as a means to create a satisfying visual continuity between house and the surrounding 'natural' parkland." Mansbach also suggested that its "mature English use" by landscape designers such as Charles Bridgeman and Stephen Spitzer falls between 1730 and 1750.

27 Denis Cosgrove and Stephen Daniels, eds., "Introduction," in *The Iconography of Landscape* (Cambridge and New York, 1988), 7.

28 Dell Upton, "Seen, Unseen and Scene," in *Understanding Ordinary Landscapes*, ed. Paul Groth and Todd W. Bressi (New Haven and London, 1997), 174 (hereafter cited in text as *SUS*).

29 Mary Louise Gill, "Problems for Forms," in *A Companion to Plato*, ed. Hugh H. Benson (London, 2006), 189; she also wrote (184): "Plato's theory of Forms is his most famous contribution to philosophy. Forms are eternal, unchanging objects, each with a unique nature, which we grasp with our minds but not with our senses. For instance, the Form of beauty … is supposed to explain the beauty of things we experience in the world."

30 Kenneth Sayre, *Parmenides' Lesson: Translation and Explication of Plato's Parmenides* (South Bend, Ind., 1996), 317 n. 37.

31 Raymond Williams, *Culture and Materialism, Selected Essays*, 2nd ed. (London, 2005), 83.

32 Robert Pogue Harrison, *Forests: The Shadow of Civilisation* (Chicago and London, 1992), 201.

33 Mark Fisher, "Knowing His Place," *Scotsman*, 2 October 2008, 44.

34 Jean Giono, *The Man Who Planted Trees* (London, 1995), 8.

35 Maurice Merleau-Ponty, *Phenomenology of Perception* (London, 1962), 139.

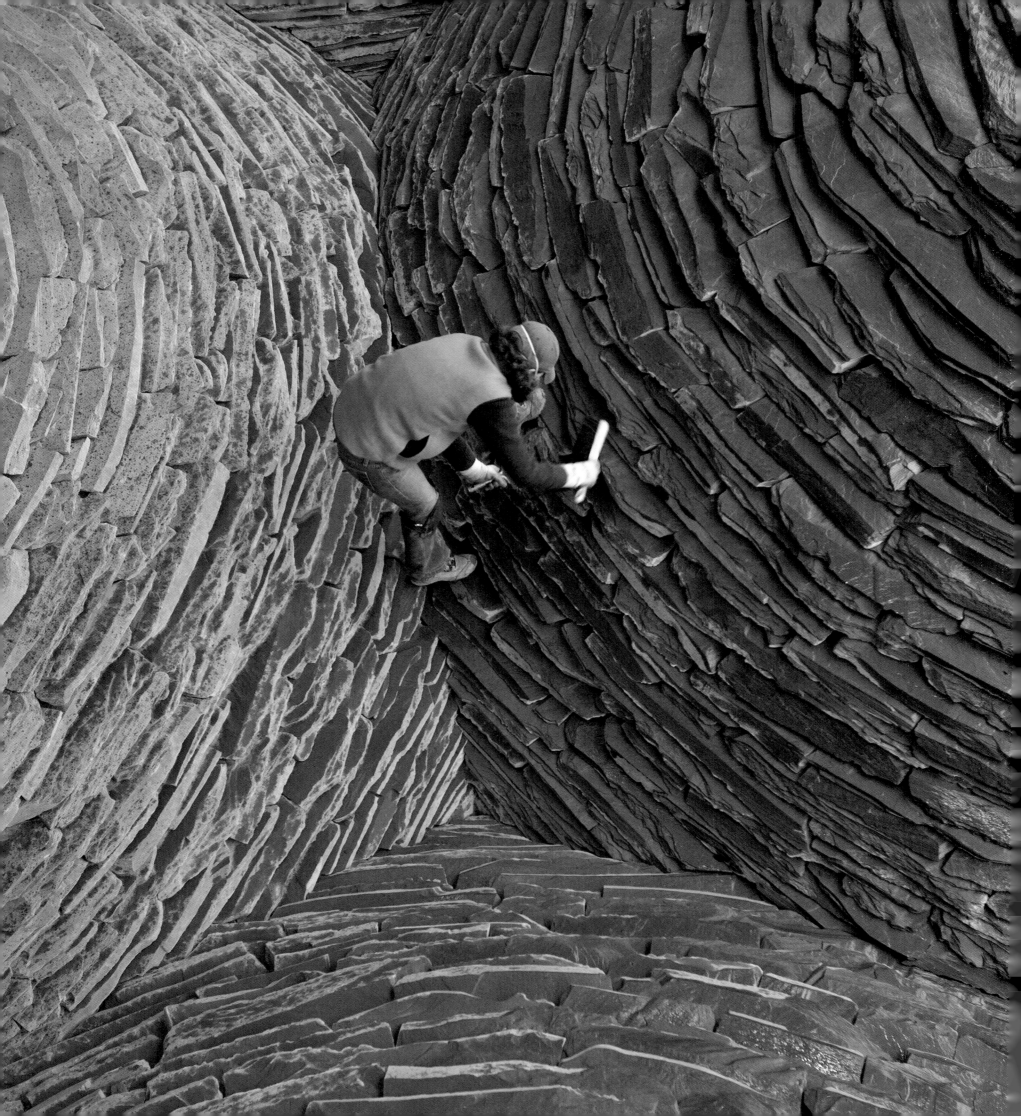

First and foremost, I thank Andy Goldsworthy for his generosity throughout this project and the production of this volume. Such gracious cooperation has long been evident in his art-making and I join with my coauthors—Tina Fiske, John Beardsley, and Martin Kemp—in chronicling the rich histories that his work has inspired. Working with them was a great pleasure; indeed, it was an honor. Their texts combine within the covers of this book to deepen our appreciation of Goldsworthy's art. Projects such as the artist's work for the National Gallery of Art, while well documented, have often gone unpublished. To properly understand the work of this process-intensive artist, the records themselves must be absorbed and presented for full consideration, in the context of fresh perspectives on Goldsworthy's oeuvre as a whole. The Gallery was extremely fortunate to have a patron who understood this need. The realization of this volume owes much to the Glenstone Foundation, and to Mitchell P. Rales, its founder; Emily Wei Rales, curator; and Stephanie Rachum, curatorial advisor. A two-month fellowship at the research and academic program of the Sterling and Francine Clark Art Institute, Williamstown, Massachusetts, provided me with an essential opportunity to focus on the contents of this book. For kindly hosting me and my family, I am grateful to Michael Ann Holly, Starr director; Mark Ledbury, associate director; and Gail Parker, program assistant. Other Clark fellows—including Ting Chang, Melissa Hyde, Mark Jarzombek, John Tagg, Jennifer Tucker—and visiting professor Hollis Clayson contributed to an extremely collegial, productive tenure in Williamstown. Such time away from my duties at the Gallery would not have been possible without the support of Jeffrey Weiss, former curator and head of modern and contemporary art, and Alan Shestack, former deputy director.

This volume benefited from the contributions of several colleagues at the Gallery. I thank research volunteer Katharine Wells, whose work was crucial in the early stages of the book, and the eagle-eyed Verónica Betancourt, assistant in modern and contemporary art, who managed data sheets and reams of information that crisscrossed the Atlantic countless times as we neared the finish line. Joining her in the department was the ever-able Sydney Skelton, who pitched in at critical moments. Many colleagues read my essay closely, offering key insights and valuable critiques: I thank, above all, Harry Cooper, curator and head of modern and contemporary art, for his keen talents as an editor and logician; Sarah Kennel, associate curator of photography, for reviewing photography-related aspects; and Joyce Tsai, research associate, Center for Advanced Study in the Visual Arts (CASVA), for important observations. In the publishing office, Julie Warnement, senior editor, worked tirelessly with each author, maintaining her graceful nature while upholding the consistency and quality standards of the Gallery. Indeed, she was the guardian angel of this book. Wendy Schleicher, the talented senior designer, created a beautiful layout that complements the spirit of the art it contains; her design dovetails the aims of the texts with the visuals of the book. Judy Metro, editor in chief, provided invaluable counsel and patiently brainstormed with me as the book came together. I also thank Joseph Krakora, executive officer; Elizabeth Croog, secretary and general counsel; Nancy Breuer, deputy general counsel; and Carolyn Greene McKee, associate general counsel. For granting permission to reprint "Museum of Stones," I thank Carolyn Forché. For discussing Goldsworthy's work with me, I am grateful to Susan Talbott, director of the Wadsworth Atheneum, Hartford, Connecticut; Leah Dickerman, former associate curator at the Gallery, now curator of painting and sculpture at the Museum of Modern Art, New York; and Pamela Lee, professor of art and art history at Stanford University. Steve Allen, master drystone waller on Goldsworthy's team, conferred on the technical aspects of the walling process used in *Roof* and provided essential photography on Hutton Roof Crags. Much of my written contribution to this book was penned at my brother Joe Donovan's house in Canada, and I am ever-grateful to him and his wife Anna for creating and sharing such an ideal writing perch. Most important, I would like to thank my dear husband, Dirk Young, for helping me puzzle out several ideas and for his scientific reading of my essay. In addition, I relied on the aid of countless friends for support and for providing clarity: Maggie Michael, Robin Slonager, and Dan Steinhilber, among others.

During the first phase of the project at Government Island, Stafford County administrator Steve Crosby and Chuck Halt, manager of the Aquia Harbor Property Owners Association, granted access to the site. I thank them both, as well as Jane Conner, historian of Government Island, who generously took time to discuss its rich history.

For the second phase—which involved the installation of *Roof*—I am grateful to numerous colleagues from all levels at the Gallery for providing their expertise and insight: Earl A. Powell III, director, whose steadfast enthusiasm for Goldsworthy's work shepherded the project through both phases, and the Board of Trustees, who gave essential support. I also thank Darrell A. Willson, administrator; and Susan Wertheim, deputy administrator for capital projects.

Among curators, past and present, who kindly offered thoughtful comments during the decision-making process are the late Philip Conisbee, Peter Parshall, Nicholas Penny, Jeffrey Weiss, Leah Dickerman, and Judith Brodie. In addition, Columbia University professor Simon Schama kindly looked at the proposal drawings and contributed invaluable ideas during the proposal stage.

The research on the sources for Washington building stones would not have been possible without the knowledge and generosity of the following people: Kevin Brandt, Bryan Dyer, Paul Evans, Doug Faris, Ann Fuqua, Tom Hahn, Outerbridge Horsey, Jack T. Irwin, Tim Johnson, Kathy Kupper, John Lockwood, David Lundy, James Perry, Steven Potter, Jesse Reynolds, Dennis Rood, Dave Runkel, Rod Sauter, Gary Scott, Constantine Serferlis, Harold Vogel, Chuck Wagner, and Perry Wheelock. The staff at the quarry in Buckingham, Virginia, particularly Tom Hughes, provided the beautiful slate for *Roof*. The late Major General Thomas Stanley Jeffrey, Jr., of Arvonia generously took time to discuss the history of Buckingham Virginia slate (particularly the Welsh émigrés who founded the quarry) with the artist.

An installation of the scale and complexity of *Roof* can only be executed with key players working as a tight-knit team: at the Gallery Lindsay Macdonald, my right (and left) hand, attended to every need, large and small, for Goldsworthy and his team, and kept the project running smoothly throughout; Mike Giamber, former deputy chief of facilities, added his can-do, problem-solving capabilities to the many issues concerning the East Building site; associate conservator Katy May invented the technique to protect the glass and allow the work to "pass" into the building; together with her colleague Abigail Mack, she logged in countless hours to create the seamless look desired. Lieutenant David Lee from the office of protection services went above and beyond his duty requirements to ensure the safety of the public during the installation and to act as Goldsworthy's "bodyguard"; Roland Martin, Gino Ricci, and Patrick Verdin in the mason shop offered their expertise and muscle during the Herculean task of safely moving hundreds of tons of slate; Karl Parker, videographer, and Lee Ewing, photographer, were stalwart in their documentation of the entire project, through all types of weather, from the blazing heat of the slate quarry in summer to the freezing temperatures of the winter installation; in the deputy director's office Elizabeth Pochter managed the budget, and Nancy Deiss and Amie Price expedited every invoice and slate order. The artist's representatives from Galerie Lelong, New York — the indefatigable Mary Sabbatino, vice president; and Mark Hughes, director — provided assistance and support every step of the way, from an early studio visit, through the nuts and bolts of organization, to the completed installation of *Roof*. Gerri Jones, former head of the program for professors-at-large at Cornell University, assembled a group of students — Jane Padelford, Katherine Schiavone, and Danna Kinsey — who joined her in backbreaking labor during the first phase of *Roof*'s installation. They were followed by the able Barrett Thornton and Bennett Grizzard from the Maryland Institute College of Art, who assisted with the second part of the installation (I thank Therese O'Malley, associate dean, CASVA, for securing their services). Last in these acknowledgments, but far from least, are Jacob Ehrenberg, Goldsworthy's outstanding project manager in the field; Eric Sawden, the artist's invaluable studio manager; and Goldsworthy's team of drystone wallers: Steve Allen, Mark Heathcote, Andrew Mason, Gordon Wilton, and Jason Wilton. Without their tradition of masterful stonework, *Roof* would scarcely exist.

MOLLY DONOVAN

206

208

This index lists the location of all works in the catalogue. Many of these works are publicly accessible and can be visited. Others are privately owned and maintained. Inclusion in this list does not constitute a representation by the authors as to the accessibility of any particular work.

Every effort has been made to locate the copyright holders for the photographs used in this book. Any omissions will be corrected in subsequent editions.

Photographs by Andy Goldsworthy © 2010. Photographs by Lee B. Ewing © 2010 Board of Trustees, National Gallery of Art, Washington.

Details of *Roof* in progress
pages ii–iii, vi–vii, x, xviii–1, 14–15, 64–65, 204, 210: photographed by Lee B. Ewing

An Uncanny Rightness
Figs. 1, 11: Photographed by Andy Goldsworthy; Fig. 2: Photographed by Tony Richards, www.lakelandcam.co.uk; Figs. 3, 4, 7, 12: Illustrated by Martha Vaughan; Fig. 5: Photographed from Wilhelm Lübke and Dr. Max Semrau, *Die Kunst des Altertums*, Stuttgart: Greiner & Pfeiffer, Kgl. Hofbuchdrucker, 1908; Fig. 6: Photographed by Ralph Lieberman; Fig. 7: Image drawn from *Storia e Destino dei Trulli di Alberobello*, ed. Enrico Degano, Schena Editore, 1997; Fig. 8: National Park Service, photographed by Jonathan Parker; Figs. 9, 17: Photographed by Lee B. Ewing; Fig. 10: Photographed from D'Arcy Wentworth Thompson, *On Growth and Form*, 2nd ed. (Cambridge, 1917), Library of Congress, Washington, Rare Book and Special Collections Division; Figs. 14, 16: Image courtesy of the Board of Trustees, National Gallery of Art, Washington, photographed by Ric Blanc; Fig. 15: National Gallery of Art, Washington, Gallery Archive, photographed by Ric Blanc

Goldsworthy's Reveal
Fig.1: Image © Tate, London 2009; Fig. 2: Photographed by Martin Livezey; Figs. 3, 29: Image courtesy of the Board of Trustees, National Gallery of Art, Washington, photographed by Ric Blanc; Fig. 4: Photographed by Judith Gregson; Figs. 6, 8: Photographed by Lee B. Ewing; Figs. 9–11: Photographed by Molly Donovan; Fig. 12: Copy photograph © The Metropolitan Museum of Art; Figs. 13–15, 23–25: Photographed by Andy Goldsworthy; Fig. 18: Photographed by Thijs Quispel; Fig. 21: Smith, E.B.; *The Dome*. © Princeton University Press, 1978, reprinted by permission of Princeton University Press; Fig. 22: Art © Estate of Robert Smithson / Licensed by VAGA, New York, NY; Figs. 26–28: Photographed by Julian Calder; Fig. 30: Photographed by Steven Allen; Figs. 31, 32: Illustrated by Martha Vaughan

Catalogue of Commissioned, Permanently Installed Works
Comparative Figures
Figs. 1–3: Photographed by Andy Goldsworthy

Catalogued Works
Cats. 1, 2, 4–40, 42–73, 75–86, 88, 93–100, 102–104, 106–109, 112–114, 116, 118, 120, 121: Photographed by Andy Goldsworthy; Cat. 3: Photographed by Judith Gregson; Cat. 41: Courtesy of Haines Gallery / San Francisco; Cat. 74: University of Hertfordshire; Cats. 89, 91: Image courtesy of Randy Thueme Design, San Francisco, CA (2005); Cat. 90: Photographed by Trina Benson (2008); Cat. 92: Top image photographed by Andy Goldsworthy, bottom image courtesy of Museum of Jewish Heritage and photographed by Melanie Einzig; Cat. 101: Photographed by Lee B. Ewing; Cat. 105: Top image photographed by Andy Goldsworthy, bottom image photographed by Alain Sauvan / Musée Gassendi; Cat. 110: Top image photographed by Andy Goldsworthy, bottom image courtesy of Yorkshire Sculpture Park and photographed by Jonty Wilde; Cat. 111: Interior photographed by Andy Goldsworthy, exterior photographed by Jeffrey Berkus, AIA; Cat. 115: Images courtesy of Yorkshire Sculpture Park and photographed by Jonty Wilde; Cat. 117: Photographed by Jerry L. Thompson; Cat. 119: Image of runners and arch photographed by Mike Bolam, image of snow arch photographed by Andy Goldsworthy; Cat. 122: Photographed by Andrew Gellatly; Cat. 123: Large image photographed by Jean-Pierre Brovelli, all others photographed by Andy Goldsworthy